HOW TO
cheat
IN
Adobe Flash CS6

The art of design and animation

Chris Georgenes

Focal Press
Taylor & Francis Group

NEW YORK AND LONDON

First published 2013
by Focal Press
70 Blanchard Road, Suite 402, Burlington, MA 01803

Simultaneously published in the UK
by Focal Press
2 Park Square, Milton Park, Abingdon, Oxon OX14 4RN

Focal Press is an imprint of the Taylor & Francis Group, an informa business

Notices
Knowledge and best practice in this field are constantly changing. As new research and experience broaden our understanding, changes in research methods, professional practices, or medical treatment may become necessary.

Practitioners and researchers must always rely on their own experience and knowledge in evaluating and using any information, methods, compounds, or experiments described herein. In using such information or methods they should be mindful of their own safety and the safety of others, including parties for whom they have a professional responsibility.

Product or corporate names may be trademarks or registered trademarks, and are used only for identification and explanation without intent to infringe.

Library of Congress Cataloging in Publication Data
Application submitted

Typeset in Rotis Semi Sans 55
by MPS Limited, Chennai, India
www.adi-mps.com

Printed in Canada

Contents

5 Character animation 140

6 Flash to video 192

7 Animation examples..216

8 Working with sound 256

9 Working with video...272

10 Interactivity.282

Contents

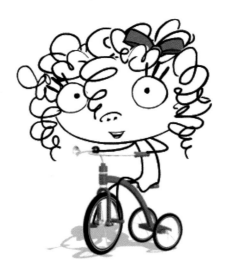

Foreword

Over ten years ago in a dimly lit basement, I started using the Flash authoring tool to create unpalatable, short, frame-by-frame animations - and discovered it was much easier than other tools I had been using to do the same thing. It's hard to believe what Flash has become over the years, and how many more people are out there using it to create content and share their work. One of the nice and inspiring things about Flash is that it attracts so many different users, from creative animators to hard-core programmers, and all sorts of people in-between.

I was assigned to work on testing a new type of motion tween for Flash a few years ago. Because the feature was already developed (but at the time untested), I needed to learn how everything worked from the ground up. Similar to other migrating Flash users, I have experienced and understand the learning curve between new and classic motion tweens! The new motion tweens are a different way of thinking about animation in Flash, however they do offer many advantages such as fewer "broken" tweens, attached motion paths, independent tweenable properties, tween presets, and preset eases. Some animations I've created in the past were faster or easier to accomplish after a bit of time spent with the new model. What about using "classic" motion tweens? Yes, there are some workflows where classic tweens are necessary and a couple cases where they're faster to use. However, the goal is to enhance and improve new motion tweens and the Motion Editor so using them is always possible and preferred.

You certainly don't need to learn everything there is to know about Flash and ActionScript to master the tool – you can choose to focus your talents on design or development, or challenge yourself from time to time by crossing over between graphics and code. But now that Flash is full of features and capable of so much, the tools can seem rather daunting to learn. But if you have helpful resources at your side, like this book, learning Flash doesn't need to be difficult. I believe the key to learning Flash is to keep it simple when you start out, take it slow, use the available resources (like books), and try to be patient. Also don't be afraid to go online and ask for help, we've all been there! Learning Flash takes some time, but it is a lot of fun and very rewarding.

Flash is an incredible tool for expressing your creativity, style, and unique ideas. Whether you're a new or existing Flash user, now is a great time to learn or use the software and get involved with the Flash community online. I hope that you use Flash with this book to get inspired, learn valuable new tricks and techniques, and create some wonderful animation. And of course, make sure to have fun with the software while you read and learn all about how to animate!

Jen deHaan
Sr. Software Quality Engineer, Flash Authoring
Adobe Systems Inc.

How to cheat, and why

The truth about cheating

The word "cheat", in most cases, has a negative connotation. To "cheat" implies deception and trickery associated with a fraudulent act. In some ways this book will show you how you can trick your audience, not unlike a magician's "sleight of hand" technique where you can control not only what is being seen, but how the viewer sees it. But this book will certainly not teach you how to be a fraud.

To "cheat" in Flash is to find shortcuts to help you work more efficiently and economically. Time translates to money and if you can deliver a great looking project on time, that means you stayed within budget and everybody wins.

My philosophy

At the end of the day, if I didn't have any fun, then it would be time to find another job. But I had to learn this lesson the hard way a few years ago while working with an animation company designing a network television series. I was designing the main characters for a show called *Science Court* (ABC), and there was a conflict between us and the network as to the choice of skin color for one of the characters. I liked green and the network preferred orange. I felt strongly that my color choice was the best and I admit I may have let myself become emotionally charged about the issue. One day I went to lunch with the animation director and we were casually talking about the color issue. It was something he said that changed my outlook on work from that day forward: *"We must have pretty cool jobs when the most stressful part of our day is whether or not a character looks too much like a frog."* I stopped dead in my tracks, instantly realizing how right he was and how silly I felt about the matter. After lunch we returned to the studio where I immediately changed the character to orange and never uttered another word about it. I even ended up liking the orange more than the green. Since then, my philosophy has always been to have fun no matter how stressful my workday gets. My job, in comparison to all other possible occupations, is the best job even on the worst of days.

Workthroughs and examples

Each workthrough in this book is designed as a double-page spread so you can prop the book up behind your keyboard or next to your monitor as a visual reference while working alongside it. Many of the workthroughs are real-world client projects I have been commissioned to design and animate. Using these projects as examples has allowed me to provide you with a downloadable zip file containing the source

files for you to open and explore. Each chapter ends with an Interlude in which I talk about everything from my own experiences as a designer and animator as well as some relevant and useful information based on the topic at hand.

Flash terminology

Not much has changed when it comes to terminology in Flash. **Symbols** have been around since the beginning and so has the behavior any symbol can have (Graphic, Movie Clip and Button). The **Timeline** has remained unchanged and **nesting** still pertains to assets and animations within symbols, one of the key strengths of Flash. If you already have a basic understanding of Flash then you will most likely be familiar with most of the terminology in this book.

Download Example Files

The download icon indicates the source file for that particular example is available for you to download from **www.howtocheatinflash.com/ downloads**. Download the ZIP file and unpackage it to your local hard drive. The unpackaged file contains all the example files found in this book and are for your learning pleasure.

Beyond the book

Be social. Visit **facebook.com/howtocheatinflash** to ask questions, get answers or post your own works of art and animation.

Follow me on Twitter@keyframer. I'm pretty consistent when it comes to tweeting about trends and technologies as well as cool new gadgets. You can also find out where and when my next speaking engagement will be.

Acknowledgments

Now I finally understand why so many authors dedicate their work to their spouses. With the utmost love and respect, I dedicate this book to Becky, who has always supported me and my career of "coloring" things.

I am eternally indebted to:

Bobby, Billy and Andrea for being the greatest characters I have ever helped create.

Mom and Dad for encouraging me to choose my own path in life.

Dave Bevans of Focal Press for his support and leadership.

Steve Caplin for all of his knowledge, vision and kindness.

Karen and Robert Williams for their love and support.

Fred Wessel and Dennis Nolan for giving me my greatest tool of all: the ability to draw.

Warm and fuzzy feelings to: Laith Bahrani, Karen Bresnahan, Joe Corrao, Tony Davis, Jen deHaan, Mike Downey, Scott Fegette, Warren Fuller, Richard Galvan, Gary "Gray" Goldberger, Jarred Hope, Thibault Imbert, Kevin Kolde, Sean Kranzberg, Christine Lawson, Shine Lee, Stephen Levinson, Dave Logan, Kirk Millett, Eric Mueller, Ben Palczynski, Davendra Pateel, Adam Phillips, Benedetta Pontiroli, Puck, Waymaure Seuell, Todd Sanders, Tim Saguinson, John Say, Aaron Simpson, Colin Smith, Evan and Gregg Spiridellis, Ed Sullivan, Steven J. Tubbrit ("Sunchirp"), Urami, Jackie Watson, Lily Welch, Willo, Lynda Weinman and Vivek.

Adobe Systems Inc., and the entire Adobe Flash team for making such a cool product.

Thanks to the following companies for their approval to use their projects as examples for this book:
Adobe Systems, Audacity, Cone Inc., Eltima, Erain, Euro RSCG Worldwide, Fablevision, Frederator, istockphoto, Jib Jab Media, Leapfrog Innovations and New Balance.

Some of the photographic images used in this book are from the following royalty-free image sources:
Adobe Stock Images
www.istockphoto.com

In memory of Max Coniglio.

How to use this book

I am a digital animator – a *Digimator* if you will. I learned how to animate using a computer. Any animation program can have a mechanical feel to it since we work by selecting options from menus much of the time. The trick I have learned is how to make a software program like Flash feel more organic, as if it were a ball of clay, starting with a basic shape and pushing and pulling it into something unique. If this book teaches anything, I hope it teaches you to think differently as to how you approach Flash. Just because the Help docs, online resources or even other books tell you how something can or should be done, don't take that as carved in stone. Take it as carved in clay, meaning you can continue to expand upon the ways the tools are used, even beyond what you may have read elsewhere.

The first few chapters focus on some of the basics of using Flash in real-world situations. I do not explain the rudimentary features of Flash, such as how to convert objects to symbols and what the differences are between Movie Clips and Graphic symbols. That is what the Help docs are for and are simply a keystroke away (F1). You bought this book to learn what goes beyond the Help docs and what can only be learned through the span of several years of experience using Flash. For you, this is the true essence of "cheating" because this book condenses those years into 300+ pages.

■No two snowflakes are exactly alike and the same can be said for artists and designers. A good drawing program will allow this individuality to be expressed without limitation.

1
Design styles

THE TECHNIQUES described in this book assume you have a reasonable working knowledge of Flash. In later chapters, we'll discuss ways of working that involve symbols, timelines and various animation techniques. This first chapter will serve as a refresher course on the fundamentals of designing for animation and introduce a few cool drawing techniques along the way.

Later on, we'll go into more detail on how to work with symbols, motion and shape tweening, and the timeline.

Drawing with basic shapes

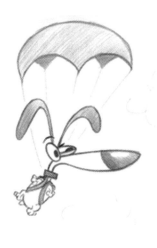

I F YOU PLAYED WITH Lego building blocks when you were a kid, you may find this drawing style familiar (or at least intuitive). You'll use several basic shapes and then connect them together. This technique requires breaking down each body part of the character into basic building blocks using the Rectangle and Oval tools. It's a fast and efficient way to simplify the character into manageable sections while achieving a very professional cartoon style.

Here, we will use shapes to cut in to other shapes. This is a very useful technique for cutting holes out of objects as well as altering the edges of shapes. Of course these techniques can be applied to background elements as well.

The key here is using simple shapes to build complex images suitable for Flash style animation, which we will get to in later chapters.

1 Here is my original pencil sketch that I have scanned and saved as a JPG file. I prefer to start with pencil on paper because I simply like the feel of this medium and the results are always a little more, shall we say, artistic.

2 After importing the scanned image, insert a blank keyframe on frame 2 and turn on the Onionskin tool. This allows me to trace the image in a new frame while using the original image as a reference.

6 To achieve the black outline, select the shape, copy it using ⌘ C ctrl C and paste it in place using ⌘ Shift V ctrl Shift V. While it's still selected, select a different color from the Mixer panel and scale it about 80% smaller.

7 The original shape is still present underneath your new shape. The trick is to position the new shape off-center from the original to achieve an outline with a varied weight.

3 Using the Oval **O** and Rectangle **R** tools allows us to quickly achieve the basic forms of our character. The Selection tool is great for pushing and pulling these basic fills into custom shapes based on our sketch.

4 Turn on the Snap option (magnet icon), and drag corners to each other so they snap together. This process is not unlike those Lego building blocks you played with when you were a kid.

5 Next, click and drag the sides of your shapes to push and pull them into curves. This is a fun process as your character really starts to take shape.

8 The parachute uses a slightly different technique I like to call "cutting in". Let's start with the Oval tool for the parachute's basic shape.

9 You can cut into this shape using different colored shapes such as this blue oval. Position it over the area you want to cut into, deselect it, then select it and hit the Delete key *Delete*.

10 Once your shape is the way you want it, you can use the Ink Bottle tool **S** to quickly add an outline to it.

Geometric and organic shapes

1 To suggest a fully mature tree with a plumage of leaves, you don't actually have to draw each individual leaf. Since the design style is targeted at young children, it's valid to keep the level of detail to a minimum. Select the Oval **O** tool and your desired fill color and create an oval shape. Next rotate it or skew to position it at an angle. Copy and paste it and scale it to add more "leaves". Rotate and position the new oval as shown above. There's no wrong decision at this stage as it is entirely up to you as to how much variation you want your tree to have.

DESIGNING WITH BASIC SHAPES is not limited to characters. For most Flash projects, I start with primitive shapes no matter what the object is I am designing, including props and backgrounds. At their most basic level, my designs start with simple ovals or rectangles and from there I build upon these shapes to create relatively complex images. This is what I love about working with vectors: the ability to push and pull them into anything I want as if they were made of clay.

 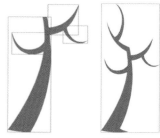

3 The trunk of the tree is designed in a similar fashion. Create a basic rectangle using the Rectangle **R** tool and use the Selection tool **V** to push and pull the sides and corners to give the trunk a slight curve and taper. Each branch is a duplicate of the tree trunk shape. Hold down **⌥ alt** and then click and drag the trunk to create as many duplicates of it as you want. Scale, skew, rotate and position each duplicate shape so that they resemble tree branches.

5 With Snap to Objects on, drag a corner point to another corner point until they snap together. This makes it easy to merge different shapes together accurately. To complete the front side of the birdhouse, create another square and drag the top 2 corner points to the bottom 2 corner points of the triangle with the Selection **V** tool until they snap together. Skew the shape with the Distort tool (subselection of the Free Transform **Q** tool) to suggest perspective.

2 Repeat the previous step by copying and pasting the same oval to suggest a larger plumage of leaves. Scale, skew and rotate the shape and position it off-center from the original oval. The objective here is to to create a non-symmetrical organic shape to suggest the imperfections that are found in nature. Remember, nothing in nature is perfectly horizontal, vertical, round or square, which is why there's no wrong way to do this. It's nearly fullproof since you can't

really make a mistake. In fact, mistakes are encouraged. As you can see I used a total of 4 ovals to complete my plumage of leaves. I could have used more or less but I felt this was just the right amount. Feel free to experiment with the number of shapes and variations for your tree. At this stage I couldn't help but add a little bit of texture to suggest some volume using the Brush **B** tool and a subtle yellow color.

4 The birdhouse is also built using simple shapes. The key here is to turn on the Snap to Objects feature represented by the magnet icon in the toolbar when you select the Rectangle **R** tool. Create a perfect square by dragging with the Rectangle tool while holding down the **Shift** key. Using the Subselection **A** tool, select one of the

corner points and press the **Delete** key. The square is now a triangle. Rotate the triangle using the Free Transform **Q** tool. Hold down the **Shift** key to constrain the rotation to 45 degree increments. Rotate the triangle until the bottom side is flat and the top side is pointed.

As you can see each shape has a bounding box around it. This is because Object Drawing mode *J* was turned on at the time the objects were drawn. This allows you to overlap objects without merging them together.

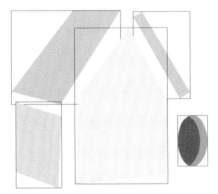

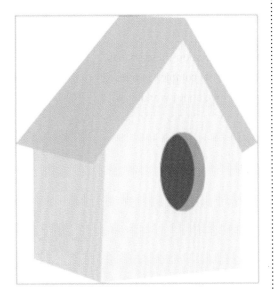

6 The remaining additional shapes for the birdhouse are also (you guessed it) simple rectangles and ovals. Keeping the Snap option turned on, drag corner points to each other to join shapes and as Object Drawings you can also overlap shapes to complete the image.

The Brush tool

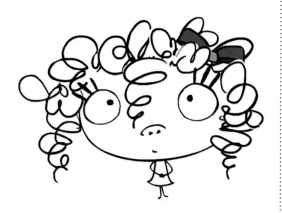

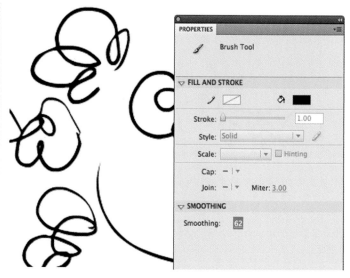

T HE BRUSH TOOL is probably the most versatile of all the drawing tools, especially when combined with a pressure-sensitive tablet. Drawing with the Brush tool is essentially drawing with shapes. It's the tool that feels the most natural due to the support of pressure sensitivity and tilt features.

Wacom makes a series of popular tablets that work great with Flash. Wacom tablets can work in conjunction with your existing mouse, or replace your mouse completely. Many digital designers use a tablet with any number of graphics editors including Adobe Photoshop and Adobe Illustrator.

When to use the Brush tool is really a matter of style and preference. For this character, I wanted to achieve a loose, hand-drawn feel, so the brush was a perfect choice.

1 The first adjustment you will want to make when using the Brush tool **B** will be the amount of smoothing you want applied. This option appears as a hot text slider in the Properties panel when the Brush tool is selected. The right amount of smoothing to use depends on personal preference. The higher the number, the smoother the line (and vice versa). For this character, we'll choose a low amount of smoothing to maintain an organic quality to the line work.

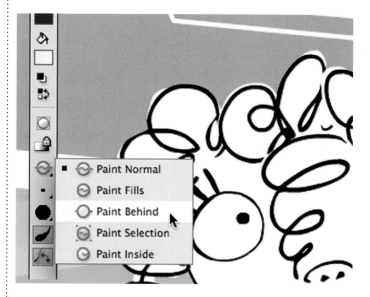

3 To remain consistent with the loose drawing style, you may want to add a fill color that bleeds outside of the outlines a little. There are several ways to achieve this by painting on a new layer below the outline art or setting the brush to "Paint Behind" and painting on the same layer.

2 Always design your characters with the intended purpose in mind: animation. Form follows function and the animation style can often dictate how a character is designed. If you are a perfectionist like me, you'll want the hair to look as much like individual curls as possible. To do this, avoid designing the hair as one large flat object. Instead, draw individual sections of curls to keep them as separate objects so they can be moved independently of each other. Turn on Object Drawing mode (subselection of the Brush tool). Object Drawing mode allows you to draw shapes as separate objects. These objects can be drawn over each other without them being merged together. You can select each Object Drawing with the Selection tool **V** and then convert each one to a symbol.

HOT TIP

Experiment with different stage magnifications when drawing. I prefer to draw on a larger scale and with the stage magnified about 400%. The result is typically a smoother line quality.

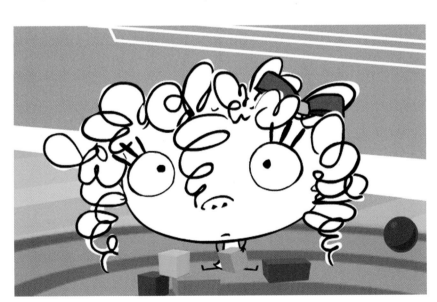

4 The final result represents the loose hand-drawn style we were after. The line quality feels natural and reflects the imperfections the human hand is capable of. We are not trying to achieve a slick design style here, but rather to convey a looser line quality representative of hand-drawn artwork. This style lends itself well to a child character as the integrity of the line is similar to how a real child would draw.

SHORTCUTS

MAC WIN BOTH

The Brush tool

1 The character sketch was created using ProCreate, a powerful drawing app for the Apple iPad. I used a drawing stylus instead of my finger because of its accuracy.

2 After importing the scanned image, inserted a blank keyframe on frame 2 and turned on the Onionskin tool, I began tracing the image in a new frame while using the original image as a reference.

IN ITS DEFAULT MODE, the Brush tool along with a graphics tablet that supports pressure sensitivity, is great for drawing shapes with a varied width. The success of the Brush tool may be due to its simplicity but that doesn't mean you can't achieve sophisticated results when using it. The Brush tool provides several options that affect how the paint is applied and with a little ingenuity, you can dictate how the Brush works based on your needs and workflow. This example shows my use of the Paint Selection setting for the Brush, allowing it to paint within the confines of a selected fill color only.

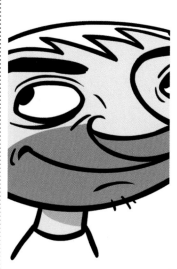

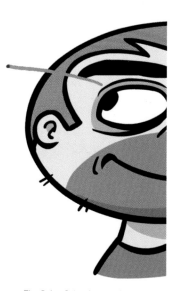

6 Paint anywhere inside the selected fill color without destroying any other part of the drawing. The shapes made with this Brush tool setting will be limited to the selected area only.

7 The Paint Selection setting is perfect for adding lines to suggest strands of hair. I also used this same technique for adding the shadows around the character's eyes.

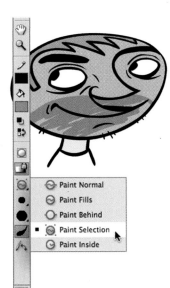

3 I traced the character using the Brush **B** tool. Typically I have the Brush tool smoothness setting at a value between 60-75 which is the setting found in the Properties panel.

4 With the character outline complete, it's time to mix a color for his skin tone and fill the head using the Paint Bucket **K** tool.

5 Select the fill color using the Selection **V** tool. To add some shading to the character, mix a darker value of the skin tone and then select the Paint Selection option from the Brush tool subselection menu.

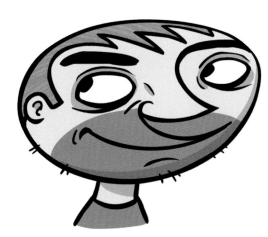

8 The Smoothing value was set to 72 for this drawing, meaning Flash smoothed the shapes created with the Brush tool just enough to remove most of my natural imperfections of drawing by hand. For a more natural-looking drawing, adjust the Smoothness to a lower numerical value.

9 Here's a version of the same character drawn with a Smoothing value of 0. The difference in line quality is subtle but if you look closely it's quite noticable how imperfect the overall image is. With no smoothing applied, the drawing can take on a completely different look and feel.

SHORTCUTS
MAC WIN BOTH

Mixing colors

THE FLASH CS6 COLOR panel gets a slight facelift. Instead of choosing between HSB or RGB we now have both displayed simultaneously and all color values are accurately controlled using hot text sliders. Mixing colors in Flash

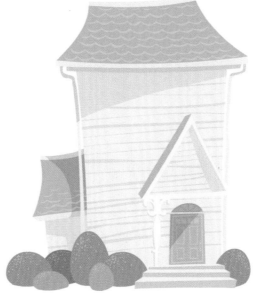

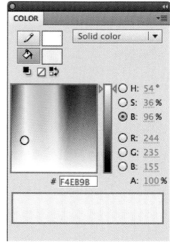

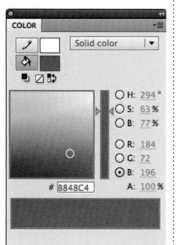

1 My typical workflow when mixing colors is to click and drag within the gradient window in order to select the approximate color I'm after. Once I have this color selected I like to use the hot text sliders to fine-tune my color selection. Hue and saturation can play an important role in the design process and for this particular background image I wanted to keep the colors muted to avoid overpowering the characters that were added later on. As you can see here, the main color of the house has a very low level of saturation but enough brightness to maintain a good level of clarity.

has never been easier or more accurate. The creative folks over at Big Pink asked me to create an animation for children between 2 and 5 years of age. Because of the target audience I wanted the animation to have a soft yet inviting color palette.

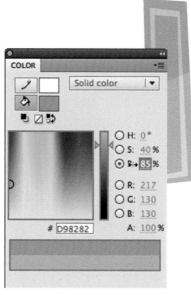

3 Once I had the overall pink color selected, mixing the darker shade of pink required a simple brightness adjustment. The large color swatch at the bottom of the Color panel will split to reveal the current color being mixed on top of the original color. This provides a visual reference for how the new color will contrast against the original color.

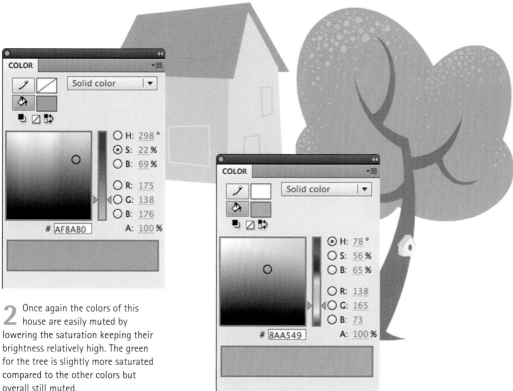

2 Once again the colors of this house are easily muted by lowering the saturation keeping their brightness relatively high. The green for the tree is slightly more saturated compared to the other colors but overall still muted.

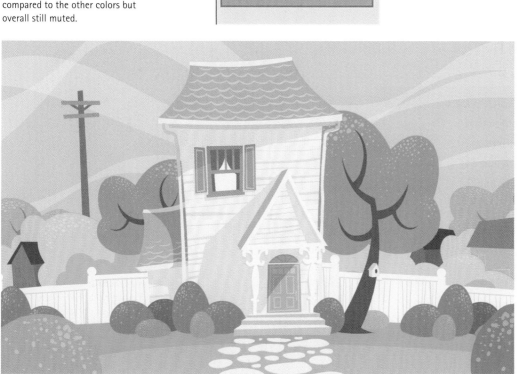

13

Advanced Color Effect

THE ADVANCED COLOR EFFECT separately adjusts the alpha, red, green and blue values of the instance of a symbol. It can be used in a variety of ways to suggest the tone of your graphic design or the mood of an entire animated scene. Let's take a look at how to adjust the color values of a symbol using the RGB hot text sliders. In the Color Effect section of the Properties panel, change the style mode to Advanced.

1 Select the symbol containing your artwork using the hot text sliders, change the value for red to 100% and both green and blue values to 0%. An overall hue of red will be applied to the symbol. Increasing the amount of green while decreasing red and blue will result in an overall greenish hue. Increasing the amount of blue while decreasing red and green will follow suit with an overall bluish hue.

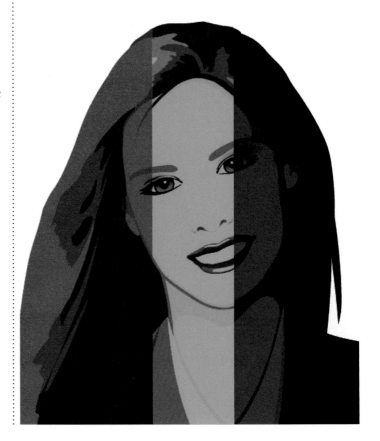

VECTOR ILLUSTRATION: CHRIS GEORGENES

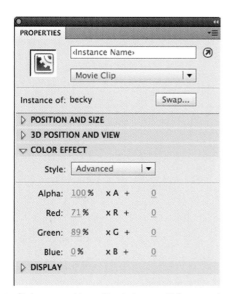

2 Red, green or blue will not always satisfy your color needs. By varying the amount of red, green and blue you can come up with almost unlimited variations of color tones to suit your design needs. Here I have an almost equal mix of red and green but no blue at all.

3 If the red, green and blue percentages aren't enough, you can produce more values by adjusting the values in the right column. These values will get added to the percentage values in the left column. For example, if the current red value is 100, setting the left slider to 50% and the right slider to 100% produces a new red value of 150 ([100 x .5] + 100 = 150).

HOT TIP

The advanced color values can also be animated over time using Motion tweens. Check out the animated example on page 16.

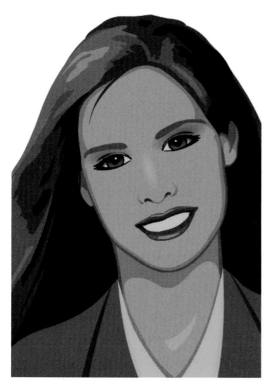

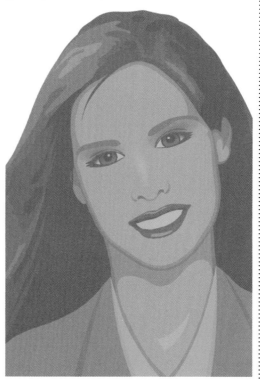

Animated Color Effect

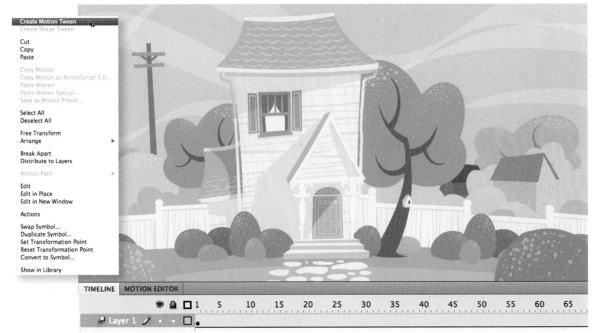

1 As animators we occasionally need to find ways to visually suggest the passing of time. One of the easiest ways to do this is to change the overall hue of an entire scene or background. As we know, this process naturally takes several hours, but through animation we can speed up time to convey the effect. In its initial shot, this quaint suburban home is designed to represent daytime, probably early afternoon given the angle of the shadow across the front door. The entire background has been converted to a symbol and a Motion tween has been created by right clicking over the symbol and selecting Create Motion Tween. Insert frames in the tween span by clicking on a frame further down the Timeline and clicking the F5 key. With the tween span extended, the hue of the entire scene can now be changed via the Color Effect section of the Properties panel.

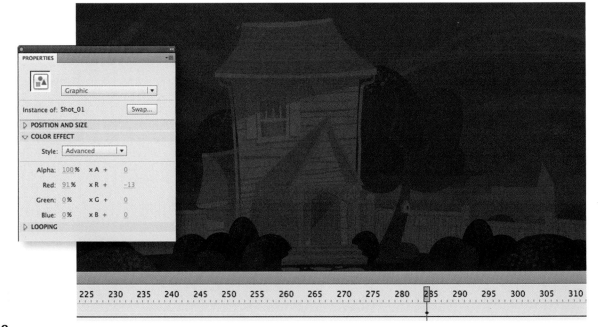

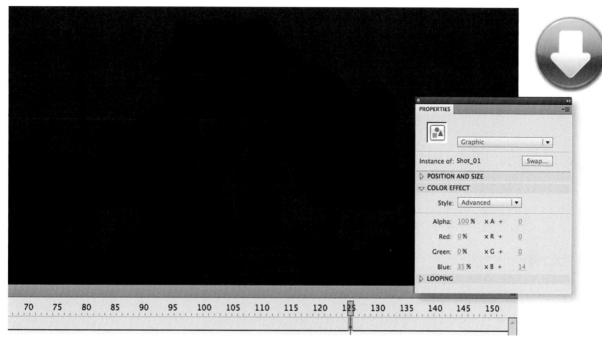

PROPERTIES

Graphic

Instance of: Shot_01 Swap...

▷ POSITION AND SIZE
▽ COLOR EFFECT

Style: Advanced

Alpha:	100 %	x A +	0
Red:	0 %	x R +	0
Green:	0 %	x G +	0
Blue:	35 %	x B +	14

▷ LOOPING

70 75 80 85 90 95 100 105 110 115 120 125 130 135 140 145 150

2 Make sure the frame indicator is at or near the end of the tween span. With the Properties panel open and Color Effect section expanded, select the symbol containing the background image. Using the hot text sliders, adjust the hue of the symbol instance. Here I have removed the red and green values by entering a numerical value of "0" for both and increased the amount of blue to suggest a cooler range of colors across the entire image. This implies a lack

of sunlight and creates a convincing night time mood. Position the frame indicator back at frame 1 and press the **Enter** key to playback the animation. The Motion Tween span will interpolate the difference in color values between the keyframes, resulting in a dramatic time lapse animation similar to the transition from day into night. You are not limited to just day and night as this technique can be used to imply a change of mood for dramatic effect.

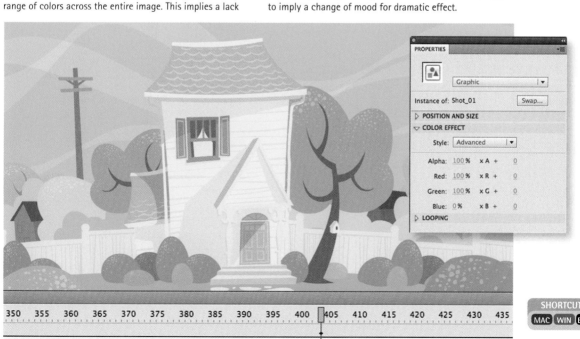

PROPERTIES

Graphic

Instance of: Shot_01 Swap...

▷ POSITION AND SIZE
▽ COLOR EFFECT

Style: Advanced

Alpha:	100 %	x A +	0
Red:	100 %	x R +	0
Green:	100 %	x G +	0
Blue:	0 %	x B +	0

▷ LOOPING

350 355 360 365 370 375 380 385 390 395 400 405 410 415 420 425 430 435

SHORTCUTS
MAC WIN BOTH

Using gradients

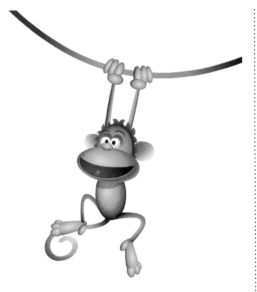

1 A simple radial gradient is used to fill most of the shapes that make up the monkey. The trick here is providing the illusion of a 3D object in a 2D environment. Four colors are used for this gradient. The critical color for this illusion is the fourth color (far right). It represents a light source coming from behind the sphere, suggesting the sphere is truly round.

GRADIENTS CAN BE VERY effective when you want to break away from the flatness of solid color fills. They can be used to add a sense of depth and dimensionality to your characters, backgrounds and graphics in general.

Gradients can also work against you due to their ease of use, resulting in generic and often lackluster images. When in the right hands, both linear and radial gradients can contribute to a very effective and sometimes realistic design.

4 To make the ear look concave, mix another radial gradient going from darkest in the center to a lighter value on the outer edge. Fill the shape with this gradient and position it off-center so that only half of the gradient is shown. Since darker colors will recede and lighter colors will appear closer to us, this otherwise flat shape now gives us the impression it is concave.

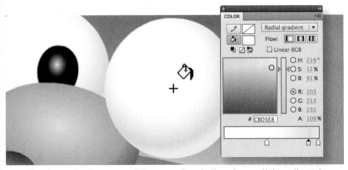

7 For those classic cartoon "ping-pong" eyeballs, mix a radial gradient the same way using white and gray colors. Color theory teaches us that to show light, you must show dark. Apply this technique to the eyes by placing them in front of a darker shape. This will help add some contrast, making the eyeballs *pop*, thereby adding depth.

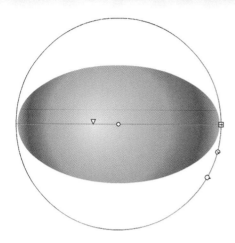

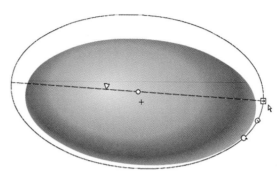

2 Edit the gradient to conform to the shape using the Gradient Transform tool **F**. Use the handles to rotate, scale and skew the gradient so it is slightly larger than the shape. Select the center control point and drag the entire gradient and position it slightly off-center from the shape.

3 Click and drag the focal point tool so that the highlight is positioned between the center of the shape and its edge. By doing this you are suggesting that the light source is at more of an angle. Notice the fourth color of our gradient is showing along the bottom and right edge. This implies light wrapping around the sphere from behind.

5 The hair is a shape filled with another radial gradient. Most of this shape will be hidden behind other graphics, so you only need to concern yourself with how the outer edge looks when the character is fully assembled.

6 The hands are really not hands at all. A few strategically positioned spheres with the same radial gradient as the face and body are used to suggest hands.

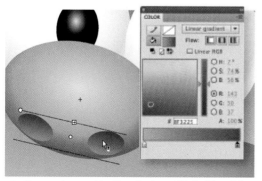

8 The nose is a combination of spheres filled with radial and linear gradients. To create the nostrils, use a linear gradient and edit it so that the darker color is above the lighter color. By themselves, the spheres are just shapes. But placed against the radial sphere, they become holes.

9 Good designs are consistent in technique. When each element is comprised of the same graphical style, the overall result will typically be consistent and fluid. Don't deviate from your plan; choose a technique and stick with it.

HOT TIP

Experiment with different stage magnifications when drawing. I prefer to draw on a larger scale and with the stage magnified about 400%. The result is typically a smoother line quality.

SHORTCUTS

19

Adding texture

1 The first task is to design your textures. A digital camera is a very handy device for this purpose. Take a walk around your neighborhood and you'll quickly find an unlimited supply of interesting textures that can be used for your designs. Use Photoshop to adjust the color, add filters and crop your images. Remember to keep the image small enough for web output.

BITMAPS CAN BE A VERY effective way to add texture to your designs. Since any image could be a potential texture, the possibilities are endless. For this frog character, I wanted a slightly more sophisticated look while still maintaining a cartoon feel. Instead of using solid color fills and some spot color shading, the use of imported bitmap textures added that extra sense of depth and richness.

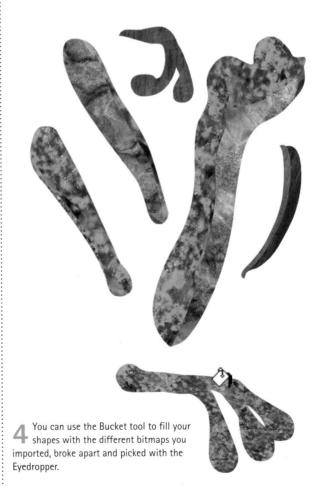

4 You can use the Bucket tool to fill your shapes with the different bitmaps you imported, broke apart and picked with the Eyedropper.

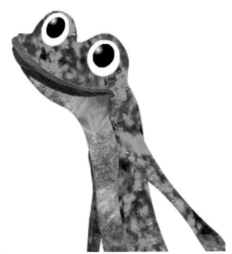

2 Select the imported bitmap and break it apart ⌘ B *ctrl* B. Click on it using the Eyedropper tool. It will now be added to the Color Mixer as a swatch.

3 Using the Brush tool, draw your shapes using the bitmap as the fill color.

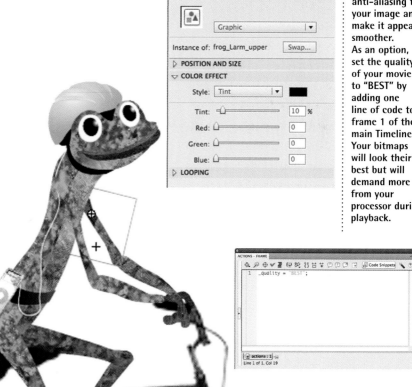

5 Most likely the bitmap fill will need to be scaled, rotated or re-positioned. Select the Free Transform tool **F**, and edit your fill using the various handles around the bounding box.

6 The final step is to convert all parts to symbols and add a slight amount of dark tint to the instances behind the character. This helps separate similar bitmap textures from each other and adds a touch of depth.

21

Adding texture (cont.)

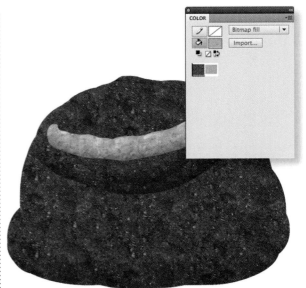

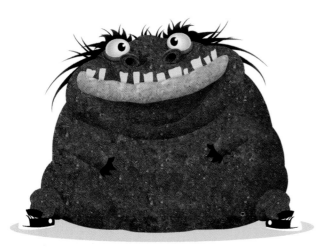

BITMAPS DON'T ALWAYS have to look flat. Introducing "Grotto", a character made almost entirely of bitmap fills and some carefully placed Flash gradients to provide the illusion of form, volume and, most of all, texture.

Here we'll look at how to give otherwise flat bitmap textures a bit more depth using some basic gradients and alpha.

1 The first step is to create your texture in Adobe Photoshop, import it into Flash, break it apart and then select it with the Eyedropper tool *I*. I created the shape for Grotto's body with the paint brush and the bitmap swatch as my fill "color". Select the body shape and convert it to a Graphic symbol.

4 Sometimes the devil is in the detail, which is evident here with the addition of some subtle highlights to the lip. On a new layer use the Brush tool to paint some shapes and then fill them with a linear gradient containing 30% white to 0% white. Use the Fill Transform tool *F* to edit the gradient as necessary.

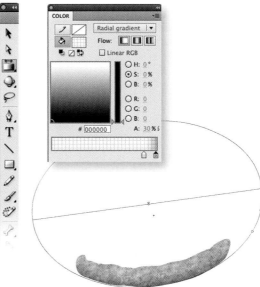

2 Edit the symbol by adding another layer above the shape layer. Copy ⌘ C ctrl C and paste in place ⌘ Shift V ctrl Shift V the body shape into this new layer. Fill it with a radial gradient with two colors; black with about 30% alpha and black with 0% alpha.

3 The mouth/lip symbol was made the same way by layering a radial gradient over the bitmap fill shape. Use the Fill Transform tool to position the gradient so it forms a shadow along the bottom half of the shape.

HOT TIP

You may also want to adjust the properties of the imported bitmap (double-click the bitmap icon in the document library and select "Apply Smoothing"). This will apply anti-aliasing to your image and make it appear smoother.

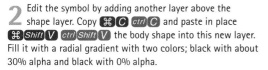

5 The nostril is another example of layering various gradients over the original shape containing the bitmap fill. Here I used a linear gradient for the inner nostril shape and a radial gradient to provide some shading for a more realistic effect.

6 When all these subtle details are combined, they can add up to a very sophisticated image. The shapes that make up Grotto are simple yet convincing, simply by layering some basic gradients over our textures.

SHORTCUTS

MAC WIN BOTH

23

The Pen tool

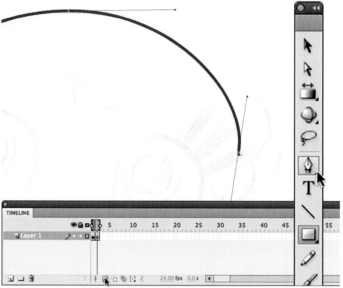

SO FAR IN THIS CHAPTER we have looked at several ways of achieving different styles of drawing: from the basics of snapping simple shapes together forming bigger, more complex shapes, to using bitmaps as textural fills. Most of the time the design process demands a combination of tools and techniques to get the job done. For this character design I went from a rough pencil sketch to a fully rendered vector drawing using the Pen tool and basic shapes. The Pen tool, in combination with the Selection tool, offers infinite flexibility when it comes to manipulating strokes and shapes.

1 Start with a scanned sketch or draw directly into Flash. Create a blank keyframe on frame 2 and turn on the Onionskin feature. Using the sketch as reference, trace the hair using the Pen tool by clicking and dragging each point as you go. This will automatically create curves with Bezier handles, allowing you to manipulate the stroke each time a point is made.

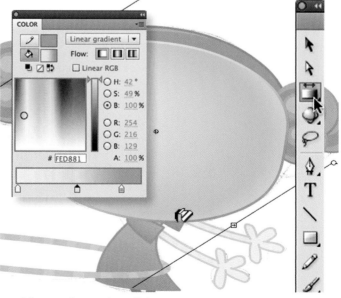

5 A linear gradient can be applied to a path without having to convert it to a shape like in older versions. For this gradient I chose to mix 3 colors: a light, mid and dark tone. With this gradient selected in the stroke color swatch in the Color panel, click on the path using the Ink Bottle **S** tool to apply it. Edit the gradient using the Gradient Transform tool **F**.

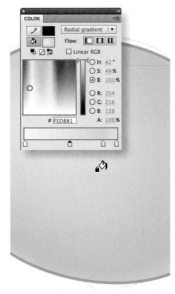

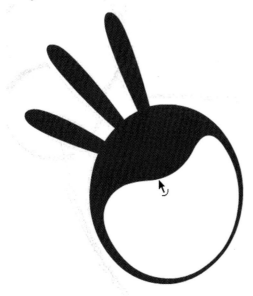

2 Using the Subselection tool **A**, modify the contours of the hair by clicking an anchor point and adjusting its Bezier handles. Once this shape is complete, temporarily cut and paste it to a new layer and lock it to avoid editing it unintentionally.

3 To add an anchor point, hover the Pen tool over the path until you see the "+" symbol appear and click. Remove an anchor point by hovering over and clicking it.

4 Once you have closed the path, fill it with a color. Here I have mixed a radial gradient to provide a sense of volume to the shape.

6 The Pen tool is clearly a useful tool for drawing paths, but in some situations the Oval and Rectangle tools are a better and faster alternative. The Selection tool **V** can be used for basic editing of paths made with the shape tools.

7 The final result is a combination of shapes and paths created with the Pen, Oval and Rectangle tools. Editing of these paths and shapes was the result of using the Selection, Subselection and Pen tools.

HOT TIP

Go to Edit > Preferences > Drawing and make sure the "Show Pen Preview" option is checked. This will allow you to see a preview of what your lines will look like as you are drawing with the Pen tool. Hold down the Shift key to snap your lines to 90 and 45 degree angles as you draw. To designate a control point as the end of your line, hold down the Ctrl/ Command key while clicking.

SHORTCUTS

Trace Bitmap

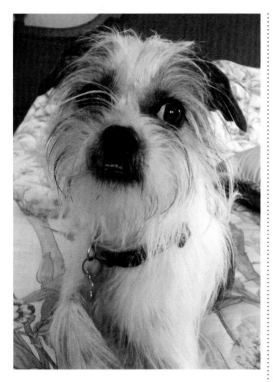

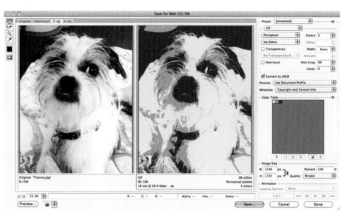

1 Start with a good quality image that has enough color contrast. Open it in Adobe Photoshop and save it as a PSD file. Now may be a good time to adjust the contrast, saturation, colors or whatever else you prefer to edit. Save for Web using ⌘ Shift ⌥ S ctrl Shift alt S and select GIF as the file format. Select Grayscale from the Color Reduction drop-down menu and limit the number of colors to two or three depending on the image and amount of colors your prefer to keep. Click Save and name your new GIF image.

PHOTOGRAPHIC IMAGES can be used to add a measure of realism to any Flash project. They can be imported and used in their original state, or they can be simpified for a unique, stylized look. The obvious approach to vectorizing photographs is to import the image into Flash and use the drawing tools to trace it by hand. But that can be very time-consuming depending on the complexity of the image.

The trick here is to average down the amount of colors your image contains, and Adobe Photoshop makes this an almost effortless task. Combine that with the Trace Bitmap engine in Flash, and you won't even have to select one single drawing tool!

4 Select the entire image and go to Modify > Shape > Optimize to open the Optimize Curves panel. With Preview selected use the slider to adjust the amount of smoothing desired and click OK.

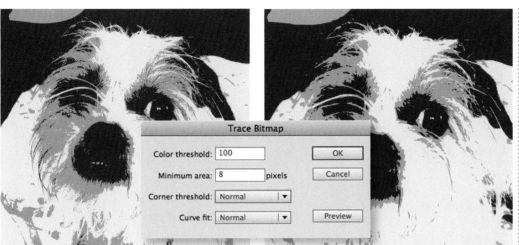

2 Import the optimized GIF into Flash ⌘ R *ctrl* R. Make sure it is selected and go to Modify > Bitmap > Trace Bitmap. In the Trace Bitmap dialog panel, you can adjust individual settings that will ultimately dictate the level of complexity your image will have when converted to vectors. The proper setting will vary depending on your image and personal preference.

3 Once the trace is complete, your image will be all vector and fully scalable. The resulting image of this dog is now only 88k but we can get it even smaller by using Flash's built-in Optimize engine.

HOT TIP

When optimizing curves using the Flash optimizing feature, set the stage magnification to 100% or lower. Total optimization may vary depending on the magnification of the stage. Optimization tends to have a greater effect with smaller objects and less of an effect with larger ones. You will have to conduct your own experimentation for the preferred ratio between optimization and image quality.

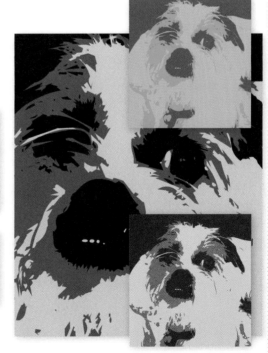

5 Flash CS6 offers Advanced Smooth and Straighten panels that provide more control over how your vector image is optimized. Both of these panels can be found by going to the Modify > Shape menu.

6 End result is an image that is very lightweight for the Web, weighing in at only six kilobytes. It is also easy to change its color scheme using the Paint Bucket tool **K** and the Color Mixer.

SHORTCUTS
MAC WIN BOTH

Image Trace (Illustrator)

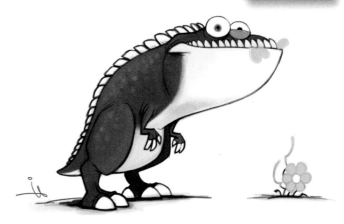

1 The original sketch was drawn by Hussam using Adobe Photoshop using subtle variations in color and shading. It will be interesting to see how well the Trace Image engine converts these subtle nuances in color from pixels to vectors. Place the bitmap into an Illustrator document by choosing File > Place.

ADOBE ILLUSTRATOR AND FLASH Adobe are two of the best vector drawing applications available. In terms of drawing tools, Illustrator has a much more sophisticated toolset than Flash does and for this reason it is worth taking a look at a new feature for Illustrator CS6; Image Trace.

Image Trace is the replacement for the Live Trace tool and for good reason: Image Trace is much more powerful and does a much better job at tracing your bitmap images.

The dinosaur character I'm using for this example was created by my friend Hussam Nassour of Dubai, United Arab Emirates. Hussam is a wonderfully talented character designer and CG artist. The dinosaur sketch is a perfect example for vectorizing using the Image Trace feature. Visit sketchwings.com to see more of Hussam's work.

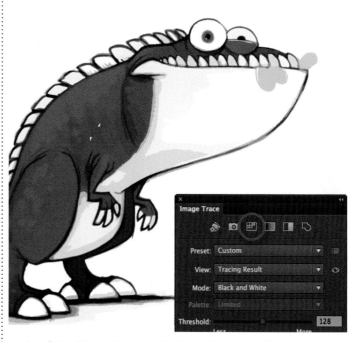

4 Low Color will trace the image with fewer colors than the High Color option. Low Color is useful if you want fewer colors and a more stylized look to your image.

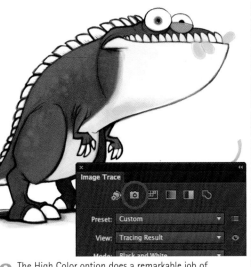

2 Open the Image Trace panel by choosing Window > Image Trace. Select the bitmap and click the Auto Color icon to begin the Trace Image conversion. The Auto Color preset will convert the image to vectors while averaging the colors to a limited number of values.

3 The High Color option does a remarkable job of converting the image to vector paths while maintaining the same integrity of the original. The converted paths look almost identical to the original bitmap.

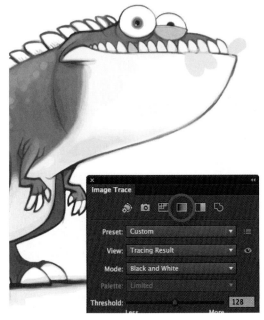

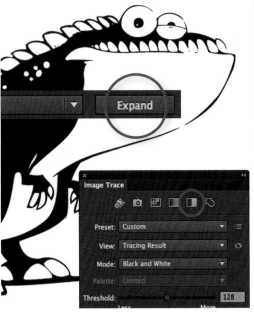

5 Grayscale converts the image to vectors while converting the colors to gray tones.

6 Black & White converts the image to black and white vector fill colors only. To edit the paths in Illustrator CS6, click the Expand button located in the main tool bar.

Shading 1: line trick

THERE ARE ALWAYS SEVERAL WAYS to achieve the same result in Flash. With all the various tools at our disposal, I am constantly finding different ways of using them to achieve various effects.

Cell shading is commonly referred to as "toon shading". This style of shading is popular with comic book style artwork and classic Disney films. I have discovered four different ways to achieve cell style shading for you to choose from.

1 Start with a basic shape that contains a fill and outline. This technique will work just as well with shapes that have no outlines.

2 Select the Line tool **N** and make sure the Snap to Objects tool is also selected in the toolbox.

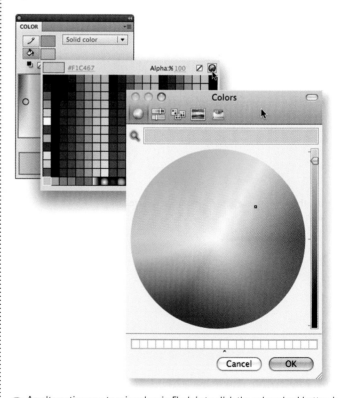

6 An alternative way to mix colors in Flash is to click the color wheel button in the upper right corner. This will open the color palette mixer that is native to your operating system. Mix your new color and click "OK".

3 Draw a diagonal line inside the fill of your shape. Use the Selection tool **V** to drag each end point of the line so they snap to the edge of the fill.

4 Use the Selection tool to bend the line so that its arc reflects the shape of the oval.

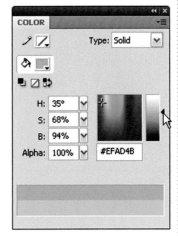

5 With the fill color selected, mix a slightly darker color using the Color panel mixer.

HOT TIP

Cell style shading can be difficult to achieve. You have to imagine that your two-dimensional shapes have a third dimension and they are affected by light and shadow. Choose a light source and keep it consistent throughout your design when adding shading.

7 Use the Bucket tool **K** to fill the shape you created with the Line tool.

8 Select the line and delete it. Easy, right? If it still isn't perfect, you can continue to use the Selection tool to edit the edge of the new fill you created.

31

Shading 2: shape it

1 Using the Rectangle tool **R**, draw a box inside your shape that contains a darker fill color (no outline).

2 Use the Selection tool **V** to pull the corners until they snap to the edges of the shape (make sure the Snap feature is turned on).

HERE'S ANOTHER VARIATION on cell style shading in Flash. This technique involves the Rectangle tool and allows for more complex shading. This may be preferable if your shapes require more complex shadows.

5 Let's take this technique one step further by adding more shading for a more realistic effect. Repeat the above procedure using an even darker color inside the shaded area.

6 Use the Selection tool to pull the corners until they snap to the edges of the shaded shape.

3 Fill the gap area created after snapping the corners to the edge of the shape.

4 Use the Selection tool to bend the edge of the darker fill color so that its arc reflects the shape of the oval. Having used the Rectangle tool, you have an extra corner to play around with. This can be useful for creating more complex shading such as with the ear shape.

7 Fill the gap area created after snapping the corners to the edge of the shape.

8 Use the Selection tool to bend the edge of the darker fill color so that its arc reflects the contour of the shape.

9 You can repeat this procedure as many times as you like. The more color values you add, the more realistic the image will be.

HOT TIP

If you would like a cool and easy way to create various hues based on your original color, give Adobe's Kuler tool a try (kuler.adobe.com). You can mix shades of color very easily and then save and download them as ASE (Adobe Swatch Exchange file). Open the downloaded ASE file(s) in Illustrator and then save your new swatch panel as an AI file and import it into Flash. An easier way would be to manually copy the HEX value from the Kuler site and paste into the Flash Color Mixer panel.

SHORTCUTS
MAC WIN BOTH

33

Shading 3: paint selected

1 Start with a shape.

2 Select the Brush tool **B** and then from the brush mode subselection menu, select Paint Selection. This will restrict any paint to selected fills only.

WE ARE ALL DIFFERENT and we tend to find different ways of using the same tools. We get used to certain techniques because they become familiar to our workflow and we become comfortable in our own individual habits. Here is yet another technique for creating cell style shading that you may prefer over the previous versions. It lends itself well to the designer who likes a more hand-drawn feel to their work.

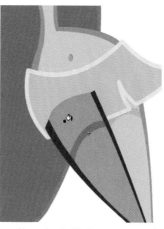

6 Next, simply fill the space created by the new fill you just painted.

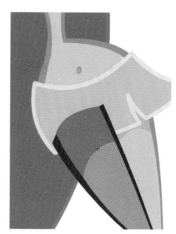

7 Voila! Now you've got a convincing cell style shading for the leg.

3 Use the Selection tool **V** to select the fill color you'll be adding the shade color to. Now use the Brush tool and adjust the amount of smoothing desired for the shape you'll paint. Next, paint inside the selected fill.

4 Don't worry about being sloppy. Once you release the brush, the painted fill will exist only inside the selected area you intended.

5 Sometimes the area may be too large to paint entirely by hand. In this situation, just draw the contour of the edge for the shaded area.

HOT TIP

Consistency is important when it comes to your light source. It helps to limit yourself to one light source if possible and create your shading based on the angle the light source is coming from.

8 The face shading can be drawn the same way. Remember the direction your light source is coming from and paint a crescent fill.

9 Fill the space created by the new fill and you are done.

10 Cell shading can add that extra dimension to your designs, giving them depth and realism.

SHORTCUTS
MAC WIN BOTH

35

Shading 4: outlines

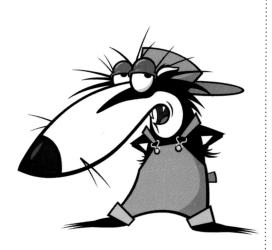

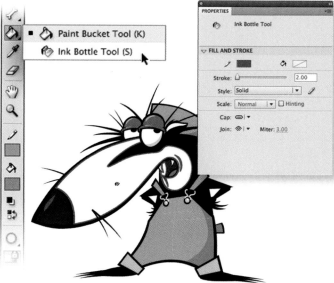

THIS VARIATION ON CELL STYLE shading works well for simple shapes and very complex shapes. If you have line work that is very loose and hand-drawn looking, this may be the technique for you. You will use the Ink Bottle to create a line around your fill. Then you can reposition this line off-center and fill the space created with a darker shade of color.

1 Start with the Ink Bottle tool **I** and a stroke color that doesn't exist anywhere in your design. Set the stroke height to around 3 or 4 point. Click anywhere within the fill to outline it with a stroke in the color you chose. Don't worry about how it looks because you will eventually delete this line entirely after you are done.

4 For this character's outfit, I applied a stroke outline to the overalls as well.

5 The stroke is selected and repositioned based on the same light source as in the previous example.

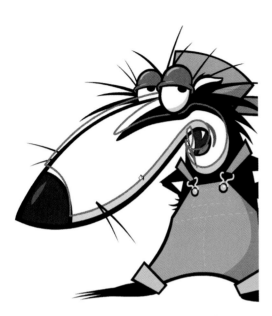

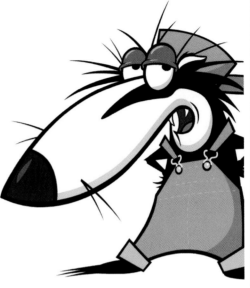

2 Select the line by double-clicking on it with the Selection tool. Next, use the arrow keys to nudge it away from the original shape in the direction of your light source. Fill this area created between the stroke and the original edge of your shape with your shade color.

3 Delete the entire stroke by pressing the *Delete* key. If your stroke has been deselected, select it by double-clicking on it with the Selection tool. Double-clicking the stroke will select the entire stroke while single-clicking on it will select a segment of it if it contains multiple points.

6 A darker shade of color is mixed and filled to create the illusion of form and realism.

7 With the stroke still selected, delete it. In some cases, the resulting shape created may need some tweaking.

8 Use the Selection **V** tool to further refine your shading based on your needs and design sense.

SHORTCUTS
MAC WIN BOTH

Realism with gradients

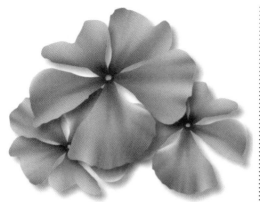

FLASH IS MUCH MORE than a tool for designing cartoon characters. Its full array of vector drawing tools is suitable for many styles of illustration. Here we will go step by step creating a realistic flower illustration. Flowers are always appealing to draw and at the same time challenging due to the subtle variations of color they often contain.

The main tools to be used for this example are the Pen tool and Gradients. The Pen tool has been greatly improved in Flash CS5 and if you are familiar with Illustrator's Pen tool, you will notice some similarities. Flash has adopted the core functionality of Illustrator's Pen tool including identical shortcut keys and hot key modifiers – not to mention identical pen cursors as well. Integration is bliss.

One particularly cool Pen tool trick is to hold down the spacebar to redirect the current point while drawing. Another nice feature in CS6 is that the auto-fill when completing an enclosed shape with the Pen tool has been removed for consistency reasons.

The more you experiment with the new Pen tool the more I think you'll like it. In fact, I think it's better than Illustrator's Pen tool.

1 The first step is to outline the basic shape of the flower's petal with a stroke color that is high in contrast to the original image. Be as precise as you want, but I recommend using the original image as a guide, simplifying where needed along the way.

2 The Pen tool **P** is perfect for this task simply because it is quick and easy to manually trace the contour of the petal by clicking and dragging along the contour of the image.

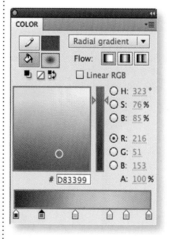

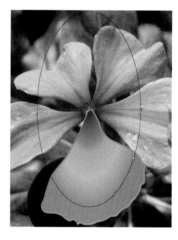

6 The initial gradient will provide the overall hue and tonal range of the flower petal. Flash lets you apply up to 15 color transitions to a gradient.

7 Fill your shape with your radial gradient and then use the Fill Transform tool **F** to edit its size, position and rotation. You can delete the stroke at this stage as it is no longer needed.

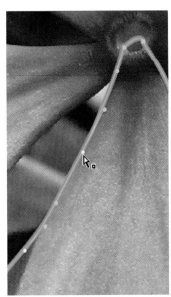

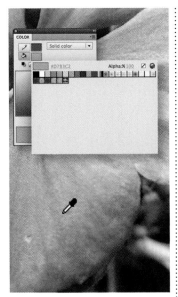

3 To close the path, position the Pen tool over the first anchor point. A small circle appears next to the Pen tool pointer when positioned correctly. Click or drag to close the path.

4 Use the Subselection tool **A** to refine your path if you desire. To adjust the shape of the curve on either side of an anchor point, drag the anchor point, or drag the tangent handle. You can also move an anchor point by dragging it with the Subselection tool.

5 Next we need to mix some radial gradients. Flash's color picker can grab colors from anywhere on your screen if you click on any of the color swatches found in the Color Mixer, Properties panel or the toolbox and drag to the area containing your desired color.

HOT TIP

To constrain the curve to multiples of 45°, hold down the Shift key while dragging. To drag tangent handles individually, Alt-drag (Windows) or Option-drag (Macintosh).

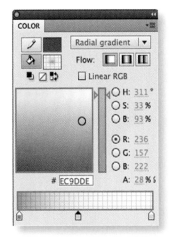

8 Copy ⌘ C ctrl C and Paste in Place ⌘ Shift V ctrl Shift V this shape to a new layer as you will be layering several gradients on top of each other to create a realistic effect. The following gradients contain varied amounts of alpha to create subtle transitions in color.

9 Fill the duplicated shape with your new gradient and use the Fill Transform tool to create the suggestion of subtle undulations within the shape. Repeat the process of copying and pasting in place this shape to new layers for each new gradient.

10 You can manipulate each new gradient using the Free Transform tool to create soft shadows and highlights. In almost all cases, you will only use partial gradients to create subtle transitions of light and shadow.

SHORTCUTS
MAC WIN BOTH

Realism with gradients (cont.)

11 It's always convincing to position soft shadows where the edge of the shape contains an imperfection. The combination of gradient colors and irregular contours makes for a very convincing imperfection.

12 This is the end result of using several variations of layered radial gradients, producing beautiful and convincing variations of color.

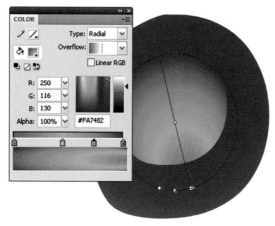

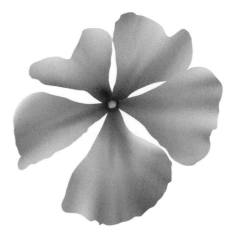

15 To achieve the effect of depth in the center of the stigma, drag the little white arrow in the radial gradient's center to move the focal point towards the edge.

16 Here's what the flower image looks like once all the petals and stigma have been illustrated. But you don't have to stop here. Let's have some fun with Flash's filters. Convert the entire flower to a Movie Clip symbol.

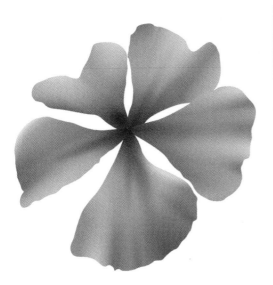

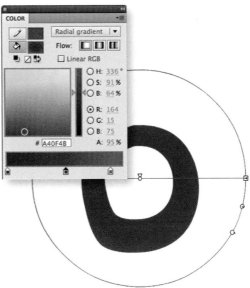

13 Repeat the same procedure for each petal of the flower image. To keep your main timeline layers to a minimum, convert each layer to a group or an object drawing and convert each petal to a symbol.

14 The center of the flower, technically named the stigma, was created with a donut-shaped fill containing a radial gradient.

HOT TIP

The technique of mixing gradients with transparency and layering them so they overlap each other, can produce effects that go beyond radial and linear gradients. You can actually use this technique to create gradients with abstract shapes and curves that go beyond what the default gradients were designed to look like. It takes a measure of trial and error to achieve the look you want, but in the end the final results may be worth the extra effort.

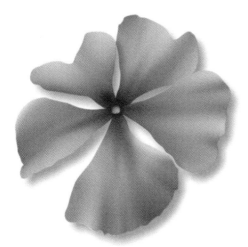

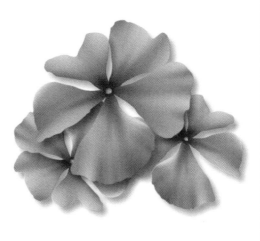

17 From the Filters panel, add a Drop Shadow. Set the blur, alpha and distance to your desired amount. You may want to also add a Blur filter to soften the overall image of the flower.

18 Duplicate the instance of the flower movie clip. Scale and rotate them to create an appealing floral arrangement. It's almost hard to imagine this style of illustration can be made entirely in Flash, right?

Spray Brush tool

Flash CS6 provides us with a design tool called the Spray Brush. The name describes its function accurately, as this tool will create a customizable spray pattern in seconds.

Upon initial use, the Spray Brush may seem simple and unimpressive. But you can customize the Spray Brush to suit your needs and extend its use across various types of applications. The Spray Brush provides unlimited customization by assigning any Movie Clip symbol from the Library to use as your spray object. Add some animation to your Movie Clip and you now have the ability to spray animations across the stage!

1 Here we will create a simple outer space scene and populate it with "stars". Start by making a background graphic the size of the stage using a simple linear gradient with dark colors.

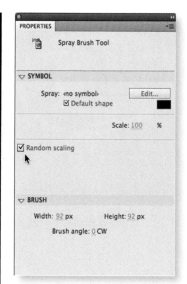

2 Use the Spray Brush tool **B** to create the stars. Customize its properties by selecting white as the color and selecting Random scaling.

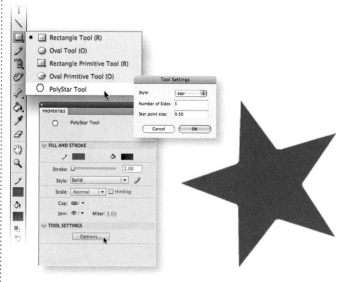

1 The Spray Brush tool is assigned a circle shape by default, but you can swap this for any Movie Clip or Graphic symbol you have in the document's Library. Here I've created a 5-pointed star using the PolyStar tool and converted it to a Movie Clip.

3 Click to create short bursts of "spray" using the default object (which is just a simple vector circle). You can click and drag across the stage to produce a continuous spray pattern.

4 With random scaling selected, the pattern (or lack thereof) produces a convincing galaxy-like effect. Throw in a planet or two and a dog in a space suit and your scene is complete.

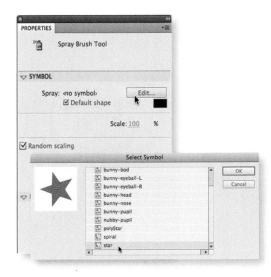

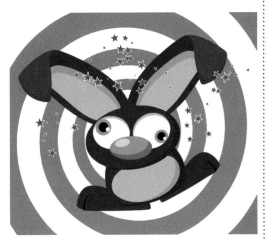

HOT TIP

You can take this effect even further if you create an animation inside the Movie Clip or Graphic symbol you select with the Spray Brush. Open the file "sprayBrush-2. fla" from the source disk and test the movie to see the effect in action.

2 Select the Spray Brush tool **B** and then click Edit in the Properties panel. The Swap Symbol panel opens to display all Movie Clip symbols in your Library. Here I've selected my "star" Movie Clip.

3 Click or drag to create a random pattern using the Star symbol. For this example I sprayed stars around the character's head to suggest it may have suffered a head injury or has become dizzy. The point is, the Spray Brush tool can make short work of repetitive tasks such as this.

SHORTCUTS

UI Design

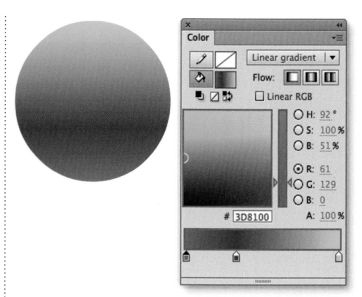

Y OU MIGHT BE WONDERING why I'm featuring a design that looks like it was created with Adobe Photoshop or Fireworks or perhaps Illustrator? It is precisely for this reason I chose this graphic because the *download available* icon used throughout this book was created entirely with Flash. I love using Flash to create graphics and buttons for user interfaces because it forces me to be simple. I also like how the Flash drawing engine allows me to quickly and easily manipulate vector shapes.

1 The first step is to create a circle using the Oval tool with a fill color only. The stroke color swatch is purposely empty to avoid having a stroke added to the shape. The fill color is a linear gradient using a variation of 3 green colors. The mid-tone is the darkest color while the color swatch on the left is of a slightly lighter value and the swatch on the far right is the brightest. This shading simulates a light source coming from above. Select the shape and convert it to a Movie Clip symbol by pressing the F8 key.

5 Since black doesn't necessarily convey a highlight very well, we need to mix a new color. In fact, another linear gradient will work well here. Using only 2 color swatches, use white for both but adjust the Alpha transparency of the left swatch to around 69% and the right swatch to 19%. Fill the shape with this gradient and adjust it by using the Gradient Transform tool. The end result should have the more opaque color at the top and the less opaque color at the bottom.

2 Copy and Paste in Place the original circle to a new layer. For illustration purposes I have filled it with a solid black color. Scale it so that it's slightly smaller than the original. I recommend locking the original layer.

3 Using the Selection tool, start outside the shape and click and drag across the bottom half of the circle in order to select only the bottom half of the circle. Press the Delete key to remove it.

4 With the top half of the circle remaining, deselect it by clicking anywhere outside of it using the Selection tool. Now click and drag the lower edge down to create a slight curve.

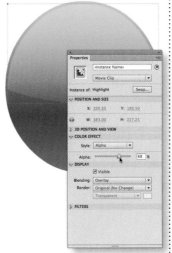

6 Select the highlight shape and press F8 to convert it to a symbol. Make sure the symbol type is Movie Clip. If it isn't, select Movie Clip from the drop-down menu. The Movie Clip type is important because it allows us to add a Blend Mode to it.

7 Select the Movie Clip and from the Blending drop-down menu in the Display section of the Properties panel select Overlay. Overlay combines Multiply and Screen blend modes resulting in light colors becoming lighter and dark colors becoming darker.

8 If the highlight is too bright, adjust its opacity using the Alpha slider in the Color Effect section of the Properties panel.

Continued...

HOT TIP

Creating the illusion of a shiny plastic button relies on subtle variations of color in your gradients. Achieving that *glassy* look can take practice to achieve. If you are having trouble getting the effect to look right, it might be that your colors have too much contrast between them. Being subtle will prove to be more effective in the end.

SHORTCUTS
MAC WIN BOTH

45

UI Design (cont.)

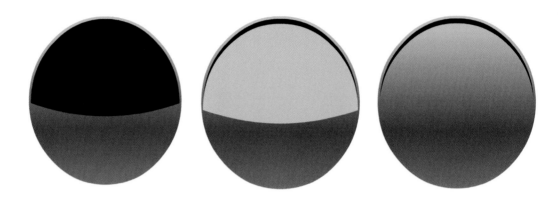

9 A convincing shiny effect relies on the illusion of reflection. Adding a highlight along the top edge of the icon begins with using a copy of the larger highlight we just finished creating. Copy and Paste in Place the same shape to a new layer and break it apart. I have filled it with black for this example.

10 Select this shape, copy it and then Paste in Place again. With the shape still selected, choose a different color from the color panel (here I chose blue) and then nudge it a few pixels downward using the arrow keys. The original black shape will be revealed underneath still intact. Click anywhere on the stage outside of the blue shape to deselect it.

11 With the Selection tool still selected, click the blue shape and press the Delete key. This will remove the blue shape as well as the original black section that was underneath it leaving behind the sliver of black as seen above. The remaining shape will be our edge highlight.

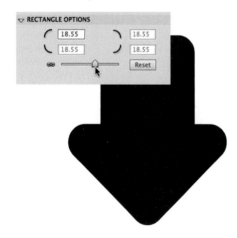

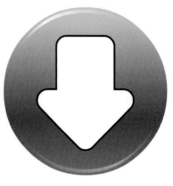

15 With both Rectangle Primitives selected, adjust the roundness of each corner using the Rectangle Options slider in the Properties panel. Break apart both rectangles and edit them to create the shape of an arrow.

16 I changed the fill color of the arrow to white and using the Ink Bottle tool, I selected black as the outline color and clicked inside the fill color to apply the outline.

17 Double-click the stroke outline using the Selection tool to select it. Using the arrow keys nudge the outline down and to the right about 10 pixels.

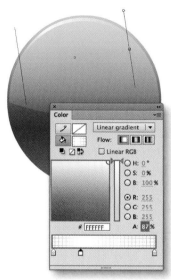

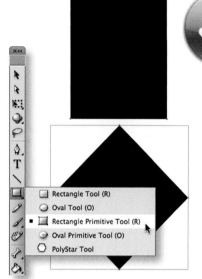

12 Mix a Linear gradient with 3 color swatches with white as the color for each. Select the swatch on the far right and adjust the color opacity to 0%. Repeat the same procedure for the far right color swatch. Select the middle swatch and lower its opacity to around 87%.

13 Copy and paste this highlight and then rotate it or flip it vertically. Position it at the bottom of the circle to create the illusion of light reflecting from below.

14 To create the arrow use the Rectangle Primitive Tool and draw 2 rectangles. Rotate one of them 45 degrees by holding down the Shift key to rotate it in 45 degree increments.

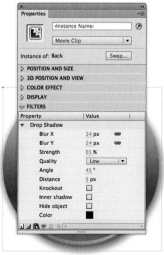

18 Using the Bucket Fill tool and gray as the color, click in the area of the arrow in between the stroke and the edge of the shape as shown above. With the stroke still selected press the Delete key to remove it.

19 Select the Movie Clip symbol that was created in step 1. Apply a Drop Shadow filter from the Filters category of the Properties panel. Adjust the amount of blur, distance and strength.

20 The advantages of using Flash for creating graphics are that they are resolution independent and that they can be animated.

SHORTCUTS
MAC WIN BOTH

The Adobe Creative Cloud

Adobe has provided a completely new way to use their extensive line of products as well as how to share your projects and files. By now you may have heard of the Adobe Creative Cloud but if you haven't, just think of it as a digital cloud where you can save, share, explore and access your work from any device with an internet connection. The Creative Cloud requires a membership and you can choose between several pricing options. Depending on your chosen membership plan you will have between 2 and 20GB of internet storage for your files. The Creative Cloud subscription model provides the option to download any of the Creative Suite products at any point during the membership. If you want to learn Adobe Flash now, download it and start using it. If you prefer to try Photoshop or Illustrator or any other Creative Suite product, that's fine too. You can install both Mac and Windows versions of the software on 2 different machines. If you have a Mac at home and a Windows machine at work, you can install the Adobe Creative Suite on both.

One of my favorite ways to use the Adobe Creative Suite is in conjunction with the Adobe Touch Apps. Using the Adobe Photoshop Touch App I can mockup my design ideas, save them to the Creative Cloud for further editing using Photoshop, Illustrator or Flash when I get home. The Creative Cloud is also a great way to share files with friends and collaborators. Learn more by visiting adobe.com/products/creativecloud.html.

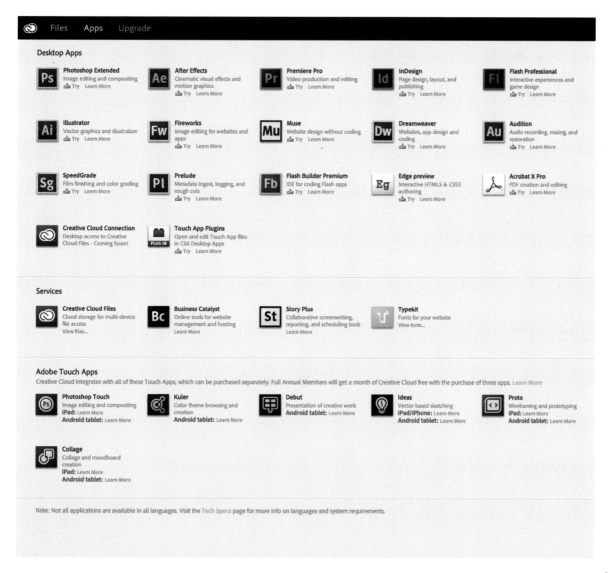

■ The most basic of objects, the cube, can be brought to life using just the Free Transform tool. With a little rotating and distorting, you can easily create an animation that gives an otherwise boring subject some life and personality. The same techniques can be applied to almost any object including characters.

2 Transformation and distortion

SQUASH, STRETCH, BULGE, warp, distort, rotate, skew, deform – what do all these transformations have in common? Hint: it's not how you felt after that second baked bean burrito you know you didn't need to eat. Answer: it's the Free Transform tool, the single most efficient and versatile tool Flash offers, and it will prove to be one of the most used tools in your daily animation workflow.

Adobe Flash CS6 offers two powerful tools: 3D Rotation and 3D Translation that allow us to transform objects in 3D space inside of Flash and animate them!

Distorting bitmaps

AS A DESIGNER AND ANIMATOR, one of the most frequently used tools in Flash is the Free Transform tool. It is the most multifaceted tool in the toolbox and will prove to be critical to the transformation and distortion of objects and then some.

Free Transform is the tool to use when you want to scale, rotate, shear and distort your images. Free Transform is also used to edit the center point of instances of symbols. You can use Free Transform to transform imported bitmaps or graphics created with the Flash drawing tools.

There are a variety of modifier keys to be used with the Free Transform tool that allow you to transform objects in different ways, as we will discuss here.

1 Enter Free Transform mode by selecting the Free Transform tool in the toolbox or by pressing the keyboard shortcut **Q**. Let's start by transforming an imported bitmap image.

2 Break apart your imported image **⌘ B** **ctrl B** before transforming it. If you want you can convert it to a Drawing Object (Modify > Combine Objects > Union).

6 Position the cursor outside the bounding box between the handles and drag to shear the object. Hold down **⌥** **alt** to shear based on the center of the object.

7 Hold down **⌘ ⌥ Shift** **ctrl alt Shift** and drag a corner handle to distort the object's perspective equally on both sides. Unfortunately Flash does not distort the image but, rather, crops it.

3 When you drag any of the four corner handles, you will scale the object. The corner you drag will move while the opposite corner will remain stationary. Hold down the Shift key to scale based on the object's center.

4 If you grab any of the four center side handles, you will scale the object horizontally or vertically. This is great for squashing and stretching the object.

5 Grab one of the corner handles to rotate the object. Hold down *Shift* to constrain the rotation to 45 degree increments. Hold down ⌥ *alt* to hinge the object at the opposite corner.

HOT TIP

Some of the Free Transform tool features cannot modify instances of symbols, sounds, video objects or text. If you want to warp or distort text, make sure to break apart the text field into raw shapes first.

8 Hold down ⌘ *ctrl* to distort the object in a freeform manner. But unfortunately again, Flash doesn't truly distort a bitmap image but rather, crops it.

9 Select the Envelope tool (sub-selection of the Free Transform tool). The Envelope modifier lets you warp and distort objects.

10 Drag the points and tangent handles to modify the envelope. Changes made to the envelope will affect the shape but not the bitmap image itself.

SHORTCUTS

The Envelope tool

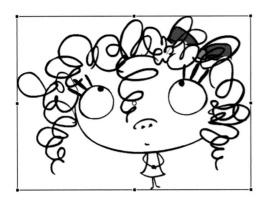

WHEN USING THE FREE TRANSFORM TOOL with raw vector objects, the Distort and Envelope subselection tools become available. This is where you can really have some fun warping and deforming shapes as if they were clay. Think of how your reflection looks in a fun house mirror and you'll start to get an idea as to what these tools are useful for. If you need to be precise with how your images are scaled, rotated or skewed, use the Transform panel to type in your values for the respective transformation.

1 Enter Free Transform mode by selecting the Free Transform tool in the toolbox or by pressing the keyboard shortcut **Q**. Select the Distort subselection tool at the bottom of the toolbox. Click and drag any of the corner handles to distort your shape.

4 The Envelope modifier is great for warping and distorting shape. When you select the Envelope subselection tool, you will notice multiple handles attached to the bounding box. Manipulating these handles will affect the shape contained within. Click and drag a corner handle to start warping your shape.

2 The Distort tool is useful for manipulating the perspective of a shape by clicking and dragging the corner handles.

3 Hold down the **Shift** key while dragging a corner handle to constrain the adjoining corner an equal distance and in the opposite direction from each other. Think of it as tapering your shape.

HOT TIP

Holding down
⌘ ⌥ ctrl alt
when dragging a
corner point will
lock the tangent
handles to their
current position.
Holding down
the same keys
while dragging
one of the side
handles will
constrain that
entire side and
all its points.

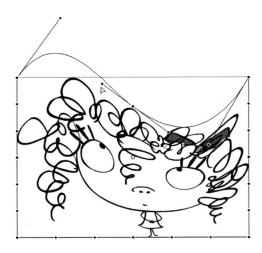

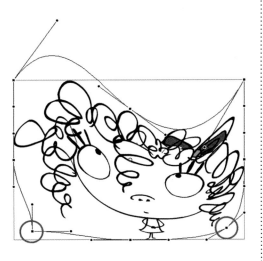

5 Drag any of the eight tangent handles to warp your shape in almost any direction. These tangent handles are located at each corner and along both horizontal and vertical sides as well.

6 You can move any of the points to a new location to further warp your shape. But be careful, once you click outside of the selected shape, the transformation will end. You can select it again and continue to warp and distort it, but the previous point and tangent positions will be lost.

SHORTCUTS

Warping

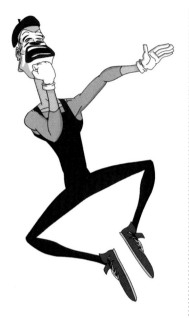

THE ENVELOPE TOOL can help shave some time off your production schedule. In this case, the Envelope tool was used to deform the head of the Evil Mime character to represent the effect of being hit by a self-imposed upper-cut. Sure, the entire head could have been drawn, but not often do we have the luxury of time to start from scratch when a deadline is looming. It was much easier to start with the head already drawn and warp it to suit our needs.

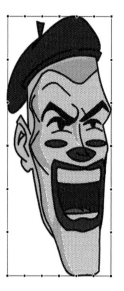

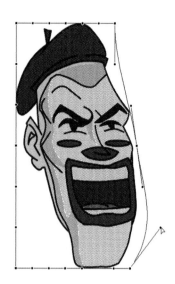

1 Duplicate the artwork of the head by creating a new keyframe in the head symbol. Select the entire head and the Free Transform tool **Q**, then select the Envelope subselection tool.

2 Using the Envelope tool, you can move the handles to deform the relative area of the head.

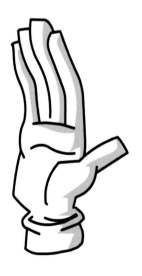

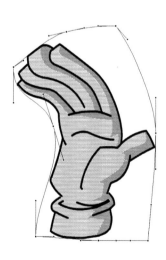

6 Here's the hand drawn in Flash using the Line tool. You may find the need for a variation of this same illustration and need to make it quickly.

7 Using the Envelope tool allows you to quickly distort the drawing into a different shape.

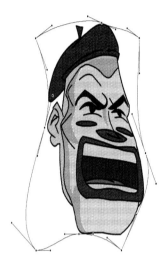

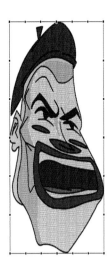

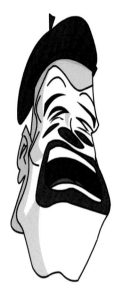

3 Continue to push and pull the Envelope's anchor points and control handles to deform the shape to your liking.

4 You can start the envelope process over by deselecting the artwork and selecting the Envelope tool again. This will reset the anchors and handles which will allow you to further distort your image.

5 Don't be afraid to manually go back into the artwork and adjust your linework using the Selection tool. Don't rely purely on the tools; often it's your own eye that is the best tool.

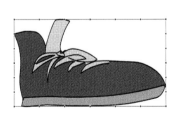

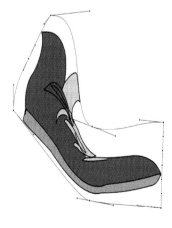

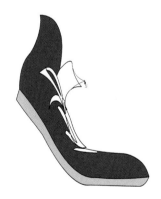

8 Here's the foot in its default state. Depending on your animation, you may need several feet in different shapes.

9 Once again, the Envelope tool gets the job done, quickly and efficiently.

10 Don't rely completely on the tools. In most cases, they can only go so far. You may want to further refine the details of your image manually.

Card flip

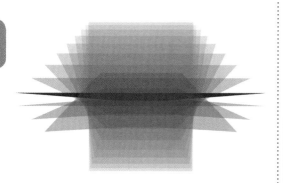

A POPULAR ANIMATION REQUEST requested on the Flash public forums is how to animate a flat card rotating or flipping 360 degrees. What makes this animation difficult for many to understand is the approach to actually making it. It is easy to assume, since Flash is a two-dimensional program, adding a third dimension simply is not possible unless the object is redrawn manually one frame at a time. But with Flash, it's all in the approach, and it doesn't have to be taken literally. Two dimensions are plenty to work within for this animated effect.

1 Start with a simple rectangle with no stroke around it. Add a second keyframe on frame 10. Select the Free Transform tool **Q** and then the Distort subselection tool.

2 Hold down the *Shift* key and pull a top corner point away from the shape. With the *Shift* key still pressed, pull a bottom corner in the opposite direction.

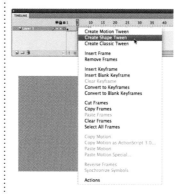

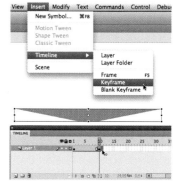

5 In Flash CS6 you have the ability to apply a Shape tween from the context menu in the timeline. So go ahead and apply one.

6 Now that you have the first half of the animation, you need to create the second half. Select frame 11 and insert a keyframe.

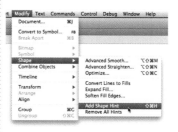

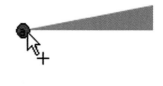

10 Let's add some shape hints to correct the problem. Select the first frame in the faulty tween and then go to Modify > Shape > Add Shape Hint **⌘** *Shift* **H** *ctrl* *Shift* **H**.

11 Drag the red "a" hint to one of the corners of your shape until it snaps.

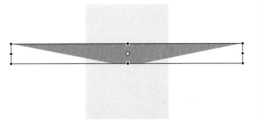

3 Click outside the shape to end the transformation. Select it again, hold down the **Shift** key and drag the bottom middle handle upward. The **Shift** key will constrain the shape vertically.

4 Turn on the Onionskin tool so you can see the previous frame. Position the newly transformed shape so that it is centered over the original shape seen through the onionskin.

7 Modify the shape in frame 11 by flipping it vertically.

8 Select the keyframe in frame 1 and copy the frame **⌘⌥C** **ctrl alt C**. Next, select frame 20 and paste the frame **⌘⌥V** **ctrl alt V**.

9 Apply a Shape tween to the latter half of your frames. You may experience a misbehaving tween like I did when writing this topic. Let's fix it.

12 Go to the last keyframe in your tween and drag the green "a" hint to the same respective corner. Repeat this procedure again for the opposite corner.

13 The final visual effect is to mix a slightly darker version of the color of the card and then use it to fill the shapes in frames 10 and 11.

14 The card will not only tween its shape, but also its color from light to dark. This color change makes for a convincing three-dimensional effect.

HOT TIP

While writing this topic, I experienced a common weakness with Shape tweens in Flash. Due to the nature of vectors and how Flash tries to calculate what it thinks you want to achieve, sometimes the tween implodes or twists in ways we never anticipated. Shape hints exist for this very reason and they are easy to learn about in the Flash Help docs. An alternative solution for this example would be to convert frames 1-10 to keyframes, copy and paste them in frames 11-20 and then reverse them.

SHORTCUTS
MAC WIN BOTH

3D Rotation

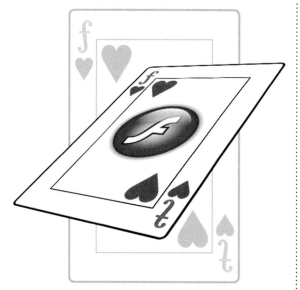

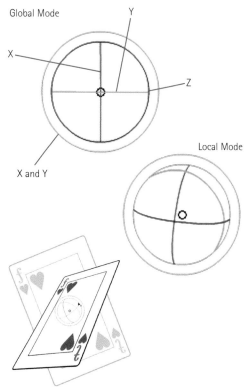

Global Mode

Local Mode

X

Y

Z

X and Y

T HE PREVIOUS CARD FLIP example demonstrates how to transform a vector shape with the Free Transform tool and "Classic Tweens". Adobe Flash CS6 provides tools to simplify the same process. The 3D Rotation tool lets you transform objects not only along the X and Y axis, but the Z axis as well.

1 The 3D Rotation tool **W** rotates Movie Clip instances in 3D space. A 3D rotation control appears on top of selected objects on the Stage. The X control is red, the Y control is green, and the Z control is blue. Use the orange free rotate control to rotate around the X and Y axes at the same time.

The default mode of the 3D Rotation tool is global. Rotating an object in global 3D space is the same as moving it relative to the Stage. Rotating an object in local 3D space is the same as moving it relative to its parent Movie Clip if it has one. To toggle the 3D Rotation tool between global and local modes, click the Global toggle button in the Options section of the Tools panel while the 3D Rotation tool is selected. You can temporarily toggle the mode from global to local by pressing the **D** key while dragging with the 3D Rotation tool.

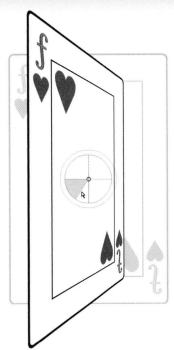

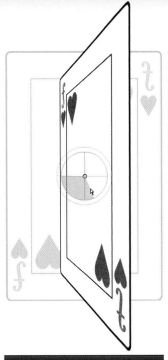

2 The first thing to do is to right-click over the Movie Clip and select Create Motion Tween. Flash CS6 will automatically insert frames based on the document frame rate to achieve a full second in the Timeline. This document is set to 24fps, therefore the duration of my motion tween is 24 frames.

3 Position the frame marker on frame 12. Select the 3D Rotation tool **W**. Click on the instance of the card and notice the 3D rotation controller that appears on top of the symbol. Click inside the 3D control and drag along the "y" axis to rotate the card in 3D space. Notice that Flash has inserted a keyframe automatically for you.

4 Position the frame marker on the last frame and continue to rotate the Movie Clip along its "y" axis in 3D space until it is 180 degrees from its original orientation. Repeat these steps as often as needed depending on the number of rotations you want to animate.

HOT TIP

Press the **D** key to toggle between global and local mode.

5 If you want to extend the Motion tween in the layer without affecting the existing keyframes, simply hold down the **Shift** key while dragging the right edge of the tween. Another way to do the same thing is to click on a frame further down the Timeline and press the F5 key to insert frames up to the selected frame.

SHORTCUTS
MAC WIN BOTH

61

Butterfly

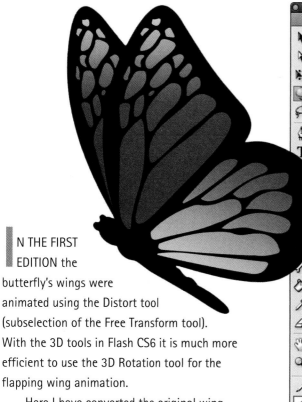

IN THE FIRST EDITION the butterfly's wings were animated using the Distort tool (subselection of the Free Transform tool). With the 3D tools in Flash CS6 it is much more efficient to use the 3D Rotation tool for the flapping wing animation.

Here I have converted the original wing graphic to a Movie Clip symbol and applied a motion tween using the new Motion Model. The advantages of using the 3D Rotation tool for this animation are faster results and a smaller file size. The smaller file size is on account of using motion tweens and several instances of the same symbol. Previous methods required each frame to be re-drawn, resulting in a frame-by-frame animation using raw vector art for each keyframe. This created larger file sizes since each frame contained all new data that needed to be loaded sequentially when viewing it online.

1 Convert the wing into a Movie Clip symbol twice so you end up with a movie clip inside a movie clip. You will want to animate the wing inside a symbol so a 2nd instance can be used for the other wing later.

Select the 3D Rotation tool **W**. Click on the instance of the wing and notice the 3D rotation controller that appears on top of the symbol. Reposition the controller by dragging it to a new location. The controller's position determines its center point. Right click over the symbol and select Create Motion Tween. Flash will automatically insert frames based on the document frame rate to achieve a full second in the Timeline. This document is set to play back at 30fps, therefore the duration of my motion tween is 30 frames. This can be easily changed by dragging the right edge of the motion tween left or right.

4 To separate the wings and add some depth to the butterfly, move the back wing to the right a few pixels and skew it slightly. You can also move the front wing to the left and skew that a little also.

2 Position the frame marker about mid-way between frame 1 and 30 (frame 15 will work). Click inside the 3D control and drag along the "x" axis until the wing is 180 degrees from its original position. Notice that Flash has inserted a keyframe automatically for you.

3 Position the frame marker on the last frame in the tween. Drag along the "x" axis inside the 3D control until the wing is back in its original position. Play back your timeline by pressing the *Enter* key to see the wing flapping along the "x" axis.

HOT TIP

Double-click the center point of the 3D control to move it back to the center of the selected Movie Clip.

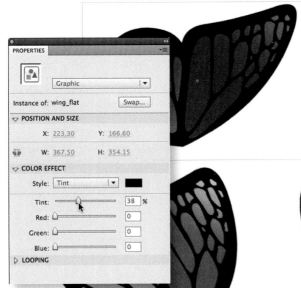

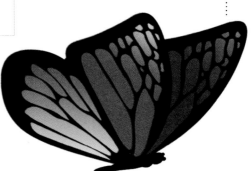

5 Copy and paste ⌘ C ⌘ V ctrl C ctrl V the movie clip containing the wing animation to use as the 2nd wing. Select it and using the Tint color effect in the Properties panel, darken it slightly to provide a sense of depth.

6 All that's left is to create a body shape, align the wings to it and publish your movie to see the butterfly take flight.

SHORTCUTS
MAC WIN BOTH

Squash and stretch

S QUASH AND STRETCH is a traditional animation technique that is widely used to give animations more realism and weight. When a moving object comes in contact with a stationary object, it will deform on impact, unless it is completely rigid. One thing that is important to remember is that no matter how much an object squashes or stretches, it always maintains the same amount of volume. The amount of squash and stretch depends on how much flexibility your object should have. Traditional animation usually contains exaggerated amounts of squash and stretch. A good example of this is a bouncing ball. When it hits the ground it actually deforms and gets squashed. It will then become stretched as it propels itself upwards. With a little Motion tweening and frame-by-frame animation in Flash, we can achieve convincing realism with relatively little effort.

1 Start with the object in its highest position. Convert it to a symbol and then edit its center point using the Free Transform tool. Move the center point to the center of the bottom edge.

2 Insert a second keyframe further down your timeline and position the ball vertically just above the horizontal guide. Apply a Motion tween with Easing set to "-100" (ease in).

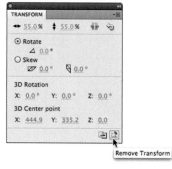

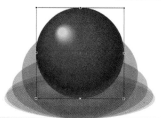

6 Start the ball's ascent by inserting yet another keyframe and removing all transformations. The Transform panel has a Remove Transform button to make this a one-click solution.

7 Copy the first frame and paste it as your last frame. This will position the ball at the end of your Timeline in the exact same position as it started. Apply a Motion tween and set the Easing to "100" (ease out).

3 In the next frame, insert a keyframe and turn on the Onionskin tool. Use the Free Transform tool to scale the ball so it becomes wider and shorter. It's important to keep the volume of the ball consistent.

4 Insert another keyframe about four or five frames further down the Timeline. Squash and stretch the ball even more. Apply a Motion tween and set the Easing to "100" (ease out).

5 Insert another keyframe a few frames down your Timeline and transform your ball in the opposite direction. Make sure it still has some deformation applied to it.

8 Flash CS6 offers a way to reuse animations. Copy Motion allows a Classic tween, its frames and symbol information to be pasted to another object. Select all the frames in your squash and stretch animation. Select Edit > Timeline > Copy Motion.

9 Insert a new layer and create (or drag from the library) a new symbol to the stage. Select this new symbol and go to Edit > Timeline > Paste Motion. Your additional symbol will now have the same exact span of frames, Motion tweens, easing and transformations. Thanks to Joe Corrao for contributing the character above (joecorrao.com).

65

Being subtle

ANYONE WHO HAS EVER heard me speak publicly about Flash and what led me to this industry may recognize the term "moment of clarity". As an artist, there have been several of these moments – the most memorable transpired long before Flash was around.

It was spring of 1989 and after four fulfilling years at the Hartford Art School, I was finally about to receive my BFA degree. My drawing style during this time could best be described as hyper-realistic. I was illustrating images that looked like actual photographs. Sometimes the illustrations would fool even a well-trained eye into thinking they were real, at least at first glance. Objects caught in motion as if snapped by some high speed camera shutter, foreshortened as if they were literally flying out from the page and about to hit you square between the eyes. I can only imagine this style represented my excitement as a young artist having this ability to push the limits of light and dark onto a two-dimensional surface, with only the best professors looking over my shoulder. I spent so many hours trying to master this drawing style that I would often have to use my left hand to pry the fingers of my right hand off of the pencil.

Most of my work was large in scale, 18" × 24" and even as large as 30" × 40". A large majority of it was lithographs and etchings that took weeks and often months to create. One afternoon I had a leftover piece of copper plate that I was about to discard. It was small, about 3" × 7", and tiny compared to what I was used to. For no particular reason I drew a rough study of a figure of a woman. I spent no more than ten minutes on the drawing before throwing it in the acid bath so it could be etched. I rolled some ink into it and printed about six copies of it. It was a simple drawing, loose in line style, and very much the opposite of the hyper-realistic style I was known for, and for this reason I didn't think it was a very impressive piece. I contemplated tossing the print and the copper plate in the trash and going back to my much larger and more realistic pieces. But something told me to hang on to it, at least for a little while. So I slid it between the pages of a book in my backpack.

Like all graduating seniors, we were celebrated with our own showing in the school's gallery. While setting up my show, I carefully chose my biggest and

most realistic drawings and prints. While hanging the last piece, the small etching of the girl slipped out onto the floor. I reluctantly decided to include it in my show next to the light switch in the darkest corner of the room.

The night of the show was a success and, a few days later, my illustration professor Dennis Nolan, who was unable to attend, asked to see my work before it was to be taken down. He was one of the professors I most admired and to this day I adore his skill and dedication as an illustrator. He quietly perused each lithograph, etching, watercolor and pen and ink illustration. When he finished, he turned to me and asked, "Want to know what is your best piece?" Confident he was going to point to the largest and most realistic piece, I was shocked when he turned and pointed to the small etching next to the light switch. My heart sunk and for a moment I felt as though I might be insane.

He explained to me that its simplicity and essential quality provoked an emotion within him and compared it to Rembrandt or Da Vinci. He told me it was a milestone not only in my career, but in any artist's career to draw like that. It was subtle, and that subtlety made more of an impact than any of the other pieces I had done in my four years as a student. The world of art changed for me that day and, in some ways, the way I looked at life changed as well. It took four years and that very moment for my eyes to be opened as an artist. I was changed forever. It taught me more than I ever thought I would be able to know and it's a lesson I carry with me to this very day. Being subtle is powerful.

■ The hula hoop appears to be around the hulagirl's waist, or is it? In the original image, above, the hula hoop is clearly in a layer above the hulagirl. By creating a mask for the hula hoop, we can hide the portion of it that overlaps the girl's waist, making it appear to be around her.

3

Masking

MASKS ARE POWERFUL. They can be used in myriad ways to achieve limitless results. Masks can make your daily workflow easier, less time-consuming and, in most cases, become your most indispensable tool.

Having the ability to control the way two or more layers interact with each other through the use of masks is vital to your abilities as a designer and animator. The coolest thing about using masks in Flash is that not only do they help you to create stunning images, they can also be animated, a very powerful concept that can be mastered quite easily.

Rotating globe

1 First step is to create the continents. A quick online image search will yield plenty of examples. Import the image into Flash and leave it as a bitmap or use the Trace Bitmap feature or manually trace it using Flash's drawing tools. Convert it to a symbol.

WHENEVER I WORK WITH MASKS, I feel like a magician. Masks provide the ability for you to create illusions, much like a magician's "sleight of hand" technique. It's all about what the viewer doesn't see and you, as the designer, have the ability to control that.

One of the more popular animation requests from Flash users is how to make a rotating globe. The first thought is that a globe is a sphere and to animate anything rotating around a sphere requires either a 3D program or painstaking frame-by-frame animation. Not so if you can use a mask. Remember, it's not what you see, but rather, what you don't see.

4 The next step is to create a mask layer using yet another copy of the circle in the bottom layer. Create a new layer above your continents, paste in place the circle and then convert this layer to a mask layer. This will prevent the continents from being visible outside this circle. All you need to do now is motion tween the continent symbol across this circle.

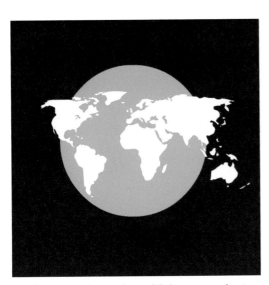

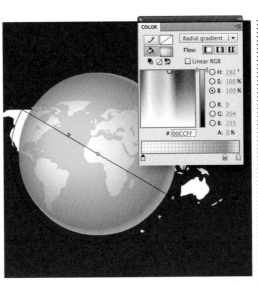

2 Create a new layer and move it below your continents. Draw a perfect circle using the Oval tool **O** while holding down the **Shift** key. Select this circle and copy it, then paste it in place on a new layer above your continents.

3 Mix a radial gradient similar to the one shown and fill the circle in the layer above your continents. Make sure to mix enough alpha into each color so the continents will show through. Using the Gradient Transform tool **F**, edit your gradient so that the highlight edge is off-center to one side.

5 To avoid too much of a delay in the animation between the first and last frames, you can add a new masked layer with a new instance of your continent symbol. The best way to make this looping animation as seamless as possible is to copy the first frame of the continents and paste it in place into the last frame of your Timeline. Then work backwards in the Timeline and position the continents outside of the circle to the right.

6 Since the first frame is exactly the same as the last frame, and each frame in between represents a slightly different position for the continents, select the symbol in the last frame and use the arrow keys to nudge it over a few pixels. This will avoid the two-frame "hesitation" in the movement of the continents every time the playhead returns from the last frame to frame 1.

HOT TIP

You can always move your entire animation into a Movie Clip symbol so that it can be easier to position, add multiple globes and/or target with ActionScript. To do this, drag across all frames and layers to highlight them in black. Right-click or Command-click over them and select "Copy Frames" from the context menu. Open your Library and create a new Movie Clip symbol. Right-click or Command-click over frame 1 of this new symbol and select "Paste Frames".

SHORTCUTS
MAC WIN BOTH

Flag waving

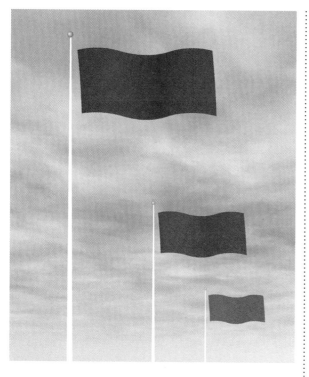

T HE WAVING FLAG is a popular "how do I...?" request in the Flash community. To be honest, it plagued me for quite some time as to how best to achieve this animation. My initial reaction was to use shape tweens and frame-by-frame animation but that proved time-consuming and had unconvincing results. Then one day, out of the blue, it hit me: if I slide the right shape across a masked area, I could create the illusion of a flag waving without having to kill myself animating it in a traditional way. It suddenly became so easy anyone can do it.

1 You will begin by making a nice long repeating ribbon shape. Start with a simple rectangle with any color fill and no outlines. Make it a little wider than it is taller.

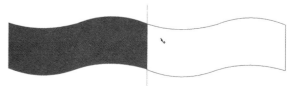

4 Repeat step three by pasting your new shape and flipping it vertically. Then attach it to the side of the shape again. See the ribbon pattern taking shape? But your ribbon is a solid color and lacking some depth, so let's continue by adding some shading.

7 Create a mask layer above the ribbon layer. Using the Rectangle tool, make a shape big enough to cover a section of the ribbon as shown. It helps to use a high contrast color.

10 Test your movie using ⌥ ctrl Enter to see the effect of the flag waving as it passes through the mask. But let us not stop there. Let's animate the mask using shape tweens to further emphasize the left and right edges of the flag waving. Use the Selection tool to bend the left and right edges. Create a keyframe further down the mask layer.

2 Use the Selection tool **V** to bend the top and bottom edges slightly so they have a nice arc to them. You will want to repeat this shape to create a pattern, so select it and copy it.

5 Mix two colors and add them to the Swatch panel. Mix a linear gradient with several color pointers alternating between these two color values. Fill your ribbon shape with this gradient and edit it so that the darker tones arc in the concave sections of the ribbon shape.

8 Next, create a keyframe somewhere down the timeline and reposition the ribbon to the left of the mask shape. Apply a motion tween.

11 In this new keyframe, bend the left and right sides of the mask shape in the opposite direction. Apply a Shape tween. Repeat this procedure until the last frame is reached. The animated mask adds an extra animated touch to the overall flag waving effect. Presto! You are done.

3 Paste your shape and then flip it vertically. Use the Selection tool to drag it so that it connects to the original shape. Once these shapes are joined together, select it and copy it.

6 Once you have the ribbon the way you want it, select it using **A** *ctrl* **A**, copy it using **C** *ctrl* **C** and then paste it using **V** *ctrl* **V**. Align it edge to edge with the original shape to essentially double its length. Convert it to a symbol.

9 To create a seamless loop of the ribbon, copy and paste in place a new instance to a second masked layer (using the same mask). Motion tween it so that it follows the original ribbon shape without creating any gaps.

12 Don't forget to add a flag pole and sky background for an even more convincing illusion. Try placing this animation in a Movie Clip symbol and drag a few instances of it to the stage. Scale them and arrange them in perspective for the ultimate flag waving effect.

HOT TIP

This is a looping animation. For best results make sure the first and last frames are identical. To do this, use copy frames, paste frames or copy the object in the first frame and paste it in place in the last frame.

SHORTCUTS

73

Iris transition

T HERE ARE USUALLY SEVERAL WAYS to go about creating the same animations and effects in Flash. Whether it be animated on the Timeline or dynamically generated using ActionScript, it allows us as users to work within our own comfort zones. A simple iris transition is an example of an effect that could be done several different ways. I personally wouldn't know where to begin coding this kind of animation, but give me a Timeline and some keyframes and I am in my element. Using a mask for this example provides us with even more options; we can easily control the direction and focus of the iris itself, where it starts and where it ends. This can be a nice touch to your storytelling if you want to focus the viewer's attention to a very specific area of the screen.

1 First step is to create a simple circle using the Oval tool **O**. The fill color is insignificant. Hold down **Shift** while dragging to constrain its proportions. Do not convert this shape to a symbol but, rather, convert the layer to a Mask layer.

4 Add a new layer and drag it over the mask layer so it becomes linked to it as a "masked" layer. This is the layer where your content will reside. If your content requires multiple layers, then make sure they are all masked or move all content into a new symbol and drag an instance of the symbol to the masked layer.

2 In frame 1, scale this circle as small as possible. Open the Scale and Rotate panel using `⌥` `alt` `S` `ctrl` `alt` `S`, type in a percentage and click OK. Use the Align panel using `⌥` `K` `ctrl` `K` to center the circle to the stage.

3 Create a keyframe a few frames down your Timeline in the same mask layer. Scale the circle so that it covers the stage completely. Convert the shape to outlines so you can see the stage underneath it. Apply a Shape tween so the circle grows from small to large, filling the stage completely.

HOT TIP

Feel free to experiment with colors other than black. Sometimes radial gradients can add some fun depth to this transition effect. It is easy to substitute different colors or textures by changing the background layer art to whatever you want.

5 Create a new layer (not masked) below all the other layers and create a black rectangle the size and shape of the stage. The color can be anything you choose, but black typically works well for this type of effect. At this stage you can reverse the animated mask by copying keyframes in reverse order and applying another Shape tween.

6 Since you are creating the iris effect with an animated mask, you can easily control what area of the stage the iris focuses on. In the last keyframe, position the circle in the last frame over the character's eye. When the animation plays, the iris will animate and close in on the eye, a typical technique used in several cartoons.

SHORTCUTS
MAC WIN BOTH

Handwriting

THIS IS ONE OF MY FAVORITE ANIMATED EFFECTS because I am asked frequently how it can be achieved, yet it is quite simple in technique. Every time I demonstrate how to make text "write" itself, the reaction is almost always the same: "Oh wow! That's all there is to it?" The example here uses an animated mask which yields a very small file size, ideal for large blocks of text.

Hand writing

1 The first step is to type some text on the stage. It doesn't matter what it says, just choose a font and start typing. By default, text fields in Flash are set to Dynamic. In some situations this may be fine but when an effect is added to the text field, the text may not render correctly in the Flash player. Such effects include masking, alpha, rotation and scaling. If you need to use Dynamic text, embed the font outlines.

Hand writing

3 Add a new layer above your text layer and convert it to a mask layer. The text layer will automatically be linked to it as a "masked" layer. In frame one, draw a rectangle just to the left of your text, making sure it is as tall as the text itself.

Hand writing

5 Now just apply a Shape tween in between these two keyframes. Lock all layers and play your movie or test your movie to see the effect of your text writing itself.

2 If you choose to change the behavior of your text field to Static, the font will be embedded in the compiled SWF and the Flash player will render it correctly even with an effect added to it. Another option is to break apart the text until it becomes raw shapes. This will insure the text renders correctly but also creates a larger file size and it will be harder to edit the text if need be in the future.

4 In this same layer, create a keyframe further down the Timeline and scale the shape horizontally so that it spans the entire width of your text.

6 If you need to use Dynamic text, you must include the font outlines so that the text renders correctly in the Flash player. To do this, select the Dynamic text field and then click the "Embed…" button in the Properties panel. The Font Embedding panel will appear, allowing you to choose the range of characters used in your animation. Try to select the minimum number of characters because embedding all characters can increase file size significantly. There's a section in the Options panel that allows you to type in just the characters that you are using on the stage. These are the only characters that will be embedded and as a result, keep the file size as small as possible.

3 Masking
Spotlight

ANIMATED MASKS, as we've seen, can provide an interesting dimension to your animation. It really doesn't take much effort to create various visual effects using an animated mask, such as this spotlight effect for a client's logo.

1 The first thing you need is some text or other image to "shine" a spotlight on to. Convert it to a symbol. The background should be dark if not completely black. In order to show light, we first need to create darkness. This technique wouldn't have the same effect if the background was very light.

2 Create a new layer above your image layer and convert it to a mask layer. The image layer will automatically be linked to it as a "masked" layer. Draw a shape using the Oval tool **O** while holding down the **Shift** key to constrain its proportions. Convert it to a symbol.

3 Add a keyframe further down the timeline and position the mask shape to the opposite side of the image. Apply a Motion tween so that the mask shape passes across the image.

4 The key to making this technique convincing is to copy and paste in place the image to a new layer below the original layer. Make sure it is a normal layer (not masked). Select the symbol and tint it to a dark color. This layer will not be affected by the mask.

HOT TIP

Don't be afraid to add more keyframes in your mask layer and position the mask symbol in various positions relative to the image it is revealing. You can also animate the mask getting larger and smaller by scaling it. Be creative and change the shape of the mask to say two circles side-by-side to suggest we are looking through binoculars.

5 Test your movie to see your animated mask pass over the original image layer while the darker instance remains unmasked and visible throughout the animation.

SHORTCUTS
MAC WIN BOTH

Focus

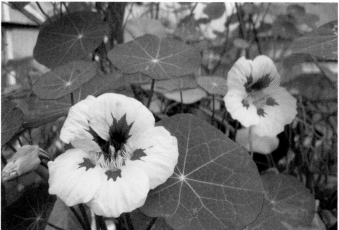

O NE OF THE MOST EXCITING NEW FEATURES in Flash is the PSD and AI importer. Since CS3, we finally have wonderful integration between Photoshop and Illustrator alike. For this example we will edit an image in Photoshop, save it as a PSD file and import it into Flash via the PSD Importer wizard.

We will also add a slight touch of ActionScript for some added interactivity. If you suffer from ActionScript-phobia, don't panic; this will be painless with only a couple of lines of simple code. If I can do it, you can as well. The code simply will hide the cursor in the Flash player and allow us to drag a Movie Clip around the stage. The trick here is the mask itself, allowing us to see the sharper image through the mask shape only. Open wide and say "Ahhhh". This won't hurt a bit.

1 First you need to start with an image, of course. This might be a good time to browse your hard drive or grab your digital camera. It doesn't have to be a raster-based image or even a photograph. It can be vector art drawn in Flash or imported from a different program. Whatever image you choose, you will need two versions, the original and a blurred version of the original.

4 Once the import process is complete, your Flash document should contain both images on different layers. Make sure the blurred image is below the sharper image.

5 Create a new layer above the sharper image and convert it to a mask layer. The image layer below will be automatically linked to it. Draw a shape in your mask layer and convert it to a Movie Clip symbol. Lock these two layers to see the mask work.

2 Open your image in Photoshop and duplicate the layer it is on so you have two copies of the same image. Apply a Gaussian Blur to one of your images. Save the file as a PSD file.

3 In Flash, import the PSD file you just created. The PSD import wizard will appear and prompt you with a variety of options. The left panel will display all the layers of the PSD file. Click on them to display options for each. You will also want to convert layers to Flash layers, place layers at original position and set your Flash stage to the same size as your Photoshop stage.

6 You are almost done! Lock all layers to see the effect. It works but it is pretty boring as the mask just sits there. Time to add some functionality.

7 Use the Selection tool **V** to select the Movie Clip symbol containing the mask shape. In the Properties panel, type in an instance name. I chose "focus" for this example. With the Movie Clip still selected, open the Actions panel and type the following ActionScript exactly:

ActionScript 1.0–2.0:
Mouse.hide();
startDrag("focus", true);

For ActionScript 3.0:
Mouse.hide();
focus.startDrag(true);

Feathered mask (ActionScript)

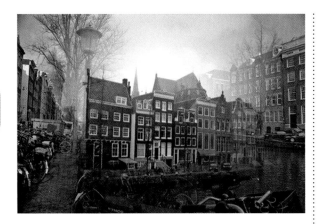

S INCE FLASH 8 and the introduction of a feature called "runtime bitmap caching", we have had the ability to create masks with that desired feathered edge. I know that oftentimes when the designer world overlaps the developer world, things can get a little blurry. To be honest, even the most code-phobic designer can use ActionScript to integrate dynamic masks into their designs. All that is required is a few lines of very simple code.

1 The first step is to create a radial gradient with 2 colors. The middle color should be solid and the outer color should be mixed with 0% alpha. This will create the feathered edge that will later be used for the mask. Using this gradient as your fill color, select the Oval ⬭ tool and draw a circle on the stage. To constrain the circle so that it is perfectly round, hold down the shift key while dragging. Convert this shape containing your radial gradient to a Movie Clip symbol. With this Movie Clip symbol selected, give it the instance name "maskMC" in the Properties panel.

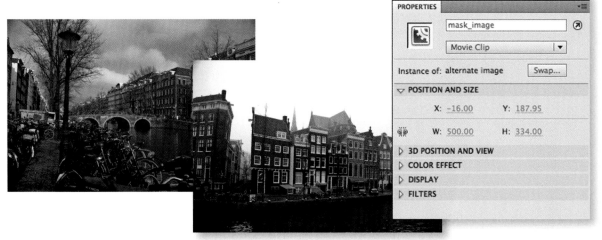

3 You will need two different images to transition between. Here I have chosen images from a recent trip to Amsterdam I took to speak at FITC (Flash in the Can). Place both images on different layers, one directly over the other. For clarity, I will refer to these as "Image A" and "Image B". Image A will simply reside on the bottom-most layer. Image B will be the one we reveal with the feathered mask using ActionScript.

4 Since the mask itself will be controlled with ActionScript, we will need to use ActionScript to composite it to the image that will be revealed during the transition. Convert Image B to a Movie Clip symbol and give it the instance name "mask_image". The only thing left to do is apply the code that tells the radial gradient to act as a mask and apply itself to Image B.

2 Double-click the Movie Clip to enter Edit mode. Select the radial gradient again and convert it to another symbol. Now we can create a nice transition effect by animating it. Using a tween, scale the symbol from very small to very large, large enough so that it covers the stage completely. Place a stop(); action at the end of this timeline.

HOT TIP

Caching Movie Clip symbols has huge advantages in Flash. You will gain significant performance increases because there is less demand on the processor to calculate the math necessary to render certain property effects. Caching also allows for more advanced levels of compositing that can not otherwise be done in prior versions of Flash.

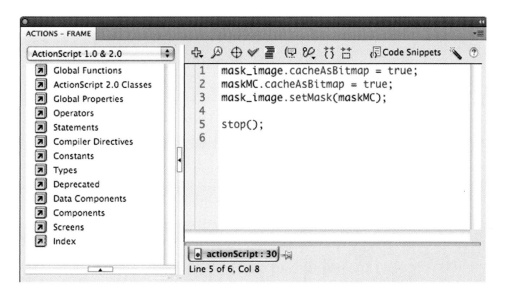

```
1  mask_image.cacheAsBitmap = true;
2  maskMC.cacheAsBitmap = true;
3  mask_image.setMask(maskMC);
4
5  stop();
6
```

5 In the Actions panel (F9) type in the following code:
mask_image.cachAsBitmap = true;
This code caches the image so that it can be masked at runtime in the Flash Player.
maskMC.cachAsBitmap = true;
The code on Line 2 will assign the Movie Clip "maskMC" to act as a mask at runtime.

mask_image.setMask(maskMC);
This will assign the mask and the image to be composited together.
That's all there is to it. Make sure you open the source file "feathered_mask_actionScript.fla" on the CD in the back of this book to see this effect in action.

A moment of clarity

I REMEMBER THE MOMENT WELL, AS I SHOULD since it was the moment when I realized what I needed to do as an artist to make my mark on the world. What I wasn't sure of was how big a mark I could make. What made the moment even more significant was that it took me over 6 years to figure it out. It began in 1989 when I graduated from the Hartford Art School (Connecticut) with a major in printmaking with a minor in Art History. I took enough Illustration classes to constitute a double major. The result: a portfolio filled with static lithographs, etchings and a multitude of illustrations of varied mediums. Animation didn't exist in the curriculum and therefore was never an option. I never considered animation as a skill I would even be good at. After graduating, I pounded the pavement with portfolio in hand, knocking on as many doors as I could. With the exception of a handful of interviews, having no experience did not get me very far. The Internet didn't really exist back then, at least not as we know it today. The term "home PC" wasn't invented yet, and I was stuck with a book filled with analog images that represented four hard years as an artist and hardly anyone to show it to.

After six years of countless random jobs (Jeep mechanic, restaurant manager, Boston Water & Sewer Collections Dept, etc...), I became aware of a local education software company that was producing a new animated series on Comedy Central. On a Monday morning I walked in the front door of this software company, gave my portfolio to the receptionist and told her I'd be back on Friday to pick it up. I turned around and walked out the door.

A month later, they hired me to work on an animated pilot for Dreamworks. At that time, the company used an old DOS-based animation program called Animator Pro (Autodesk) that soon became obsolete. We turned to Flash and little did I realize the impact it would have on my career. Initially we were using Flash to animate for broadcast shows. We didn't have a clue how to use it for the Web until we got a deal to produce an animated series for shockwave.com (now atomfilms.com). I was put in charge of this project and

had to ramp up my knowledge of Flash very quickly. During this time, my contact at Shockwave asked if I could speak at the Flash Forward conference in New York City. I agreed without knowing exactly what that meant.

I drove the 3 hours from Boston to NYC the day of my session. I shared the stage with two brothers, Gregg and Evan Spiridellis, who had just started a small company in NYC called Jib Jab (ever heard of it?). We became fast friends and remain so even to this day.

That evening was the Flash Forward Film Festival, held in a huge theater with a very large screen that displayed the best use of Flash in several categories. Awards were being given and the excitement in the air was palpable. I never anticipated that a software program could generate such a buzz. I was witness to a culture being born, an entire society of Flash users who shared a common bond as if it were some secret handshake or cryptic language. And there I was, standing in the middle of their nest, surrounded by the frenetic buzzing and energy derived from this program.

It was my first experience seeing the best of the web being celebrated on a huge stage and it suddenly all made sense to me why I was there, what I was involved with, and what I had to do. It was my first moment of clarity.

To describe the image of me standing in the back of the theater, watching this phenomenon transpire, recall the scene from The Blues Brothers film where John Belushi is in the church chanting "The band!" as he is struck by a holy beam of light through the church window. That was me. I knew from that moment on what I needed to do. I drove home as my head was spinning with ideas about how I was going to display my art with Flash for the world to finally see. It was a 3-hour drive and I never even turned on the radio the whole way.

■ The Yahoo! Super
Messengers, in a
classic superhero
pose. The above
version is a bit
lackluster if not
completely boring.
Below is the same
shot with the help
of some simple
motion effects.
The difference
is an animation
with a bit more
punch (sorry, pun
intended).

4

Motion techniques

LET'S FACE IT, Flash is about motion. In some cases, the more motion, the better. Motion can emphasize the intensity of an action sequence and can add a measure of realism to your animations. Whether it is making text fly around a website or animating a character in an action sequence, providing convincing motion effects can be critical to their success visually.

In this chapter we will examine the differences between the new Motion tween and the Classic tween methods as well as look at a few of what I consider to be the most valuable motion effects that you can use in your everyday life as a Flash designer and animator.

Motion Presets

MOTION PRESETS ARE PRE-BUILT MOTION TWEENS that can be applied to an object on the stage. With the object already selected, choose the desired preset from the default list in the Motion Presets panel and click the Apply button. The preset animation has been applied to your new object. The default presets provide a great starting point but you'll likely want to make your own. Flash CS4, and now CS5, provide the ability to save your custom animations as presets that can be reused over and over. You can build up libraries of animations that not only can be easily applied to any object on the stage, but can also be shared across the entire Flash design community.

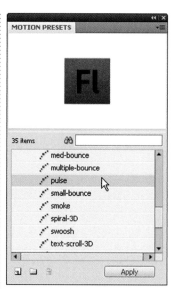

1 Go to Window > Motion Presets to open the Motion Presets panel. This panel looks a lot like the Library panel with its preview window on top and list of folders and preset objects below. Just select a preset to preview it.

2 Make sure you have an object selected on the stage before selecting a Motion Preset animation. Once you have a preset selected, just click the "Apply" button. Your object on stage is now animated.

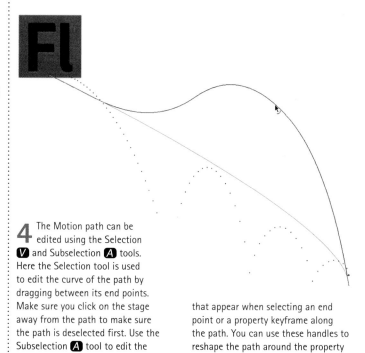

4 The Motion path can be edited using the Selection **V** and Subselection **A** tools. Here the Selection tool is used to edit the curve of the path by dragging between its end points. Make sure you click on the stage away from the path to make sure the path is deselected first. Use the Subselection **A** tool to edit the control points using the Bezier handles that appear when selecting an end point or a property keyframe along the path. You can use these handles to reshape the path around the property keyframe points.

3 Once the preset is applied, Flash applies a Motion tween to the object containing the property animation data. You can leave the animation as is or use it as a starting point by editing the animation to suit your needs.

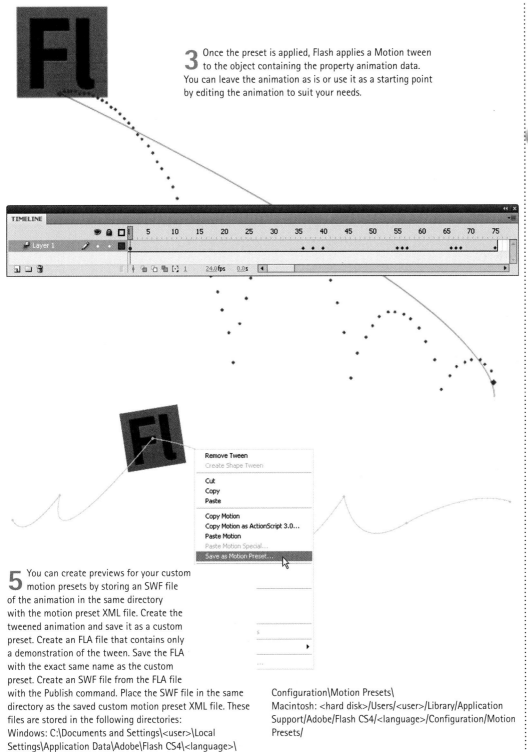

5 You can create previews for your custom motion presets by storing an SWF file of the animation in the same directory with the motion preset XML file. Create the tweened animation and save it as a custom preset. Create an FLA file that contains only a demonstration of the tween. Save the FLA with the exact same name as the custom preset. Create an SWF file from the FLA file with the Publish command. Place the SWF file in the same directory as the saved custom motion preset XML file. These files are stored in the following directories:
Windows: C:\Documents and Settings\<user>\Local Settings\Application Data\Adobe\Flash CS4\<language>\

Configuration\Motion Presets\
Macintosh: <hard disk>/Users/<user>/Library/Application Support/Adobe/Flash CS4/<language>/Configuration/Motion Presets/

HOT TIP

To apply the preset so that its motion ends at the current position of the object on the stage, Shift-click the Apply button or select End at Current Location from the panel menu. You can also apply a motion preset to multiple selected frames on separate layers, as long as each selected frame contains only a single tweenable object.

SHORTCUTS
MAC WIN BOTH

89

Motion and Classic tweens

S O MUCH HAS CHANGED since Flash CS4. But so much has remained the same. What does this mean for the veteran Flash animator who already has tried and tested workflows that can't be broken? What features are you more likely to adopt and which ones will help you create new animation techniques that might increase your production?

If you remember one thing about the two tween methods in Flash CS4 and now CS5, remember that the Classic tween is frame-based while the new Motion tween is object-based. There are advantages and disadvantages to using either and the difference depends on what kind of object you are animating and what that object needs to do for you. There are so many different object types that can be tweened in Flash: Movie Clips, Graphic and Button style symbols, imported bitmaps and text fields. The two different tween methods can complicate matters when trying to understand what tween to use with what kind of object.

Let's start by comparing both tweening methods side by side and find out why Flash CS4 and CS5 offer both.

Motion tweens have more than 1 type of keyframe. The black circular dot in the first frame of the span indicates the assigned target object. If this dot is hollow (white), it means the object has been removed and a new object can be assigned.

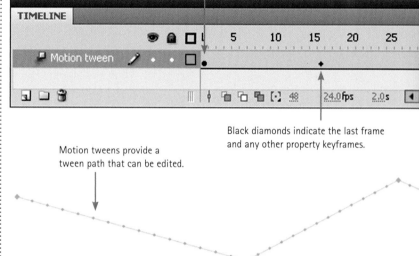

Black diamonds indicate the last frame and any other property keyframes.

Motion tweens provide a tween path that can be edited.

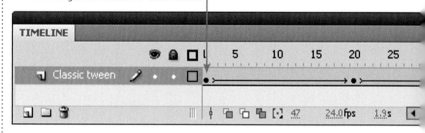

A black dot at the beginning keyframe with a black arrow and blue background indicates a Classic tween.

Use Classic tweens to animate between two different color properties, such as tint and alpha transparency. Motion tweens are limited to 1 color effect per tween.

Motion tweens are indicated by a solid light blue colored layer span. Unlike the Classic tween span, there are no horizontal dashed or solid lines or arrows indicating a broken or completed tween.

Classic tweens can not be saved as Motion Presets. You can only save Motion tweens as preset animations in Flash CS4.

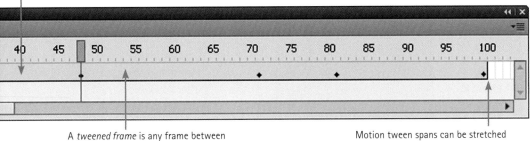

A *tweened frame* is any frame between keyframes within a tween span.

Motion tween spans can be stretched and resized in the Timeline and are treated as a single object.

You can animate a 3D object using a Motion tween but 3D is not supported with Classic tweens.

HOT TIP

If you remember one thing about the two tween methods, remember that the Classic tween is frame-based while the new Motion tween is object-based. With motion tweens, you cannot swap symbols or set the frame number of a graphic symbol to display in a property keyframe. Animations that include these techniques require Classic tweens.

Classic tweens use keyframes. Keyframes are frames in which a new instance of an object appears.

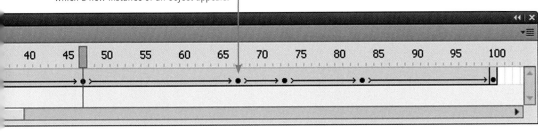

Classic tweens can not be stretched and resized in the Timeline like Motion tween spans can. Classic tweens are comprised of frames that have to be selected individually and inserted or removed in order to stretch or shorten the animation.

91

Creating Motion tweens

THINK OF THE MOTION TWEEN as a Classic tween on steroids, allowing you to animate each property individually across an entire motion span. This was difficult if not impossible with previous versions of Flash and Classic tweens. The combination of Motion tweens and the new Motion Editor allow for a myriad ways to create motion in Flash. The flexibility of having each property independent of each other is enough to make your head spin. If that wasn't enough, one of the most popular timeline-related enhancement requests is now a reality: the ability to lengthen and shorten the Motion tween and have all keyframes interpolated automatically. With Classic tweens this can only be done manually and the more layers, frames and keyframes, the more of a nightmare this process can be. Let's take a look at more differences between these two tween methods.

1 Motion tweens can be applied to symbols and text fields. A tween span in a layer can contain only 1 object or 1 text field. However, you can have multiple objects nested inside a single object being Motion tweened. To apply a Motion tween, right click over the object on the stage and select Create Motion Tween from the context menu.

3 The quickest way to create an animation is to simply move the object to a new position on the stage. Flash will automatically create a motion path that can be edited using the Selection **V** and Subselection **A** tools.

2 Flash automatically lengthens the tween span to accommodate a full second's worth of frames based on the document's frame rate. If your frame rate is set to 24 frames per second then your span becomes 24 frames long. The playhead marker is automatically positioned at the end of the tween span.

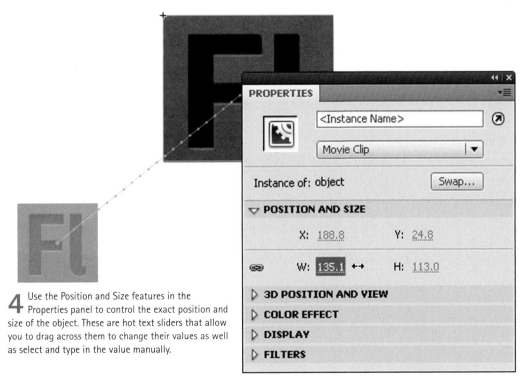

4 Use the Position and Size features in the Properties panel to control the exact position and size of the object. These are hot text sliders that allow you to drag across them to change their values as well as select and type in the value manually.

Working with Motion spans

S O HOW DOES THIS NEW MOTION TWEEN model work anyway? Not only has Adobe changed how tweens are created and applied, but how we work with frames, keyframes and the tween span itself. The new Motion tween is very different from its predecessor visually, sans any dashed or solid horizontal arrows, or vertical lines indicating the "sync" feature being turned off. The Motion tween span is simple and straightforward, uncluttered and unadulterated, yet provides the ability to create sophisticated animations that go beyond the capabilities of the Classic tween method.

1 It's ironic that Flash CS5's Motion tween span looks so plain and simple yet offers so much power and flexibility just under its serene facade. You will not find horizontal lines with arrow heads in between keyframes. You will not see dashed lines signifying broken tweens or vertical lines representing non-synced keyframes. This is a brave new world for Flash tweeners and to steal a line from Flash animation legend Iaith Bahrani: "All of your tweens have finally come true."

4 To move a span in the Timeline, select it by clicking on it and then click and drag it to a new location in the layer.

7 To split a tween span into two separate spans, Ctrl-click (Windows) or Command-click (Macintosh) a single frame in the span and then choose Split Motion from the span context menu.

2 To lengthen the duration of your animation, drag either the left or right edge of the span to the desired frame. Flash will automatically interpolate all the keyframes in the span according to its new length. To add frames to a span without interpolating the existing keyframes, hold down `Shift` `Shift` while dragging the edge of the span.

3 You can select a range of frames in a Motion span by holding down `⌘` `ctrl` while dragging across the desired frames.

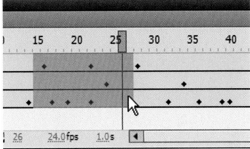

5 To select a single frame or keyframe in a Motion span, hold down `⌘` `ctrl` and click the frame or keyframe. Once selected you can drag the keyframe to a new frame, or alt click to duplicate it while dragging it to a new frame.

6 To select a range of frames in a Motion span, hold down the `⌘` `ctrl` key while dragging across the range of frames and layers you want to select.

HOT TIP

When working with Motion spans, keep in mind that controlling nested animations inside a Graphic symbol (see "Lip Syncing, nesting method" in Chapter 5), is very limited. Any settings for Graphic symbols (Loop, Play Once and single frame) are applied once to the entire span. They can not be applied to individual property keyframes in the span. Therefore your ability to control nested animations is lost, which is the main reason why Adobe retained the Classic tween method.

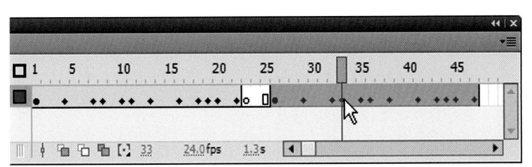

8 You can duplicate a Motion span by selecting it and then holding down the `⌥` `alt` Alt key while dragging it to a new location. This is super easy way to duplicate an animation across layers and other Motion spans. If you drag

a Motion span and overlap it with an existing span, the frames shared by both spans will be "consumed" by the span being moved into this position.

SHORTCUTS
MAC WIN BOTH

95

Editing Motion paths

IF YOU ARE ALREADY FAMILIAR with Flash and the Classic tween method, then you may have, at one time or another, experienced some frustrations trying to work with a frame-based tween model. Throw in the need to animate your object along a path and your workflow just increased even more. Previously, if we needed to animate an object along a path, a guide layer needed to first be created, then linked to the object layer, and then the object needed to be manually *snapped* to both ends of the path with the aid of the Snap tool. The new Motion tween method eliminates the need for all of these extra steps.

1 Right click over the object and select Create Motion Tween. Flash automatically creates a Motion span in the Timeline. With the playhead over the last frame of the span, drag the object to a new location to expose the Motion path on the stage.

2 Use the Selection **V** tool and click anywhere on the stage away from the Motion path to insure it is deselected. Reshape the path by simply dragging it anywhere along the segment.

6 Use the Free Transform **Q** tool to scale, rotate and skew the Motion path as you would an object.

7 In some cases it may be easier to create a complex path by drawing it on a new layer with the Pencil **Y** or Pen **P** tool.

8 Select the stroke and then copy it **⌘ C** **ctrl C**. Select the Motion span in the Timeline or the object on the stage and paste your stroke **⌘ V** **ctrl V**.

3 With the Subselection tool, you can expose the control points and Bezier handles on the path that correspond to each position property keyframe. You can use these handles to reshape the path around the property keyframe points.

4 Position the playhead on a frame where the object resides midpoint along the path. Drag the object to reshape the path automatically.

5 You can reposition the entire Motion path and the animation by selecting it with the Selection **V** tool and then dragging it to a new location.

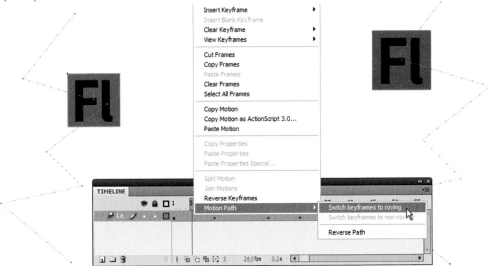

9 If you dig a little deeper into Flash CS5's context menu, you may discover yet another new feature called "switch keyframes to roving." The dictionary defines *roving* as: "*not assigned or restricted to any particular location, area, topic, etc.*" In keeping with that definition, Flash describes a *roving keyframe* as : "...keyframe that is not linked to a specific frame in the Timeline." What this means in Flash terms is, say

you create an animation like the one pictured above, where an object is following a path with several unequal segments. Each segment spans a different number of frames causing the object to travel at different speeds along each segment. If you want the object's movement to be fixed, then right click over the span and go to Motion Path and select *Switch keyframes to roving*.

HOT TIP

With the Subselection tool selected, hold down the ⌘ *ctrl* key to temporarily perform free transforms to the Motion path.

SHORTCUTS
MAC WIN BOTH

97

Motion Editor properties

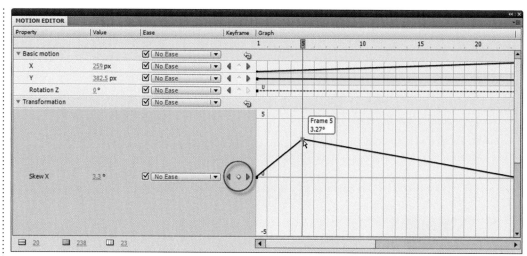

1 Select a Motion span in the timeline and then open the Motion Editor. If it isn't already open, go to Window > Motion Editor. This panel lets you view all the different properties and property keyframes of the selected tween. Each property is displayed as an individual horizontal row that when clicked on expands vertically. Once you have created a tween in the Timeline, the Motion Editor allows you to control the tween in several different ways. To add

a keyframe, position the playhead on the desired frame and click the "Add or remove keyframe" button (circled). A keyframe is added to the frame in the selected property and you can use the Selection **S** tool to click and drag it. Dragging it vertically increases or decreases the amount and direction of the skew. You can also drag the keyframe to a different frame.

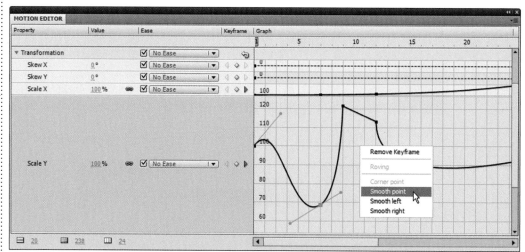

3 Right clicking over a keyframe along the property curve will provide several curve options: corner point, smooth point, smooth left, smooth right. A corner point is a point that has no curve applied to either side of it. A smooth point

is the opposite of a corner point with curves on both sides. Smooth left and right will apply a curve to either side of the point respectively.

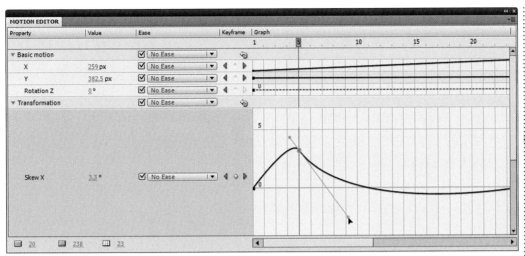

2 You can edit the curve by holding down the Alt key while clicking the keyframe. This will expose the Bezier curves and handles allowing you to fine-tune the shape of the curve. Using these controls is basically the same as how you would edit strokes with the Selection 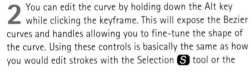 tool or the

Pen 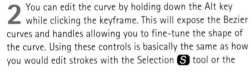 tool. Moving a curve segment or control point upward will increase the property value. Moving a curve segment downward will decrease the value. You can continue to add additional keyframes to create complex curves for complex tweened effects.

HOT TIP

The basic motion properties X, Y, and Z are different from other properties. These three properties are linked together. A frame in a tween span that is a property keyframe for one of these properties must be a property keyframe for all three of them. In addition, control points on the X, Y, and Z property curves cannot be edited with Bezier controls.

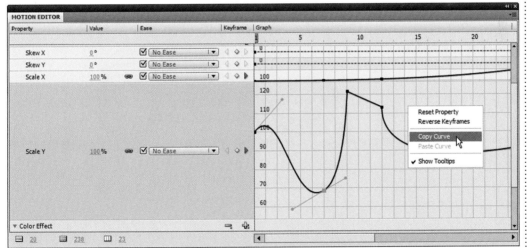

4 One of the coolest features of the Motion Editor is the ability to copy and paste curves from one property to another. To copy a curve simply right click anywhere in the graph area (away from the curve itself) and select Copy

Curve. Expand a different property and right click in the graph area and select Paste Curve. You can also copy curves between custom eases and properties.

Custom easing

1 Adding easing to your animation using the Motion Editor is very easy and flexible because you can select individual properties to apply the easing to. The Motion Editor also provides several preset easing curves to get you started. In the car example, a very basic ease has been applied to the motion of the car so that it eases in from a still position. This provides a realistic motion to the car.

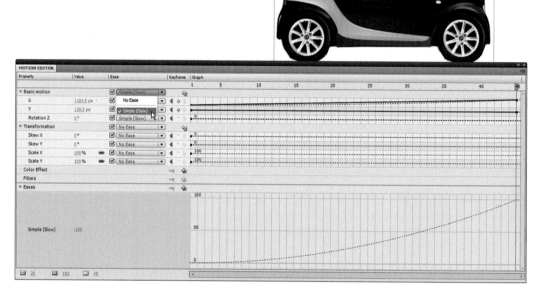

3 The types of easing that can be created in the Motion Editor are limited only by your imagination. I highly recommend experimenting with various easing curves and the effect they have on your animations. It's the best way to get a feel for how a curve affects various types of motion in a Motion span.

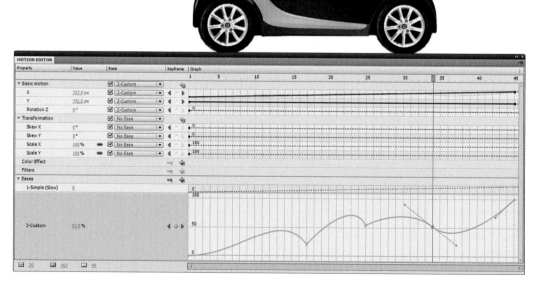

2 One of the most frequently used eases in my workflow is to ease in and ease out within the same span. Click on the "+" symbol in the Eases row and select "Custom". A new row will be added to the Eases category allowing you to edit the curve. Drag the vertex handles to reshape the ease curve similar to what is pictured in the example. I usually try to shape the curve like the letter "S".

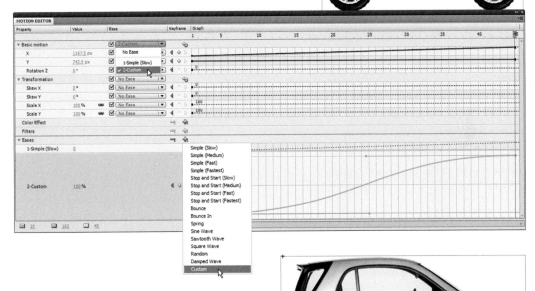

4 In this example I animated the car in random positions on the stage which created several keyframes and several spans of varied lengths. I switched the frames to roving and applied keyframes and easing using the Motion Editor. The resulting effect is an erratic motion as if the object is completely out of control.

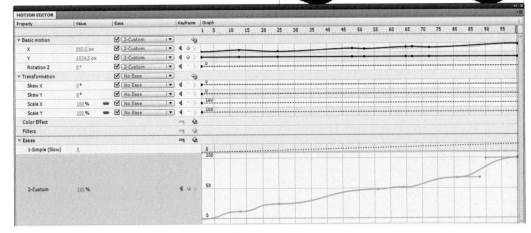

101

Motion tweens and 3D

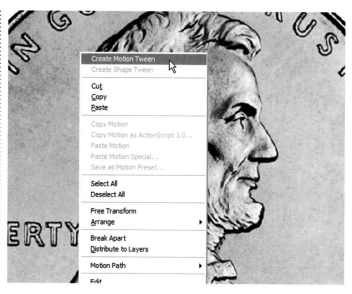

F LASH HAS ALWAYS BEEN a 2-dimensional design and animation program. Making a 2-dimensional object appear to spin in a 3-dimensional space has been a popular effect but very difficult due to the lack of that 3rd dimension. Flash CS4 and CS5 now offer 3D capabilities in the form of 3D Rotation and Transformation tools.

1 Let's start with the image we want to spin. It can be anything you want but I have chosen a coin because it seems this is the exact object many people want to use to animate spinning anyway. I am using a bitmap of a 1 cent US penny but you can use a coin of any currency either as an imported bitmap or drawn with Flash's drawing tools. Either way, make sure to convert the artwork to a Movie Clip symbol and then right click over it and select Create Motion Tween.

4 Next, position the playhead marker on the last frame and rotate the object the rest of the way so it is facing us as it was in frame 1. Playback your animation to see the coin spin in 3D space.

5 But wait! Something's not right. Flash spins the coin to the right during the first half of the animation but then reverses direction during the second half. This is easily corrected by placing the playhead on the frame just after the second keyframe and rotating the object slightly more.

2 Select the 3D Rotation tool **W** and with the playhead on a frame other than frame 1, drag the object along its Y axis (horizontally).

3 Do not try to rotate the coin 360 degrees and expect Flash to know what you want it to do. You will need to divide the animation in half by stopping the coin rotation just short of the half way point.

HOT TIP

Experiment further by adjusting the Perspective angle and Vanishing point in the "3D Position and View" section of the Properties panel. You can get some very interesting 3D perspectives by applying more depth to your object.

6 With the 3D rotation complete, try experimenting by editing the object's position relative to its center point. Edit the instance of the object by double clicking on it. Move the object away from the center point (represented by the "+" cross hairs). The further you move the object from its center point, the more dramatic the effect of the 3D rotation. Here I turned on the Onionskin feature so you can see each frame of the effect when the symbol has been moved horizontally from its own center point.

103

3D Position and View

1 Setting up your "stage" is the most time consuming part of the process. The more elements in your scene, the more convincing the 3D effect will be. Here I have built a landscape consisting of background and midground elements, all converted to Movie Clip symbols and each residing on its own layer.

ONE OF THE MOST REQUESTED features from animators over the years has been the addition of a camera in Flash. Having the ability to build scenes involving a background, midground and foreground has always been a part of the production process. With a camera comes the ability to zoom and pan easily through a scene, requiring the movement of only one single object (the camera) instead of simulating a camera by moving all the contents around the stage.

Cameras only work in 3D environments and Flash, up until now has never supported 3D except for ActionScript-generated 3D engines. But if you are like me, that level of ActionScript prowess is beyond reach.

Flash CS5 still doesn't support an actual camera but we do have the next best thing: 3D Position and View, specifically a "Z" axis that we can now utilize to simulate a virtual 3D stage more effectively than with previous versions of Flash.

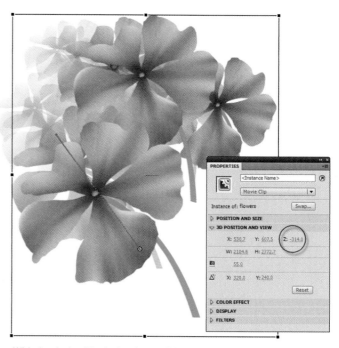

4 With the playhead in the last frame of the Motion span and the Properties panel open, select each Movie Clip individually and use the "Z" axis hot text slider to scale and position each object outside the stage. You will likely need to edit the X and Y axis to position the object precisely where you want it.

2 To suggest an even more convincing sense of depth I have included several foreground objects by adding several instances of a Movie Clip containing the flower graphic from Chapter 1.

3 Determine what frame you want the "camera" zoom to begin and insert keyframes for all of the layers containing the objects that will eventually be moved along the Z axis. Apply Motion tweens to each of the Movie Clips.

HOT TIP

Locate this source file on the CD in the back of this book. It is called "landscape.fla" and it is located in the folder named "Chapter 12". Scrub the timeline with various layers turned on and off to see just how each object is animated relative to other objects on other layers. It is a sophisticated effect when completed and will make much more sense by playing with the original source file.

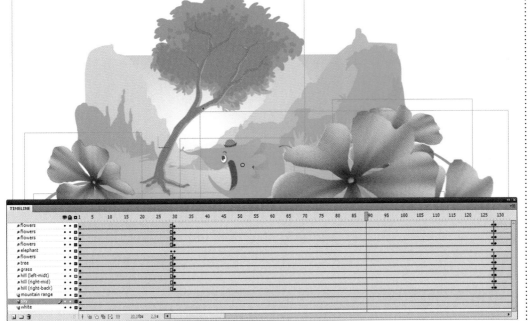

5 For this shot we are simulating a camera zoom, meaning the shot will move us into the scene. Since Flash doesn't have a true Camera, we simulate a zoom by scaling each object from its original size to a larger size. The direction of the zoom is dictated by the final position of each Movie Clip. The key to the success of this effect is how much the objects move in relation to each other. Foreground objects move faster and scale larger than the objects furthest away from us in the background. The sky and largest mountain range do not move at all while the flowers closest to us move and scale the most. This is what gives the viewer a sense of true depth in the scene.

Basic bone armature

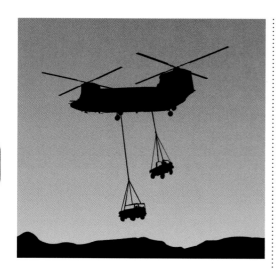

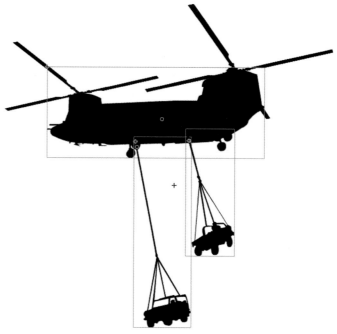

THE BONE TOOL is arguably the simplest of tools to use for creating complex animations. But in the real world, many of us do not have the need or desire to create complex designs or animations on a day to day basis. Not all Flash users are designers and in many cases their ability to create complex animations is limited. But that does not mean professional level animation is unachievable using Flash. For this example I chose a very simple vector image from iheartvector.com.

1 The first step is to determine and isolate what areas of the image you want to animate individually. Select these areas and convert them to symbols.

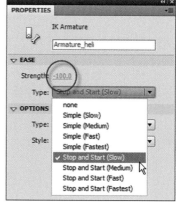

4 The bones themselves should not rotate. The Jeeps are suspended by cables at fixed locations. Select each bone and then disable their rotation property in the Properties panel.

5 It is true that you don't even need the Bone tool for this particular example. The same rigging could be done by editing the center point of a symbol to achieve the same rotation.

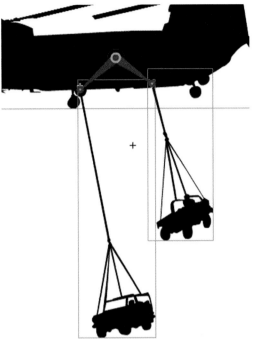

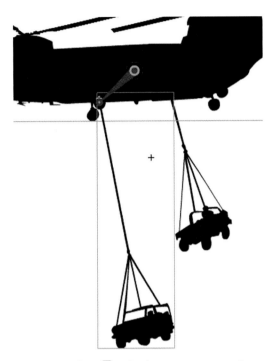

2 Select the Bone **X** tool and create your armature by dragging from the *parent* symbol to the symbols you will be animating. Here the parent symbol is the helicopter itself while the suspended Jeeps are the *children*.

3 This armature requires only 2 bones, both originating from the same point. This is more like setting up a hinging mechanism than an Inverse Kinematic bone structure.

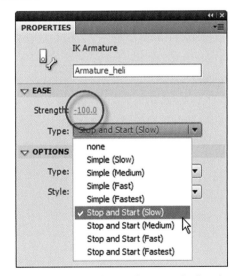

HOT TIP

Try nesting the entire animation in a symbol so you can then apply a Motion tween to make the entire helicopter hover up and down or move across the scene horizontally.

6 With all of the objects prepared for animation, all that is left to do is right click over the symbols containing the Jeeps and apply Motion tweens. The distance each Jeep sways is a matter of personal preference. The more they sway, the windier the conditions they are in.

7 For some added realism, apply some easing in and easing out by selecting the Motion tween span and then the Stop and Start (Slow) ease. Set the strength to -100.

107

Complex bone armature

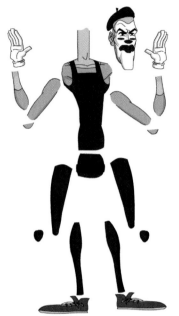

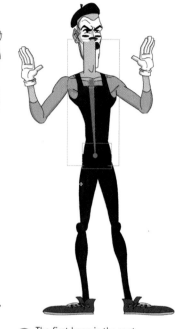

WHEN IT COMES TO CHARACTER animation, the Bone tool can be quite useful. Applying bones to a character is often referred to as "rigging". The first step is designing the character so that each body part is a separate object that can be articulated with a bone armature. The next step is adjusting the rotation and translation of each bone to limit how much it rotates and moves along its X and Y axis. This is the most critical detail of the Bone tool because you don't want the character's limbs and joints to bend past their anatomical limits.

1 Here's the exploded view of the character and all its various body parts. Notice the arms and legs have elbows and knee caps to help eliminate gaps between objects when rotated.

2 The first bone is the root (sometimes referred to as a "parent" bone) in the chain. It seems logical to assign the main torso or chest object to this root bone. Here I have linked the torso and the pelvis objects together.

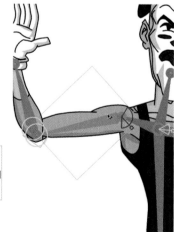

6 When adding bones to symbols, the stacking order can often change based on the original design. To correct this, right click over the necessary symbols, go to Arrange and then select the appropriate action.

7 Next, constrain the rotation and translation for each bone. Select a bone and in the Properties panel check the Constrain boxes for each of these properties and use the hot text sliders to set each value.

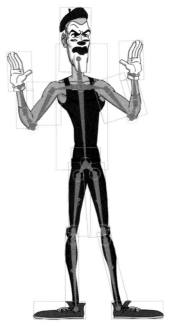

3 Working downwards, I branch off from the pelvis symbol to both upper leg symbols. The pelvis symbol is important because it increases articulation while hiding any potential gaps between the legs and torso when rotated.

4 The lower portion of the character rigging is complete. Bones were added from the upper leg symbols to each knee cap, then to each lower leg symbol and then ultimately each foot symbol.

5 Continuing from the root bone, connect both upper arms, elbows, forearms and hands. The final step in the armature is adding the last bone from the root to the head symbol.

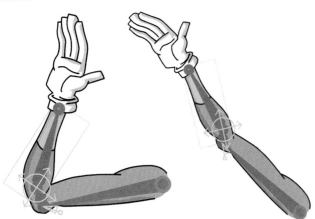

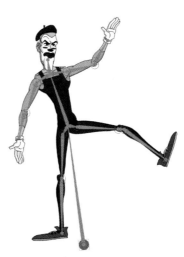

8 By default, bone translation for the X and Y axis is disabled. When each translation is enabled, a bone can move along the X or Y axis to an unlimited degree. Select Enable in the Joint: X Translation or Joint: Y Translation section in the Properties

panel. A two-headed arrow appears perpendicular to the bone on the joint to indicate that X axis motion is enabled. Adjusting the minimum and maximum values helps you control the position of the bone, especially when rotation is disabled as well.

9 Another technique I have been playing with is having the root bone start on a "ghost" symbol. A ghost symbol is not part of the character design. Its sole purpose is to separate the root bone from the actual character for even more articulation.

Joint rotation and constrain

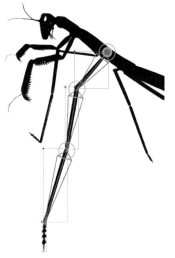

T HE BONE TOOL IS GREAT FOR creating cool armatures that can be easily animated by articulating them. To create more realistic motion, you can control the movement of your armature by constraining its rotation and translation. For example, two bones that are part of an arm could be constrained so that the elbow cannot bend in the wrong direction. You can enable, disable, and constrain the rotation of a bone and its motion along the X or Y axis. When X or Y axis motion is enabled, a bone can move along the X or Y axis to an unlimited degree, and the length of the parent bone changes to accommodate the motion.

1 Insects make perfect Bone tool examples because of their segmented body styles. Here I have applied an armature using the Bone tool to one of the legs.

2 In its current state, the bone chain will allow each segment to rotate 360 degrees without any constraints or limitations. From an anatomical perspective, this may not be the desired behavior.

6 Repeat the same procedure for the opposite direction.

7 You may want to set different constraints for each bone within the same armature. For accuracy's sake, it might be a good idea to do a little research and find out just how an insect like this one actually moves in the real world.

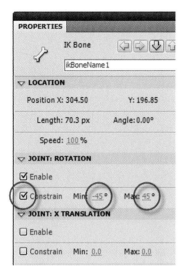

3 Select the root bone and in the Properties panel check the "Enable" and "Constrain" options in the Joint: Rotation category. Use the hot text sliders to change the value based on the amount of constraint you want for the root bone.

4 Rotational constraint is represented graphically by an arc at the end of the bone. Any adjustment to the value of the constraint will affect the arc and how much the bone can move in either direction.

5 You will likely decide through trial and error how much constraint to apply. Change the value, rotate the bone in 1 direction and check to see if the right amount of constraint has been applied.

HOT TIP

To limit the speed of motion of a selected bone, enter a value in the Joint Speed field in the Property inspector. Joint speed gives the bone the effect of weight. The maximum value of 100% is equivalent to unlimited speed.

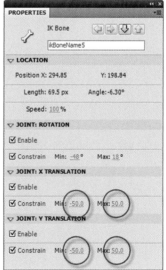

8 With 4 different segments per leg, it can get complicated quickly. Setting rotational constraints should help keep each movement under control.

9 In addition to rotation constraints, you can also set constraints to the X and Y translation of each bone. This will set limitations on the amount of movement the bone has along the X and Y axes. In some situations you may want to set the value(s) to "0" to eliminate any movement along these axes.

Bone tool easing basics

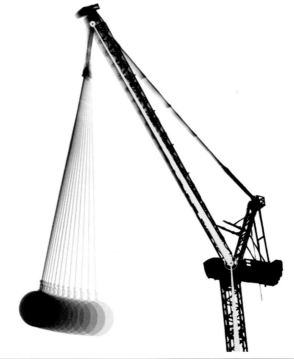

Easing is always the icing on the cake for me when I am producing animations. It's usually the final step in my process. Once all key poses are created and Motion tweens applied, the final step is applying easing for that extra touch of realism. Easing is usually applied in 2 ways: *easing in* and *easing out.* Easing in calculates the rate of each frame so that the animation starts slow and gradually increases speed. Easing out is the opposite where the rate of speed is reduced as the animation plays. A perfect example of easing is when a ball is thrown towards the sky. Gravity's constant force gradually slows the ball down until it changes direction, returning to Earth with a gradual increase in speed. With easing, you can adjust the rate of change to the values for more natural or more complex animation.

1 Using an image of a crane is about as basic as it gets. The armature consists of only 2 bones since all we need to move is the cable with the ball attached. The animation requires that the ball travels back and forth much like a pendulum. To imply gravity we need to apply an ease in and an ease out for each direction the ball moves. Position the ball to the far right or far left in the first keyframe. Move the playhead to the middle of the span and position the ball in the opposite direction. ⌘ *ctrl* +click the first keyframe, right click and select Copy Pose. ⌘ *ctrl* +click the last frame and right click and select Paste Pose. You now have a swinging ball on a crane that loops back and forth seamlessly.

To add the easing, select any frame between the first 2 keyframes. In the Properties panel use the Ease drop down menu to select Slow and Stop (Slow). Adjust the easing strength to -100 using the hot text slider. You can also click on this value to select it and type in "-100". Repeat this same procedure for the 2nd half of the armature span.

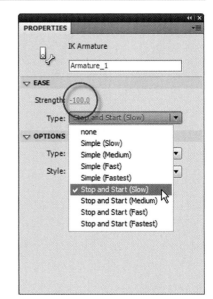

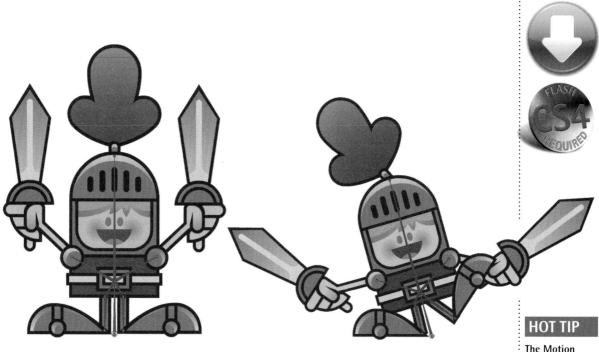

2 Here's a slightly more complex Bone armature involving a cartoon figure with a head and 4 limbs. I used an extra symbol that was not a part of the character's design for the root bone to be attached to. You can see this root bone start between the character's feet. The concept here was to assign the root bone to an object not integrated into the character's design. This allows for all of the character's symbols to be assigned non-root bones, allowing more articulation.

Once all the key poses have been created, all that is left to do is to add some easing from pose to pose. This helps create a more natural movement for the character. Just like with the crane example, select any frame between the keyframes and in the Properties panel use the Ease drop down menu to select a preset ease. Adjust the easing strength to -100 or 100 depending on your needs. If you want the preset to ease in, then use a negative value. A positive value will apply easing out to the animation. The value refers to the strength of the ease.

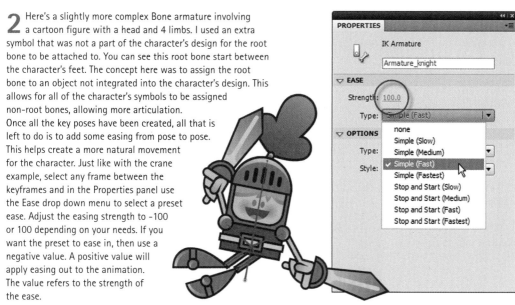

HOT TIP

The Motion Editor does not support IK spans. Therefore, you can not apply custom easing to armatures. The only easing for IK armatures is the presets available in the Properties panel. Having the ability to create custom eases and possibly edit the property curves of an armature span may be a valid feature request for a future version of Flash.

SHORTCUTS
MAC WIN BOTH

Bones and shapes

BONES ARE NOT LIMITED TO SYMBOLS. You can apply a bone armature to a single shape. The difference between symbols and shapes when working with the Bone tool is, you can add multiple bones to the interior of a single shape. This is different from symbols because you can have only one bone per instance. Once bones are added to the selection, Flash converts the shape and bones into an IK shape object and moves the object to a new pose layer. Once a shape is converted to an IK shape, it can no longer merge with other shapes outside the IK shape.

Manipulating a shape with an armature can produce more organic looking animation. Case in point, here I need to animate the tail of a cat waving back and forth. With the Bone tool I am able to quickly and easily produce a very natural and realistic looking tail-like motion.

1 Before applying a bone structure to the tail, it is best to start with the tail drawn without any curves. The reason is, if we start with a curved tail and apply the bone armature, then it becomes much more difficult to curve the tail in the opposite direction without the integrity of the shape becoming compromised. A straight position is neutral and can be easily manipulated in either direction. For this animation we will make the tail move from left to right in a whip-like fashion.

2 We want the tip of the tail to have the most flexibility and the bottom of the tail to be the most rigid. The root bone is the very first bone created in the chain and all subsequent bones are its children. Select the Bone **X** tool and drag inside the tail shape from the very bottom in an upward direction. Once the root bone has been applied, Flash will automatically place the shape in a container called an *IK shape object*. This new object is automatically moved to a new *pose layer*.

5 Insert several frames in the armature pose layer and then move the playhead somewhere in the middle of the span. Articulate the tail in the opposite direction simulating an "S" curve again. Use your best judgement as to how much curve you want your tail to have. There are no rules here when it comes to artistic license.

3 Continue adding bones to the shape, working your way upwards until the entire armature spans the entire tail. What may be the most important detail of this technique is making each bone slightly shorter than the previous bone moving up the tail. The reason for this is to allow the tail to become more articulated towards the tip. If you were to create longer bones towards the tip, articulation would suffer and you would end up with severe 90 degree bends instead of several softer bends representing a more curvy tail overall.

4 Once the armature is complete, position the tail in the desired starting shape in frame 1. Here I have grabbed the tip of the tail and articulated it into an "S" curve.

HOT TIP

You can also add bones to shapes created in Object Drawing mode.

6 The key to creating a realistic wavy tail is to add a little secondary animation. Place the playhead a few frames after the initial starting pose and curl the tip of the tail in the opposite direction it is traveling in. This provides more of a "whip" effect as the tail begins to change direction.

7 To make this tail loop seamlessly, ⌘ ctrl +click frame 1 and then right click over it. Select Copy Pose.

SHORTCUTS
MAC WIN BOTH

Bones and shapes (cont.)

8 ⌘ *ctrl* +click the last frame in the armature span and right click again. This time select Paste Pose.

9 Next, add the secondary animation as we did in step 6 by placing the playhead a few frames before the last frame and creating a more dramatic curve in the opposite direction the tail is moving.

12 Create a new symbol in the Library using the drop down menu in the upper right corner of the Library panel. The symbol can be a Movie Clip or a Graphic symbol but for this example I recommend Graphic behavior so you can see the animation inside the Flash authoring environment.

13 Once the symbol is created you will be inside this symbol and ready to add the armature you copied earlier. Right click over the stage area and select *Paste*. The entire armature and its animation will now be nested inside your new symbol.

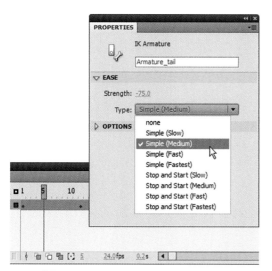

10 Without easing, the tail feels too rigid and mechanical. Select any frame between the first 2 keyframes and from the Properties panel select an ease preset using the drop down menu in the Ease category. To ease in and then out between these 2 keyframes, set the strength of the ease to a negative value using the hot text slider. Repeat this step for each keyframed pose.

11 In most situations you could consider the animation complete. For all intents and purposes it is, but for this particular character I want to make sure the tail animation is as visible as possible. Therefore I want to Motion tween it back and forth along the X axis. To do this, it is best to tween the entire tail animation inside a symbol. Right click over the tail armature and select *Copy*.

The last few steps were necessary only because of the design of the character's torso. It may not be necessary to nest your animation and Motion tween it behind your character but I felt this was a perfect example of how nesting animations can solve a lot of design challenges.

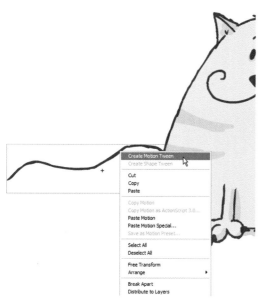

14 Navigate back to the main timeline and create a new layer below your character. Drag an instance of the symbol containing the animated tail to the stage and position it relative to the character. The tail animation starts with the tail pointing to the left, so favor the left side of the character when positioning the symbol. Right click over the symbol and select Create Motion Tween.

15 Scrub the timeline and watch the tail animation reaches the half-way point where the tail is pointing to the right. Hold down *Shift* *Shift* and use the right arrow key to position the tail symbol towards the right side of the character. Copy the first frame of this Motion tween and paste it into the last frame creating a seamless loop. Now the tail is comprised of 2 simultaneous animations.

SHORTCUTS

MAC WIN BOTH

Bind tool

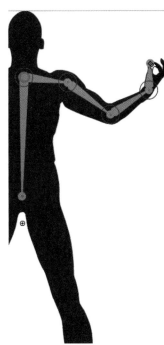

WORKING WITH VECTORS has many advantages. Vectors are resolution independent and help maintain small file sizes suitable for the Web. They are also easy to edit using control points and Bezier handles. But even vectors are not without their imperfections. If you have ever attempted a Shape tween you probably have experienced inexplicable anomalies with shapes behaving in unexpected ways. In that situation we have Shape Hints to help correct the problem.

In Flash CS4 and CS5, shapes can be manipulated by using the Bone tool and like Shape tweens, there can be some hits and some misses. That's where the Bind tool comes to the rescue. The Bind tool allows us to fine tune how control points are affected by the armature.

1 As with any Armature, designating where the root bone should be assigned is the first step. This particular object, being a single flat shape, makes that decision relatively easy. I chose the mid-torso area for the root bone.

2 From the root bone continue building the armature by adding bones to the upper arm, the forearm and then the hand.

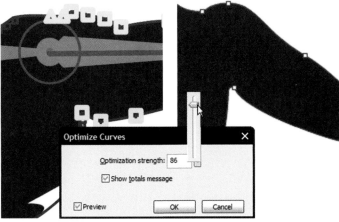

5 if your shape has a large number of vector points, it may be worth it to optimize ⌘ ⌥ Shift C ctrl alt Shift C the shape as much as possible to eliminate any unneeded points.

6 An optimized shape will have a lower number of points. As a result, your bone armature should work better because there will be less deformation within the shape itself.

3 Manipulate the armature by grabbing the last bone in the chain (in this case the hand) and moving it around the stage. In the above example you can clearly see some unwanted deformation below the arm along the side of the body. This is where the Bind **Z** tool comes in handy.

4 Select the Bind **Z** tool and then select a bone in the armature. The control points assigned to the selected bone are highlighted in yellow. To add points to a bone, *Shift* *Shift*+click an unhighlighted control point. To remove points from a bone, ⌘ *ctrl*+click a highlighted control point.

7 An optimized shape retains its integrity a lot more than an unoptimized shape. But as you can see here, there's still no guarantee there will not be any imperfections.

8 Use the Bind tool to assign or unassign control points for each bone along the armature to correct any anomalies with the shape. It's much easier to work with fewer points associated with an optimized object.

9 Add more bones to the armature to accommodate the entire shape. The same process applies to each limb: manipulate the armature, check for deformations and imperfections (if any) and adjust using the Bind tool.

SHORTCUTS

Speed tool

F LASH HAS A SPEED TOOL? Yes it does. The Speed tool is probably the most unknown and undocumented tool in Flash. Speed is available when the Bone tool is used to link multiple symbols together or when bones are applied to a shape. The amount of Speed is adjusted to each bone individually.

So what does Speed actually do?

When you manipulate an armature in the Flash authoring environment, the bones move freely as expected. When the Speed of a bone is decreased in value, it will have more resistance when being moved around the stage. For character animation, adjusting the Speed for each bone can help armatures feel more realistic. Bones applied to larger objects can have less Speed while smaller objects can have more Speed. If used correctly, the Speed feature can provide real-time realistic feedback during the animation process.

1 By default the Speed value for all Bones in an armature is 100%. The goal here is to use Speed to change the way the armature feels when manipulated within the Flash authoring environment. In the arm armature I want the upper arm to have the most resistance. Using the Selection tool **V**, click directly on the bone to select it.

4 With the second bone selected, adjust the Speed value to 75%, so that the bone will move with a little more agility than the parent bone.

5 The red circle at the end of the bone armature is a home-grown technique I use to provide an extra bone to control the hand. This extra bone allows me to apply constraints to the hand symbol which otherwise would not be possible.

2 With the bone selected and the Properties panel open, reduce the amount of speed using the hot text slider or by highlighting the value and typing in a new one. I want this particular bone to have the most resistance, so I gave it a value of 15%. If the value is 0%, then the bone will not move at all.

3 The second bone in the armature is attached to the forearm symbol. I want this symbol to have less than 100% speed but more than its parent bone (the upper arm). When manipulating the armature, I want the forearm to feel a little more flexible than the upper arm bone. Select the forearm bone using the Selection tool **V**.

HOT TIP

The addition of an extra symbol placed just beyond the hand is incredibly useful for a couple of reasons. Not only does it add that necessary extra bone to the armature that is needed to constrain the last symbol in the chain, but it also provides an accessible handle to manipulate the armature. Just make sure to remove the artwork in the extra symbol before publishing the animation. I prefer to convert the layer containing the artwork to a Guide layer - that way it will not be included in the published file. You can always convert the layer back to Normal if you decide to continue editing the animation at a later time.

6 The last bone in the chain has the Speed setting at the default of 100%. With the speed adjustments applied, the armature will move now with much added realism difficult to convey using an image. When you drag the armature from the very last bone (pictured here as the red circle), the hand will move with zero resistance while the forearm will have a slight amount of resistance and the upperarm will feel very sluggish. The result is a very realistic feeling that you are moving a real arm as if physics and gravity are in play. Speed is a very cool authoring tool animation feature that will help you pose your armatures more efficiently and effectively.

SHORTCUTS
MAC WIN BOTH

Pinning

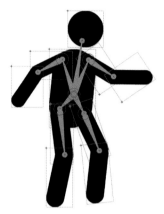

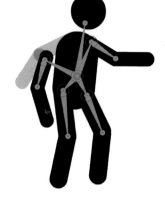

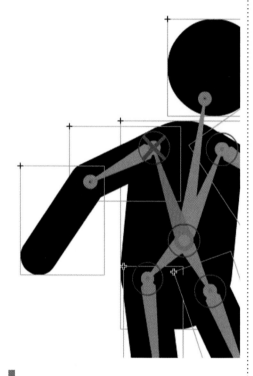

I N AN EFFORT TO ADD MORE control to the Bones of an armature, Adobe has added a feature called Pinning that allows individual bones to be locked down to their current position while the rest of the armature can be articulated. Pinning is particularly useful for controlling the armature on a bone to bone basis allowing for tighter and more precise control when manipulating the character.

1 I've started off by creating a simple stickman character linked together using the Bone tool. The first bone links the body to the head and all subsequent bones are drawn from the parent bone to the limbs.

2 With the basic armature as is, moving the arm will dislocate it from the shoulder. This situation is where Pinning will come in handy.

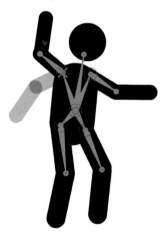

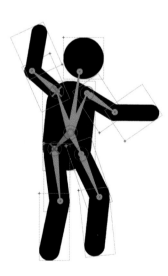

5 The child bone can now be rotated at the shoulder without becoming dislocated from the body.

6 You can pin multiple bones within the same armature. Here I have pinned all the bones that connect to the parent bone to insure none of the child bones become dislocated during the animation process.

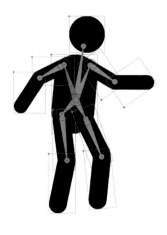

3 Select the bone that links the parent bone to the arm bone as shown above in blue. In the Properties panel you will notice the Pin selection in the Location category. Simply check the Pin box to pin the selected bone to its current position.

4 A red circled "X" appears where the selected bone links to its child bone. This red X indicates where the bone is now pinned and where the connecting bone will hinge.

7 You can turn on and off pinning for any bone in an armature as needed throughout the IK span. No matter how long your animation is, at any point in the IK span any bone can be pinned and unpinned without affecting your existing animation.

HOT TIP

If you want to rotate the entire character and its armature structure, use the Free Transform tool **Q** to select and rotate the entire assembly. You can also scale the entire armature using the same process.

Basic shadow

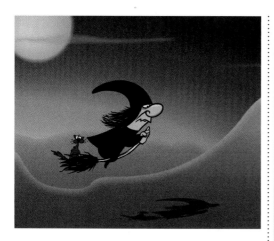

SHADOWS CAN ADD depth to your project. This is the most basic way to add a shadow to an animated character. Its simplicity does have its limitations, however. In this chapter you will learn more advanced shadow techniques with greater flexibility, but some may not be supported in older versions of the Flash player. Depending on your target audience and your client's technical requirements, you may need a technique that will allow you to publish to older player versions. This is one such technique.

1 For the best result, place your character animation inside a symbol. This is commonly referred to as "nesting". The next step is to simply copy the symbol of your character using ⌘ C ctrl C. Create a new layer and move it below the character layer. Paste the copy of the symbol using ⌘ V ctrl V into this new layer.

4 With the Free Transform tool Q still selected, click and drag horizontally outside the bounding box in between the handles to skew the shadow.

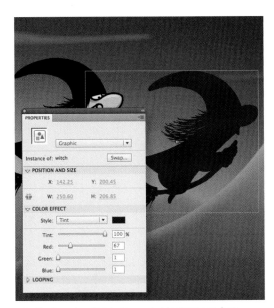

2 Next, apply a tint to the symbol instance you just pasted. The tint needs to have a strength of 100% to completely hide the character's details. The color of the tint should also be a darker color value than the background.

3 Position the shadow instance and with the Free Transform tool, scale it vertically to suggest some perspective of it being cast against the ground.

HOT TIP

This technique works great when your entire character animation resides in a symbol. Using a duplicate of this symbol for the shadow serves a dual purpose: since you are re-using a symbol, your movie will be efficient in terms of file size. Another advantage to using a duplicate symbol is when you revise or add more animation to the original symbol. Since both instances reference the same symbol in the Library, the shadow instance will be updated as well.

5 You may want to scale your shadow slightly smaller to suggest more depth. Play around with its position relative to the original character for the best results. Because the shadow symbol is a duplicate of the original animated character symbol, it will also animate in sync with the character. This will result in a convincing shadow effect. Since you have not used any special filters, this shadow effect is supported by all versions of the Flash Player.

SHORTCUTS
MAC WIN BOTH

Drop shadow

S EPARATION BETWEEN CHARACTER and background can be critical to the overall impact of your animations. There are several ways to approach adding shadows for characters but, with animation, the approach can seem a bit daunting at first. Flash CS5 makes this as easy as possible with the use of Filters.

1 Filters can only be applied to Movie Clips. If your animation is not in a Movie Clip, you'll need to remedy this by selecting the entire range of frames and layers and then Copy Frames from the right-click context menu.

2 Create a new Movie Clip symbol from the Library panel. Select the first frame of this symbol and, from the right-click context menu, select Paste Frames.

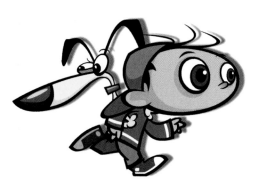

For this example we will take a look at the Drop Shadow filter in its purest form. The technique that follows this one will provide a cool way to use the same filter that adds more depth and perspective.

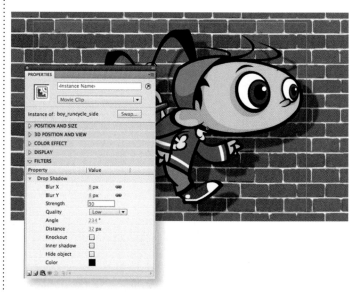

5 If you have a complex background, set the opacity to around 30-40%. This will allow the background values to show through the shadow itself for a realistic effect. I usually spend most of my time adjusting the angle and distance of the shadow relative to my light source. Test your movie to see the Movie Clip and shadow animation.

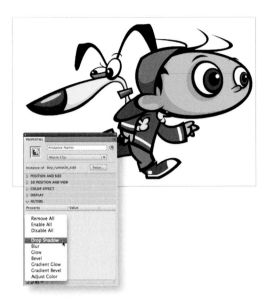

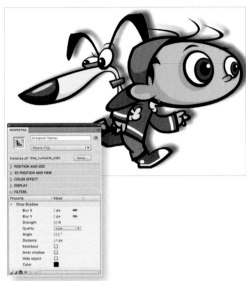

3 Drag an instance of this Movie Clip to a new layer on the main Timeline. Delete all the original frames and layers as they are no longer needed. Select your new Movie Clip instance and from the Properties panel select the Drop Shadow filter from the Filters section.

4 Adjust the amount of blur, opacity, angle and distance to achieve your desired results. You can also select the color of the shadow by clicking on the swatch color.

HOT TIP

Adjust the strength of the shadow to suggest more or less contrast between our character and wall. Less strength (less opacity) will suggest a softer light, such as an overcast day. Higher strength (more opacity) will suggest a stronger light, such as a very sunny day.

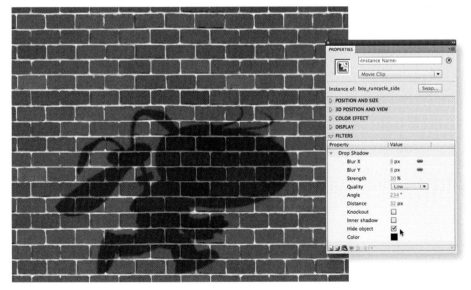

6 Select the Hide object feature to hide the Movie Clip. The drop shadow will remain on stage. Test your movie to see just the shadow animation. Experiment with some of the other options, such as Knockout and Inner shadow. You can also click the little lock icon next to blur to remove the X and Y constraint. Apply more blur to X or Y for even more interesting results.

Perspective shadow

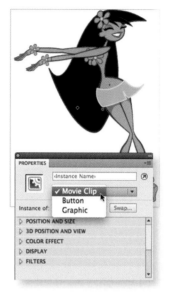

S O FAR WE'VE LOOKED at how to add a drop shadow filter to an animated character using a Movie Clip and the Filters feature. But the drop shadow can be a little limiting in some situations. To place a character in an environment that has more depth and perspective to it, the drop shadow will not work very well since it tends to flatten the perspective. You may need a shadow that provides the illusion of perspective and depth.

1 Select your Movie Clip instance and copy it using ⌘ C ctrl C. Create a new layer below it and paste it in place using ⌘ Shift V ctrl Shift V .

2 Lock the top layer to avoid editing it. Select the instance in the layer below it and, using the Free Transform tool Q, edit its center point so that it is positioned on the bottom edge.

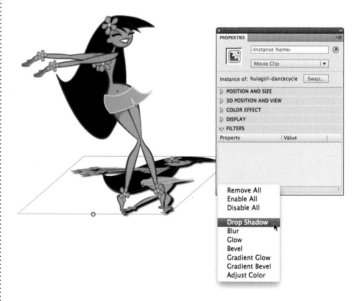

5 With the symbol still selected, apply a Drop Shadow filter to it.

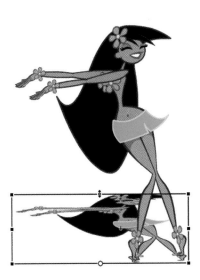

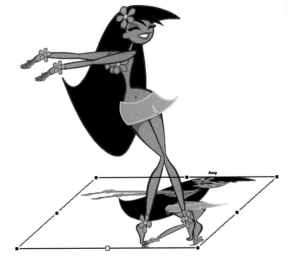

3 Scale the symbol downward by dragging the handle in the top center. Notice that the center point positioned on the bottom edge limits that edge from scaling.

4 Next, skew the symbol by dragging in between the handles outside the top edge.

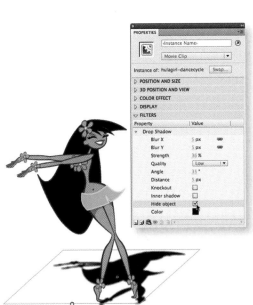

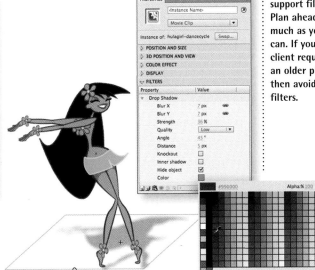

6 The "cheat" to this technique is to select the Hide object feature. Now all you'll see is the Shadow filter itself.

7 Play around with the options provided. You can adjust the amount of blur, opacity, quality, angle and distance. You can even change the overall color of the filter itself.

SHORTCUTS
MAC WIN BOTH

129

Blur filter

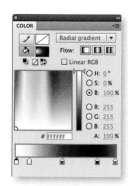

1 The billiard ball is simply a circle with a radial gradient. The trick is mixing the gradient using five colors: highlight, midtones, shadow and then a lighter value to the far right. This is the most critical color as it suggests light coming from behind the shape, creating the illusion that it is three-dimensional. Use the Gradient Transform tool to edit the center point as well as the scale and rotation.

T HE BLUR FILTER is a very handy tool for creating a more realistic motion blur compared to just a linear gradient. Filters can only be applied to Movie Clip symbols, so you will need to plan ahead if your animation relies on several nested animations that need to be in sync with each other. With a combination of Motion tweens and some basic ActionScript, you can control what each Movie Clip does and when it should do it, not unlike the director of a movie.

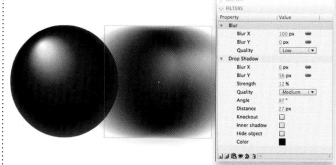

4 To add a realistic blur effect to the ball as it is Motion tweened across the stage, select it and in the Filters panel drop-down menu, select the Blur option. Since the ball is traveling horizontally, we do not want any vertical blurring. So click on the little magnet icon to unlock the blur constraint. Set the amount of blurring in the X dialog. The Y dialog box should be set to "0".

7 When two or more balls collide, you must target each instance and tell them what to do. On the main timeline you can control what they do with keyframes and Motion tweens. The nested animations must be targeted with ActionScript since a Movie Clip's Timeline is independent of the main Timeline. Both movie clip timelines are controlled with one line of code each. The nested animations then play until they reach a Stop action.

2 Convert your sphere to a Movie Clip symbol. All of the ball animations are nested in this symbol, consisting of a starting roll, rolling to a stop and a continuous roll. Check out the source file on the CD to see how these animations were made using a mask and motion tweening the symbol "8" across the sphere.

3 Copy and paste, or drag multiple instances of this symbol from the Library to the stage, each on its own layer. Select them one at a time and type in a unique instance name in the Properties panel. This will allow you to target them individually.

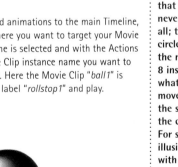

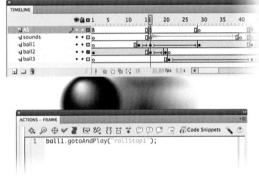

```
1   ball1.gotoAndPlay("rollStop1");
```

5 The technique is to use Motion tweens and the Blur filter to provide the illusion that these balls are moving at an extreme rate of speed. Once a ball makes contact, its speed is dramatically reduced, at which point the Blur filter is removed by adding a keyframe and clicking the "-" symbol in the Filters panel.

6 To synchronize the nested animations to the main Timeline, add a blank keyframe where you want to target your Movie Clip(s). Make sure the keyframe is selected and with the Actions panel open, type in the Movie Clip instance name you want to target, then tell it what to do. Here the Movie Clip "ball1" is being told to go to the frame label "rollstop1" and play.

HOT TIP

Locate the file named "8ball. fla" from the CD included with this book. Double-click one of the ball symbols to see how it was animated using Motion tweens and a little masking. You can add to this timeline by creating additional ball rotations. The illusion here is that the ball never rotates at all; the white circle with the number 8 inside it is what actually moves across the surface of the circle shape. For similar illusions made with masks, see Chapter 3.

```
1   ball1.gotoAndStop(ball1._currentFrame);
```

8 You can use _currentFrame to start or stop the ball on whatever the current frame happens to be. This is particularly handy when the timing of the animation changes on the main Timeline and you don't want to constantly have to update the nested animations. When this script is called, whatever the current frame is inside the targeted Movie Clip, its playhead will simply stop.

Flying text

REMEMBER THE FIRST time you learned to use a mouse? Or to tie your shoes? These tasks seem so simple now, but some things are just plain easier after someone shows you how. It's the "not knowing where to start" that can be frustrating.

Well, consider this your start. I'm going to show you how simple it is to achieve some basic cool motion effects in Flash CS5 – effects that look really difficult to build, but, once you know how, are not so hard to create. Specifically, you'll make objects appear to move very fast using an animation effect known as Motion blur.

1 First, you need to create the two objects used for this effect: text and a linear gradient. The linear gradient should have at least three colors, the middle color should be a value similar to the main color of the object and the left and right colors should be the same color as your background. If you have a complex background, mix these two colors with 0% alpha so the blur blends into the background.

3 About three to five frames down your Timeline, add a new keyframe (F6). Holding down the Shift key, use the right arrow key to move the gradient across the stage. Position it wherever you like; just make sure it remains on the stage entirely (do not position it off the stage).

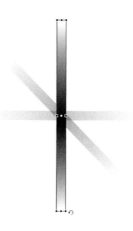

5 This effect is not limited to a horizontal format. Rotate the gradient 90 degrees.

6 Align the text below (or above) the gradient using the Onionskin tool to help guide you.

2 To create the animation for this effect, convert the linear gradient to a symbol and place it about halfway off of one side of your stage. You might want to start the animation on a frame other than frame 1 to provide a moment for the viewer to anticipate the action.

This technique works quite well with objects other than text. Balls, bullets, superheroes, cars, just about any object in action that requires a high rate of speed will work with this effect. You will likely want to play around with a combination of frame rate and the length of your Motion tweens depending on your project. The advantage with this effect is you do not need a very fast frame rate (although it does help). You can achieve the same results with a lower frame rate as long as the number of frames in the Motion tweens are fewer than compared to a higher frame rate.

4 Apply a Motion tween to make the gradient symbol move across the stage. Next, create a blank keyframe in the frame after your second keyframe and drag your text symbol to the stage from the Library panel ⌘ C L. Turn on the Onionskin tool so you can see the previous frame and where the linear gradient is positioned. Align your text to the right of the gradient. Play back your animation.

7 Repeat the same procedure as you did for the horizontal effect. Motion tween the gradient vertically from outside the viewable stage area. Then, in the frame after the tween, add a blank keyframe and position and align the text below the gradient. Reverse the procedure to make the text fly out and off the stage. I'm sure you will have a lot of fun with this effect as it is one of the easiest to master, yet it looks so good!

flying text

Combining effects

BECOME A KEYFRAMER

1 Type out your text using the Text tool. This particular font is pretty complex and already suggests movement. Your text, however, can be hand-drawn graphics depending on the style of project you might have.

3 With every letter still selected, right-click over one of them and select Distribute to Layers. This will create a new layer for every letter and each letter will be placed into its own layer for you. A true time saver if ever there was one. Now is a good time to convert each letter to a Graphic symbol.

T HERE ARE SOME ANIMATED EFFECTS that look so advanced, it's difficult to determine how they were actually made. It is often assumed the skill level necessary to create such advanced motion graphics is well out of the reach of the average Flash user.

Not true in most cases. When we watch animated motion graphics, if the frame rate is fast enough, the human eye may not be able to see everything that is happening. As a result, our mind fills in what may not even be there. The good news is, we can use this natural shortcoming of the human eye to our own advantage when creating "advanced" motion effects. In my experience I have discovered that the most visually appealing animations are a combination of multiple techniques happening at the same time.

5 Next, to create the effect of each letter fading in one after the other, you will stagger each Motion tween to overlap the one below it. Starting with your second letter, select the range of frames in the Motion tween, then drag them down the Timeline a few frames. You can also select a frame before the tween and press F5 (Insert Frames) to push each Motion tween down the Timeline.

BECOME A KEYFRAMER

2 With the text field still selected, break it apart using ⌘ C ctrl C once. This will split the text field into individual text fields per letter. This retains the properties of the font and you have the ability to edit each letter as such. If you wish, you can break it apart one more time to convert the font into raw vector shapes.

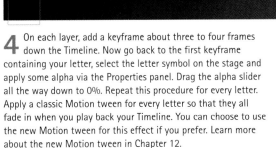

4 On each layer, add a keyframe about three to four frames down the Timeline. Now go back to the first keyframe containing your letter, select the letter symbol on the stage and apply some alpha via the Properties panel. Drag the alpha slider all the way down to 0%. Repeat this procedure for every letter. Apply a classic Motion tween for every letter so that they all fade in when you play back your Timeline. You can choose to use the new Motion tween for this effect if you prefer. Learn more about the new Motion tween in Chapter 12.

HOT TIP

Check out the "Extending Flash" chapter to learn about JSFL and how you can create your own commands for repetitive tasks such as applying a Motion tween. Once something is an actual command, you can then create a custom key shortcut for it. This will save you about two clicks every time you need to apply a tween. That can add up quickly over a period of days, weeks, and months. Every minute saved is a minute earned in this industry.

BECOME A K E

6 The final step is to select the first frame of each animation and use Shift while pressing the left arrow key. This will position each letter with 0% alpha to the left and on playback will create the motion of each letter flying into position while fading in at the same time. Once again, there is nothing particularly difficult about this effect. All you have done is use Motion tweens with some alpha fades. This is still a very basic Flash animation technique. The only difference is the timing of each letter relative to each other. Throw in a slight amount of movement and suddenly you have what looks like an advanced animated text effect.

SHORTCUTS

Blur filter (text)

1 It is usually a good idea when creating animated effects to work backwards. Start with the final frame, insert frames to extend your entire Timeline and then add keyframes to the last frame.

SOMETIMES YOU MAY NEED a blur effect that is more realistic than the linear gradient method. The Blur filter is perfect for creating realistic blurs, even animated ones. Filters were introduced in Flash 8 and to create the same blur effect in older versions, we had to export the object from Flash as a PNG file, open it in Photoshop (or any graphics editor of choice) and apply the Motion blur. Then we would have to export from Photoshop as a PNG file and import back into Flash. Thankfully, those days are long gone with the ability to not only apply filters, but to animate them as well.

3 In frame 1, select a Movie Clip symbol on the stage and apply a Blur filter from the Filters panel. Click on the small black magnet icon to unlock the blur constraint. Use the slider to adjust the amount of blur for the X axis only.

5 For objects that fly in vertically, limit the amount of blur to the Y axis. Remember to use your Shift and arrow keys to maintain alignment between keyframes, unless of course you want to have your object travel at an angle.

2 Go back to frame 1 and begin the animation process by positioning the objects that will animate into view off the stage. Hold down the **Shift** key while pressing the arrow keys to maintain alignment and move the object incrementally ten frames.

4 Drag the keyframe in your last frame closer to the first keyframe and apply a Motion tween. The symbol will animate from outside the stage into its original position. The Blur filter will also be motion tweened from the amount of blur in the first frame to no blur in the last frame.

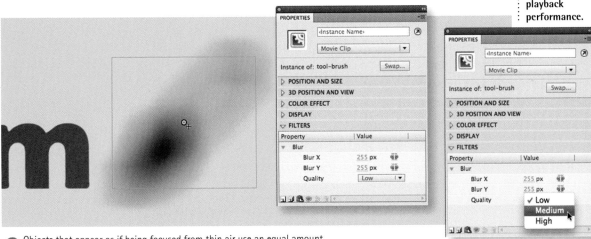

6 Objects that appear as if being focused from thin air use an equal amount of blurring for both the X and Y axis. Did you know you can set a blur amount beyond what the slider allows? The slider taps out at a value of 100, but you can type in your own value up to 255.

SHORTCUTS
MAC WIN BOTH

137

Selective blurring

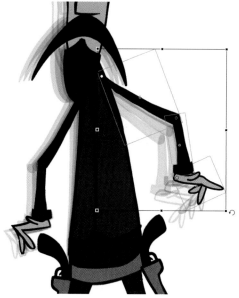

1 The first step is to add a little anticipation (refer to the "Anticipation" topic to learn more). Rotate the arm into a position that suggests he is about to grab something (refer to the "Hinging" topic to learn more about rotating body parts based on a custom center point). I also added some "itchy-finger" animation to build up the anticipation and focus the attention on his hand.

HERE'S ANOTHER COOL TRICK to suggest movement between two keyframes. Open the "cowboy.fla" from the included source CD and play back the animation. The technique being used is basically a mixture of frame-by-frame animation with a variation of blurring and stretching. Look closely at the movement of his arm when he reaches for the gun. There's only two frames where this effect is used and at 24fps it's almost impossible to see. Yet the effect is still visually effective as it really smooths out the motion of his arm through the gesture of reaching and drawing his weapon.

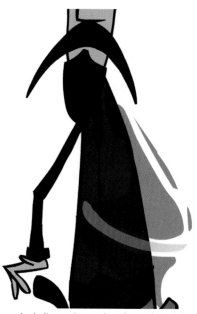

4 The next frame is similar to the previous frame. I used the Brush tool again to draw new shapes using the same colors. Turn on the Onionskin tool to see the previous frame as a reference.

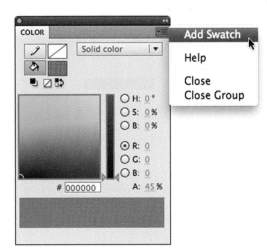

2 Replace the arm with some very simple shapes drawn freehand style with the Brush tool. The fill for the arm is a mixture of black and about 30% transparency. The fill that represents the hand is the flesh tone mixed with some transparency as well.

3 You can mix in a little alpha by typing in a percentage manually or using the handy slider bar. Add this new color to your Swatch panel using the upper right corner drop-down menu.

HOT TIP

The selective blurring technique works best when it is barely seen. If it stays on stage long enough for the viewer to notice it as an object, it has performed a disservice to your animation effect. In essence, this technique should enhance the motion as a whole, not introduce an additional component to it. It should be subtle and used sparingly for a greater overall effect.

5 After two frames of blurring, it is time to bring the original arm back to the animation and in a new position. You will notice I also added some brush strokes behind the arm to suggest the arm is still moving but decelerating.

6 When a gun is fired, the resulting action is referred to as "recoil". We have Sir Isaac Newton to thank for showing us that every action has an equal and opposite reaction. This law of physics is critical for us to understand and, when necessary, incorporate into our work.

Background blurring

IF YOU WATCH animated shows on television then I'm sure you've seen the Motion blur technique, where the characters remain relatively still while the background is being blurred. This provides the illusion that the character is flying through the air at an incredible speed. Visually it's a very dramatic effect and can be used in myriad ways during an action sequence.

The illusion here is that the background is actually moving through the shot, but in fact it doesn't have to be and in most cases never really moves at all. In this example the shapes that represent the motion simply wiggle slightly in a very short loop. What makes this effect convincing is a combination of color, line work and of course the character itself.

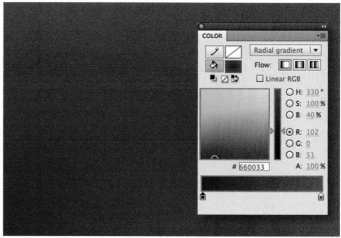

1 Start with a radial gradient as the undertone of your shot. Use the Gradient Transform tool **F** to position the gradient in the lower left corner. It is where the character will fly in from and helps provide some needed depth to the scene.

4 Select all lines and convert them to a Graphic symbol. Edit this symbol by adding several keyframes on the same layer. This will duplicate the lines for each added keyframe. Select all lines in each keyframe and click the "Smooth" tool (Crush subselection tool) a few times. Make sure the amount of smoothing is different for each keyframe. The idea is to create an oscillation between frames.

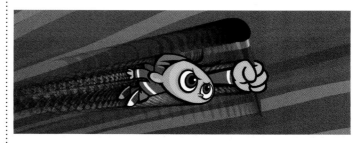

2 Create a new layer and use the Line tool with a stroke color high in contrast to your gradient colors. Draw some lines to use as directional guides.

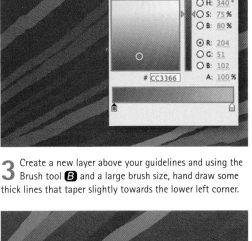

3 Create a new layer above your guidelines and using the Brush tool **B** and a large brush size, hand draw some thick lines that taper slightly towards the lower left corner.

5 On the main Timeline I added some random shapes flying through the shot in the same direction as the background lines. This helps emphasize the speed and direction the character is moving.

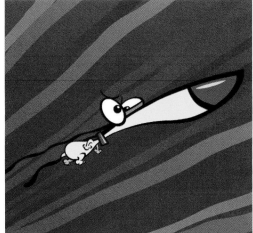

6 The final touch is to add your character. This effect works best when your character is drawn in a way that reflects the speed and wind resistance they would encounter.

7 You can emphasize the dramatic effect by motion tweening the character from off the stage into its final position. Combine this effect with some of the Motion blur effects previously learned in this chapter and you'll have a killer action sequence.

HOT TIP

With the background as a nested looping animation, you can easily re-use it for other similar shots that need to imply very fast motion. As a symbol you can transform it by scaling, skewing and even tinting it based on the design of your shot.

SHORTCUTS
MAC WIN BOTH

Learning to be simple

ONE OF THE MOST DIFFICULT challenges for me as an artist was to learn how to simplify my drawing style. Early in my career my work consisted of large scale lithographs depicting weeks of painstakingly complicated imagery. Spending days and often weeks on each print wasn't uncommon for me. But if you asked me to whip up a simple cartoon character, I wouldn't even know where to start.

Fact is, simplifying my drawing style didn't come easily. I was literally thrown into the world of cartoon animation when asked to join an animation team at a local production company. They already had an established series on a popular cable network channel (*Dr. Katz, Comedy Central*), and my job was to design and animate a pilot for Dreamworks. It was a nice way to get thrown into the world of animation, resulting in a very diverse artistic direction for me. I embraced the challenge.

The next several years provided me the experience of designing and animating several successful television series and animated content for the Internet. We used Flash for everything, including storyboards, animatics, character and background design and, of course, animation. We were a paperless studio and Flash was our Swiss army knife of software tools. As Flash matured with each version, my skill level using it was maturing also.

Strict deadlines and cut-throat delivery dates meant working fast. Working fast meant keeping the drawing style simple, which I became very good at through practice. Not unlike a classical musician ending up performing children's pop music, it was my fine art training that helped pave the road to cartoon animation.

Ironically today, I am considered a cartoonist and

character animator as opposed to a fine artist. The ability to draw with simple shapes and lines did not come easy to me. Admittedly, I continue to find it a challenge creating graphics that are iconic in style. To break down an image into a few simple shapes and have it still be appealing and even the least bit amusing is a daunting task. Sometimes I can nail it in a few minutes of sketching, other times it can take a few hours of pushing and pulling shapes until I think they work together. All too often my efforts get tossed aside and spend the rest of their lives stored onto a cold and dark back-up hard drive. Being asked to author this book has granted me the opportunity to choose some of the more successful designs as feature topics for the sole reason that they help make the book more visually appealing. What you don't see are the hundreds of failed attempts and design blunders I have created to reach this level in my career. There does exist an island of misfit characters where the majority of habitants are the result of my own handiwork.

Michelangelo was once quoted as saying "I saw the angel in the marble and carved until I set him free." As modest as he may have been, his perspective on design is timeless. Apply this thinking to your own approach when designing anything from a character, logo, background or even a website. All the best details are there in front of you; it's everything else that needs to be removed.

■ From concept sketch to finalized animated body parts; just how does a Flash animator get from point A to point B? What is the workflow when it comes to animating characters in Flash? This chapter looks at several real world examples of actual characters and how they were built, and why.

5 Character animation

IT IS TIME to get down and dirty. In previous chapters we looked at how to achieve a wide variety of design styles, transformations and motion effects. But the concept of how to bring all these techniques together to create a successfully animated character can remain a mystery. When is it advantageous to nest certain animations and why? How can swapping symbols be effective? What exactly does the Sync feature do? What is the most effective way to synchronize a character's mouth and lips to a voice-over soundtrack?

These questions and more are explained in the following pages. So roll up your sleeves and get ready for a fun ride into the world of Flash character animation.

2.5D basics

TWEENING IS A GREAT WAY to add quick and simple animation to your Flash movie. But what if you could push the tweening method to its limits and give more realism to your character? What if you could harness its simplicity and make it work in ways not too many other Flash users have thought of? What if you have learned everything there is to know about tweening, go back to the first 10% of that knowledge, and take a left turn? Where would that take you?

In this example, I'm going to reveal a truly killer Flash animation technique that will actually create a 3D optical illusion that has fooled even the most discerning eye. The cool thing is you never leave the Flash environment and remain in the 2D realm. You are now in a dimensional limbo. If it's still 2D but looks like 3D, then what exactly is it? Welcome to what is commonly referred to as "2.5D animation".

1 Let's start with a few basic shapes that resemble eyes and a mouth on a face. You can add some horizontal and vertical guides to help keep these objects aligned with each other. Before you start editing these shapes, insert keyframes a few frames down the timeline across all layers. You will see why this is useful later.

4 Move the other eye over as well but scale it slightly wider as it gets closer to the middle of the head. This is where, if it were truly mapped to the surface of a three-dimensional sphere, it would be at its widest at the point where it is closest to us.

5 Next, move the mouth over in the same direction and scale its width slightly smaller like you did for the first eye. You might want to push the mouth closer to the left edge to provide more space between the mouth and the right eye. This will help make it feel as if the mouth is truly wrapping around the head like the left eye is starting to do.

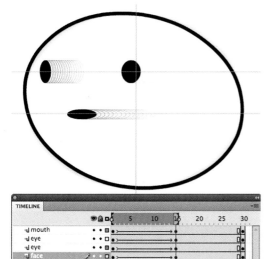

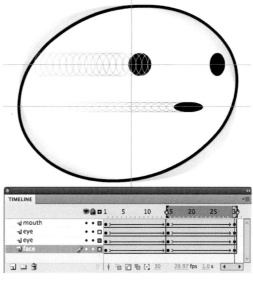

2 Insert keyframes across all layers between the first and last frames of your Timeline. Start with the head symbol by skewing it with the Free Transform tool. Since you will be creating the illusion of the head turning to the left, skew this shape by clicking and dragging just outside the bounding box in this direction.

3 Next, select the left eye symbol and position it close to the left edge of the head shape. Use the Free Transform tool to reduce its width slightly, creating the illusion of the eye moving away from us around the surface of the head.

HOT TIP

Don't be afraid to push the limits of this technique. I see my students attempt this style of animation and all too often they hardly move the features across the face enough to make the illusion convincing. Play back your animation frequently to test the overall effect. You can always add or remove frames if the animation is too slow or too fast. Add a little easing to make it look even more realistic.

6 Now all you have to do is apply Motion tweens to all the layers. Drag across all layers to select them and apply a Motion tween from the context menu or Properties panel. Remember when you added keyframes to the final frame in step 1? Now all you need to do is apply Motion tweens to the latter half of your Timeline to return the head to its original position.

7 Repeat the same procedure but in the opposite direction to make the head appear to turn to the right. Experiment by making the head move from left to right by removing the keyframes in the middle of the Timeline.

2.5D advanced

LET'S APPLY THE SAME technique, as explained in the previous example, to a more sophisticated character. This character is comprised of several individual objects, all of which were designed and composed with this animation technique in mind. The spatial relationship of each object to each other is important as they will all need to move, skew and scale together, but at varied amounts. The effect is based on the whole being greater than the sum of its parts. There's nothing overly sophisticated about creating this technique but the result can look very complex on the surface.

1 The first step is to make sure all objects have been converted to symbols and you have edited their center point to your desired location (check out the "Edit Center" topic on page 162). For this technique to be successful, it's often useful to design your characters in three-quarter view as opposed to a profile view or facing us directly.

4 Next, skew the hair to the right from its bottom edge. Since you want to convey this object coming around the front of the character's face, move it over to the right and scale it horizontally to make it slightly wider than it is in the first frame. This creates the illusion that it is moving not only across the face, but also slightly towards us as well.

2 If you want to create a seamless loop by making the head eventually return to this same exact position, select a frame (across all layers) somewhere down the Timeline and add a keyframe (F6). It pays to think ahead because you have avoided having to copy and paste the keyframes from frame 1 later. Select another frame (across all layers) an equal distance between your first and last keyframes.

3 This middle frame is where you will edit your character. Start by using the Free Transform tool **Q** to skew the symbol instances. Here I have skewed the hat, which is comprised of two separate symbols, a front and a back. Selecting and skewing them together insures that they remain aligned which each other. It's helpful to lock all other layers temporarily while you do this.

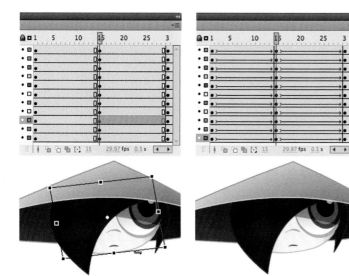

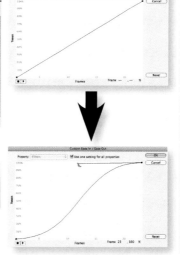

HOT TIP

Character design is critical for this effect to be successful. Keep it simple and stylized because the more anatomically correct your character is, the harder it will be to animate in this style.

5 Repeat this process for each object, combining various amounts of skewing, scaling and positioning. The smaller symbol representing the hair on the right side is the only symbol, in this example, that gets positioned to the left. Moving it behind the head emphasizes the illusion that the head is a sphere that objects can seemingly "wrap" around.

6 The final touch is to add easing using the Custom Ease panel. The straight path represents no easing. The "S"-shaped path represents easing in and out within a single tween.

SHORTCUTS

2.5D monkey

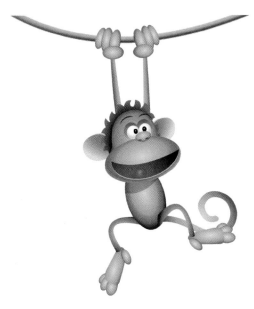

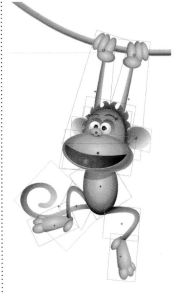

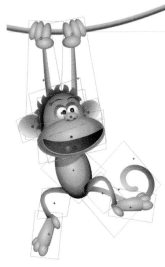

T HE KEY TO REALISM lies within the shading. The same 2.5D animation technique is being used here, but this time the graphics are drawn using gradients to promote an even more convincing faux three-dimensional effect.

1 Start with the character at a three-quarter angle in frame 1. Let's call this "point A".

2 In your last frame, create what we'll call "point B". The challenge is getting from point A to point B through the use of tweens.

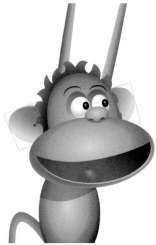

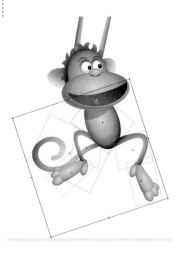

6 The ears play a pivotal role in this effect. At this new angle, we can see more of the left ear and less of the right ear.

7 Once the head symbols are transformed and positioned where you want them, lock their layers, select all the body parts and rotate them.

8 Next, adjust the legs and tail individually by selecting and rotating them.

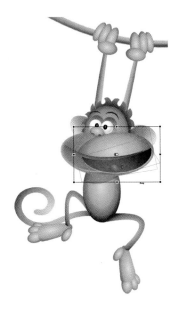

3 Using the Free Transform tool, rotate, skew and move each symbol into its "point B" position. Here the mouth symbols are transformed first.

4 Next, transform the nose, eyes, pupils and eyebrows. Pay close attention to the spatial relationship between each of these objects and our perspective at this new angle.

5 The head and hair symbols are rotated and positioned accordingly. At this angle, we see more of the hair from the left side and less on the right.

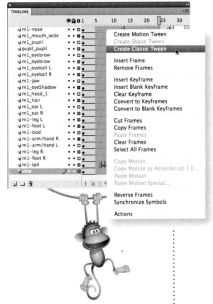

9 Select everything except the arms and hands and move the monkey over using the right arrow key. Hold down Shift to move in ten-pixel increments.

10 Rotate the arms so they align with the monkey's new position. Their center point is positioned where the hands grab the vine to make this even easier.

11 Apply motion tweens to each layer and play back your animation. Final adjustments are usually necessary at this stage.

151

Lip syncing (swap method)

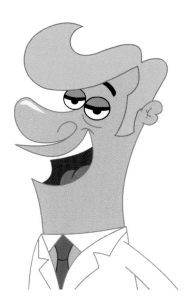

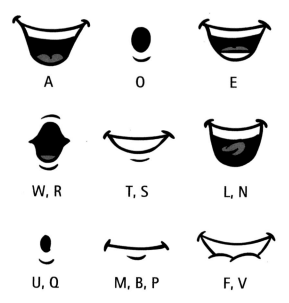

A **O** **E**

W, R **T, S** **L, N**

U, Q **M, B, P** **F, V**

L IP SYNCING IS AN ART form in its own right. It is the art of making a character speak to a pre-recorded vocal soundtrack. This technique involves the creation of various mouth shapes and matching them to the appropriate dialog. This technique can also be very time-consuming, especially if your dialog is very long. You can be as simple or as complex as you want. There's a big difference between South Park and Disney style animation when it comes to matching mouths to sounds. There are two basic methods of lip syncing in Flash which we will look at here.

1 Here are the standard mouth shapes to use as a guide. Each shape corresponds to a specific sound or range of sounds. Each sound is noted below each shape. For most animation styles, you do not need to create a different mouth for each letter of the alphabet. In most situations, certain mouths can be reused for a variety of sounds.

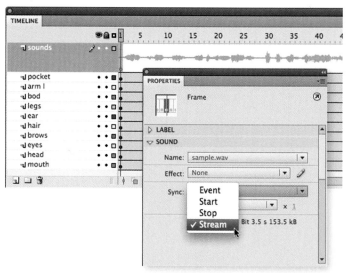

4 The next step is to import your sound into Flash. Sound formats supported are WAV , MP3, Aiff and AU. Go to File > Import to Stage and locate the sound file on your hard drive. Once imported, create a new layer in your Timeline and select a frame. Using the Sound drop-down menu in the Properties panel, select the sound you just imported. Next, set the sound from the default "Event" to "Stream".

When you name each mouth symbol, include a description of what dialog sounds it should be associated with. This simplifies the process of choosing the appropriate symbol by allowing your eyes to scan down the list of names in the Library without needing to select each symbol to see the thumbnail.

2 Using the standard mouth shapes as your guide, draw your character's mouth shapes, taking into consideration the design and angle of your character. After drawing each mouth, convert each one into a Graphic symbol.

3 Based on the design of your character, you will likely want to have your mouth symbol on its own layer. This makes it easier to edit it for animation.

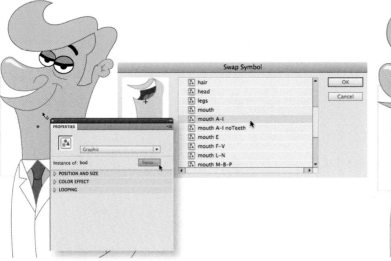

5 On the main Timeline where your character resides you can animate the mouth talking by creating keyframes and using the "Swap Symbols" method via the Properties Inspector. The Swap Symbol panel will open, allowing you to scroll through your Library.

6 Click once to preview each Library item and click OK to replace the instance on the stage with this symbol. It helps to name your mouth symbols starting with the same three letters as they will be sorted by name in the Swap Symbol panel, making it easier to find the mouth you want.

7 Click OK to swap the symbol instance on the stage with this new symbol from the Library.

SHORTCUTS
MAC WIN BOTH

Lip syncing (nesting method)

THROUGH YEARS OF ANIMATING in Flash, I have developed what I think is an even better and faster way to lip sync a character. A few years ago I was working in a full production environment with teams of animators producing several series for television and the Web. Most of these episodes were 22 minutes in length with several characters and plenty of dialog. Lip syncing quickly became the most dreaded of tasks. Using the Swap Symbols method is certainly a useful approach, but when you have 22 minutes of lip syncing to do and only two days to finish it, finding a faster method becomes a production necessity. The Swap Symbols method requires a minimum of four mouse clicks for each swap.

1. Select the symbol instance.
2. Click the "Swap" button.
3. Select the new symbol.
4. Click "OK".

Over the course of thousands of frames and symbol swaps, those clicks can add up to an enormous amount. Shaving off just one click per mouth shape can, over time, save valuable production costs (not to mention an animator's sanity).

This is where "nesting" really shows its strength and versatility. By nesting all your individual mouths into a single symbol, you can control the instance of this symbol with the Properties panel. This method eliminates the need to swap symbols and also saves time.

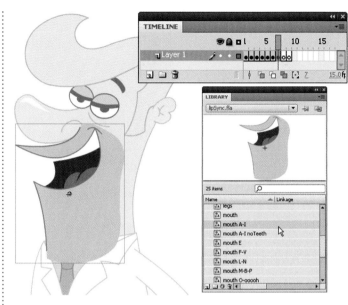

1 The first step is to place all your mouth shapes into a Graphic symbol. I recommend editing an existing symbol on the stage to help you align your additional mouths to the character on the main Timeline. Double-click the mouth symbol on the stage to enter Edit Mode. Create a blank keyframe for each additional mouth. If your mouths already exist as symbols, open your Library ⌘ L ctrl L and drag each mouth to its own keyframe. Use the Onionskin tool to help align each one.

5 The convenience of nesting is obvious when you transform (rotate, scale, flip horizontally or vertically, etc.) your character; all nested assets are transformed as well.

6 Often you may need a custom mouth animation, for example, a mouth that whistles. Right-click over your mouth and select Duplicate Symbol. Give it a descriptive name.

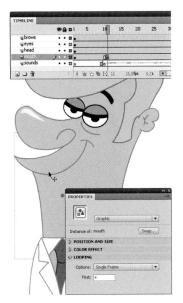

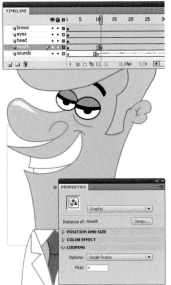

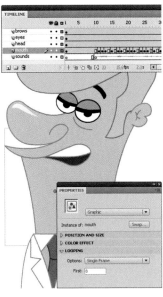

2 Back on the main Timeline, open the Properties panel and select your "mouth" symbol containing all of your mouth shapes. As a Graphic symbol, the Properties panel will allow you options to control the instance.

3 Add a keyframe to the mouth layer, select the mouth instance and in the Properties panel select Single Frame. In the Frame input box, type in the frame number that corresponds to the mouth shape needed.

4 Scrub the Timeline (drag the playhead back and forth) to hear the next sound. Repeat the same process by adding keyframes, and typing in the corresponding frame number for the mouth shape needed.

7 Remove the unneeded symbols by selecting them and choosing "Remove Frames" from the right-click context menu. Keep the symbol that closely represents a "whistle" shape.

8 Animate the whistling mouth as a short loop. Here I used the Envelope tool to distort my original mouth shape after breaking it apart.

9 On the main Timeline, add a keyframe and select the "whistle" symbol containing your new animation. In the Properties panel select "Loop" from the drop-down menu.

SHORTCUTS
MAC WIN BOTH

To sync or not to sync

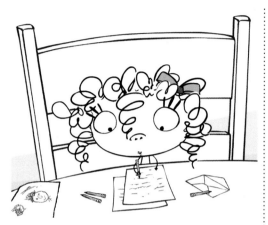

T O SYNCHRONIZE A NESTED ANIMATION inside a Graphic symbol with the main Timeline, select the Sync option in the Property Inspector. Sync is a feature that is available when a Motion tween is applied. Select a keyframe with a Motion tween to find the Sync option in the Properties panel. What this means for nested animations is that the nested frames will be synchronized with the main Timeline.

In Flash CS3, Sync was inconsistently on or off depending on how you applied a Motion tween: if you applied a tween from the drop-down menu in the Properties panel, then Sync was UNCHECKED. If you applied a Motion tween via the right-click context menu, then Sync was CHECKED. The Sync feature was indicated on the Timeline when a keyframe is followed by a vertical line.

Flash CS5 consistently turns on the Sync feature by default no matter how the Motion tween is applied.

So when would you use Sync? When would you want to avoid it? Let's first take a look at a situation where Sync would not be useful.

1 In order for you to see the effectiveness of the Sync feature, you need a nested animation to work with. A mouth symbol with several mouths on different keyframes will do just fine. Thumbnail views of each frame was selected using the Frame View drop-down menu in the upper-right corner of the Timeline panel (to the right of the frame numbers). This is a handy way to see the contents of each frame.

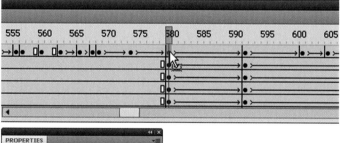

5 When you apply a Motion tween and want the ability to control the frames nested inside graphic symbols, select a keyframe in the tween and turn off the Sync feature via the Properties panel. Note that this only applies to Classic tweens in CS4/CS5 and not the new Motion Model.

2 The Frame View drop-down menu offers several choices for you to customize the way your Timeline looks. My personal favorite is the "Short" setting, which lowers the overall height of each layer.

3 You can take lip syncing a bit further by tweening the mouth on the main Timeline. This adds a second layer of animation since this mouth symbol contains nested mouths as well.

4 Using the Free Transform tool, scale and/or skew the mouth depending on the vocal sound and apply a Motion tween. The Sync option becomes a factor when Motion tweens are applied.

6 In the Timeline, the top image indicates a keyframe with Sync turned on. The bottom image indicates a keyframe with Sync turned off.

7 Having the ability to assign a specific frame number is critical for lip syncing. If Sync is selected, you will not be able to edit the current frame number. Once Sync is turned off, then you are free to change the frame number pertaining to the nested animation.

Sync (Classic tweens)

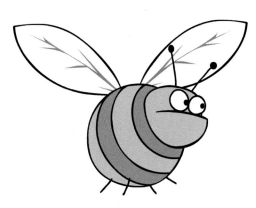

O NE DAY THE CLIENT ASKS for you to animate their company's character logo across their website splash page. You use several keyframes and Motion tweens to animate their character (nested inside a symbol) along a motion guide and deliver the final version to your client and await their feedback. Unfortunately the client changes their mind and asks if you could change the bee character to a dog with a jet pack instead. Do you have to do the entire animation over again? No, because you can always swap out the bee symbol for another symbol. But you have to swap out each instance of the bee for every keyframe you made in the animation. What a drag! The more keyframes on the Timeline, the more monotonous and frustrating this task can be.

Sync to the rescue!

1 Let's start with a simple animation involving a nested character animation in a Graphic symbol motion tweened along a guided path. Apply a Classic tween using the Tween drop-down menu in the Properties panel. The Sync option will be turned on by default. Nothing too complex going on here. The bee symbol contains some nested animations (wings flapping, eye movements and the bee sneezing).

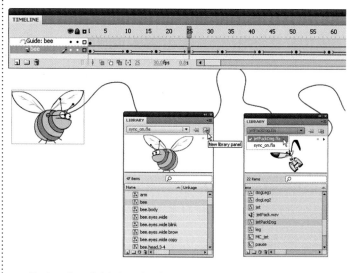

4 You just about finish the animation when the phone rings and your client informs you that they want to change the bee to a totally different character. Thanks to Sync, your time and hard work will not be wasted. Go to File > Import > Open External Library and navigate to an FLA containing the replacement symbol and click Open. You can also click the New Library panel button to open the Library of an FLA already open in Flash. A new Library panel will open displaying the symbols and assets contained in the selected FLA. Click and drag the preferred symbol from the external Library to the Library of your current document.

2 Insert a keyframe somewhere in the Motion tween. Use the Free Transform tool **Q** to rotate the symbol. Feel free to scale or skew the symbol as well. Because the first keyframe is "Synced", all subsequent keyframes will have Sync turned on by default as well.

3 Continue to insert keyframes every few frames and transform your symbol by rotating and scaling. The idea here is to make this simple Motion tween relatively complex for the example purposes.

HOT TIP

Use the Sync option to control different symbols within the same Motion tween. Turn off sync for certain keyframes if you want to swap to another symbol for that keyframe. Turn on Sync to keep the same symbol in sync with the main Timeline. This method will not work with Movie Clip symbols. Use only Graphic symbols because only Graphic symbols can be synced to other Timelines using the Sync feature. Movie Clips have Timelines that are independent of all other Timelines and need ActionScript to be synced to other Timelines.

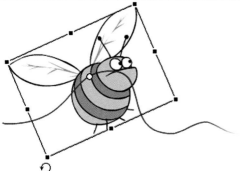

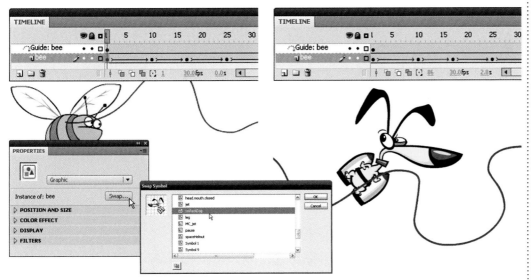

5 Select the bee character in the first frame of your Motion tween. In the Properties panel click the Swap button and locate the new symbol you just added to your Library and click OK.

6 Since every keyframe in the Motion tween has the Sync option selected, your entire animation will be updated across all keyframes. Crisis averted, go and make yourself another cup of coffee, catch up on your email overflow and get back to your client in a little while. Make sure to sound out of breath when you call them to tell them the changes have been made (just kidding).

SHORTCUTS
MAC WIN BOTH

159

Sync (Motion tweens)

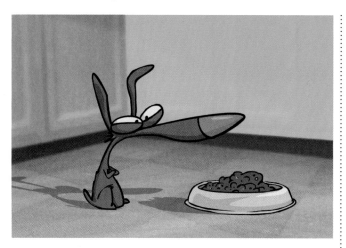

T HE NEW MOTION TWEEN changes everything when it comes to tweens and what we can do with them. If you remember one thing about them, remember this: the new Motion tween is *object-based* while the Classic tween is *frame-based*. This means much of what we used to do in previous versions was in the Timeline when it involved animation: creating and removing keyframes, applying tweens, creating and applying motion guides, copying and pasting frames, etc.

With Motion tweens most tasks are applied to the object on the stage while Flash does most of the work for us. For this particular animation, the joke is always on the dog. Each of his meals are dropped into his dish and each time the meal is different (as well as revolting and inedible). Knowing this scene will be reused countless times, it was critical to build it in a way that made it easy to swap out the object that falls into the bowl. If you thought using the Sync feature to swap symbols across animations couldn't be easier, think again.

1 The first step is to draw the object that is to land in the bowl and convert it to a symbol. Position the symbol above the bowl and almost off the top edge of the stage. Since the Motion tween is *object*-based, right-click over the symbol and select "Create Motion Tween". Flash will automatically create a motion span in this layer and insert a duration of frames equal to a full second based on the document's frame rate. This will likely be plenty of time as this animation won't last beyond 1 second.

4 Once you have the animation complete, swapping out the current symbol for an alternative symbol is surprisingly easier than using the Sync method from previous examples. Thanks to the new Motion tween, all you need to do is open the Library panel, find the symbol you wish to use in place of the current symbol and drag it to the stage (make sure the layer with the motion span is selected). Flash will prompt you to confirm that you want to replace the existing tween target object. Click OK.

2 Insert some time before the animation actually starts, which was always a bit cumbersome when using "Classic" tweens. With the new Motion tween all you need to do is click and drag the left edge of the motion span and drag it to a new frame. Position the frame indicator somewhere around frame 15, hold down the *Shift* key and drag the symbol vertically so it ends up inside the dog bowl.

3 To provide the illusion of weight to the dog food, additional keyframes and positions were added as well as some squashing and stretching (see page 64). To make the effect even more convincing, the dog bowl itself can be animated as if it is reacting to the impact of the food.

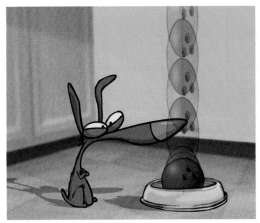

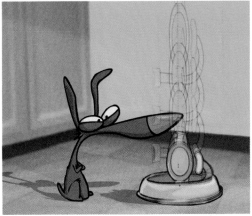

5 Your new object has now been applied to the entire motion span, replacing the original object across all keyframes and properties. Using this technique has obvious advantages over the Sync method: instead of selecting the first keyframe in a Classic tween and swapping out the symbol from the Library, the Motion tween method is a simple case of dragging a new object to the stage containing the animation.

6 You can even select the span and press the *Delete* key to remove the object entirely from the animation. All of the Motion tween data is retained, allowing you to drag a new object to the stage or copy and paste a new object into the existing span.

HOT TIP

To remove frames or cut frames from within a span, Ctrl-drag (Windows) or Command-drag (Macintosh) to select the frames and choose Remove Frames or Cut Frames from the span context menu.

To extend the presence of a tweened object on stage beyond either end of its tween, Shift-drag either end frame of its tween span. Flash adds frames to the end of the span without tweening those frames.

SHORTCUTS
MAC WIN BOTH

Hinging body parts

WITH FREE TRANSFORM, we can edit the center point of a symbol instance, thus editing the point on which the symbol rotates or "hinges" itself. Any simulation to inverse kinematics is purely coincidental. This technique does not allow you to link objects together in a chain like the Bones tool does (see page 160), but can be useful for manipulating objects individually.

1 Select the Free Transform tool **Q** and then click on one of your symbols on your stage. The center point of the symbol is now represented by a solid white circle. Simply click and drag this circle to a new location. In my example, I moved the center point of the arm to where the shoulder is (approximately).

4 You can select multiple symbols across multiple layers and hinge them as if they were one single object. With the Free Transform tool still selected, hold down the **Shift** key and click on multiple symbols on the stage. The center point will now be relative to the center point of all the symbols selected.

2 With the same tool rotate the arm symbol. It will "hinge" based on its new center point, making it easier to position each arm movement in relation to the body symbol.

3 Repeat this process for each body part you want hinged. As you can see I even hinged the ear symbol as well. Now you can start animating by creating additional keyframes and apply Motion tweens throughout your Timeline.

HOT TIP

To select multiple objects, it is often easier to click and drag with the Selection tool across the objects on stage. Make sure you set the center point for each symbol on frame 1 of your Timeline. If the center point is different between keyframes where a Motion tween is applied, your symbol will "drift" unexpectedly.

5 This can be very useful for hinging the head of a character which may contain multiple symbols (eyes, mouth, nose, hair, etc.).

6 The center point for each individual symbol will be retained but the center point representing multiple selected symbols will not be remembered once they are deselected.

SHORTCUTS

MAC WIN BOTH

Bone tool (Inverse Kinematics)

INVERSE KINEMATICS (IK) is an exciting tool for animating an object or a series of objects in relation to each other using what is commonly referred to as an armature or a chain. This tool is called the Bone tool in Adobe Flash CS5.

Not unlike a marionette puppet, the Bone tool allows symbol instances and shape objects to move in a chain-like fashion. It made sense to me to introduce this feature using an actual chain example for simplicity's sake.

I have included a folder named "CS5 Bone tool examples" on the source CD included in the back of this book. This folder contains several examples that showcase the Bone tool.

1 To create a chain you need 2 or more objects. Here I have created 2 simple chain graphics using the Rectangle tool and a stroke color. They were converted to Movie Clips and have a Bevel filter applied to them for a touch of realism.

2 I have duplicated these 2 symbols several times and configured them to form a straight vertical chain. Now that the objects are configured, it is time to create the chain.

6 Insert some frames in the armature layer your chain now resides in. Position the playhead in the last frame.

7 Drag the chain again in the opposite direction. A 2nd keyframe has been automatically added. Now you can playback your animation and watch the chain move from left to right.

3 Select the Bone tool **X**, and start with the top-most symbol. This will be the root or parent symbol. Drag from the top of this symbol to the top of the next symbol in the chain. A solid bone will be displayed between both objects.

4 Repeat this procedure until all objects are linked together to form a chain. The exact location over the object where you release the mouse is where the bone will be attached. An object can have only one single attachment point.

5 Click the last object in the chain (in this example it is the bottom-most chain link graphic) and drag it to the left. All the other links in the chain will follow in a realistic fashion.

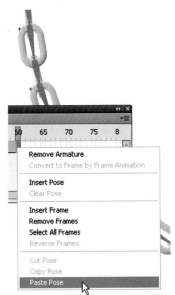

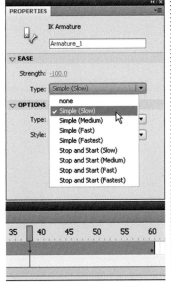

HOT TIP

You can apply different types of easing in between different sets of keyframes throughout the same span. Just select a frame in between a span, set the type and strength of the ease and repeat.

8 To create a seemless looping animation, right-click over the keyframe in frame 1 and select Copy Pose.

9 Insert more frames in the armature layer by clicking on an empty frame further down the Timeline and pressing the F5 key. Right-click over the last frame in the span and select Paste Pose.

10 Select a frame in the span and select one of the easing presets from the drop-down menu in the Properties panel. Use the hot text slider to control the strength of the ease.

165

Bone tool (cont.)

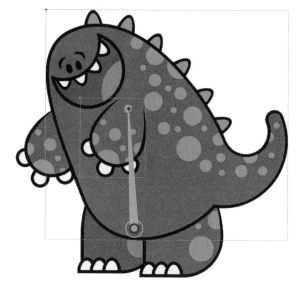

H OW DOES THE BONE TOOL WORK WITH A CHARACTER? Now we're getting into some fun new territory with Flash CS5. Here's a great character design from talented character designer Steven J. Tubbrit, founder of Sunchirp (http://sunchirp. blogspot.com).

This character is a perfect next step for learning about Inverse Kinematics. It is a relatively simple design with only a handful of movable parts yet complex enough to keep our attention.

1 The first step is to convert all body parts to Graphic or Movie Clip symbols and arrange them roughly in their default positions. They can either be on the same layer or different layers. Using the Bone tool **X**, click and drag from one symbol to another. The first symbol in the chain becomes the root (sometimes called the parent) symbol of the entire chain. It appears with a circle around the head of the bone.

4 Simply select the object you want to arrange and right-click over it, select Arrange and then the desired stacking order relative to the other symbols. Send to Back will place the object behind all other objects. Send Backward will position the object behind the next object directly below it.

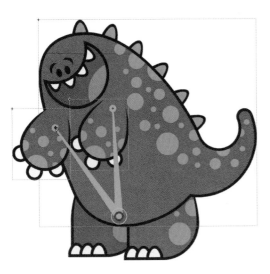

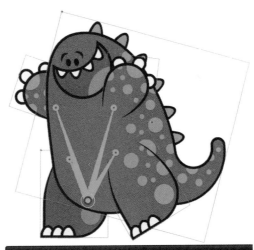

2 This armature is different from the previous "chain" example in the previous example. Instead of linking one object after another, here it is best to link the next object from the same starting point as the root bone you made in step 1. The reason for this is because the body of the dragon is simply too large to link other body parts any other way. Each bone will need to originate from the same point.

3 Repeat the process of linking body parts with the Bone tool by dragging from the same starting point. You'll notice as you link objects, they will swap depths with each other. You will have to stack them again in the right order after your armature is created.

HOT TIP

You can add new objects to an armature even after the armature has been created. Start by placing the new object in its own layer. Drag a new bone to it from the original armature and Flash will move the instance to the pose layer of the armature.

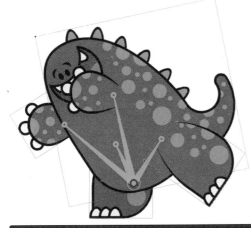

5 Click and drag any of the bones to manipulate your character. Position the playhead on a different frame and create a new pose by manipulating the armature.

6 Continue to position the playhead on different frames and adjust your character's pose. When you playback the Timeline you will see the character animate from pose to pose.

Closing the gaps

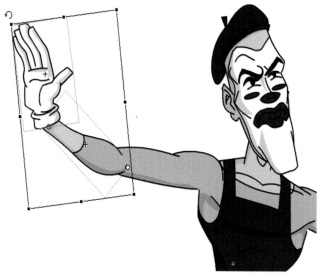

1 The Evil Mime character for the Yahoo! Super Messengers project was designed in a very anatomically correct style. This caused some problems during the animation process, specifically the joints between limbs. When the arms or legs are in their original positions (as they were drawn originally), there's no gap.

FORM FOLLOWS FUNCTION in Flash. The more stylized the design, the more flexibility you will have when it comes to adding motion. On the other hand, the more anatomically correct your character is designed, the less you can get away with when the time comes to animate it.

Sometimes a project comes along where the design style demands realism. As a result, the animation technique demands attention to detail, which can be limiting to a certain degree. One particular issue is bending arms and legs at their respective joints, and the unsightly gap between them that is often created. The solution: "caps". At least that's what I like to call them. An elbow cap for the arms and a knee cap for the legs can solve the dreaded gap problem.

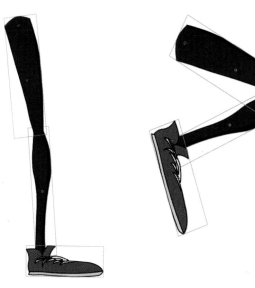

5 The leg, like the arm, works quite well when in a straight position. The upper thigh blends perfectly into the calf and shin.

6 The problem arises when these body parts are pushed to their anatomical limit when rotated and bent at the knee (or lack thereof).

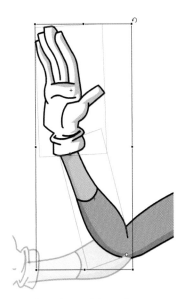

2 Once the arm is bent, the gap appears between the forearm and upper arm symbols. This is a problem inherent with this style of line work.

3 The solution is to add a new symbol in the form of an elbow. This new "cap" can be used as "filler" to hide that ugly gap between limbs when rotating.

4 Use the Free Transform tool to skew the cap symbol so it aligns with both arm symbols bridging the gap between them, so to speak.

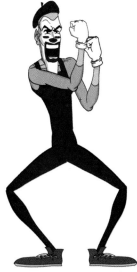

7 Once again, adding a knee cap symbol solves this problem quite nicely.

8 Position the knee cap in between the upper and lower leg symbols and align as necessary. Use the Free Transform tool **Q** to skew and scale the knee so that it fits properly.

9 It may seem like a lot of work to add elbow and knee caps, and subsequently more layers to your Flash document. But in the end, the results of your hard work and attention to detail will not go unnoticed.

Bitmap animation (Jib Jab)

J IB JAB MEDIA gained widespread notoriety for its election year shorts "This Land" and "Good to be in DC", which featured George W. Bush and John Kerry during the 2004 Presidential campaign and were viewed online more than 80 million times.

The Jib Jab team uses both Photoshop and Flash to create the majority of their animation, and the process involves sketching, photography, Photoshop collage and, of course, Flash animation.

In this tutorial, you'll be instructed on how to make a President Bush dance cycle. You'll need a photo of President Bush's head, a camera and an understanding of tweens, guide layers and the basics of character animation.

Special thanks to Aaron Simpson (www.coldhardflash.com), and Gregg and Evan Spiridellis (www.jibjab.com) for their generous contribution to this book. This is Flash animation gold.

1 For this type of animation, you should define the proportions and the action your character will be executing. Start by drawing the first pose for your character.

2 Sketch the second pose and when you're finished, you should have a clear idea of the photos you'll need to animate with.

6 You should only build one arm, as we'll flip these assets and reuse them on the opposite side. Here the arm was cut out using another Quick Mask.

7 The arm looks too thin on the shoulder area. Press ⌘ ctrl T to enter Transform mode and click the Warp icon, then manipulate the Bezier handles to give it a cylindrical shape.

3 Photograph a front view of a jacket, shirt and tie and then a separate photo of a fist. In this situation, you can reuse the arms as legs, and create a vector foot.

4 Open your photograph file in Photoshop. Press **Q** to enter Quick Mask mode and, using a hard edge brush, select the area you want to animate separately.

5 Here's the body section after cutting it out with the Quick Mask feature. Make sure the background is transparent.

HOT TIP

Check out Steve Caplin's *How to Cheat in Photoshop CS5* for some of the best tips and tricks for how to extend your Photoshop knowledge. it's a great companion book to have next to this one.

8 Next, select a circle where you want the elbow joint to be and save that selection in a new channel.

9 Here is the lower arm graphic after being cut out from the overall arm.

10 Here the upper arm receives a little more transforming with the Warp tool for good measure.

PSD Importer (Jib Jab)

ONE OF THE COOLEST features in Flash CS5 is the PSD Importer. You have the ability to import PSD files straight into Flash! This is a great feature that integrates Photoshop and Flash seamlessly.

1 Here is how the layers look in the Photoshop file. Many of the images have transparent backgrounds. Transparency is one of the many features preserved when importing.

2 In Flash go to File > Import and navigate to your PSD file. The PSD Importer wizard will launch automatically. Besides having a convenient thumbnail preview of each layer, you can also select or deselect which ones get imported. Other options include maintaining editable layer styles, conversion to Movie Clips, compression and how layers are distributed in the Timeline (layers or frames).

6 The shoulder should rotate where it meets the torso, and the forearm should rotate at the elbow.

7 The image of President Bush is easily found by doing an image search on the web. Assets like the hands can be shot with your own camera and edited in Photoshop.

8 Reuse the arm assets for the legs by copying and pasting them to new layers. Then scale and stretch the copied version and align it to your character as the thigh and calf.

3 Flash also offers a PSD Importer preference panel that allows you to set your own defaults for each option. Just go to Edit > Preferences and click on the PSD File Importer category in the left column.

4 You may prefer to convert your images to symbols after importing. Keep your Library organized by using symbol names the same as the names of your images.

5 Edit the center point of each symbol using the Free Transform tool **Q**.

HOT TIP

Besides File > Import, you can also drag and drop a PSD file onto the Flash stage to invoke the PSD Importer wizard. Always maintain RGB color values in Photoshop to preserve their consistency when importing into Flash.

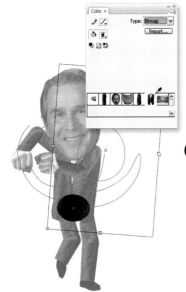

9 The pelvis area was created with a shape and a bitmap fill from one of the imported bitmap images. Use the Gradient Transform tool **F** to scale it to show only the blue fabric.

10 In frame 1, pose your character based on your initial sketch. You can choose to have your sketch to the side or directly underneath your symbols. Whichever way you prefer, the main objective is to position your character in this same gesture. In your second keyframe, pose your character in its final state using your sketch as a guide. You can't flip your symbols horizontally or you will ruin the Motion tween.

SHORTCUTS
MAC **WIN** **BOTH**

173

Motion guides (Jib Jab)

MOTION GUIDE LAYERS let you create paths along which you can tween instances of symbols, grouped objects, or text blocks. You can link as many layers as you want to a Motion Guide layer and have multiple objects follow the same path. A normal layer that is linked to a Motion Guide layer becomes a guided layer.

Motion guides are useful because, without them, a normal Motion tween is linear, meaning it moves in a straight line only. If your object needs to move along a curve, a Motion Guide is necessary.

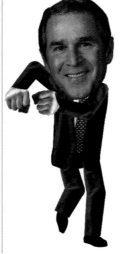

1 Create a Motion Guide layer for the left hand by selecting the hand layer and clicking the Motion Guide layer button in the Timeline panel.

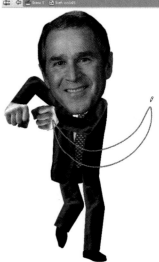

2 The hand layer will automatically be linked as a guided layer. Draw your desired path using the Pencil or Pen tool.

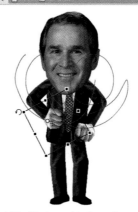

6 Add a Motion guide for each additional object you need to animate along an arc and draw the appropriate path needed.

7 Using a combination of Motion guides, paths, transformation and tweens, you can animate any object along in any direction you prefer.

3 Make sure Snap is selected (magnet icon) and drag your symbol until it snaps to your Motion guide.

4 Add additional keyframes as necessary and snap your object to the path. Use the Free Transform tool to rotate your symbol as well.

5 In your last frame, snap your symbol to the end of your Motion guide and add your final transformation.

8 The legs and feet do not need to be guided along a Motion path since they only move in linear directions.

9 The final step is to place your character in its intended environment by adding a background. The American flag shown here was edited in Photoshop and imported into a layer below all the other layers.

HOT TIP

Test your work often by using Ctrl + Enter. Flash will generate an SWF file and play it for you within the Flash authoring environment. This SWF can be found in the same directory where you saved your FLA file.

SHORTCUTS
MAC WIN BOTH

Walk cycle

LET'S FACE IT, as an animator you are eventually going to be faced with the task of making somebody or something walk. For whatever reason, newcomers to animation regard walk cycles as being extremely difficult. Why? I won't lie to you, they are. Well, in an anatomically accurate way, they can be very challenging. As an animator, you will find it nearly impossible to avoid the walk cycle, so it may be best to face your fear head-on right now. You just might learn that walk cycles aren't all that difficult to accomplish. There are several ways to make the task of animating a walk cycle very difficult or relatively easy. Let's examine the easy way.

The best way to create a walk cycle in Flash is to animate the character walking in place, as if on a conveyor belt. The main idea here is to drag an instance of this looping walk cycle animation to the stage and use a Motion tween to animate the character walking across the scene. We'll get more into that after we tackle the actual walk cycle.

1 Design your character in three-quarter view. At this angle the character is simply easier to animate, especially when it comes to walk cycle animations. Next, convert your entire character and all its parts into a Graphic symbol. You will be working entirely inside this symbol to create your walk cycle.

2 Let's concentrate on just one leg for now. In fact, turn all other layers off so only one leg of your character is visible. This character's leg is made up of three different symbols: an upper thigh, a lower leg and a sneaker. This is a straightforward setup with enough flexibility for a simple walk cycle.

4 Notice that I didn't use the same sneaker for every frame. Depending on the position of the leg, I duplicated the original symbol, gave it a new name and edited its shape to reflect its new position. This is the type of detail I love to add to my animations and I really feel, as subtle as it may be, it adds a lot to the overall look and feel of the character's movements.

8 Feel free to experiment with the amount of frames between each of your leg positions. You can have more frames for when the foot is sliding back along the ground (so it travels slower) and fewer frames while the leg is off the ground (so it travels quicker), returning it quickly to its initial position. This can create the illusion that the character is heavy, or perhaps carrying something heavy. If you do the opposite and have the foot slide quickly across the ground and slower when off the ground, it may suggest your character is on a slippery surface, such as ice.

3 Position the leg into several major walk positions using keyframes. Start with the leg planted firmly on the ground. The next position is the foot still on the ground but bent so the heel is up off the ground. Then create another keyframe and position the leg just before it is lifted off the ground. Next, position the leg completely off the ground and in its most rearward position. The final keyframe shows the leg is in its most forward position off the ground. Use the Free Transform tool to rotate each leg symbol until they

are in the desired position. Notice there are several slightly different shapes to his sneaker based on the amount of weight (or lack of) being placed upon it. When it is fully compressed on the ground its bottom edge is flat. Just before it's lifted off the ground, it is bent just after the toe. When it is entirely off the ground, its bottom edge is slightly rounded. These may seem like very insignificant details, but in the grand scheme of things, they can make all the difference.

5 Turn on the Onionskin tool and adjust the playhead brackets so you can use your established leg positions as references. Create keyframes across all layers that contain your leg symbols.

6 Use the Free Transform tool **Q** to rotate and move each leg symbol into an intermediate position relative to the keyframes you already created. The number of frames between the major leg positions will determine the characteristics of the walk cycle.

7 Experiment with the frames between each leg position. Adding more frames when the foot is sliding back along the ground will create the effect of the character gripping the surface. Add fewer frames while the leg is returning to its initial position.

9 Play back your animation constantly so you can get real-time visual feedback as to your process. This type of animation work is trial and error and depends on your personal animation style to get the walk cycle to look and feel good to you. Don't get frustrated, it simply takes practice. Sometimes it helps to not think of it as an actual leg. Try to imagine it's not a leg at all but some kind of mechanical assembly like a basic pulley or lever system. This thought process can make animating less daunting and a lot more fun. Open the "**leg_simulation.fla**" from the included source CD. This FLA contains an example of a walk cycle experiment. I made it to show how a walk cycle can be thought of in mechanical terms. It was a fun experiment because it removes the intimidation factor that is associated with animating a walk cycle.

HOT TIP

Before you start, it may be a good idea to put down your stylus and go for a walk. I'm sure the fresh air won't hurt, but the intention is for you to study how your body moves during the act of walking. As an animator you will find that studying from real life will be your greatest resource. Notice your right leg and left arm move in the same direction with each other. Same thing happens with your left leg and right arm. It is details like these that your animation will benefit from.

SHORTCUTS
MAC WIN BOTH

Continued...

177

Walk cycle (cont.)

ONCE YOU ARE FINISHED creating enough keyframes and leg positions, and you are satisfied with the movement of your leg, we can now move on to the other leg. Since you already animated one leg, there is no reason to start from scratch with the second leg (unless the other leg is designed differently). Therefore, delete the other leg entirely from the stage. Seriously, go ahead and delete it. We don't need it any more. Trust me.

10 Hold down the **Shift** key to select multiple layers and drag them to the trashcan icon or click on the trashcan icon to delete them from the Timeline.

11 Select the entire range of frames and layers of the leg you previously animated. Right-click (Control + click) over the highlighted area and select "Copy Frames" from the context menu.

15 Select this entire range of frames and layers by clicking and dragging across all of them.

16 Click and drag this entire range of frames and layers to the left until they start on frame 1. Remove the residual frames by selecting them and "Removing" them from the right-click context menu.

20 As we did with the leg animations, animate just one of your character's arms and then copy and paste its keyframes into a new layer(s) to achieve the second arm. Select the first half of your arm/hand animation and place it after the latter half of the animation.

21 Select and drag the entire arm/hand animation so it starts again on frame 1 and remove the residual frames that are left behind.

12 Add a new layer below your existing leg, select the entire range of frames, right-click over them and select "Paste Frames" from the context menu.

13 Lock all layers except these three you just copied and pasted. Select the first half of this duplicated leg animation by clicking and dragging across layers and frames.

14 Click and drag the entire section of highlighted frames down the Timeline and place it after the latter half of the animation.

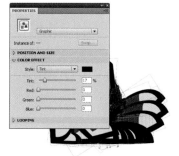

17 Using Edit Multiple Frames, select the new leg symbols and use the arrow keys to nudge them to the right and up slightly. This will help separate the two leg assemblies.

18 Apply a color tint to the leg symbols using black with approximately 30% strength. This gives the illusion the back leg is in shadow and helps create a sense of depth.

19 Animate the arm and hands by rocking them back and forth. You can use frame-by-frame or Motion tweens depending on your needs.

HOT TIP

Be careful when using the Edit Multiple Frames feature. Make sure only the layers you want to edit are unlocked and all other layers are locked to avoid accidents.

22 Turn on Edit Multiple Frames again and select this entire range of arm/hand symbols. Click on them once with the Selection tool and apply the same color tint as the legs.

23 With Edit Multiple Frames still turned on, use the arrow keys to nudge them up and to the right slightly.

24 You can add to your walk cycle animation by adding some motion to its head and body. It comes down to personal preference and your individual animation style.

SHORTCUTS

179

Advanced walk cycle

Contributed by Ben Palczynski
www.hiylea.com

1 Pick a starting point to draw. The initial step as the front foot contacts the ground will do. It helps to use a horizontal guide to help keep things aligned and level.

2 Now draw the halfway position where the standing leg is straight and central. Turn on the Onionskin tool to use the previous drawing as your reference for scale and alignment.

T HIS IS AN EXAMPLE of a traditional walk cycle animation where each frame is drawn completely by hand. What makes this particular animation "advanced" is that it requires not only drawing skills, but a sense of rhythm and timing. Ben makes it look easy, but with some dedication and practice, you can achieve great results.

One of the most well known and highly praised resources for character animation is *The Animator's Survival Kit* (Richard Williams). Williams explains everything you could ever want to know about all kinds of walk cycles and it's a reference no animator should be without. It's one of those books that should be next to your workspace at all times.

5 Turn onionskinning on over the whole animation so you can look for the arcs of motion to check that things are generally lined up. If something is jittering in your animation this can help you spot where it is.

8 Drag this nested walk cycle to a new layer on the main Timeline and Motion tween it across the stage.

9 The head "turn" uses the same "globe" technique as shown in Chapter 3 (Masking).

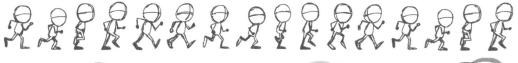

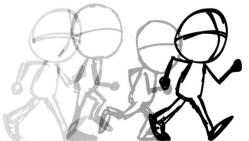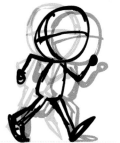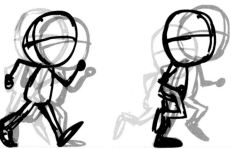

3 Continue drawing the key main poses using the Onionskin tool to reference your previous keyframes.

4 Now do the poses in between these positions. The more keyframes and poses you add, the smoother and slower your animation will be. Experiment with frame rate and number of keyframes for your walk cycle.

6 Next, center the drawings so you can create a nested loop. Combine any layers you have for each frame, turn on Edit Multiple Frames and span all keyframes using the Frame Indicator brackets. Use the Align panel to center them all.

7 Place these keyframes in a symbol if they aren't already. Draw your character or drag pre-made body parts from the Library into a new layer above your walk cycle. Align each body part according to each sketch for each keyframe.

10 To prevent your character's feet from slipping along the surface as it walks across the stage, set the symbol to graphic and playback to loop. Turn on the Onionskin tool and make sure that the feet overlap fully when they're placed on the ground. The advantage of having the walk cycle nested in a single symbol is the ability to scale the walk cycle quickly and easily. You can also flip the walk cycle horizontally to make the character walk in either direction.

181

5 Character animation

Walk cycle examples

Contributed by Colter Avara
www.tumblrdorfscastle.tumblr.com

COLTER AVARA IS A FRIEND and talented designer. Recently he was experimenting with walk cycles and sent them to me for feedback. I loved them so much I asked if he'd let me provide them as examples. Colter's walk cycles are wonderful animations created in Flash using traditional frame-by-frame animation. He started with the initial contact pose, the passing position pose and then the ending contact pose. Then he worked backwards by drawing in the keyframes in between each of the key poses.

1 Timing is key! Most cartoony walks can be animated on 8's, which is actually 3 steps per second at 24 fps. Most people walk on 12's, which is 2 steps per second, but it varies. Everyone walks differently. Check your own walk sometime, and while you're at it study real people and try to observe as much from real life as possible. First you'll want to create keyframes 1, 5 and 9.

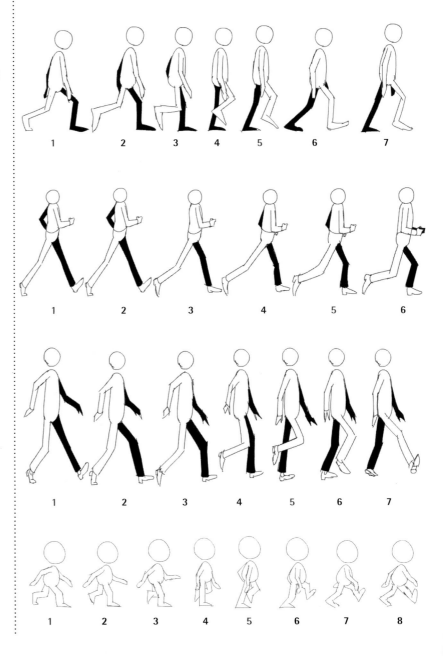

2 You'll then draw opposing contact poses on frames 1 and 9. Contact poses are points in a walk where your character's heel first makes contact with the ground. Once you've drawn in frames 1 and 9, you'll then draw a passing position on frame 5. Passing positions are mid-points where the stepping leg passes the balancing leg during a walk. These poses can really set the tone of a walk, so experiment!

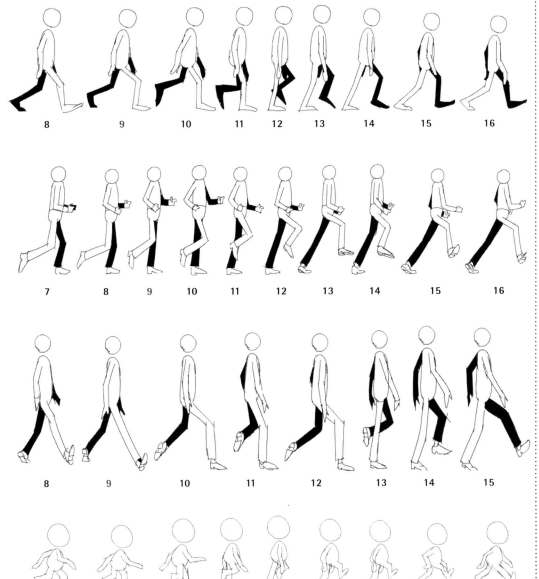

HOT TIP

The numbers below each of the walk cycle poses indicates the frames each pose resides. The frame numbers in red indicate a key pose. In some cases the actual walk cycles contain more frames than what could fit on these pages. Locate the source files for these examples and play the timeline to see the complete walk cycle animations as Colter intended.

183

Anticipation

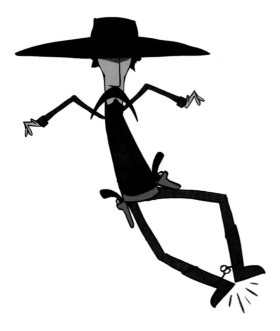

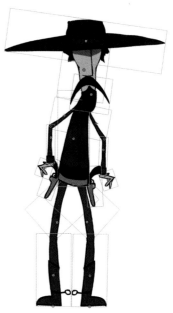

1 Here the character is in its initial position. Not much going on in terms of action but we can assume he might do something due to the slight tension in his stance and his hands being in close proximity to both holstered guns.

BY DEFINITION, anticipation is the preparation for a particular action or movement. It can also be used in animation to attract the viewer's attention to a specific event that is about to occur. An example of this would be an archer pulling an arrow back along its bow or a baseball player raising his arm to throw a ball. Anticipation can also be used to build suspense in a scene. It tells the viewer something is about to happen, and the longer the anticipation is, the more suspenseful it can be.

Anticipation is critical to making believable animation. Without anticipation, your animation may appear too abrupt and unnatural. It is important as an animator to study from life and notice how we move and react anatomically.

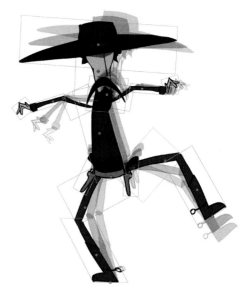

4 The first step shows the character still on one foot but also leaning back a little further and crouching lower with all his weight on this one leg. This is obviously not a comfortable gesture that could be held for very long. Hence the anticipation that something is about to happen.

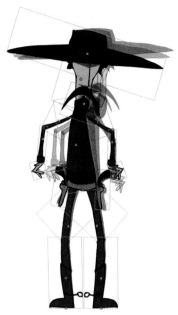

2 To anticipate the action, animate the cowboy in the opposite direction he will be moving. Make a new keyframe across all layers where the next position change will occur and use the Free Transform tool **Q** to rotate and position your character. Apply a Motion tween and some easing out to imply physical tension within our character.

3 Sometimes an animation requires more than one keyframe position to achieve the right movement and gesture. For this particular animation I used four different gestures for the anticipation animation, each with a Motion tween and some easing applied.

HOT TIP

Refer to the topic in this chapter on "Hinging body parts" to help you rotate symbols based on a customized center point.

5 Here I am pushing the envelope by adding even more tension in the character's overall gesture. There's no doubt he is about to react in a very physical way.

6 Sir Isaac Newton showed us for every action there is an opposite but equal reaction. In keeping with this law of motion, animate the character moving in the opposite direction and ultimately performing the anticipatory action.

Drawing upon oneself

Contributed by Laith Bahrani
www.monkeehub.com
www.lowmorale.co.uk
www.jcbsong.co.uk

THE MOST COMMON TECHNIQUE I USE
to make a character or an object appear
as if it's drawing itself into the scene is
purely frame-by-frame animation anyone can
achieve. Although the effect can be quite labor
intensive, it can also be visually effective if you
want to achieve a very organic hand-drawn
effect. The basic principle involves starting
with a finished drawing; then over a series
of keyframes, cut away bits of the drawing
with the Lasso tool. You will work backwards
starting on what will eventually be the end
keyframe of the animation. When you play
back the animation from frame 1, the drawing
will appear to draw itself. The same effect
can be achieved by using a mask to reveal the
character or object. I find this works best on
areas of color as opposed to lines. Let's look at
how you can incorporate both techniques to
animate a chicken character to appear to draw
itself.

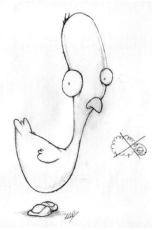

1 The first step to animating the
chicken character is to spend
decades studying and sketching this
wonderful species of bird. As you can
see I skipped this part and just scanned
in the first chicken I drew. Resize the
scanned sketch into a workable and
desirable size in Photoshop and then
import it into Flash.

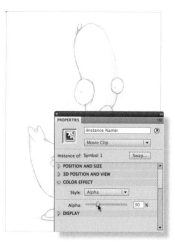

2 With the scanned sketch imported
and on the stage, convert it to a
Movie Clip. This will be the drawing
guide and this is how I do a lot of my
characters. Adjust the alpha of this
"guide" to about 50% so the contrast
of the lines you draw over it will be
clearer.

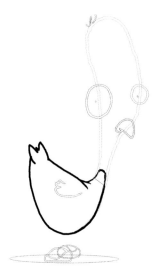

6 Now lock all the layers and then
unlock just the body outline
layer; doing this helps ensure you only
work on the appropriate area. Insert a
keyframe in frame 2. Select the Lasso
tool **L** and cut away a small portion
of the line.

7 Repeat this procedure of adding
keyframes and removing small
portions of your line work until they
are completely removed. Select the
entire range of keyframes, right-click
over them and select "Reverse Frames"
from the context menu. Repeat this
process for all other outline layers.

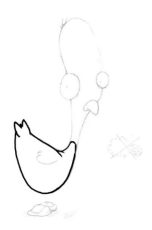

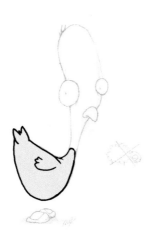

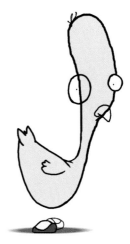

3 Build the chicken character up in layers, keeping individual parts on separate layers. The techniques of splitting a character up are fairly universal and logical – head/body/arms/legs/eyes/mouth (or in this case beak). Create a new layer (above the guide) and, using the Paintbrush tool, draw the outline of the chicken's body.

4 When you've drawn the body outline, fill it with a color. Next click on the filled color area to select it, cut it using ⌘X ctrl X, create a new layer underneath the outline, and paste the fill using ⌘ Shift V ctrl Shift V. Create one more layer, above the others, and draw the wing as an outline only. This gives you three layers for the body: one for the outline and one for the fill and wing.

5 Create the head and other parts in the same manner. Add a new layer for each new body-errr-chicken part, keeping them all separate. Remember to cut and paste each color fill to individual layers as well. If you are familiar with character animation, then you are already used to working with multiple layers and layer folders.

HOT TIP

Instead of using the Lasso tool to select and delete a small portion of your line work, you may want to try using the Eraser tool or the pressure-sensitive eraser on the opposite end of your stylus (if you have one). In terms of style and pacing it's worth keeping in mind that if you cut big pieces away at each keyframe the line will appear quickly and could look a bit jumpy.

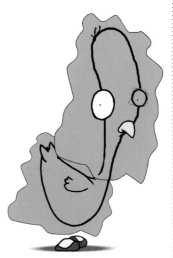

8 To create the effect of each color fill being "drawn" in, add a new layer above the body layer and convert it to a mask layer. In this layer create an irregular shape and convert it to a symbol.

9 Insert a keyframe in the mask layer in a frame at the end of your Timeline. Position the symbol containing your shape so it completely covers your fill color for the chicken's body. Apply a Motion tween to animate the mask so it "reveals" this color fill.

10 Add a mask layer and create new mask shapes for each color fill. Motion tween each one into position to reveal each chicken part. Lock all layers or publish your movie to see your animation effect

SHORTCUTS
MAC WIN BOTH

Looping backgrounds

Contributed by Kirk Millett
www.kirkmillett.com

1 The key to a seamless looping background is creating graphics that can be joined together seamlessly. The rock formation art is only slightly wider than the stage. By duplicating it and aligning its left edge with the right edge of the original, you can double its width.

BACKGROUNDS ARE CHARACTERS TOO. They can often take on personalities all their own and be brought to life just as much as a character (with eyes, a mouth, arms, legs, etc...) can. Backgrounds are also a classic way of complementing a character's actions within its environment. Remember Fred Flintstone's marathon runs through his own living room? Even though we'd see the same lamp and hanging picture pass by over and over, we remained focused on the action and story. An effective background loop will allow your viewers to do the same. The illusion is created by repeatedly tweening background art across the stage. The art has matching left and right edges so multiple copies can be seamlessly stitched together. A greater sense of depth can be achieved when individual background elements are placed on separate layers and moved at different speeds.

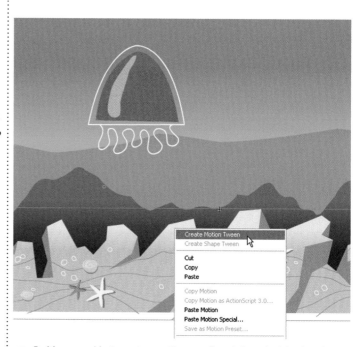

3 Position your objects on stage so they are aligned along the left edge of the stage. Right-click over them and select Create Motion Tween. Flash will create motion spans for you in each object's respective layers. The duration of each tween needs to be consistent, ending on the same frame number to allow the animation to loop seamlessly. Drag the right edge of each span to the right to accommodate the overall length of the timeline. This particular animation is 162 frames long. The trick here is the ability to "tile" your background graphics so they seamlessly align with each other when positioned horizontally.

2 Join and group multiple art copies on each layer. The back layer should have shorter art and use more duplication than the foreground layer. This will allow the back layer to move more slowly than the foreground layer, even though their tweens will use the same amount of frames. This is commonly referred to as a "2.5D" effect since it creates the illusion of a third dimension (Z-axis), but you never leave Flash's two-dimensional environment. That third dimension simply doesn't exist except in the viewer's mind as they watch the foreground and background elements move across the screen at different rates.

4 Place the frame indicator in the last frame of your timeline. Position the background graphic so that it aligns perfectly with the instance in the first keyframe. It's good practice to check the alignment of these graphics by testing your movie several times.

5 Adding a foreground element can add a convincing sense of depth to the overall scene. Because the plant is closest to us in relation to the other elements, it moves at a faster speed.

6 The central character or object can also have movement. The squash and stretch motion of the jellyfish clip completes the illusion of motion across a seemingly never-ending underwater terrain. Here I have taken this illusion even further by duplicating the jellyfish and animating them in the opposite direction of the scrolling background. This suggests even faster movement and suggests the jellyfish may be racing each other.

Tradigital animation

T HE FUSION OF TRADITIONAL AND DIGITAL ANIMATION has given us "tradigital" animation. I don't know who invented the term but the effect was first shown to me by Ibis Fernandez (www.2dcgi.com), a well known and talented animator who blew me away when he sent me a sample of this technique a few years ago. Up until that point in my career, I had been using Flash for four years and thought I knew every trick in the book. It was clear to me I had more to learn.

Tradigital animation is the result of traditional animation techniques translated by the use of digital tools. The end result may look traditional, but the process is very different and less time-consuming. When a client deadline is looming, traditional animation goes out the window. A common argument among traditionalists is that tweens are too easy to use and often become relied upon for every aspect of an animation. This may result in your animation looking very mechanical and stiff. So where do you draw the line (sorry, bad pun)? What technique should you use? Motion tweens? Shape tweens? Frame by frame?

Answer: All of the above. Don't limit yourself to just one technique if you don't have to. Use the technique that the action calls for, even if it means combining two or more techniques. What is so impressive about this particular technique is the fluidity of the movement you can achieve. Draw image "A" and then image "B" with the Line (or Pencil) tool; then with each line segment on its own layer, shape tween from "A" to "B". Merge all your layers, clean up your lines, add some fills and shading – voila! You're a "tradigitalist".

1 For this technique to be a success, you need two different drawings of your character or object. Object Drawing mode is highly recommended here as each stroke will remain as a separate object that can still be edited. It is also critical because you will later distribute each stroke to its own layer.

2 Insert a blank keyframe (F7) in a new frame (frame 30 will do), and draw the new angle of your character or object. The trick here is to use the same number of strokes as you did in the first drawing. You could also choose to insert a keyframe (F6) and edit the same strokes to reflect your new angle.

6 Make sure you have the Merge Layers extension installed (see Chapter 12 and the source CD). Make sure all layers and keyframes are selected and go to Commands > Merge Layers. This will run the JSFL command that will compress all keyframes and layers to one single layer for you. The time you just saved will allow you to grab another cup of coffee.

7 You can delete all the old layers as they will all be empty after the merge. Go to File > Save As and save this file with a new name. This is important because you may decide to make some changes to your image at some point in the future. After all layers are merged, this becomes very difficult.

3 For both drawings, select all of your strokes, right-click over them and select Distribute to Layers from the context menu. Since this will create a whole new set of layers for each drawing, you will need to select all the keyframes for one drawing and drag them to the other drawing's layers.

4 Drag across all layers, right-click and select Create Shape Tween from the context menu. Previous versions of Flash didn't offer this option in the context menu. If you are using an older version of Flash, apply the Shape tween using the Properties panel or drop-down menus. Now is the time to add easing if preferred.

5 Next you need to prepare your layers for merging. Drag across all layers and frames, selecting them all in black. Hit the F6 key to convert all the Shape tweens to keyframes. While selected, remove the Shape tween using the Tween drop-down menu in the Properties panel. Go to File > Save and save your work at this point.

HOT TIP

Flash doesn't have a built-in "Merge Layers" feature. Not sure why this feature was never considered but with JSFL (JavaScript Flash), we can make our own features. David Wolfe has created a "Merge Layers" extension for Flash that is available on the source CD in this book. Techniques like the "tradigital" topic would take at least five times longer to create without the use of a Merge Layers extension. So make sure you check out how to use this handy extension in Chapter 12 and install it before attempting the technique on these pages.

8 Next, you need to break apart strokes from the Object Drawing mode. Why? Because if you have overlapping strokes and want to add color fills to your image, it needs to be flattened one step further for editing. Turn on the Edit Multiple Frames feature and adjust the frame indicator brackets to span all keyframes. Break apart (Ctrl + B) to merge all strokes.

9 Use the Selection tool while holding down the Shift key to select all unwanted strokes and delete them. In this situation it is simply a fact of life that, as an animator, eventually you will have to perform the tedious chore of cleaning up after yourself or, even worse, someone else's work.

10 As tedious as the last step was, here's your reward, a very slick looking animation that looks like it was made using three dimensions. But it gets even better when you add color and shading.

Continued...

Tradigital animation (cont.)

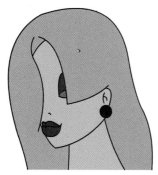

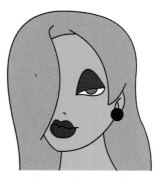

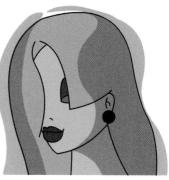

11 Once all your strokes are connected and cleaned up, mix your colors and start filling. You will need to apply all color fills across all keyframes by hand. Flash has no automatic way of doing this for you.

12 Occasionally you may find an area of your image will not accept the fill color. Usually the cause for this is a gap between strokes that is hard to see. Make sure Snap is turned on and use the Selection tool to drag their end points until they "snap" together.

13 Let's take this effect to the next level by adding shading. Add two new layers above your animation and draw two shapes in each new layer. Use the color black mixed with about 30% alpha. Make sure the brush has Smoothing set to 100. The fewer vector points the better.

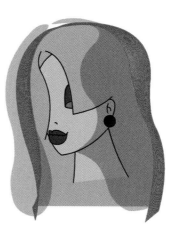

17 Turn on the Edit Multiple Frames feature and make sure the Frame Indicator brackets span all keyframes. Select all (Ctrl + A) and break apart (Ctrl + B) all Drawing Model objects to merge all the strokes together.

18 Copy all frames of your outline from the previous step and paste them into a new layer above your shading layers. Make sure all other layers are locked, turn on Edit Multiple Frames, select all strokes and change their color to bright red or something in contrast to the character itself.

19 Turn off Edit Multiple Frames, and unlock the two layers containing the shading animations. Select all frames across all three of these layers and go to Commands > Merge Layers to compress them down to one layer. Delete the remaining empty layers.

14 Insert a keyframe in both layers in your last frame of your animation. Move the left shape about 20 pixels to the left and the right shape the same distance to the right. Use the Selection tool to bend their outlines to reflect the new contour of your character and apply Shape tweens.

15 Remember the previously saved version of this animation? Open it and find the layers containing the outline strokes of your character. Select them and Copy/Paste Frames, into a new document. You will use these strokes to "cut" away the shading you will not need.

16 Select all frames and layers and convert them all to keyframes (F6). While they are still selected, remove the tween from the Tween drop-down menu (Properties) and merge all layers using the Merge Layers JSFL extension (Commands > Merge Layers).

HOT TIP

Shape tweening in Flash is a "Voo-doo" science. Results can often be unexpected depending on the amount of vector points the object(s) is comprised of. The biggest tip is to keep your shapes as simple as possible if you need to tween them. This is why in step 14 I chose to insert a keyframe and work with the exact same shapes from frame 1. I know they will have exactly the same number of points and increase the chances of my Shape tween being successful. If any of the shapes "implode" during the Shape tween, you may have edited them a bit too much.

20 Use the Selection tool to click anywhere outside the shapes to deselect them. Select the shaded area outside of your character's outline and delete it. Repeat this procedure for every keyframe.

21 The final step is to double-click the red stroke (double-clicking selects all segments in the stroke), and delete it. Repeat this for every keyframe until you are left with just the shading shapes inside the contours of the original character.

22 Next, test your movie and sit back to enjoy the fruits of your labor. This technique is great when you want to add some realism and drama to your shot. But remember to plan ahead carefully to avoid having to spend more time making revisions.

SHORTCUTS
MAC WIN BOTH

Brush animation

O NE OF MY RESPONSIBILITIES as the Director of Mobile Design for the Game Show Network is creating Flash animations for our Flash game titles. For some of these animations I have created ambient effects such as explosions, flying birds, floating clouds and rolling fog to name a few. This example deconstructs the creation of a very specific effect animation for a solitaire game where a brush is needed to provide the transition effect for the game cards. As the game is launched and the cards are dealt across the screen, the brush is programmatically moved across the screen to "dust off" the back of the cards to reveal their face value. The original brush reference was drawn at a single angle and sent to me by our staff illustrator in the form of a layered Adobe Photoshop file. It was my job to envision the brush at a different angle and animate it as if it were directly in front of the user. This animation was one of the more complicated effects for me to create because it required several hours of hand-drawn animation combined with a little Flash ingenuity.

1 Coincidentally I used the Brush **B** tool to sketch the brush image at the angle shown above. At this stage I kept my drawings loose as I was only trying to achieve the basic motion of the brush.

2 With the Onionskin tool turned on I inserted a blank keyframe **F** **7** and sketched the brush at a slightly different angle. I started with circular butt end of the handle and continued drawing the rest of the brush.

6 With the animatic stage completed I created a new layer. This next step borrows from the previous tradigital technique from the example on the previous pages. Concentrating on just one plane of the handle, I drew a rectangle using the Rectangle **R** tool with black as my stroke color and no color as my fill in frame 1. Using the Selection **V** tool I clicked and dragged each corner of the rectangle to create the perspective using the sketch as my guide. In frame 10 I inserted a blank keyframe **F** **5** and drew another rectangle using just strokes in the shape of the plane with the sketch as a guide.

3 The next frame the brush was drawn at an angle where the butt-end of the handle is almost completely facing us. The top plane representing the body of the brush is lacking any perspective since it is directly facing us at this angle.

4 Here the brush angle has rotated enough to see its opposite side.

5 The Onionskin tool is useful for making sure the alignment of the handle is in check during this phase. I used the circular end of the handle as my visual aid to keep the brush aligned throughout the rotation in each frame.

HOT TIP

I've been using Flash for over 13 years and you might think that after all this time I would be bored of using the program. Truth is I constantly set challenges for myself in an effort to become a better designer and animator and this brush animation is a perfect example of raising my own bar. I wasn't sure when I started this effect if it was going to work out or even look good. The important thing is to start somewhere and keep it simple. I enjoy challenging myself because with failure or success comes learning either way.

7 Repeat step 6 by inserting new layers for every new stroke or plane. To complete the body of the brush I used a total of 6 new layers. The different strokes for each layer are shown above in different colors for illustration purposes.

8 Here is how the timeline layers look at this stage of the process. Each layer contains a minimum number of strokes that represent the body of the brush. The reason for keeping the strokes on separate layers is to make it easy to animate each stroke using Shape Tweens in the following steps.

SHORTCUTS
MAC WIN BOTH

Brush animation (cont.)

9 Use the Selection tool while holding down the Shift key to select all unwanted strokes and delete them. In this situation it is simply a fact of life that, as an animator, eventually you will have to perform the tedious chore of cleaning up after yourself or, even worse, someone else's work.

| Remove Tween |
| Create Shape Tween |
| Create Classic Tween |
| |
| Insert Frame |
| Remove Frames |
| |
| Insert Keyframe |
| Insert Blank Keyframe |
| Clear Keyframe |
| Convert to Keyframes |
| Convert to Blank Keyframes |
| |
| Cut Frames |
| Copy Frames |
| Paste Frames |
| Clear Frames |
| Select All Frames |
| |
| Copy Motion |
| Copy Motion as ActionScript 3.0... |
| Paste Motion |
| Paste Motion Special... |
| |
| Reverse Frames |
| Synchronize Symbols |
| |
| Actions |

11 With the entire animation converted to keyframes, I selected each range of keyframes that still had shape tweens applied, right-clicked over the selected area and chose Remove Tween from the popup menu. Removing the tween from those keyframes just helps clean up the timeline and is not necessary.

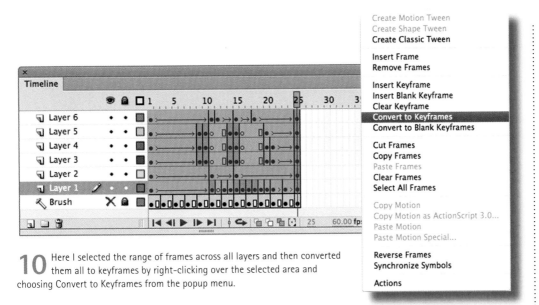

Create Motion Tween
Create Shape Tween
Create Classic Tween

Insert Frame
Remove Frames

Insert Keyframe
Insert Blank Keyframe
Clear Keyframe
Convert to Keyframes
Convert to Blank Keyframes

Cut Frames
Copy Frames
Paste Frames
Clear Frames
Select All Frames

Copy Motion
Copy Motion as ActionScript 3.0...
Paste Motion
Paste Motion Special...

Reverse Frames
Synchronize Symbols

Actions

10 Here I selected the range of frames across all layers and then converted them all to keyframes by right-clicking over the selected area and choosing Convert to Keyframes from the popup menu.

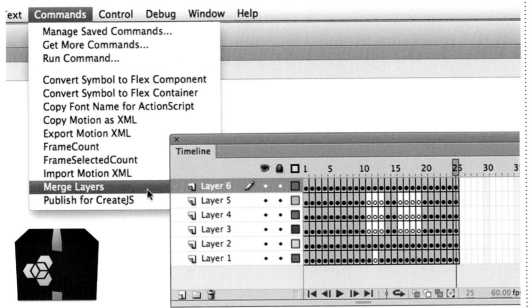

12 The next step was to merge all the layers down to a single layer. The reason for merging is to have each stroke on the same layer so that the Fill **K** tool can be used to fill the closed shapes. To merge all keyframes across all layers manually would be painfully redundant work. Since Flash doesn't have a native feature for this specific task, we luckily have David Wolfe to thank for his handy Merge Layers extension that is available on his website *toonmonkey.com/extensions.html*. With the extension installed it can be accessed from the Commands menu. Select the entire range of frames and layers and then choose Commands > Merge Layers.

Brush animation (cont.)

13 With all of the strokes merged into a single layer, I could now use the Fill **K** tool to add color to the brush handle. Here I mixed a couple brown colors to add shading as well as a linear gradient for the handle to create the illusion of it being round. I manually added color to the brush on every keyframe.

16 The next challenge was to create and animate the bristles of the brush. In an effort to keep things simple, I used the Rectangle **R** tool to draw a simple square fill. I then used the Selection **V** tool to manipulate the corners and sides to look like the shape in the image above. I inserted a keyframe **F 6** in frame 7 and using the Selection tool again, I manipulated the shape as seen in the 2nd image above. I then applied a Shape Tween to these frames to animate the shape. The reason I limited the animation to 7 frames was to help prevent the shape tween from breaking apart which can happen when the shape is transformed too much from one frame to the next. The remaining bristles animation was created the same way using shape tweens across short sequences of frames.

HOT TIP

It's difficult to see, but the solid colors in the brush handle are really linear gradients. I sometimes like to create gradients with subtle variances in color values to help create the illusion of various amounts of light reflecting off each surface. It's a tiny detail that adds a lot to the overall effect.

14 Using the Selection **V** tool, I manually selected the strokes from each frame and deleted them, leaving behind just the fill colors.

15 Here I added some texture to simulate wood and a small shadow being cast by the handle to create a stronger illusion of this being a 3D object. This step was not necessary but I like going the extra mile to take my animations to the next level.

17 Once the overall bristle animation was complete, I selected all the frames in the layer across all the shape tweens and converted them to keyframes. Next I used the Selection **V** tool and selected a small portion of the shape.

18 With the shape selected I pressed the *Delete* key to create a notch in the shape allowing me to now manipulate it further.

19 Using the Selection **V** tool, I dragged the corners to create a thin notch as shown above.

Brush animation (cont.)

20 Repeat steps 18 and 19 to add additional notches in the shape to create the illusion of bristles.

21 Go to the next keyframe in the timeline and repeat steps 18-20, but in this keyframe the notches should be slightly thinner.

22 In the next keyframe the same steps are applied, but the notches should be smaller and fewer in number. The idea is that the bristles are coming together and the spaces between them are going away over time.

26 The final step was to add the dust animation. Using the Brush **B** tool, I drew the dust as solid shapes using the brown color as seen above.

27 With each keyframe I drew the dust over again using the Onionskin tool as my guide. In this keyframe the dust is slightly smaller in volume.

28 Over time the dust begins to disappear. The trick to making dust look real is to slowly animate the edge of the dust closest to the brush faster than the leading edge of the dust.

23 As the brush changes direction, so do the bristles. As the bristles extend away from the brush handle, the notches begin to appear. Repeat steps 18-20 to create the illusion of bristles once again.

24 In this keyframe I only needed to add a small number of notches. The animation is very quick during playback and not much detail can be discerned by the human eye.

25 Here is the keyframe where the bristles are spread out the most. This frame contains the biggest notches and the largest number of them as well.

HOT TIP

Keep it simple! I was unsure how to animate the bristles and decided to start with a basic rectangle shape to make the animation process much simpler. Having drawn and animated each individual bristle would look realistic but not necessary. The dust animation was also not very difficult because I kept it as simple solid shapes drawn with the Brush tool. The trick here was to not overthink the design.

29 With the trailing edge of the dust moving faster, more of the dust particles break apart and start to disappear from the direction where they are originating from.

30 Here the dust is mostly small blobs, continually getting smaller and breaking apart.

31 In the final keyframe the dust is almost completely gone. Open the example file if you haven't done so already, and in the last scene you will find the dust animation.

How did I get here?

I SPEAK AT MANY CONFERENCES, schools and user groups throughout the country. It's a very fun thing to be able to do as it allows me to not only share tips and tricks; it also connects me with other designers and animators on a personal level. Don't get me wrong; email, chat and phone are great ways to communicate, but they are no substitute for sharing the same physical space with other developers, designers and animators who all share the same interest.

Being able to travel to conferences in various cities and connect with users from all over the world has given me the ability to tap into the pulse of the culture that surrounds Flash. I hear first hand the thoughts, opinions, gripes and questions users have about this industry. There is always one particular question I am asked by students, teachers and fellow users: "How did you get to where you are now?" Now, I am very well known for dragging out even the shortest of stories and the answer to this question is lengthy to begin with. With limited space on these pages I will give it my best shot to provide you the abridged version.

The road that led me to where I am now was, to say the least, full of twists, turns, roundabouts and in some areas, U-turns that led to dead ends. It was hardly eight lanes of traffic-free straightaways with clear signs with arrows pointing me away from hazards and obstacles. But somehow, throughout the journey, I still managed to make all the correct turns, even when I didn't know where each one would eventually take me. I was somehow able to remain on course, toward the direction that led to me to where I am now. Ten years ago if you told me I was going to be a successful freelance animator, I would have laughed. Even the realization of it now makes me chuckle to myself.

I first started using Flash in 1999 and had never seen anything like it. At that time I was a Creative Director for a small animation studio in the Boston area and we turned to Flash as our main animation program. Most of the content we created was for broadcast television and my understanding of how to deliver engaging content for the Web was minimal at best. That was all about to change. Shockwave contracted us to create an animated series for their site www.shockwave.com. I was already a fan of Shockwave, which made this project particularly exciting. It became a crash course on how to use Flash

to create animation optimized for the Web that also had a fully functional game incorporated into a preloader for dial-up users. As a company we had no experience developing for the Web. As an individual, this was a brave new frontier. To make it even more interesting, I had strict deadlines to meet, which all but eliminated the research and development portion of the process. I was smack in the middle of all this unfamiliar technology, directly between the Shockwave producers and my own bosses. All eyes were on me to figure out the artistic and technical issues involved with delivering engaging and interactive content. Funny thing was, I was very new to vector-based animation and my skill level with ActionScript was not too much beyond a gotoAndPlay command. Despite my technical shortcomings, I embraced the challenge. Ask me if I was under-qualified and I would answer "yes", but not without the confidence to deliver the project complete and on time. It just meant I needed to roll up my sleeves a little further.

The series was a success. I managed to fulfill every technical and artistic requirement and delivered it on time. None of which would have been possible for me without the help of the Flash community. I frequented the Macromedia Flash forums and various online resources such as www.moock.org, www.were-here.com and www.ultrashock.com, where I found an endless community of users willing to provide a helping hand. The most important aspect of this experience wasn't about the amount of learning I achieved, but rather the community and its selflessness to help others. My community involvement became a daily ritual, and over time, I found myself providing more answers than questions. Not only did I advance quickly, I made many friends and networked myself into a few high-profile freelance gigs. I started to specialize in animation and motion graphics for the Web. I was hooked.

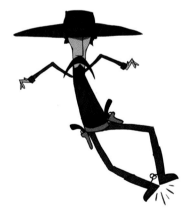

It was an exciting time to be a Flash user as the Internet was literally bursting with dynamic and engaging content. It was the beginning of the "dotcom" boom and little did I know just how much of an effect it would have on my career.

(...cont.)

A couple of years later, Macromedia announced the creation of the "Team Macromedia" program and soon after a Macromedia employee suggested that I personally submit my application. I wasn't sure exactly why but decided to fill out the application anyway. To my surprise, I was accepted into the TMM program. I was now officially recognized as a member of the Flash community by the company that makes Flash. This was so cool! I was now one of "those" guys. Since the Adobe/Macromedia acquisition, this program continues under the name Adobe Certified Experts, which I guess makes me not only a "team" member but also an "expert". But as far as I'm concerned, I am just a user of Adobe's products, still working in the trenches just like everybody else, exactly where I want to be.

My community affiliation has provided many opportunities to be a featured speaker at various conferences and user groups. These experiences have given me an up-close and personal way to network with peers from around the world, not to mention how much fun it is to be among hundreds and sometimes thousands of users who share the same excitement and passion as I do.

Aside from populating the online Flash forum with technical answers, I found myself delivering live Flash technical presentations via Adobe Connect and what is commonly referred to as "Tech Wednesdays". One such presentation has been overwhelmingly popular (http://my.adobe.acrobat.com/p46515568/). This was my very first recorded Breeze presentation and it has been one of the most popular resources for Flash character design and animation on the Web. The surprising aspect of this presentation was that I was merely filling for the original presenter who had to cancel last minute. With no time to prepare anything, I

simply demonstrated what I do on a daily basis for clients and sometimes for self-amusement. It was just another day at work for me, but this time I had the world looking over my shoulder. Luckily it was a topic that many users were very interested in. Due to its popularity I was asked to host more online presentations, all of which were recorded and featured on Adobe's website. This is one of my most rewarding community experiences due to the number of users who continue to benefit from these recordings.

Ask me how I ended up here and I will tell you it was the result of hard work, a little luck and the generosity of the Flash community. Ask me why I volunteer so much of my time helping others, and I will tell you, because I remember how precious the help was from others when I needed it most. I am proud of my accomplishments as a Flash user and when there's an opportunity to pass along this knowledge to others, then we can all benefit. It's what makes the community vibrant and alive for the benefit of all who wish to get involved. Flash is just a tool, but it is the community that surrounds this tool that transforms it into a culture.

http://my.adobe.acrobat.com/p46515568/
http://www.adobe.com/devnet/flash/articles/design_character_pt1.html
http://www.adobe.com/devnet/flash/articles/design_character_pt2.html
http://www.adobe.com/devnet/flash/articles/adv_char_anima.html
http://www.adobe.com/devnet/flash/articles/tween_macrochat.html
http://www.adobe.com/devnet/flash/articles/character_animation_ik.html
http://www.adobe.com/devnet/flash/articles/lipsync_macrochat.html
http://www.adobe.com/devnet/flash/articles/spring_tool.html

SHORTCUTS
MAC WIN BOTH

One day your client may request that their online content be re-purposed for video. They may look to you for answers as to how possible this process is. Rest assured, Flash to video is widely produced for a variety of broadcast content. The line between online and off-line Flash content is officially blurred.

6 Flash to video

FLASH IS EVERYWHERE. Not only is Flash developed for online and offline movies, websites, games and applications, but also for DVD and broadcast television. In fact, my first years as a Flash user were spent authoring Flash content for several broadcast animated series. Exporting from Flash to video formats (QuickTime and AVI) to be imported and edited in an Avid workstation was my only authoring requirement of Flash. I had no knowledge of Flash for the Web, including ActionScript, optimizing, preloaders and even buttons of any kind. It was analog Flash at its purest and that was the Flash world I lived in.

Document setup

SOME OF THE MOST POPULAR Flash to video questions I am asked are: What Flash content can be and cannot be exported to video? Why do some animations play in video format while others do not? What frame rate do I use? What is NTSC? What is PAL? What is the resolution for a 16:9 screen? What is the correct stage size? Should I be concerned about color correction? What video format should I export to? Do you export the audio from Flash? Are you getting enough sleep? (OK, that last one was from my mother, but you get the idea.) This entire chapter is devoted to the topic of getting your Flash project to video format. Sounds simple enough but there's a lot to know, so let's boogie.

1 Let's start with the basics and open a new Flash document. Open the Document Properties panel using ⌘ ctrl J or click the "Size" button in the Properties panel. Here you can determine the width and height of the movie and its frame rate. But before we change anything we need to decide what aspect ratio we are authoring to.

720 x 486 720 x 540

3 NTSC doesn't use square pixels; they are rectangular. A problem arises when you develop content for video on your computer because you are creating square pixels to be displayed as rectangular pixels. That means your video will look slightly stretched. To compensate for this, adjust the width of the movie so that the aspect ratio is 720 x 540.

720x576

5 PAL (Phase Alternating Line), the predominant video standard outside the Americas, also uses the 4:3 aspect ratio but uses a 720 x 576 pixel aspect ratio. The frame rate is 25 fps. PAL has a greater resolution than NTSC and therefore has a better picture quality. Its higher color gamut level produces higher contrast levels as well. But the lower frame rate, compared to NTSC's frame rate, will not be as smooth.

6 Film uses 24 fps, which is also a popular frame rate among animators. Although you can use 24 fps in your Flash project, when you export it to video, you will need to convert the frame rate as well. This is easily done during the export process by specifying the appropriate frame rate.

Standard Television
4:3

Widescreen Television
16:9

2 NTSC (National Television Standards Commission), the video standard used in North America and most of South America, uses a 4:3 aspect ratio, which essentially means the width and height of a standard television set. To break it down in even simpler terms, 4:3 means that for

every four units wide, the picture is three units high. Apply this formula to a 16:9 screen and you'll get 16 units of width for every nine units of height. Simple arithmetic so far but it's about to get tricky.

4 NTSC uses a frame rate of 29.97 fps. You can export Flash movies that have different frame rates such as 12, 15, or 24 fps and convert them to 30 with video editing software, although a movie converted from 12 to 30 fps will not look as smooth as a movie originally authored at 30 fps.

You can save your NTSC Flash document as a Template if you plan to create multiple files (File > Save as Template...). You can also create your own template categories by creating new folders in the "Templates" folder on your local hard drive where Flash CS5 is installed.

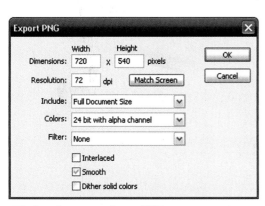

7 Exporting your movie as a PNG image sequence is often the best and most popular method. Go to File > Export Movie and select PNG Sequence as your format. I highly recommend creating a new folder to save your image sequence to since the number of images Flash creates is directly related to the number of frames in your animation

(which can easily be hundreds or even thousands). A PNG sequence insures your animation is frame accurate with lossless compression. If you are using After Effects to further refine or add effects to your animation, importing a PNG sequence is not only supported, but is also treated as a single object, making it easy to manage.

HOT TIP

Using a video-based aspect ratio for the Web is always a good idea. You never know when the client might ask you to convert the Web-based Flash movie into video format to be burned onto DVD to be shown at their next big company summit meeting.

SHORTCUTS
MAC WIN BOTH

209

Title and action safety

TELEVISIONS DO NOT generally display the entire width and height of your movie. In almost all cases, televisions will show a smaller portion of the true display size. Using a visual guide that represents the potential stage area in danger of being cropped will help guarantee that what you create in Flash shows up in its entirety on a variety of television sets.

1 There's nothing worse than finding out too late that the title sequence you labored over for ten hours appears on most televisions with several characters cropped, or is even completely invisible. To prevent this, you need to define which area is considered the safe zone within the dimensions of your movie. There are two safe zones to consider: the action-safe zone and the title-safe zone.

2 The title-safe zone is smaller than the action-safe zone because it is much more important to insure that all titles are clearly legible without any chance of a single letter being cropped. For this reason, the title-safe zone lies 20% in from the absolute edge of the video. When you add titles to your movie, make sure they are positioned entirely within this safer title-safe zone to avoid being cropped.

3 The action-safe zone lies 10% in from the absolute edge of the video. You can assume that everything falling within this zone will appear on a television screen. Anything outside this zone can be potentially cropped and not visible. Compose your scenes based on the area within the action safety zone, assuming this will be the only area not cropped by the majority of televisions.

4 Place the title-safe zone in your Flash project on its own layer above all other content. When you are ready to export to video, delete this layer to prevent it from being included in the video file. If you don't want to delete it from your document, just convert the layer to a guide layer. Guide layers will not be included in your final export.
Convert the layer containing the title-safe graphic to outline mode to reduce its visual impact and make it less noticeable. You can easily change the color of outline mode by clicking on the color swatch in the layer and selecting a different color in the swatch panel.

HOT TIP

Flash CS5 supports the "Export Hidden Layers" option. Go to File > Publish Settings > Flash tab to locate this feature. When this feature is turned off, all layers with visibility turned off will not be exported. The advantage here is not having to delete the layer from your timeline. You just need to remember to turn off its visibility before exporting.

5 View > Pasteboard will allow you to see the work area beyond the stage dimensions. This is useful for working with graphics that extend beyond the width and height of the stage. Having the title safety visible will indicate where the stage is in relation to your artwork. This is particularly useful for simulating camera moves such as panning and zooming.

CS5 video templates

ONE OF THE NICEST new features of CS5 is actually more of a convenience. Adobe has provided us with an easy way to create Flash documents for video output in the form of templates. These template files provide everything you need to get started if you are producing content for video output. In some cases it is actually a good idea to use these formats for Web content as clients often will need to output their content to both the Web and video formats.

1 Go to File > New... and in the New Document panel click on the Templates button near the top. In the Category section select Media Playback. The Templates section will update with all of the various template files needed to produce content for video output. Select the

template that best applies to your needs. The NTSC templates are for video output in America while PAL is used throughout Europe.

3 The title safety provides a clear defining boundary for text-based content as well as action-based content (everything other than text). The title safety region is indicated by guides that represent a 20% margin of the viewable area. The action-safe guides represent

a 10% margin of the viewable area. To help discern between these 2 regions, the borders contain a fill color mixed with alpha transparency to allow for the content underneath to still be seen. Keeping within these guides insures your content will not be cropped on older screens.

2 Each template file is already created with the correct aspect ratio and frame rate. There's nothing else you need to do to this file except add your content.

4 The timeline consists of 2 layers; the action safe layer and an empty layer for content. The action safe layer is already converted to a guide layer so that it will not be included during export to SWF, to video or as an image sequence. There is only 1 layer for content but depending on your needs you may need more. Feel free to add as many layers as you like.

SHORTCUTS

Safe colors

COLOR IS CRITICAL to the success of your final file format. Since Flash is technically a Web-based authoring tool, the range of colors far exceeds the color range a television can display. This example will show you how to mix colors while keeping them television-safe and also provides instructions as to how to replace the default color palette with a color-safe one (included on the CD in the back of this book).

1 Your computer monitor is designed to display the full range of RGB color values (0-255). Television can only display a limited range of color values. There's a good chance you may be using colors in your Flash movie that fall outside the television value range, resulting in very noticeable color bleeding.

3 To add your new color as a swatch, use the drop-down menu in the upper right corner of the Color Mixer panel. An alternative method for adding colors to your Swatch panel is to hover over the empty area below the existing swatches. Your cursor will automatically become a paint bucket and when you click anywhere in this area, the current color will be added.

2 You will need to limit this range to between 16 and 235. The RGB color value of the darkest color (black) is 0-0-0. For television this must be limited to 16-16-16. This should be your new black color for any project exported to video. The RGB value of the lightest color (white) is 255-255-255. This must be limited to 235-235-235 for export to

video format. Since this will be the brightest color in your palette, it will appear to be stark white in comparison to all other colors. The color red has a tendency to bleed more than any other color so it may be a good idea to compensate more than you need to by lowering the value to around 200-16-16.

NTSC.clr

4 Sometimes the default color palette is not needed and simply gets in the way of your workflow. This is a good time to remove or replace the current swatches. You can start all over by mixing and adding new colors one at a time or by importing an existing color set, color table or even a

GIF file. From the drop-down menu choose Replace Colors and navigate to the *.clr, *.act or *.gif file containing the colors you want to use. Here I have imported an NTSC safety color palette provided by Warren Fuller (www.animonger. com). This palette is included on the source CD (NTSC.clr).

6

Safe colors (Kuler)

T HE ADOBE KULER PANEL is supported to Flash CS5. Access it by going to Windows > Extensions > Kuler. Kuler (pronounced *cooler*) began as a Web-based application (http://kuler.adobe.com/) for creating color themes that can be saved and shared with other Kuler users all over the world. The success of Kuler has spawned a vast community of designers from around the world as well as thousands of themes on the Kuler website that you can browse and download to use in your own projects. Kuler is now integrated into Adobe Illustrator® CS4, Photoshop® CS4, InDesign® CS4, Fireworks® CS4, and Flash® CS4 Professional software. As a stand-alone color mixer, it provides several options the standard Flash color mixer lacks. Here I will show you how to use Kuler to mix NTSC safe colors to add to the Flash Swatch panel.

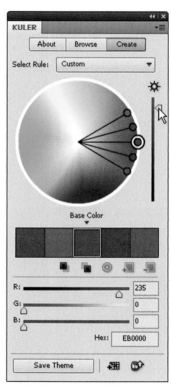

1 Open the Kuler panel and then click on the Create button to begin mixing your colors. The default theme shows a set of colors that follow the Analogous color rule. The Base Color is the color that determines the other colors in your theme using your selected color rule.

2 Select a different rule using the rule drop-down menu. Choice of rules include Analogous, Monochromatic, Triad, Complementary, Compound, Shades and Custom. For this example "Custom" will do. The Custom rule will unlink your colors so you can move the color markers around the wheel individually.

3 The first step to limiting the brightness of a color is to simply adjust the vertical brightness control. Slide the handle down until the brightest value is 235 or less to insure the color is not too bright for NTSC standards.

For a video on the Kuler panel, see www.adobe.com/go/lrvid4088_xp.

For an article on Kuler and color inspiration, see Veerle Pieters' blog at http://veerle.duoh.com/blog/comments/adobe_kuler_update_and_color_tips/.

Browse, search, and save themes directly from your desktop with the Adobe AIR™ application. Drag individual themes to your desktop, where they can be scaled to any size (requires Adobe AIR). http://www.adobe.com/go/kuler_air.

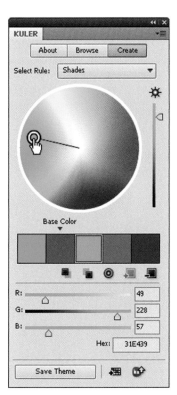

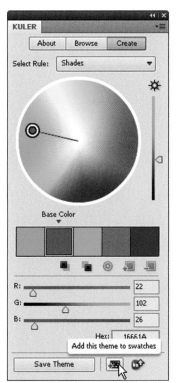

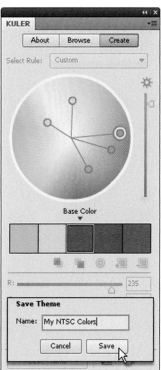

HOT TIP

Double-click any of the swatches in the color group to set the color of the stroke or fill in Flash depending on which one is currently active.

4 Select the Shades rule to create different shades of the base color. If mixing NTSC safe colors, just pay attention to the RGB values and change them if necessary.

5 Add the theme to Flash's Swatches panel by clicking the Add To Swatches Panel button at the bottom of the panel.

6 You can also share your themes online by clicking the Save Theme button. Provide a descriptive name and click "save". Then click on the Upload to Kuler button to share your theme with the Kuler community.

Ape Escape

As you can see here the duration of this scene is at 2.3 seconds. The entire duration of this shot is only about 5 seconds long. Each episode is a total 2 minutes in duration, made of several 5 to 10 second shots. Each 2-minute episode could be anywhere from 10 to 20 different scenes.

APE ESCAPE IS BEST KNOWN AS a platform game for Sony's Playstation gaming console. But it is also an animated series for television. Recently I was asked to help animate a few scenes and thought it would make for a great example of how a professional production creates animation with Flash as its primary tool for television broadcast. Many of the animators worked virtually, including myself. We shared files via FTP (File Transfer Protocol) and we were initially given storyboards in Quicktime format to work from. The main characters were already set-up for us in Flash-ready and each episode was broken down into several small chunks of time, specifically from 5 to 10 seconds in length. This created more files but they were very small in size and easily shared via the Web. All we had to do was upload the Flash source file so that the post-production crew could then export a PNG image sequence or Quicktime movie and edit all the scenes together using a video editing tool.

Ape Escape 2 © 2003 Sony Computer Entertainment, Inc.
Ape Escape animated series © 2008 Bellport Cartoon Company, Inc. and HFP Productions 3, LLC.

All animation is either on the main timeline or nested in graphic symbols, keeping them in sync with the main timeline. The rule is, if it plays inside of the Flash authoring tool when you scrub the playhead or play your animation, it will export to video format successfully. This is true for all versions of Flash.

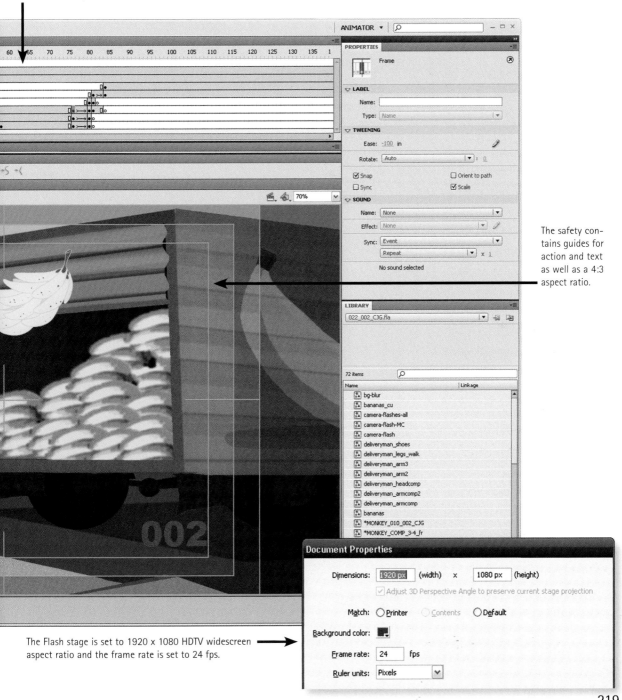

The safety contains guides for action and text as well as a 4:3 aspect ratio.

The Flash stage is set to 1920 x 1080 HDTV widescreen aspect ratio and the frame rate is set to 24 fps.

Keeping it all in sync

W HAVE TWO OPTIONS for authoring Flash for video output. The old school method requires everything to be on the main Timeline. Movie Clip symbols have to be avoided altogether since their Timelines are independent of the main Timeline and only render during runtime in the Flash Player.

Flash 8 introduced filters and the ability to add drop shadows, blurs and other cool effects to Movie Clip symbols. But due to the dynamic nature of Movie Clips, they had to be avoided as well. Flash CS3 introduced the Quicktime Exporter which solves this problem and is a feature in Flash CS4 and now CS5. We will take a look at that later in this chapter.

For now, let's take a look at the old school method of creating Flash animation for export to video. This is analog Flash in its purest form, straight-ahead Timeline animation, streaming sound and nested Graphic symbols.

1 If your Timeline contains Movie Clips, you must convert them to Graphic behavior. To convert a Movie Clip to a Graphic symbol, select the Movie Clip instance on the Stage and change its behavior from Movie Clip to Graphic using the Properties panel. Then change its property from Single Frame to Loop or Play Once depending on your needs.

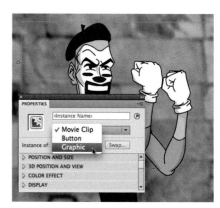

3 One of the disadvantages of using scenes is confusion during the editing process as it can be difficult to find assets within multiple scenes. Another disadvantage with multiple scenes is having more content in your FLA, which can result in a very large file size. This increases the chances of corruption and loss of work. It's usually better to work with several smaller files, then edit the individual exported video files together in your video editor.

5 Layer folders are a great way to organize your Timeline, especially if your animation involves a great number of layers, which is often the case with animation. Layer folders combined with nesting animations can go a long way in making efficient Timelines. You can place all your character animations inside a Graphic symbol. This makes it much easier to edit and control your entire scene from the main Timeline if you need to position, scale, pan, zoom as if playing the role of a Director. Since the nested animations are inside Graphic symbols, you can still scrub the Timeline with the playhead to see the animations play.

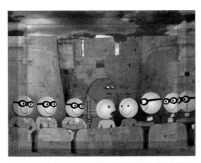

2 Scenes are a great way to manage long Timelines. For example, you could have your title sequence in Scene 1, your story in Scene 2 and ending credits in Scene 3. Using scenes is similar to multiple files chained together since each scene has its own Timeline. The Timeline of each scene combines into a single Timeline in the exported file. The advantage here is having the entire project in one FLA.

HOT TIP

To keep the file size of your FLA(s) as small as possible, it is sometimes good practice to avoid inporting high quality stereo sound files. If you are planning on editing several exported video files together in your video editing program, then import a compressed MP3 audio file into Flash to use as a "scratch track". Place the sound file(s) on its own layer so that it can be easily deleted before export. Since Flash CS3, CS4 and now in Flash CS5, you can simply turn off the visibility of this layer to exclude it from export. Use the high quality stereo sound file in your video editing program instead.

4 The Flash Timeline has its own limitations. 16,000 is the number that represents the maximum number of layers in a single Flash movie as well as the maximum amount of symbol instances and number of frames. It is rare to see this number reached in any situation, but it is good to understand the limitations in order to avoid them. A Flash document that is 16,000 frames long at 30 fps is nearly nine minutes long. A file that large will cause problems even in the best situations. The file will take longer to open as well as to save. It will exhaust

your system's resources and make it harder to work with multiple Flash documents open at the same time. It will also take a very long time to export to video and will create an enormous file. If you export to AVI, you will very likely exceed the 2 GB limit that is placed on AVI files on most operating systems. Best practice is to break up your project into several smaller FLA files, typically between 30 and 60 seconds each. I often work with FLA files less than 20 seconds in length. It makes the entire process more manageable when animating, exporting and editing.

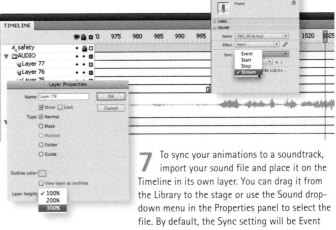

7 To sync your animations to a soundtrack, import your sound file and place it on the Timeline in its own layer. You can drag it from the Library to the stage or use the Sound drop-down menu in the Properties panel to select the file. By default, the Sync setting will be Event and must be changed to Stream. The Stream behavior embeds the sound into the Timeline and will be in sync with any Timeline animation. You can adjust the height of a layer by right-clicking over the layer name and selecting Properties. In the Layer Properties panel you can set the layer height to as much as 300%. This can be useful if you want to see the waveform in as much detail as possible.

6 You can quickly expand all layer folders by right-clicking over any one of your folders and selecting "Expand All Folders" from the context menu. Collapsing all folders is done the same way.

QuickTime Exporter

XPORTING FLASH MOVIES to video format used to require that all animation be on the main Timeline. Dynamic content such as ActionScript, button symbols and Movie Clips could not be exported to a fixed-frame video format. This included Movie Clip animations, filters, ActionScript and just about anything dynamically loaded into your SWF file.

Welcome the Flash CS6 QuickTime Exporter. You now have the ability to export dynamically created Flash content including effects generated with ActionScript as well as effects created with movie clips and filters.

Proceed with caution when using the Flash CS6 QuickTime Exporter. If the dimensions of your document are particularly large (for example, 720 x 540 pixels), it may be necessary to change the frame rate of the Flash movie to avoid dropping frames during the export process. Why does this happen? The QuickTime Exporter, during the export process, is actually capturing the playback of your movie as an SWF movie in the background. Various aspects of your animation can cause frames to be dropped and the exported QuickTime file to not be frame-specific as intended in the Flash Timeline. A large stage size, a high frame rate, multiple filters and animated effects can all contribute to frames being dropped during the export process.

1 When setting up your Flash documents that will eventually use the Quicktime Exporter to render your content to video format, you will want to use a frame rate of 29.97. The reason for using 29.97fps is to avoid rendering problems that may occur when other frame rates are used. The problem with using a frame rate other than 29.97 is that frames in the exported QuickTime movie will distort in unexpected ways. It has also been reported that some frames will get dropped as well. If the Flash document is set to a frame rate of 29.97 then the exported QuickTime movies will render successfully without any distortion or skipped frames.

2 You have more than one option when you export your video, and there are slight differences depending on whether you are authoring in Mac OS or Windows. Basically it comes down to three different options: AVI (Audio Video Interleave), Apple QuickTime, or an image sequence. Formerly your choice of platform dictated your format. Macintosh users exported to QuickTime and Windows users exported to AVI. Now both formats are compatible across platforms.

3 When you export from Flash to QuickTime, you will have several options to choose from. Typically it is good practice to keep your movie as uncompressed as possible and at the highest color bit available. You can change the width and height of your movie based on a maintained aspect ratio, or you can choose to change the aspect ratio by deselecting this option. Select "Ignore stage color" to add a transparent alpha track to your video. You must select a video Compression Type that supports 32-bit encoding with an alpha channel such as Animation, PNG, Planar RGB, JPEG 2000, TIFF, or TGA. You must also select Millions of Color+ from the Compressor/Depth setting.

4 The Movie Settings panel allows you to adjust the video and sound settings. If you are exporting sound, you can set the amount of compression, sample rate, sample size and number of channels.

You can also prepare your movie for the Internet if it is intended for online viewing. Select "Fast Start" to allow the movie to start playing from a Web server before the movie has completely downloaded.

If you plan on importing your Flash animation to After Effects or Premiere, export as a PNG sequence. After Effects CS5 also supports SWF format as well. So you can simply publish your Flash movie to SWF and import that into After Effects.

5 If you choose to click "Settings", the Standard Video Compression Settings will open, allowing you to refine how your movie will be exported. This is where you can select the compression type and frame rate, and click the QuickTime Settings button to select the type of compression desired. Typically no compression is best but I have had great results using the Animation codec. In this panel you can also adjust the color depth and change the frame rate (useful if your Flash movie isn't using a standard frame rate for video), as well as set the amount of keyframing and, once again, the size.

223

SWF & FLV Toolbox

BY ELTIMA SOFTWARE

T HE SWF & FLV TOOLBOX is a very handy 3rd party program that converts Adobe Flash files (SWF), Flash Video (FLV) and Projector (EXE) files to several different formats (AVI, JPEG, GIF and BMP). You have complete control over the settings for each file format including codec control, keyframe rate, movie quality, bitrate, cropping, resizing and more. I've been using this software quite a lot recently and I really like its ease of use and no-frills interface.

Find out more by visiting www.eltima.com. *SWF & FLV Toolbox is only supported for the windows platform as of this writing.*

1 The first step is to publish your Flash document to generate a SWF file. Launch SWF & FLV Toolbox, click the Browse button and select the SWF file. Select the output format and click Convert. That is basically all you need to do to convert your SWF files to a different format. Of course you have advanced settings to play with as well.

3 Select an audio codec and configure your desired audio settings to include your sound in the converted video file (if sound was published along with the original SWF file).

2 The advanced settings provide the option to crop your SWF file to any width and height by dragging the edges of the crop marquee or by typing in the numerical values. You can also resize the SWF by providing new values for the width and the height.

4 You can easily convert any SWF, FLV or Projector EXE file to a Windows screensaver file. SWF & FLV Toolbox offers several options that allow you to customize your screensave by adding a title, website URL and email address.

Graphics tablets

THERE ARE SOME THINGS I JUST CAN'T WORK WITHOUT, and one of them is my Wacom tablets. They are indispensible when it comes to my workflow and actually save valuable production time on a daily basis.

My first experience with a graphics tablet of any kind was during my employment at a small production company creating animated television shows. Early on we had very small budgets and therefore relatively cheap equipment to work with. We used Summasketch graphics tablets (Summagraphics) and even though they got the job done, they were pretty clumsy to work with. The main reason was the lack of wireless technology as the stylus was not cordless. It constantly got in the way of my arm as I moved across the tablet's surface and would get pretty twisted and tangled. If you weren't careful you could easily get the cord on the wrong side of a full cup of coffee and with one artistic stroke of the stylus, end up with a huge mess. The learning curve was not so bad, however. It took me about three full days to get used to not looking where I was actually drawing. There's a slightly uncomfortable feeling of not looking at the actual surface where your pen meets the paper. Once I got used to looking at the computer display and not my own drawing hand, the next learning hurdle was the relationship of the tablet angle and the display angle. If my tablet was rotated as little as an inch or less, any vertical or horizontal lines became exponentially difficult to draw. Alignment between the tablet and monitor became important and soon I had a specific setup that worked for me, which was having the tablet to the right side of the computer and at a slight angle towards me. Some of the other animators had their tablet directly in front of them, center to their body. Of course left-handed people had their tablets to the left of the computer or centered. There was one particular illustrator who, being left-handed, used his tablet with his left hand and trained his right hand to use the mouse. Truly an ambidextrous advantage.

Eventually, as the company became more successful, the budgets grew. Better equipment was being purchased and soon we graduated to Wacom tablets.

My appreciation for the quality of Wacom tablets is directly related to having used tablets of lesser quality. The look and feel of the Wacom tablet was truly awesome. Not only is the stylus cordless, it requires no battery either. The tablet surface is super smooth and a joy to work on. Some people find it to be too smooth and one nice trick is to tape a regular piece of copy paper to the tablet. The stylus will work fine and the extra friction lends to a more realistic drawing feel.

Wacom has recently introduced a new budget-friendly line of graphics tablets called "Bamboo". There are 2 different kinds: the Bamboo and the Bamboo Fun. The Bamboo is 7.8 × 7.3" in size while the Bamboo Fun offers 2 different sizes: 8.4 × 7.3" or 11.0 × 9.3". Both share similar technical specs but when compared to the Intuos 3 line, they offer about half the features. But if you are on a budget, or you are more of a casual user, the Bamboo is very capable.

I have used tablets in various sizes: 4 × 6, 6 × 8, 9 × 12 and 12 × 12. My personal preference is the 6 × 8 and the 9 × 12 sizes. As Goldilocks found out while visiting the home of the three bears, these sizes are "just right". I don't have to physically move my hand and arm as much as I do with the 12 × 12 version and the 4 × 6 is simply too small for any serious graphics work. My 17" laptop display is in perfect harmony with the 6 × 8" tablet and they both fit perfectly in my laptop bag.

Then there's the ultimate in graphics tablet technology and what I consider the best piece of hardware around, the Wacom Cintiq 21UX. I can honestly say I fell in love within the first 5 seconds of using it. With the Cintiq you work directly on the screen, allowing you to take advantage of your natural hand–eye coordination since you are looking directly where you are working. There is little or no learning curve because of this natural "pen-on-paper" approach. The Cintiq works with any Graphics application and is especially useful with Flash and Photoshop. It feels as close to natural as any paperless production process could.

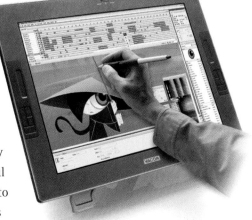

■ Surprisingly, the most impressive of Flash effects are often the simplest to create. The above characters are animated running in place as a looped sequence. It looks cool as it is but if you copy and paste an instance of it, flip it vertically and lower its opacity, you can achieve the sense that the surface they are running on is reflective and maybe even a bit slippery.

7 Animation examples

I HAVE SPENT MY FAIR SHARE of time on various Flash online forums, reading, learning and providing my own perspective when needed. As a result, I have seen what animation techniques and examples Flash users are always requesting. I will often create a sample FLA and make it available for everyone to download and dissect for themselves. It's very difficult to teach design and animation in text format and, often, a simple FLA can make all the difference.

This chapter contains some of the most popular "How do I..." animation requests from Flash users as far back as Flash version 4. If this chapter teaches you one thing, I hope that it teaches you how to think differently about how you approach Flash as a tool.

Super text effect

S O OFTEN THE SIMPLEST OF ANIMATION TECHNIQUES is the most effective visually. Take this simple website introduction for Superbusy Records as an example of simplicity at its finest and how to get the most bang for your buck with the basics of Flash animation. The text animation is comprised of basic Motion tweens and scaling, and the bee animation takes advantage of some old school blurring with a linear gradient. Timing is everything and the fast-paced editing of this animation makes it look more complicated than it truly is.

1 Start off with a text field set to Static and type in your text. Nothing fancy here, just some basic text to get you started.

4 Select all layers on a frame somewhere down the Timeline (frame 30 will do) and insert a keyframe for every layer by hitting the F6 key. Go back to frame 1 and select your first letter. Use the Scale and Rotate (Ctrl + Alt + S) to scale it to 400% or greater.

7 The bee graphic is introduced using a simple linear gradient first; then the bee "pops" into position. This technique is identical to the "Flying text" topic in Chapter 4.

2 Break apart the text field once using ⌘ B ctrl B and each letter will be broken apart but still editable. Break apart twice to convert your text to raw vector shapes. Your text will no longer be editable once broken down this far. You can choose to break apart only once if you think you might want to edit the text at a later time.

3 Select each letter individually and convert each to a Graphic symbol. Once all letters are converted, select them all, right-click over them and select Distribute to Layers from the context menu.

5 Apply a Motion tween to animate this letter scale from 400% to 100%. Select the keyframe in frame 30 and move it to around frame 5. Play back to test the speed based on your frame rate. Adjust the tempo as necessary by adding or removing frames in the Motion tween.

6 Repeat this procedure for each letter. Then stagger each letter's animation by sliding the Motion tween down the Timeline so each letter animates into place one after the other. Your Timeline tweens should resemble a staircase.

8 The bee is a Movie Clip containing a very simple, two-framed animation of the wings. The original wing is replaced with a radial to provide the illusion that it is blurred because it is moving faster than our eye can see.

9 The blur animation is comprised of only two frames with the radial gradient slightly rotated between them. The looping of these two frames at 30 frames per second is enough to convince us that they are oscillating at a very high speed. Adding the appropriate sound effect makes it even more convincing.

231

Page turn

1 Start with a simple rectangle with a linear gradient fill or your own color fill preference. Convert it to a Movie Clip symbol and apply a drop shadow filter to add a little depth.

2 Duplicate the cover symbol, and place it on a new layer above the original. Edit the graphic inside by filling it with a different color. Add some text or an image of your choice.

PAGES THAT CURL up and away to reveal more pages are always an appealing effect for introducing content on your website or as buttons to other web pages. There are variations created entirely with ActionScript, but my AS skills are not anywhere near the level required to generate this effect dynamically. But that doesn't mean you can't add some interactivity by placing this animation in a Movie Clip and controlling its playback when the mouse rolls over it. I leave that part up to you (see Chapter 10 for a detailed explanation about adding interactivity to your Flash project).

For more robust and dynamically controlled page flip effects, check out:

http://page-flip.com/
http://www.flashpageflip.com/
http://www.pixelwit.com/blog/page-flip/

6 Insert a new layer and create a triangular shape that resembles a page curl similar to the example above. The easiest way to make this shape is to start with a rectangle. Turn on the Snap tool and drag one corner until it snaps to another corner. Now that you have made a triangle, move the remaining three corners into the positions as seen in the above example.

7 Mix a linear gradient using three colors. The first and last color swatches should be the brightest and similar in value. The middle swatch should be the same color but darker in value. Fill the curl shape and use the Gradient Transform tool **F** to rotate and position the gradient so its bottom edge shows a slight amount of the lightest value.

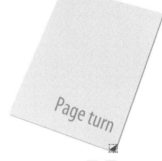

3 Insert a new layer again above your existing layers. Convert it to a mask layer and draw a shape that spans the lower right corner. Insert a keyframe in frame 30 so that a duplicate of this shape is created.

4 Select the shape in frame 1. With the Free Transform tool **Q**, position the center point at the bottom corner. Hold down **⌥** **alt** and scale the shape until it is very small.

5 Holding down **⌥** **alt** will constrain the shape based on its center point. Apply a Shape tween so the shape grows from small to large. This animation will reveal the content page.

HOT TIP

You can duplicate this effect to create additional page curls, allowing the user to turn more pages to reveal more content. Nest the page curl animation into a Movie Clip symbol and drag multiple instances of it to individual layers. With some basic ActionScript, you can control the page turns during runtime in the Flash player.

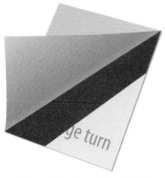

8 Convert the shape from step 7 to a Graphic symbol and double-click it and add a new layer inside this new symbol. Create another shape in this new layer using the rectangle tool for the shadow created by the page curl. This shadow will be cast onto the page below, so draw the shape to span only the area necessary inside the content page.

9 Fill this shape with a linear gradient consisting of two colors. Mix about 50% alpha into the first color and 0% alpha into the second color. Use the Gradient Transform tool **F** to rotate the shadow so that it fades away from the curl. Convert both shapes to a Graphic symbol.

10 Animate the curl just as you animated the mask in steps 4 and 5. Insert a second keyframe in frame 30 and select the curl graphic in frame 1. With the Free Transform tool, move the center point to the lower corner, hold down **⌥** **alt** and scale it until it is the same size as the mask shape in this frame. Apply a Motion tween.

SHORTCUTS
MAC **WIN** **BOTH**

Smoke with gradients

THERE ARE SEVERAL WAYS TO ANIMATE SMOKE and each technique is based on the style of the smoke itself. Do you need your smoke to be a cartoon style smoke cloud? Maybe you want a more realistic billowing of soft puffy clouds? How about a very stylized smoke effect with curling hard-edged shapes simulating the basic movement of smoke? There are many different ways to achieve the same results in Flash, whether it's with ActionScript or animation. Flash has always been a blank canvas for us to express ourselves. Let's take a look at a few ways to approach the dynamics of the elusive smoke cloud.

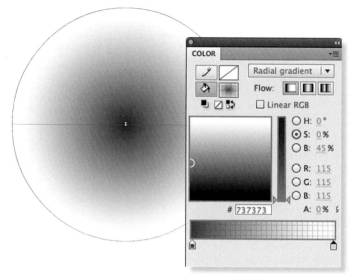

1 Create a radial gradient with a dark gray center and the outer color mixed with 0% alpha. Create a circle with the Oval tool ⭕ with this gradient as your fill color (no stroke). Convert this shape to a Graphic symbol.

4 Select the entire Motion tween, copy all frames and keyframes, insert a new layer and paste all frames into it. Select the graphic in the first frame and move it a few pixels in any direction. Do the same for the Graphic symbol in the last keyframe. Select the entire Motion tween and drag it down the Timeline a few frames. Repeat this procedure until you have several layers of slightly different animations of your gradient starting small and rising while fading out completely.

2 Select the Graphic symbol and convert it to a Movie Clip symbol. Double-click this Movie Clip to enter edit mode. This is where the animation will take place.

3 Insert a second keyframe several frames down the Timeline. Scale the Graphic symbol to about 200% and move it up about 75 pixels. Apply a Motion tween.

5 On the main Timeline, copy and paste the Movie Clip containing your "smoke" animations to a new layer. Drag the keyframe to a frame later in the Timeline; frame 25 will work fine. Select the instance and flip it horizontally to help change its appearance from the original.

6 Since the animation is inside a Movie Clip, it is best to stop the Timeline once the second instance is introduced on the Timeline by adding a stop action. The Movie Clip instances will continue to play and loop. Since they start on different frames, they will overlap to produce a constant flow of smoke.

235

Smoke stylized

STYLE WILL ALMOST ALWAYS DICTATE the animation technique. Often the client will request a specific artistic style based on a pre-existing logo or company identity. The challenge here is to be consistent, not only with the artwork but also with the animation style. A realistic smoke animation would look nice but not match the client's style preference. It's time to be inventive and to create a smoke animation that is stylized, yet simple and effective. Oh, and the client needs it yesterday.

1 The easiest way to start is with the final shape you will want as your stylized smoke shape. This shape can be drawn with any of Flash's drawing tools. I recommend no outlines stroke.

2 Insert a keyframe (F6) in frame 2 and, with the Lasso tool, select a small section at the top end of the smoke shape and delete it.

6 Copy and paste all frames into a Graphic symbol so it can be re-used later. Create a second keyframe down the Timeline and, with the Free Transform tool, skew it and move it up about 30 pixels.

7 Create a third keyframe further down the Timeline and adjust the alpha to 0% so it fades out. Apply another Motion tween and maybe a little more skewing.

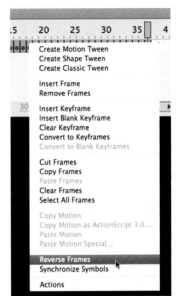

3 Repeat the process of inserting a keyframe and selecting a small section of your shape and deleting it. Use your keyboard shortcuts to make this task faster and easier.

4 Toggle between F6 and the Delete key while selecting sections of your shape until it has been completely removed from your stage.

5 Select the entire range of keyframes and then right-click over them to bring up the context menu. Select Reverse Frames. This will reveal your shape when you play back your animation.

8 Add another layer and drag an instance of the same symbol (containing your animated shape) to the stage. Flip it horizontally and repeat steps 6 and 7.

9 Add a third layer and repeat steps 6 and 7 again. Play back your animation frequently and adjust the amount of skewing, tweening and the overall timing as necessary.

10 You may want to apply a bit of easing out to the symbols as they fade away. Although it may not be necessary, it might just add that final touch to your overall effect.

Full steam ahead

FILTERS ARE ANOTHER GREAT WAY to create realistic smoke or, in this example, steam. Since the image we are working with is an actual photograph, the animation needs to be just as convincing. Without the presence of steam, this cup of tea looks cold and somewhat unappealing. Not only can you use filters to blur objects in Flash, but you can also animate these filters.

1 Start off by drawing some simple shapes with the Brush tool. They should be random and abstract.

2 Select this shape (or shapes) and convert it to a Movie Clip symbol. With this symbol still selected, convert it to a Movie Clip once again so you end up with two Movie Clips, one nested inside the other.

6 Select the Movie Clip instance in the second keyframe and apply another Blur filter. Increase the amount of blurring so it is slightly more than the blurring in the first keyframe.

7 Select the Movie Clip instance in the third keyframe and apply another Blur filter. Increase the amount of blurring even more than you applied in the second keyframe.

3 Double-click the Movie Clip symbol on the main Timeline to edit it. Insert a second keyframe a few frames down the Timeline and scale the original Movie Clip symbol as shown above.

4 Insert a third keyframe down the Timeline and scale the Movie Clip even wider and position it a little higher.

5 Go back to the first keyframe and apply a Blur filter using the Filters panel (Window > Properties > Filters).

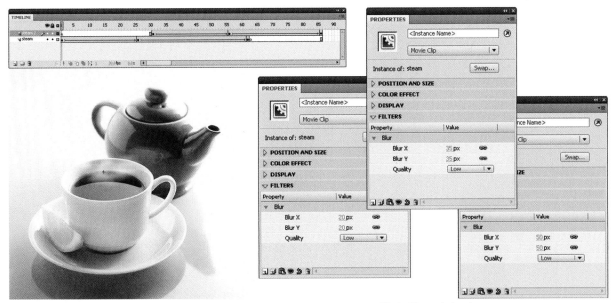

8 Apply Motion tweens to all keyframes. Play back your animation and make adjustments as necessary. You may want to adjust the amount of blurring, alpha or transforming to your animation. You can also create a second steam animation by creating a new layer and drawing more shapes; convert them to a Movie Clip symbol and repeat steps 1 through 7. Then select and drag the entire range of keyframes and frames down the Timeline so they start after the original animation. This will help eliminate the repetition of one single looping steam effect.

Handwriting effect (frame-by-frame)

Flash

Flash

IN CHAPTER THREE I showed you how to create the effect of text writing itself using a mask. While the mask technique yields a smaller file size, it doesn't look as realistic. At the expense of a few extra bytes, you can create a more realistic version of this effect with a little manual labor and patience.

1 The first step is to start with some text. You can either hand write this yourself using the Brush **B** tool or type some text using the Text **T** tool. This technique requires that the text be actual vector art. If you used the Text tool to type text into a text field, you will need to break it apart until it is actual vector art. To do this, select the text field and use ⌘ **B** ctrl **B**.

shsh

4 With the frame indicator still on frame 2, work backwards by erasing a small portion of the last letter in the word you created initially. I prefer to use the eraser end of my Wacom stylus but you might prefer to use the eraser tool itself. Once you finish erasing make sure you press the F6 key to insert a new keyframe.

5 Before moving on make sure you have inserted a new keyframe by pressing F6. I typically keep a finger at rest over the F6 key while I'm executing this technique. Make it a habit to erase, press the F6 key, erase more, press the F6 key and so on...

2 As you can see here, make sure your text field is broken apart until it is converted to vector art. Older versions of Flash required the text field be broken apart once while more recent versions require the text field be broken apart twice.

3 The next step is to insert a keyframe in the timeline on frame 2. Select this frame and press the F6 key. This is the frame where we will start animating.

6 Moving from right to left keyframing and erasing the text you will eventually get to the end where your text has been completely erased from the stage. If you scrub the Timeline from right to left you will see the effect take place.

7 The only thing left to do is select the entire range of keyframes, right click over them and select Reverse Frames from the context menu.

Fireworks

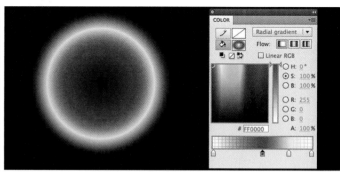

1 Start with a radial gradient with at least four colors. The middle and outer colors should be mixed with 0% alpha. The second and third colors are based on your own fireworks color scheme. Convert the gradient to a Graphic symbol.

EVERYBODY LOVES FIREWORKS. There's nothing like a warm summer night under the stars watching the skies light up with the brilliance of pyrotechnics. You can make every day the fourth of July by animating your own fireworks display, and there's no danger of getting hurt either. With some simple gradients, a little masking and some tweens, you'll be hearing "Oohs!" and "Ahhhs!" in no time.

5 Insert keyframes for both layers somewhere down your Timeline and scale them both up about 300%. The gradient should be at least as big as the mask.

6 Insert two more keyframes much farther down the Timeline and scale both the mask and gradient about 125% more. Fade out the gradient to 0% alpha.

10 Since this stroke and its Shape tweened animation simulate the ascending explosive, you will need to slide the actual fireworks animation down the Timeline to make room for it. At this point, it comes down to artistic license and how you want the entire animation to play out. Here I have the ascent disappear just before the burst effect appears. The speed of the ascent can be adjusted by adding or removing frames during the Shape tween.

2 You need to create a mask that resembles the shape of exploding fireworks such as in this example. Convert it to a Graphic symbol.

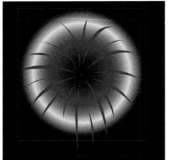

3 Place the radial gradient in the masked layer so when the layers are locked, the gradient shows through the mask only.

4 Scale both the mask and gradient in frame 1 so they are very small. Scale the gradient even smaller than the mask.

HOT TIP

If you have a solid color background such as black, it is best to avoid Motion tweens with alpha because they can be very processor intensive – especially if multiple animations are overlapping. Instead of alpha, tint to the same background color instead. Tint is much more processor friendly and playback will always be better as a result.

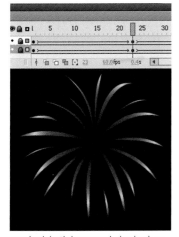

7 Lock both layers and play back or test your movie. You should have a pretty convincing fireworks explosion.

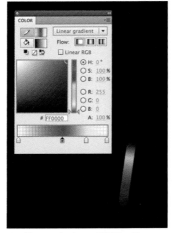

8 Draw a stroke and fill it with a linear gradient that contains two swatches mixed with 0% alpha at both ends.

9 Shape tween the gradient so it starts at the bottom of the stroke and ascends until it reaches the top and beyond so it disappears.

11 If you nest this animation in a symbol, you can duplicate it in the Library to create additional fireworks with different colors.

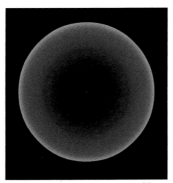

12 Edit the duplicate symbol(s) with a new radial gradient symbol. The darker the background the more vivid the fireworks will be.

13 Drag multiple instances of your fireworks to the stage and start them on different frames to vary their timing.

Soft reveal

FLASH LACKS THE ABILITY to create masks with soft edges. When you use masks in Flash, you are limited to a hard edge, even if the mask contains a gradient with one color mixed with 0% alpha. Perhaps someday a future version of Flash will support masks with feathered edges. Until then, we need a work-around. So far the only solution I have been able to come up with is not even a mask at all. It's a simple gradient with at least one color mixed with 0% alpha. In the end, the effect is successful because it is what the viewer doesn't see that convinces them visually.

1 Start with a radial gradient (shown here with orange for clarity) with two colors. The outer color should match the solid color background which you will need for this effect to work. The middle color should be mixed with 0% alpha to make it completely transparent.

Use the Rectangle tool **R** to make a very large shape with this radial gradient as your fill color.

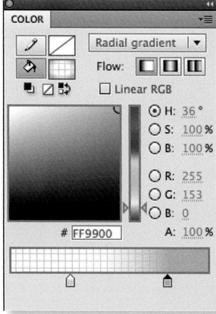

2 Convert this rectangle to a symbol and place it on a layer above the image you want to reveal. Scale the rectangle large enough so you can see the entire image through the middle color that you made transparent.

In frame 1, position the rectangle so that the image below it is completely obscured from view. This is if you want to start your animation by revealing the image over time.

3 Create a second keyframe somewhere down the Timeline and position the gradient so that the image below it is clearly seen through its transparent center. Apply a Motion tween and play back your animation.

Star Wars text

TEXT EFFECTS ARE ALWAYS a popular request among Flash users - specifically the "Star Wars" effect made famous during the opening scene in the original 1977 film. The effect is relatively simple to create but comes with a price: playback performance can suffer. Proceed with caution and test your animation often to make sure playback doesn't suffer. Remember, the text must be legible without giving the reader a headache.

This is how to make a "Star Wars" style opening text effect. It ain't too hard once you know how. This is how to make a "Star Wars" style opening text effect. It ain't too hard once you know how. This is how to make a "Star Wars" style opening text effect. It ain't too hard once you know how. This is how to make a "Star Wars" style opening text effect. It ain't too hard once you know how. This is how to make a "Star Wars" style opening text effect. It ain't too hard once you know how. This is how to make a "Star Wars" style opening text effect. It ain't too hard once you know how. This is how to make a "Star Wars" style opening text effect. It ain't too hard once you know how. This is how to make a "Star Wars" style opening text effect. It ain't too hard once you know how. This is how to make a "Star Wars" style opening text effect. It ain't too hard once you know how. This is how to make a "Star Wars" style opening text effect. It ain't too hard once you know how. This is how to make a "Star Wars" style opening text effect. It ain't too hard once you know how. This is how to make a "Star Wars" style opening text effect. It ain't too hard once you know how.

1 Start by typing your block of text. Try to use a simple and bold font that is easy to read. You will be transforming this text and animating it. Since it will be constantly moving, priority should be making sure it is legible and easy to read for the viewer. Select your text field and break it apart until the text becomes raw vector shapes. The amount of vector information will be substantial and will most likely cause some performance issues during playback. This is another reason to choose a font that is as simple and clean as possible as it will produce fewer vector points.

3 Insert a new layer and convert it to a guide layer. Make sure the layer containing your text is not "guided" or linked to it. You can drag the guide layer below your text layer to prevent them from being linked together. Anything on a guide layer will not be included in the exported SWF. Flash CS5 offers a nice feature that provides the option to export or not export hidden layers. This option is accessible by going to File > Publish Settings > Flash tab. On this layer use the Line tool to draw a stroke at the same angle as your text field. Copy and paste it in place, flip it horizontally and position it on the opposite side of your block of text.

4 Add a second keyframe and scale your text until it fits inside your guides at their smallest point. You will need to insert several frames between these two keyframes and apply a Motion tween.

2 The next step is to simulate the perspective needed to provide the illusion that the text is receding. Select the Free Transform tool **Q** and then the Distort (subselection) tool. While holding down the **Shift** key, drag one of the upper corners horizontally towards the middle of the

text. Holding down the **Shift** key constrains the proportions of the transformation by distorting the adjacent corner in the opposite direction. Convert this block of text to a Graphic symbol. If you have several blocks of text, it might be best to keep them as smaller individual symbols.

5 The final step actually breaks the one and only perspective rule this animation relies on. I also think it is the most important step since it really helps provide the illusion of the text disappearing into infinity, yet it is so simple. In the very last frame of the tween, select the symbol containing the text field and, using the Free Transform tool, scale it vertically using one of the 2 middle handles along the top or bottom edge. In essence you will be squashing the symbol to make

it flatter (do not widen it).
For smooth playback, you will need a combination of hundreds of frames and a high frame rate. The exact amount depends on the amount of text, the font style and how large (width and height) your movie is. The larger the movie, the more processor intensive it will be. Any animated effect that uses a combination of these factors can cause poor playback performance. Test often and know your target audience.

HOT TIP

You could try this effect with a block of text made in Photoshop that is distorted in the same perspective. Import the text as a bitmap with the same solid color background as your Flash movie. It may result in a more processor-friendly animation sequence but will suffer from loss of quality when scaled. Flash doesn't scale imported bitmaps very well and the results may not be visually appealing. The trade-off is using crisp vector text with some possible performance issues during playback. Test often is your best defense.

SHORTCUTS
MAC **WIN** **BOTH**

Color adjustments

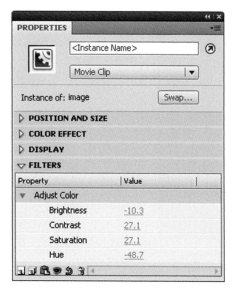

BEFORE FLASH 8 introduced filter effects, advanced bitmap effects meant having to spend time outside of Flash editing several duplicates of the original image. Depending on the desired effect(s), several different versions of the same image would have to be created and imported into Flash. With Flash CS3, CS4 and now CS5, this process became much easier.

Using only one single bitmap image and the Adjust Color filter, you can create some striking color effects with minimal time and effort. The advantages of using this filter technique include smaller file sizes and faster results that can be mixed with any of the other filters.

1 To convert a full color image to gray scale, slide the Saturation slider all the way to the left.

2 Click the Reset button in the Filters panel to return each color setting to "0".

3 To adjust the overall color hue of your image, use the Hue slider. Here the Contrast and Saturation have been slightly adjusted as well.

1 The imported image here has been blurred and adjusted using the Blur and Adjust Color filters.

2 Here the Saturation and Hue have been increased as well as the Contrast.

3 Here's the original image without any filtered effects.

4 Each of these color adjustments can be keyframed and Motion tweened to create smooth color transitions.

5 Any of these color effects can be visually effective when introducing images for a variety of uses.

6 You can also add some basic ActionScript to control color changes when the user rolls over various menu buttons.

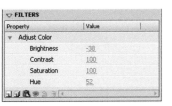

HOT TIP

You can copy a filter effect by clicking on the "Copy Filter" button in the Filter panel. Then you can paste it to another Movie Clip instance elsewhere in your Flash document.

▽ FILTERS	
Property	Value
▼ Adjust Color	
Brightness	-38
Contrast	100
Saturation	100
Hue	52

▽ FILTERS	
Property	Value
▼ Adjust Color	
Brightness	-34.6
Contrast	91.2
Saturation	91.2
Hue	-164.1

▽ FILTERS	
Property	Value
▼ Adjust Color	
Brightness	-38
Contrast	56
Saturation	-75
Hue	-71

SHORTCUTS

MAC WIN BOTH

Vertigo

CAUTION: THIS EFFECT MAY CAUSE temporary headaches and possibly some minor nausea if stared at too long.

Well, perhaps it won't cause sickness but it is a great effect for representing vertigo: a balance disorder that causes a spinning sensation. If you are familiar with Alfred Hitchcock's film "Vertigo", you will already be familiar with how this visual effect can be used to induce the image of something or someone spinning out of control. With animation, it can also represent time travel or a worm hole or even the beginning of a dream sequence or hallucination.

1 The success of this effect is in the one single graphic: the spiral. It was created in Adobe Illustrator using, you guessed it, the Spiral tool. Flash does not have a tool like this so Illustrator proved to be a huge time saver. Of course you can always draw this spiral graphic by hand using the support of a pressure-sensitive stylus, but that would certainly require a very skilled hand.

3 This is a great effect to place a character or an object on top of. Place the object in a Movie Clip symbol and rotate it in the opposite direction as your swirl. This will enhance the effect by providing the illusion of the object traveling through time or space and may even induce some minor headaches and nausea.

2 Convert your spiral graphic to a symbol. Insert a second keyframe about 100 frames from the first keyframe. Apply a Motion tween. Of course nothing will happen on playback because no change has been made to either instance of the spiral. Select a frame anywhere along the Motion tween and in the Rotate drop-down menu, select CW (clockwise) or CCW (counter-clockwise). Type in the number of rotations desired.

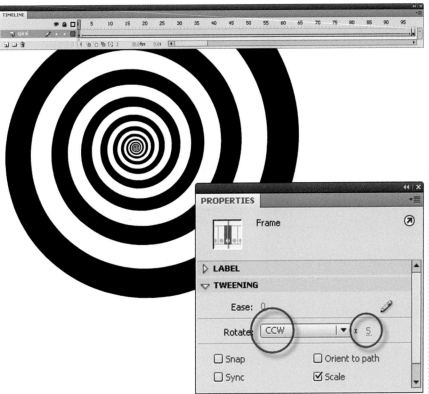

4 It's time to have some fun! Change the colors of your spiral and then select the character or object (make sure it is in a Movie Clip) and experiment with some of the Blend Modes available from the Properties panel. There are some interesting effects to play around with here that may provide some cool results.

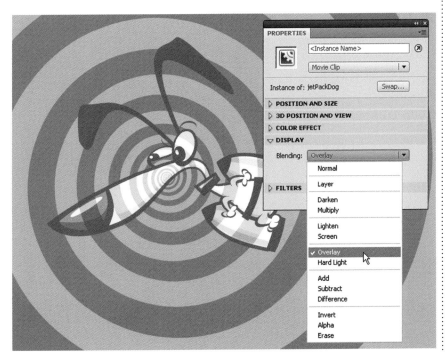

SHORTCUTS
MAC WIN BOTH

251

Let it rain

1 Use the Brush tool to draw your rain drop. Gravity suggests that the shape of the drop is thicker and rounder at its bottom. Fill your raindrop with a solid color or a radial gradient for some extra realism. This is a style choice for you to decide.

2 Convert your drop to a Graphic symbol and rotate it slightly. The amount of rotation is up to you based on how strong a rain storm you want to have. The more angle your rain has, the more wind is suggested.

THERE ARE SEVERAL WAYS to approach animating rain, probably because rain falls in several ways depending on wind conditions. I chose an average style of falling rain that can easily be expanded upon based on your own needs.

Rain, to our advantage as animators, is repetitive. Reusing assets is one of the strengths of Flash. You only need to animate one raindrop and then populate your scene with multiple instances of it. You can then control how your rain acts by adjusting the angle at which it falls, its speed and how many instances of it appear at any given time.

6 Copy all frames of your circle animation. Insert a new layer and paste the frames into it. Select all the frames in this new layer and drag them about five frames further down the Timeline.

7 Navigate back to the main Timeline and transform your water drop symbol (containing its animation) by dragging the middle handle along the top or bottom edge (Free Transform tool).

3 Insert a keyframe further down the Timeline. In frame 1, position the drop outside of the stage. In your second keyframe, position it near the bottom of your stage area. Apply a Motion tween.

4 Let's create a ripple effect for the raindrop after it reaches its destination. Using the Oval tool **O**, draw a circle with a stroke color only. Hold down **Shift** to constrain its proportions. Convert it to a Graphic symbol.

5 Convert it to a Graphic symbol again and double-click it to edit it. Insert a second keyframe and Motion tween it from small to large over approximately ten frames. Select an instance in the last frame and apply 0% alpha so it fades out completely.

8 Place the symbol containing your ripple animation in a blank keyframe (F7) in the frame after your raindrop animation. Position the ripple just below the raindrop in its last frame. Copy all frames in this layer.

9 Paste these frames into a new symbol. Add several layers and continue to paste your animation into each one. Select and drag each layer's animation so that they each start on their own unique frame number.

10 Now that you have a rain sequence nested in a symbol, drag as many instances of this symbol as you need to the stage. Scale them and even tint some darker to suggest more depth to your scene.

Playing with fire

1 Start by making several overlapping rectangles (with no stroke outline). Don't concern yourself with color at this stage of the process; any color will do.

NO FLASH ANIMATION BOOK is complete without a topic involving fire. How many times have you ever wanted to animate fire and had no idea how to even approach it?

The first technique that comes to mind for animating flames is Shape tweening. It just seems like the appropriate choice because of the nature of fire and how flames dance and flicker. But in my experience, Shape tweening doesn't seem to ever produce realistic results. Often, the shapes "implode" or simply morph in all the wrong ways. The effect of fire is simply not achievable using tweens.

Motion tweens are not an option for the obvious reason that they can only be applied to instances of symbols.

ActionScript might be a solution, but, if you are like me, your scripting skills are not up to the challenge of producing fire from within the Actions panel.

Don't be frightened by what I am about to say, but frame by frame is the best option for animating fire. Don't be fooled; it's not that hard or time-consuming.

5 Ultimately your flames in frame 1 should look something like this. Try to alternate the direction of each flame. Fire is random and travels in unpredictable ways.

9 Create a Linear gradient using bright red and bright yellow as the two colors.

10 In each keyframe, select all and drag the Bucket tool vertically inside your flames to fill them. The gradient will follow the direction you drag in.

2 Use the Selection tool **V** to pull edges to create peaks.

3 Fire is naturally unpredictable. Avoid repetition with your shapes.

4 Try to incorporate some shapes with "S"-shaped curves for some added realism.

6 Insert a keyframe (F6) on frame 2, turn on Onionskin and begin editing the next frame by pulling each point higher and lower.

7 "Punch" holes in the flames by drawing different colored shapes and deleting them. Fire is not solid; it will break up as it rises into the air.

8 Continue to create keyframes and edit the shape of your flames in each one by pulling and pushing with the Selection tool.

11 Copy all frames of your animation and paste them into a new Graphic symbol. Add three new layers to the main Timeline and drag instances of this symbol to each of them. Delete your original layer. Select one of the instances and flip it horizontally. Scale two of the instances so they are much wider than the stage. Position them off-center from the stage while leaving one of the instances at its original size and position. Create a background shape with the same linear gradient to make it look like the entire scene is ablaze.

Torch

CREATING ANIMATIONS FOR GAMES often requires creating short looping animations that do not generate large file sizes. These short looping animations work well when they can be reused over and over again throughout the game. This flame example was created for a game where the character carried a torch. The tricky thing about fire as we know from the previous example is that it is unpredictable. Animating elemental effects usually requires a hand-drawn technique because automated tools such as tweening are too consistent in their interpolation to be used for the creation of anything random, such as fire. But don't be intimidated by the thought of hand-drawing each frame because you can use the random nature of fire to your advantage.

1 The first frame is drawn using the brush tool **B** and a graphics tablet with pressure sensitivity. The idea here is to draw a single shape that has long wispy flame-like shapes coming off of it vertically. I try to make each flame different from the next with the tallest flames towards the center and the shorter flames to the sides.

4 Once you have a few frames drawn it is always a good idea to playback the animation in a loop to see how it is shaping up. You can loop the timeline within Flash by choosing Control > Loop Playback.

2 Here I have the original fire drawing on a layer that has been converted to outlines. In a new layer below it is where I draw the next fire drawing. Having the original drawing outline on the layer above helps me use it as a guide. Onionskin would normally be used in this situation but often times the current drawing will hide the edges of the drawing in the previous frame. With an image such as fire it is much easier to draw when you can see the entire outline of the previous drawing.

3 Fire is unpredictable. Keeping this in mind I try to draw the individual flames so that they are animating in different directions. If the flames move in a predictable way then it will look unrealistic.

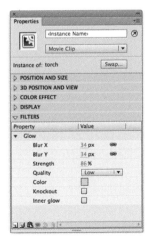

5 This flame animation required 7 individual drawings to complete the loop. The flame color was changed to white because the game background was black.

6 All frames were copied into a Movie Clip Symbol so I could apply a Glow filter. Using yellow as my glow color, adjust the amount of Blur and Strength to create a soft glow effect.

7 Test the movie to see the torch flame come to life complete with the glow filter for added effect.

257

Lightning

1 The main lightning bolt is drawn using the brush tool **B** and a graphics tablet with pressure sensitivity. Lowering the amount of smoothing helps achieve a realistic looking bolt due to the imperfections caused by the human hand. Nature is not perfect, and therefore your lightning bolt should have imperfections also. Try to vary the weight of the bolt as well as the direction it goes by drawing with a loose carefree hand.

LIGHTNING IS ONE OF THE EASIEST and most fun elemental effects to animate. Lightning can be used in scenes for atmospheric effect, and it can be very effective to say the least. As an animator, I'm always trying to push my skills as far as they can go, and recently I've been trying to learn how to animate special effects. I've been taking a 2D animation effects course written by Adam Phillips, and I highly recommend it. One of the first lessons is learning how to animate lightning and even though I already knew how, Adam's lesson provided me with a few tips and tricks I hadn't ever tried. This example is a combination of my own technique as well as what I learned from Adam. Learn more about Adam's course here: **bitey.com/2010/08/bca-fx**

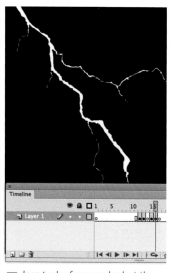

5 Insert a keyframe and select the eraser **E** tool. Carefully remove areas of the lightning bolt from the outside edges to create the illusion that it is breaking apart.

6 As an added effect, convert the first bolt of lightning to a Movie Clip symbol and then apply a Glow filter to it from the Properties panel.

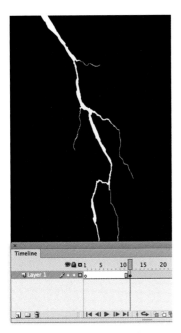

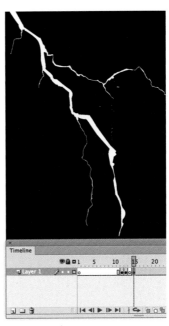

2 You can add thinner branches breaking off from the main lightning bolt itself. These branches are usually very thin so reduce the size of the Brush before drawing them.

3 The frame following the lightning should be completely white. This white frame creates a high contrast effect that leaves a residual image in the viewer's eye. It is a very powerful and easy effect to create.

4 The next frame is left blank, exposing just the black background. The frame after that contains a new lightning bolt drawing.

7 The color of the glow is entirely up to you. It can be almost any color depending on the subject matter. Green or blue can suggest a fantasy theme while red may look more real-world.

8 With the color selected, adjust the amount of blur and strength using the hot text sliders. It is easy to abuse the blur effect so remember that being subtle usually works better here.

9 Test the movie to see the lightning bolt in action.

Winter wonderland

L ET IT SNOW, LET IT SNOW, LET IT SNOW. Creating constantly falling snow is fun. Like the rain example, snow can be animated several different ways. The easiest way is to Motion tween a snowflake symbol along a Motion Guide path. Other methods include using ActionScript-generated snow, but don't ask me to show how that is done because I admittedly do not know how to write scripts on that level. Let's stick with my "analog" method of animating in Flash shall we?

The more snow you create, the more processor intensive your animation becomes. Proceed with caution and test your animation frequently to make sure the constant looping snowfall doesn't cause unexpected playback issues. There's nothing worse than creating a cool animation only to find it skips and chugs during playback.

I highly recommend Chris Jackson's book **Flash + After Effects** (Focal Press) because he teaches you how to create snow in Adobe After Effects that is easily imported into Flash. His book contains a ton of other cool examples that you will find very useful on a day to day basis.

1 Start with a snowflake design using the Line tool. It's hard to make a mistake here since there's no real way to create an incorrect snowflake pattern. Make one "arm" of the snowflake, convert it to a symbol or as an Object Drawing. Copy it using ⌘ C / ctrl C and paste it in place using ⌘ Shift V / ctrl Shift V, then rotate it 45 degrees. Repeat until you have pasted enough to complete the pattern.

4 Here's what your Movie Clip's Timeline should look like (give or take some frames or layers). Notice the *stop()*; action in the last frame of the top layer. This prevents this Movie Clip from looping. Since all instances of the snowflake Movie Clip are present, they will loop by default.

2 Convert your snowflake to a Graphic symbol and then convert the Graphic symbol to a Movie Clip symbol. Double-click the Movie Clip and edit it by inserting a Motion Guide layer. Draw a curvy stroke for the guide and Motion tween your snowflake along the path (traveling downward of course).

3 You now have a Movie Clip containing an animation of a snowflake tweened along a motion guide. Next, in your Library panel, create a new Movie Clip and insert several new layers. Drag an instance of your snowflake Movie Clip into each layer. Position each snowflake Movie Clip randomly throughout your scene. For each layer, select and drag the keyframe in frame 1 to a different frame number so they each start playing at different times. Make sure each snowflake animation begins outside of the viewable area of the stage.

5 On the main Timeline, place an instance of your Movie Clip containing your snowflake Movie Clips onto the stage in its own layer. You can place multiple instances of this Movie Clip around your stage as many times as you like. But be aware that the more instances of the snowflake animations you have present on the stage, the more processor intensive your movie will be. If maintaining a high frame rate is your priority, you may want to experiment by using a simple oval shape for your snowflake graphic. Remember, fewer vector points means better playback.

SHORTCUTS
MAC WIN BOTH

3D perspective

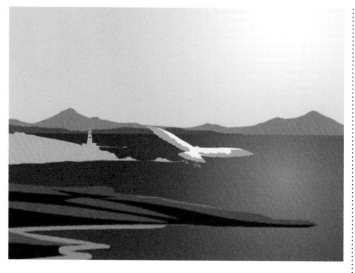

1 Start with a simple background graphic that shows a clear horizon line. Here the sky and ocean are convincingly represented using 2 simple radial gradients. This simple illusion is created due to the alignment of the gradients vertically, thereby making our eye translate the bottom gradient as a reflection.

ADAM PHILLIPS IS BEST KNOWN for his award winning Brackenwood series: http://www.biteycastle.com/content/animation_brk.html. The rest of his animation is equally as brilliant and I highly recommend treating yourself to his entire website: http://www.biteycastle.com/

Adam has generously provided a couple of killer Flash examples that showcase Flash CS5's 3D capabilities. Flash CS5 allows you to create 3D effects by moving and rotating movie clips in 3D space on the stage. Flash represents 3D space by including a *z axis* in the properties of each Movie Clip instance. You can add 3D perspective effects to Movie Clip instances by moving or rotating them along their *z axis* using the 3D Translation and 3D Rotation tools. Moving an object in 3D space is called a *translation* and rotating an object in 3D space is called a *transformation*. You can take advantage of this powerful new 3D feature for scenes like this one where the perspective of a landscape fly-over animation needs to look realistic.

4 Verify the playhead is in the last frame of your tween span in the Timeline. Open the Properties panel and select the first Movie Clip symbol. Use the Z axis hot text slider in combination with the X and Y axis sliders to position your object off the bottom edge of the stage.

2 Next some background elements are added to provide depth to the scene. A mountain range divides the sky and ocean while some shoreline elements are positioned in the distance. The plan for this scene is to provide the illusion that we are flying towards the horizon along the shoreline. To set this up from the start, begin with your shoreline objects at their starting point, scaled down at their furthest point away from the "camera". Convert them to Movie Clip symbols.

3 Distribute each of these Movie Clip objects to layers, then right click over each of them and select Create Motion Tween. Do not use Classic tweens since they are not supported by the 3D Translation and Transformation tools. I recommend going to View > Pasteboard and making sure you can see beyond the stage area of your document. This will help you when positioning your objects beyond the viewable stage area.

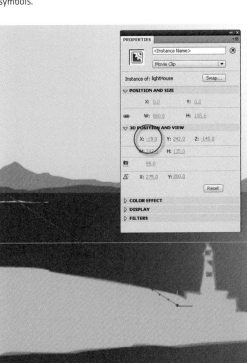

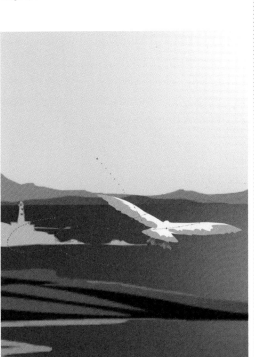

HOT TIP

It is worth noting that these 3D tools will not work with objects on mask layers. You can not convert a layer containing 3D objects to a mask layer either.

5 Repeat this procedure for all the remaining objects on the stage. You will also want to increase or decrease each tween span to adjust the timing of each object to prevent them from all moving simultaneously.

6 Adding the Gull animation to the foreground adds 2 important elements to the scene: it enforces the illusion of depth as well as something interesting to look at. Even though there's no "camera", upon playback, the human eye will perceive us as literally flying through the scene.

SHORTCUTS

263

Bone and Spray

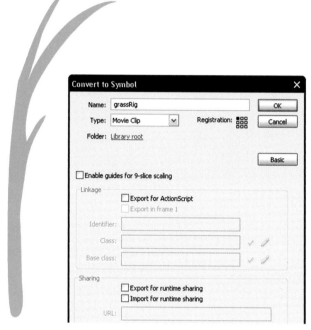

HERE'S ANOTHER COOL EXAMPLE from Adam Phillips that combines two tools in Flash CS5: the Bone tool and the Spray Brush tool.

What's a little different about the Bone tool here is that it is being applied to a shape instead of a symbol object. This blade of grass is then animated by manipulating the armature inside a Movie Clip symbol.

The advantage of using the Spray Brush tool is having the ability to assign this custom grass Movie Clip as the object to be sprayed.

1 Start with a blade of grass drawn with the Brush tool **B** or a shape tool. It doesn't really matter as long as it remains as raw vectors. Select it and convert it to a Movie Clip symbol. Then double click this symbol to enter *edit in place* mode.

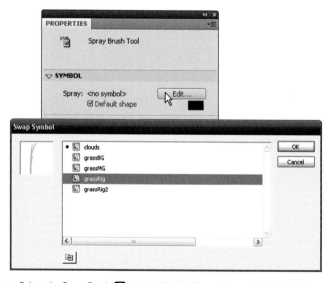

4 Select the Spray Brush **B** tool and in the Properties panel click the Edit button. The Swap Symbols panel will open allowing you to select a Movie Clip symbol from the document's Library. Select the grass symbol containing the animation. Click "OK". The hard part is over.

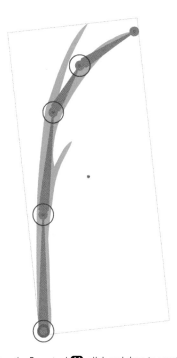

2 Using the Bone tool **X**, click and drag to create a chain of bones inside your shape. Flash will automatically place this shape in a container. Animate the shape by inserting frames in this layer and manipulating the armature by dragging the last bone in the chain.

3 Flash will insert keyframes automatically wherever the playhead is in the Timeline when you manipulate the armature.

HOT TIP

Be mindful of your target audience when creating several instances of an animated symbol. Flash renders frames on the fly in real time and if the animation is too complex, older machines with slower processors may experience difficulty during playback.

5 All that's left to do now is use the Spray tool to "paint" the animated grass across the stage. With each spray, the objects are automatically grouped. You can select a group and convert it to a symbol in order to apply a color effect. Adjust the brightness or apply a tint color to suggest some depth between groups of grass.

6 Add in some additional background elements to complete your scene. Hours of production time were saved here by nesting an animation made with the Bone tool and taking advantage of the Spray Brush tool. Locate the SWF file in the "Chapter 7" folder on the CD to see the final animation.

SHORTCUTS
MAC WIN BOTH

Sausage grinder

APOLOGIES IN ADVANCE TO ALL VEGANS who may be reading this. Sausage Kong is a Flash game developed by Thibault Imbert (Product Manager, Adobe Flash Player) and myself to help showcase the more advanced features of the latest Flash Player. This is the type of game that gets created when two unrestricted guys go completely rogue and put their creative minds together sans a babysitter (and when I say "creative" I really mean "twisted"). The reason I chose the grinder animation for this example is because it takes advantage of several design and animation tools in Adobe Flash CS5. From the Deco tool to Motion and Classic tweens, you don't have to limit yourself to a single tool. It is often the combination of several techniques that make for a better product.

Thibault Imbert: www.bytearray.org

1 The gears were drawn with the help of the Deco tool **U**, specifically the Decorated Brush. Select Step Wave from the Advanced drop-down menu to create the pattern seen above. Draw a circle with these settings and you have yourself a quick and easy drawing of a gear.

5 The important aspect to this animation is identifying the parts that need to move. Once identified, draw each part separately and convert them to symbols. Here is an exploded view of all the individual parts of the grinder.

2 You may need to connect the 2 ends of the gear together by breaking apart the group it is contained in and snapping the 2 strokes together.

3 Using the pencil tool and the same stroke size, draw 2 inner circles and then attach them by drawing some support sections.

4 Select any overlapping stroke segments and delete them. You can then fill the gear with your color(s) of choice.

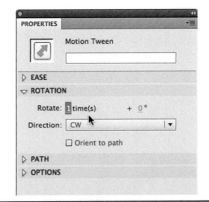

6 Convert the gear to a symbol and then copy and paste it to create a 2nd gear. Distribute each gear to its own layer. Right click over each one and select Create Motion Tween.

7 Select each motion span for each gear and in the Properties panel set each gear to rotate using the Rotation tools. Type in the number of rotations as well as the direction (clockwise or counter-clockwise).

SHORTCUTS
MAC WIN BOTH

Sausage grinder (cont.)

8 Both gear animations were converted to a single symbol. I wanted them to be viewed "inside" the grinder so I designed a porthole style window as separate assets. The red shape is the mask that limits the visibility of the gears to the window area only. The gray circle is the background color, the irregular shape seen on top of the gray shape is the window highlight and the bezel is shown at the very top.

9 Here is the assembled window porthole with the masked gears. You can see the layer ordering of each object in the Timeline. The irregular shape with the alpha gradient is the only artwork inside the bezel. There was no need to provide anything else as this small piece of art was enough to provide the illusion of glass.

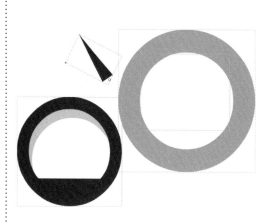

12 Here's the exploded view of the pressure gauge. Once again I have used very simple shapes to build this gauge keeping in mind that it will be scaled down quite small, so keeping it simple was crucial. The needle was kept as a separate object because I intended to animate it.

13 With each object distributed to layers I was able to animate the needle moving back and forth. Notice the center point was positioned at the bottom of the needle to allow it to rotate based on where it would be normally hinged.

10 The meat catcher is made up of 4 different graphics, each converted to a symbol and is distributed to layers. An 8-frame animation was created of the catcher moving up and down in a slightly erratic nature. Those 8 frames were copied and pasted to lengthen the animation Timeline.

11 With the layers converted to outlines it becomes easier to see the subtle motions of the catcher between the frames. A combination of Motion and Classic tweens was used to create this effect.

14 The flashing lights couldn't be simpler to create. The glass highlight was reused from the porthole (gears) example and the light flashing effect was simply a 2nd keyframe with a brighter "lens" color.

15 Here's the entire grinder assembled and in fine working order. Check out the source file on the CD in the back of this book to see the entire animation.

From the inside out

I AM A DIGITAL ANIMATOR. A "digimator" if you will. I learned how to animate on a computer, which is inherently different than the traditional animation process. Sure, it shares some similarities when it comes to animation techniques, but ultimately any animation program can have a mechanical feel to it since we work by selecting options from menus much of the time. The trick I have learned is how to make a software program like Flash feel more organic, as if it were a ball of clay, starting with a basic shape and pushing and pulling it into something unique. If this book teaches anything, I hope it teaches you to think differently as to how you approach Flash. Just because the Help docs, online resources or even other books tell you how something can or should be done, don't take that as carved in stone. Take it as carved in clay, meaning you can continue to expand upon the ways the tools are used, even beyond what you may have read elsewhere. If 100 people were given their own ball of clay, they would all create something unique. No two clay creations would be the same because of the organic nature of the medium. Clay can be pushed and pulled in any direction, and this is how I will teach you to approach Flash.

Many years before Flash even existed, I studied everything from art history to sculpture, color theory to lithography and, above all, how to draw. This combination made the progression to the world of computer graphics and animation tremendously helpful. I feel just as comfortable with a mouse or stylus in my hand as I do with pencil, paintbrush, airbrush or printing press. They are all just tools, nothing more. Each tool is just as powerful as the other. A quick and loosely sketched pencil drawing can have just as much impact visually as a full-blown animated action sequence that took three months to complete. It's the subject matter that counts and this applies to Flash as well. Several people have asked me why I am so forthcoming with my home-grown

 tips and techniques and why I'm not afraid that many will use them to emulate my own personal style. As with the ball of clay metaphor, everyone is different, and therefore everyone will express themselves in a unique fashion whether it's through a ball of clay or an animation program like Flash. These are just tools, and in different hands come unique results. I'm here to show you how I use these tools for my own self-expression. Your own results may, and probably will, vary.

I have spent several years adopting and inventing Flash drawing and animation techniques. This book will show you different ways of approaching Flash and how to make it work for you. Whenever possible, I will try and avoid explaining what is readily available in the Help docs and the multitude of online resources. You bought this book for a reason, to learn what isn't found anywhere else. You will get a first-hand look at how I create characters and motion graphics from scratch, and learn how Flash, as a tool, can be pushed and pulled, limited only by your imagination.

My philosophy, with tools like Flash, is to learn as much as I can, then go back to the first 10% of what I learned, and take a left turn.

271

■ Having the ability to record your own high quality sound effects, vocals and musical soundtracks opens up a world of artistic possibilities. Many of my daughter's candid recording sessions have inspired several popular original animations, one of which was chosen as a Flash Forward Film Festival finalist.

8
Working with sound

FOR ME, ANIMATION IS about timing and rhythm. I've always been visually sensitive to the moving image, and as a drummer for three decades, my senses are also very fixed on musical patterns. The combination of animation and the right soundtrack can be a wonderful experience for both senses. When the right sound complements the perfect animation, it can produce a most memorable experience for the viewer.

In this chapter we'll look at how you can incorporate sounds into your animations, where to find them, and how to record, edit and load them dynamically.

Recording sounds

SOUNDS CAN ENHANCE your animation in wonderful ways. Recording and designing sounds is an art form all its own and a job typically left to dedicated sound editors who have an innate ability to edit, mix and craft sounds into works of audible art. But chances are you don't have a dedicated sound designer at your disposal 24 hours a day. Since Flash does not record or create sound files, you need to find or record your own and import them into Flash. So what is the best way to find, edit and incorporate sounds into your Flash projects? The easiest way is to purchase sound effects from your local music store or online. A quick search on Amazon.com for "sound effects" will return a few dozen audio CDs available for purchase. These are handy to have around, but may include some legal restrictions as to how you can use the sounds. Some publishers may retain the royalty rights to the contents of CDs, limiting you to non-commercial usage. This may pose some legal

Get yourself a good microphone. I'll be honest, you will get what you pay for when it comes to the quality of recording. There are several different microphones designed to record sounds for almost every situation you can think of. The cheapest solution would be something like the Logitech USB microphone that can be found at your local computer supply store for around $20 US. A microphone like that is great for transferring your voice during an Internet phone conversation, but I wouldn't rely on it for high quality recordings.

On the other hand, you don't need to spend your next five paychecks on the most professional studio microphone either. The microphone pictured on the right is an AKG Perception 400 and retails for around $300 US. It produces great sound whether you are recording voice, sound effects or musical instruments. It is a condenser microphone, which tends to be more sensitive and responsive, making it well-suited to capturing subtle nuances in sounds. The best feature of all is the three different recording settings you can switch between depending on the recording situation. You can set it to record only what is directly in front of the microphone, which is great for voice, sound effects and instruments. If you have two voices or instruments next to each other, there's a setting to record bidirectionally. The third is an omnidirectional setting that will record sounds in a 360 degree pattern around the mic. This is great for picking up general room or ambient sounds.

issues for you and most importantly your client, who would rather avoid paying legal fees for a few *thumps*, *swooshes* and *pop* sound effects in the project you delivered to them six months prior. Another potential issue with published sound effects CDs is their sound quality. Depending on the equipment used to record and edit the sounds, there is no guarantee they are of high enough quality to justify using them. It's always a good idea to try to find out the technical information regarding the actual

sound files before you purchase the CD. You will want sounds that are high quality, usually 44 kHz, 16-bit stereo. You may also want to edit your sounds by applying effects or editing loops, or even compose original soundtracks. For this you'll need to choose a decent audio editing program. Some of you may already be using an audio editing application, but for those of you who are unfamiliar in the area, we'll take a look at what's available a bit later in this chapter.

Next, you need a way to get your shiny new microphone to connect with your computer. Once again you have a variety to choose from. Assuming you don't need every bell and whistle available, a good choice is something like M-Audio's FireWire Solo mobile audio interface. It has a standard XLR microphone input and a 1/2" guitar input, allowing you to record guitar and vocals simultaneously. There are also dual line inputs for effects, drum machines and other outboard gear. The biggest decision to make when purchasing an interface like this is whether you want to use USB or FireWire connectivity. FireWire may provide faster data transfer over USB, but double check that your computer's hardware supports FireWire. If not, you can purchase a FireWire card separately.

So now how much can you expect to spend? An audio interface is between $200 and $400 US depending on how many features it offers. The M-Audio FireWire Solo mentioned here will

set you back about $250 US, but I found one on sale for $200 at my local music vendor. Throw in a microphone stand and cable and you could be looking at spending around $600. Yeah, I know what some of you are thinking: "I just spent that much to get Flash! Are you kidding me?" I can understand this being an expensive decision but I'm providing information based on equipment I feel provides the best bang for your buck. There are many less expensive microphones to choose from, some with USB connectivity that avoid the need to purchase a FireWire interface. It's a balance between the level of quality you prefer and the size of your budget.

Samson USB Microphones

CONDENSER MICROPHONE TECHNOLOGY is becoming increasingly sophisticated. There are a number of quality microphones that connect to your computer using **USB** only. There's no need to purchase additional hardware and cables and in most cases, the microphone is extremely portable due to their small size.

Any one of these microphones is an affordable way for the casual or professional animator to capture high quality sounds for their animations. Learn more at **samsontech.com**.

The best bang for your buck may be the **Samson Go Mic**. The **Go Mic** is a portable USB condenser microphone that literally fits in the palm of your hand. The microphone chassis alone is only two and a half inches in height and just over an inch wide. The microphone is attached to a weighted base using a ball joint allowing it to be angled in almost any direction. The base can sit on any flat surface or mounted to the top of your laptop screen using the integrated clip. The base has four integrated rubber feet to help limit external vibrations and a hole to provide the option to mount it to a microphone stand.

The **Go Mic** provides a 1/8-inch output so you can connect your headphones. The **Mini-B** size **USB** connector is also located on the same side of the microphone.

The **Go Mic** comes bundled with **Cakewalk Music Creator** software but I opted to stick with **Adobe Audition** because of my familiarity with it. The Go Mic is designed to work with a variety of editing software such as **Apple Logic**, **Garage Band**, **Sony Sound Forge**, **Cubase** and more. Out of the box, I connected the Go Mic to my **MacBook** Pro and it was instantly recognized by **OS X** and **Adobe Audition**. No need to download drivers, the Go Mic just works. I was recording within seconds and my initial spoken-word tests were surprisingly crisp and balanced.

What good is portability if it doesn't come with some form of protection when bouncing around the bottom of your laptop bag? **Samson** includes a zipper case with the **Go Mic** to eliminate the fear of the microphone getting dirty or damaged in transit.

You can also tailor the Go Mic to your recording environment by switching between **cardoid** and **omni-directional** polar patterns. The cardoid setting records sound in one direction while **omni-directional** captures sound in all directions. Use the cardoid setting for recording vocals in front of the microphone. Sounds from the sides and behind the Go Mic will be rejected. **Omni-directional** is great for situations where you are recording the environment - perfect for ambient sounds or live music situations. Good news for those of you on a limited budget; as of this writing, the **Go Mic** can be found on amazon.com for under $50 US. The **Samson Go Mic** is an outstanding product for recording high quality sounds with portability. With a **Go Mic** and a laptop, the world is your stage.

Other quality products from Samson are the **Meteor Mic** and **G-Track** microphones. Both are **USB** condenser microphones with additional features that go beyond their Go Mic counterpart. The **Meteor Mic** (pictured left) has a large 25mm condenser diaphragm (the **Go Mic** diaphragm is 10mm). The **G-Track** (pictured right) boasts a built-in audio interface and mixer and a 19mm diaphragm. The power of the **G-Track** is its ability to record vocals and an instrument at the same time making it ideal for studio musicians.

Audacity®

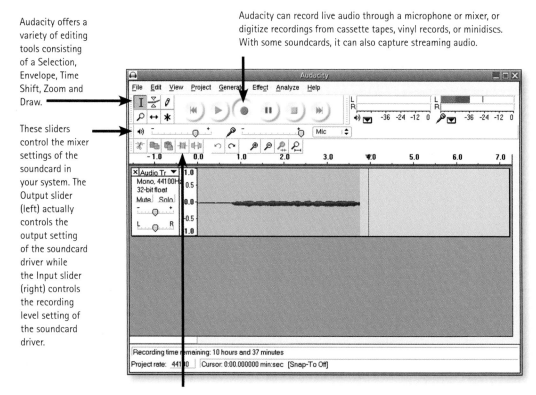

AUDACITY IS A FREE downloadable audio editing application that boasts a surprisingly robust feature set. Audacity can record live audio through a microphone or mixer, or digitize recordings from cassette tapes, vinyl records, or minidiscs. With some soundcards, it can also capture streaming audio. Audacity supports several popular audio file formats allowing you to cut, copy, splice and mix various files together as well as change their pitch and speed. If you have a limited budget, look no further and even if you can afford software that offers more, Audacity still might be enough to satisfy your needs. Go to http://audacity.sourceforge.net/ to learn more and download the installer. I've also included the installer file on the CD included with this book (look in the "Chapter 8" folder).

Audacity offers a variety of editing tools consisting of a Selection, Envelope, Time Shift, Zoom and Draw.

These sliders control the mixer settings of the soundcard in your system. The Output slider (left) actually controls the output setting of the soundcard driver while the Input slider (right) controls the recording level setting of the soundcard driver.

Audacity can record live audio through a microphone or mixer, or digitize recordings from cassette tapes, vinyl records, or minidiscs. With some soundcards, it can also capture streaming audio.

Audacity's handy Edit Toolbar allows you to cut, copy, paste, trim, silence your audio and more.

Audacity certainly doesn't make its most basic of controls hard to find. Cursor to Start, Play, Record, Pause, Stop and Cursor to End are all oversized and easy to find.

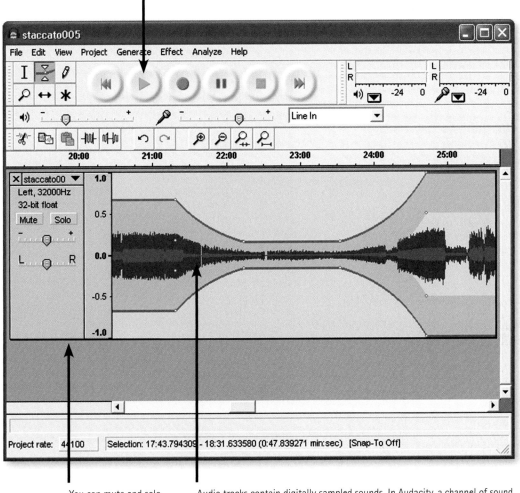

You can mute and solo (isolate) when working with multiple tracks.

Audio tracks contain digitally sampled sounds. In Audacity, a channel of sound is represented by one mono audio track and a two channel sound by one stereo audio track. You can specify a different sample rate for each track. You can import audio of any sample rate or bit depth and Audacity will resample and convert it to the project rate and bit depth on the fly.

Adobe® Audition® CS6

AUDITION IS A VERY ROBUST audio editing program from Adobe that offers a fully integrated set of audio-editing and restoration tools. This is a complete audio-editing program from recording to editing to mixing and exporting. It is packed full of features too long to list here.

If you are a sound editor and composer, Audition will satisfy most if not all of your needs. I use it for recording voice over, sound effects and also sounds from my digital keyboard. I can then switch over to Multitrack View and mix all my sounds together using an unlimited amount of stereo mixing tracks. Audition offers over 50 real-time audio effects including echo, flange, reverb, and more. You can even record and edit MIDI.

Simply put, if you need a complete audio studio out of the box, Audition delivers.

The workspace in Audition is completely customizable. You can scale and drag panels to new locations and in configurations that suit your working needs. As you rearrange panels, other panels will resize themselves automatically to fit the workspace.

Switch between Edit, Multitrack and CD views easily.

Work with more than 50 real-time audio effects including echo, flange, reverb, and more. Manipulate recordings with digital signal processing (DSP) tools, mastering and analysis tools, and audio restoration features.

Apply various colors to your
tracks for easy identification.

Manage your customizable workspace
with the Workspace drop-down menu.
You can add or remove workspace
layouts similar to how you can in Flash.

HOT TIP

Also included
with Audition is
the "Loopology"
collection, a
CD containing
hundreds of
drums loops,
percussion,
guitar, bass
and many more
instruments for
you to use in
your projects.

View and zoom controls provide a helpful way to isolate
and focus on specific portions of your audio track(s).

281

Sound in Flash

THE EDIT ENVELOPE WINDOW offers some limited sound editing features without having to leave the Flash environment. There's enough features here to control the starting and ending points of your sound file, as well as some basic fading effects. But don't expect much more beyond that.

As much as Flash could use a few more bells and whistles in this area, it was never meant to be a sound editing program in the first place. Let's leave that for the dedicated sound editing applications and use Flash for what it is. We can't expect Flash to do everything can we?

1 Select frame 1 in your Flash document and then go to File > Import > Import to Stage and select your WAV or AIF file. Your sound will be in frame 1 but you will need to insert enough frames to accommodate its length. By default, the sound will be set to Event. Use the drop-down to change the sound's behavior.

Event: This is used to play a sound at a particular point in time, but independently of other sounds. An Event sound will play in its entirety even if the movie stops. An Event sound must be fully downloaded before it will play.

Start: The same as Event, except that if the sound is already playing, no new instance of the sound plays.

Stop: This stops the selected sound.

Stream: This is used to synchronize a sound with the Timeline and, subsequently, the animation. Streaming sounds will start and stop with the playhead.

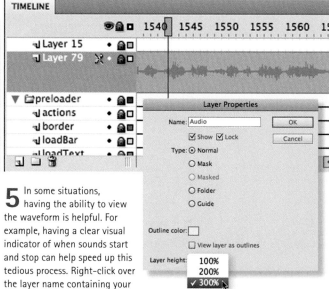

4 To change the start and end points of a sound, drag the Time In and Time Out controls in the Edit Envelope. The tricky thing about this is, without the ability to scrub the waveform in the envelope window, it's a game of hit or miss (mostly miss). If you need to continue a long sound file across multiple Scenes, you will have to add a new instance of the sound to each scene. Next, determine where the sound ended in the previous Scene and manually adjust the Time In controller for the current Scene so that the sound starts where the previous Scene ended. It's not an exact science and not an ideal solution if your audio file is one continuous sound (such as a musical score).

5 In some situations, having the ability to view the waveform is helpful. For example, having a clear visual indicator of when sounds start and stop can help speed up this tedious process. Right-click over the layer name containing your sound and select Properties from the context menu. In the Layer Properties panel, locate the Layer Height drop-down menu and select 300% to increase the height of the layer to its maximum.

2 Click the Edit button in the Properties panel to open the Edit Envelope window. Here you will see the waveform of your sound file and a few basic control features. The Effect drop-down menu offers some convenient effects to add to your sound.

Left Channel/Right Channel: Plays sound in the left or right channel only.

Fade Left to Right/Fade Right to Left: Shifts the sound from one channel to the other.

Fade In/Fade Out: Gradually increases/decreases the volume of a sound over its duration.

Custom: Lets you create custom in and out points of sound using the Edit Envelope.

3 You can add up to eight envelope handles by clicking anywhere within the sound window. Each handle can be dragged around to control the volume of the sound at that point in the sound file. The higher the handle is positioned, the louder the sound. To remove a handle, drag it out of the window. To change the sound envelope, drag the envelope handles to change levels at different points in the sound. Envelope lines show the volume of the sound as it plays.

Once the sound has been set to Stream behavior, you can then drag the play-head across the Timeline to hear your soundtrack. The default Event setting sends the sound to your system's soundcard and forgets about it. It is no longer part of the Timeline and will not maintain sync with any animation. The only way to stop an Event sound from playing while in the Flash authoring environment is to hit the Esc key. Event sounds are typically used with shorter sounds and attached to buttons.

6 Many people have experienced a serious issue with sounds, even when set to "stream", falling out of sync with the animation in the Flash Player. The only solution I have found for this is to change the default MP3 compression in the document's Publish Settings panel. Go to File > Publish Settings and click on the Flash tab. The default MP3 compression is 16 kbps, Mono. Click the "Set..." button next to the "Audio stream..." and change the bit rate to 20 kbps or higher. I personally recommend 24 kbps as the minimum compression setting. Click "OK" and test your movie. Your sync issue should now be resolved.

Dynamic sounds (AS3)

I'T'S ALWAYS FUN when sound and graphics come together to create an engaging and dynamic experience. This example uses ActionScript 3.0 to assign sounds to invisible buttons. The sounds are triggered when you roll over individual drums and cymbals. Each sound file in the Library is exported for ActionScript, allowing you to assign each sound to a different keyboard command as well. As a result, the Flash movie converts your keyboard to a musical instrument.

This is just one of an infinite number of ways sound and ActionScript can be combined to create a fun, interactive experience.

1 The first step is to create an invisible button for the area you want to assign a mouse command to. On a new layer above your image, draw a solid color in the same shape as your image. Convert the shape to a Button symbol and then double-click it to enter Edit Mode. Drag the Up keyframe to the Hit frame. The Hit state dictates the active area of the Button and will not be visible in the compiled movie. Back on the main Timeline the button is semi-transparent for editing purposes. With the instance of the Button selected, type in a descriptive instance name in the Properties panel so you can assign some commands to it.

4 The first line creates a suitably named variable and sets it to an instance of *Tom1*. You'll do this for each sound clip class, which preps each sound for play. The other lines here show how to trigger the sound with a keystroke. Set the focus to the stage, then add a "key down" event that checks for the event's charCode. In case it's 68 or 100, play the *sndTom1* sound. What are 68 and 100? These happen to be ASCII codes for the letter *D*. See asciitable.com for a chart (you'll want the Dec column).

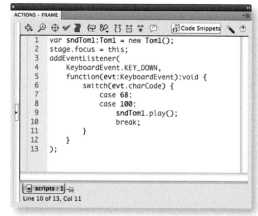

```
var sndTom1:Tom1 = new Tom1();
stage.focus = this;
addEventListener(
    KeyboardEvent.KEY_DOWN,
    function(evt:KeyboardEvent):void {
        switch(evt.charCode) {
            case 68:
            case 100:
                sndTom1.play();
                break;
        }
    }
);
```

6 Now that you have created a hit area and assigned a mouse and key command to trigger a sound dynamically, repeat steps 1 through 5 for each additional sound you want to add to your project. In the dynamic_sounds_AS3.fla provided on the source CD, I have created an additional 12 invisible buttons "mapped" to specific areas of the image of the drum set. Each Button was given a unique instance name.

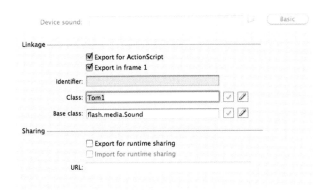

2 Import your sound file into your Flash document. In the Library panel, right-click over the sound and select Linkage from the context menu.

3 In the Linkage Properties panel, click the Export for ActionScript checkbox. That will automatically check the Export in the first frame for you. If you're using AS3, provide a unique Class name (AS2 uses Identifier instead). Here, I've named it "*Tom1*". The Base class must be "*flash.media.Sound*" but Flash is smart enough to fill that in for you. When you click OK, Flash may give you a warning about a missing class in the classpath. That's the *Tom1* class you just named, so let Flash generate its automatic fix. If you like, check "Don't warn me again" to avoid a repeat wearning. Click OK.

5 If you want to trigger the sound with a mouse movement, add the desired mouse event handler to your *btnTom1* button and have the function play the corresponding Sound instance. Check out the sample file to see how easy it is to repeat this small block of code as often as necessary.

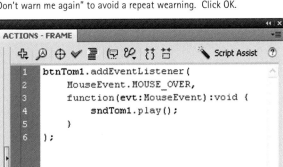

```
btnTom1.addEventListener(
    MouseEvent.MOUSE_OVER,
    function(evt:MouseEvent):void {
        sndTom1.play();
    }
);
```

7 Open the Library and you'll find a total of 13 sounds, each exported to ActionScript and given a unique Class name. Open the Actions panel and you'll see all the ActionScript has been provided as well.

This example was written by David Stiller (quip.net) in AS3. He has also written a version in AS2 which has also been provided on the source CD. We hope that these samples will provide a springboard for your own dynamic sound projects and experiments. Have fun!

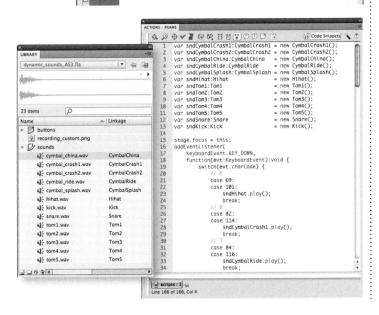

285

My wishlist for Flash CS7

IK Pinning Update

Adobe answered my request to add pinning to the Bone tool so we can lock any bone within an armature at any point in the timeline. While pinning works great, the problem now is with the very first bone in an armature or what is referred to as the root or parent bone. The root bone is pretty much locked down to stage and can't be moved using the Selection tool. The only way to move it is to use the Free Transform tool to select the root bone and then rotate or move it to a new position. The problem with using the Free Transform tool to move the root bone is that it defeats the purpose of having the IK armature in the first place not to mention it being cumbersome to switch between tools in the first place.

Layer Parenting

This is a feature found in other programs (After Effects and Toon Boom Animate) that allows you to link objects to each other by dragging layers to other layers to create a hierarchal relationship between them. This means that if I have a symbol of a hand on Layer 1 and a symbol of a forearm on Layer 2, I can drag the hand layer to the arm layer and they will become linked together in a parent/child relationship. On the stage, if I tween the arm, the hand will follow – and most importantly on an arc.

Convert a range of frames and layers to a symbol

Wouldn't it be great to have a button on the Timeline that when pressed, turns on those brackets (same as the Onionskin and Edit Multiple Frames brackets) that would allow us to select a range of frames across all layers to be converted to a Graphic or Movie Clip symbol?

Naming and organizing color swatches

A feature found in other animation programs that allows you to name and organize color swatches.

After Effects-style timeline

When working in the Motion Editor I feel slightly disconnected from what is happening on the stage – and as an artist I would rather have my fingers in the actual clay as opposed to using a tool to manipulate a tool to manipulate the clay itself. The Motion Editor panel demands a lot of screen real estate and unless you have a second monitor it is very cumbersome to use.

A single tween model

As of CS4, the introduction of a new tween model has been quite confusing for most newcomers to Flash. I get asked frequently what the difference is between the two tween models and when to use one tween type over the other. Fact is, the new Motion tween is object-based while the old tween (now called Classic tween)

is frame-based. To the seasoned veteran Flash user, both tweens have their distinct purpose. But to the user just launching Flash for the first time, it is not obvious as to what the differences are between the two tween models. I would love to see a single tween model that shares all the features of both tweens.

Filters and Blend Mode support for Graphic symbols

Animators demand frame-accurate sequences, which is why Graphic symbols are favored over Movie Clips. As a result, animators seldom take advantage of the many filters and blend modes offered only for Move Clip objects. I would love to see these features carried over to Graphic symbols someday.

An improved QuickTime Exporter

The new QuickTime Exporter compiles an SWF in the background and then tries to render each frame to video format. Frame accuracy is not always as reliable as we need it to be. The work around is to export a SWF or PNG sequence, import that into Premiere Pro or After Effects and then export a Quicktime movie. I would love to see a true frame accurate QuickTime Exporter in Flash. It has been reported that using a Flash document frame rate of 29.97fps will help eliminate dropped frames.

Layer properties

I would love the ability to adjust the alpha transparency of an entire layer (and all the contents on that layer) across all frames and keyframes. Add to that the ability to apply blend modes to layers and also merge layers together.

Graphic symbol management tools

Flash animators rely on the nesting of assets, especially animations within animations etc. Managing these graphic symbols can be blind work because the Flash Properties panel provides limited information as to the symbol's nested content. It would be very valuable to scrub and see a thumbnail preview of the nested frames of a graphic symbol and then have the ability to display the desired frame on the parent timeline using the Properties panel.

There will always be features we will want to see added to or improved in future versions of Flash, which is why Adobe offers us our own wishing well:

adobe.com/cfusion/mmform/index.cfm?name=wishform

Feel free to drop in a coin or two and make your voice heard. The best part is, Adobe is listening.

The above image shows a video sequence composited with Flash animation for a popular children's television program. The bottom image shows an animation in the FLV format, seamlessly integrated into a website.

Working with video

FLASH VIDEO HAS REVOLUTIONIZED online video. Since its inception, the FLV format has grown exponentially as the favored medium for delivering video content. Google Video, YouTube, AOL, Yahoo! Video and MySpace are just some of the websites that have adopted Flash as their method of video deployment. Not to say other media players such as QuickTime, Windows Media and Real Player are "dead" by any means. But in comparison, it's as if they stood silently by as Flash boarded the Internet video bus and drove away.

This chapter features two separate client projects that show how video was used with Flash in different ways to achieve two very different goals.

9 Working with video

Importing video (pre-CS4)

BETWEEN THE LIONS is a popular children's education television series designed to foster the literacy skills of its viewers, while playfully demonstrating the joys of reading. Teaching is done through the use of catchy songs and, often, animated shorts. This particular segment combines live action puppet characters, music and animation.

The main characters were videotaped against a blue screen. The idea is to replace the blue screen with animation. It was our job to create the animated sequences while maintaining sync with the provided video and ultimately deliver the final product suitable for high quality broadcast television.

Between the Lions is produced by WGBH Boston, Sirius Thinking, Ltd. and Mississippi Public Broadcasting. BTL ®, TM and characters WGBH Educational Foundation, © 2007 WGBH & Sirius Thinking. Animation production by Pileated Pictures.

Between the Lions ®

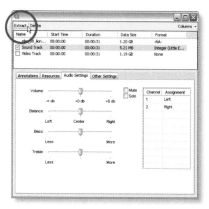

1 The purpose of the blue screen is to provide an evenly lit, monochromatic field of color that can be easily keyed out using a video editor and replaced with a different image or video. Open the video in QuickTime and go to Window > Show Movie Properties and extract the audio track as a WAV file. Import this into Flash on its own layer and set it to Stream to sync with the animation.

3 Once the wizard has finished importing the video, insert enough frames on the main Timeline to accommodate its length.

4 Import the audio track you extracted in QuickTime earlier and place it on its own layer. Set its behavior to Stream.

7 The script called for the live action puppet to react to an animated character falling from the sky. Having the video in a Graphic symbol embedded into the main Timeline made it easy to sync the animation with the puppet's reaction.

8 Once the animation is complete it's time to export it to video format. But you don't want the embedded video to be included. Convert this layer to a guide layer so it will not be included in the exported file. You could also delete this layer.

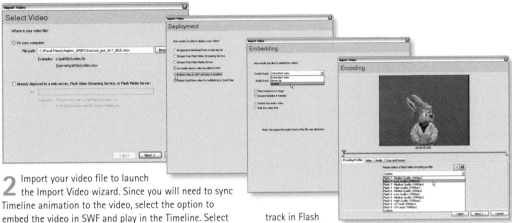

2 Import your video file to launch the Import Video wizard. Since you will need to sync Timeline animation to the video, select the option to embed the video in SWF and play in the Timeline. Select Graphic as the Symbol type to embed the video and then finally choose an encoding profile. Since this video track is for reference only, select a low quality profile. The video

track in Flash will be deleted before exporting the animation and added later in After Effects using the original uncompressed video file.

HOT TIP

To help keep your Flash file size as small as possible, reduce the width and height of the video before importing it. For this project the video was only used in Flash as a timing reference and its quality was not a priority. When selecting an encoding setting, a lower quality will be less processor intensive during playback in the Flash authoring environment. This will make it easier for you to get a sense of timing without having to export to video format every time you want to check your work.

5 Since the video was converted to a Graphic symbol during the import process, you can transform it over time with Motion tweens.

6 The video is Motion tweened smaller to make room for the animation sequences. Don't worry about how the blue screen looks at this stage, it's only used as a reference.

9 The exported animation from Flash is composited with the high quality video of the live action puppet in Adobe After Effects. The blue screen is replaced with an alpha channel so the animation can be seen through it. Syncing both the video and animation sequences back together is

easy since they both share the same frame rate (29.97 fps) and start on frame 1. As video files, all you need to do is place them both on the After Effects Timeline on the same starting frame. A drop shadow was applied to the live action puppet as a final touch.

Importing video

ADOBE® MEDIA ENCODER CS5
Version 5.0.0.402 (64-bit)
Copyright © 2002–2010 Adobe Systems Incorporated and its
Licensors. All Rights Reserved.
See the Legal Notices in the About Dialog.

Loading ImporterMPEG.bundle

FLASH CS4 and CS5 no longer support the direct importing of QuickTime MOV files. You must convert the file to an FLV or F4V using the Adobe Media Encoder that comes bundled with Adobe Flash Professional CS5. The reason animators may need to import a MOV file into Flash is because this is the file format in which a storyboard or animatic may be given to them. Other uses may be to rotoscope over video. A recent client asked me for a very realistic flag waving effect and I knew Motion or Shape tweens were not going to suffice. So I shot my own video of a flag waving in the breeze using a consumer level video camera. Once converted to a format Flash CS5 will support, I was able to import the video footage directly to the Timeline and use it as my animation reference.

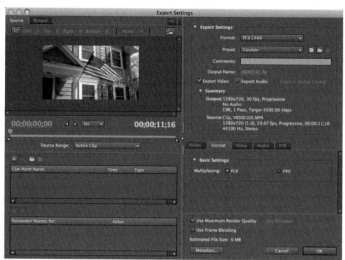

1 Launch the Adobe Media Encoder application and then click the "Add..." button and navigate to the video file on your hard drive. The Export Settings window pictured above will open and present you with a variety of options as to how you want to encode your video file. You can also add multiple files and batch encode them all in one fell swoop. Here I have added my flag video, deselected the Export Audio option and selected the FLV format. You have the option to select a shorter range of video from your source file.

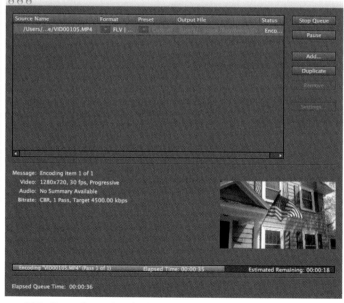

4 With all encoding options in place all that is left to do is click the Start Queue button in the upper right corner of the encoding window. Encoding information is displayed alongside a thumbnail of the video and progress meter.

2 Click the Video tab to access the codec settings. Here you can encode an alpha channel (if present), resize the video and adjust the frame rate if desired. Here I have unchecked the Resize Video option and checked the Render at Maximum Depth option.

3 Bitrate by definition is the average number of bits of video or audio that is transferred in a span of 1 second. Since this video is being used as reference only, the bitrate is not critical. I prefer to set the quality relatively high and continue on to the next step.

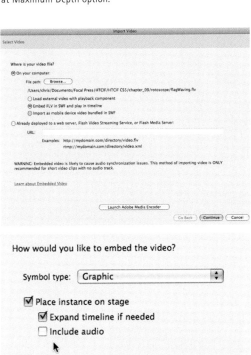

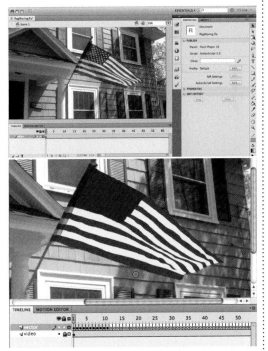

HOT TIP

Difficult effects can be easier to animate when you have a good reference to work from. Having a way to shoot live action video can be a great way to start the creative process. The process of animating by tracing over each frame of video footage is known as Rotoscoping.

5 Go to File > Import and select your encoded video file. In the Import Video screen select "Embed FLV in SWF and play in timeline" option. Click "Continue" and then select Graphic as the symbol type and make sure "Place instance on stage" and "Expand timeline if needed" are selected.

6 Flash will place the video in a Graphic symbol on the Timeline and expand the Timeline to accommodate its length. Create a new layer and start tracing each frame of video using your drawing tool(s) of choice.

Flash Video (FLV)

FLASH MAKES IT EASY to add video into your project. The best part is that video can be treated like an object in Flash, allowing you to layer it, add ActionScript and even animate it. Depending on your project needs, video can be imported into the Flash Timeline or kept external of the SWF and progressively downloaded.

Due to the ubiquity of the Flash Player, the client was confident integrating Flash video into their website while providing their audience with an engaging online experience.

1 Let me explain why Flash video was used for this project in the first place. The client's logo incorporates a photograph of a rubber band. The concept is to animate the rubber band flipping and catching the "Cone" logo in a *rubber band-like* way. It is rare that I ever need to leave the Flash toolset, but in this situation, Flash simply doesn't offer the essential tools to manipulate

a photograph in such a way. I turned to Anime Studio Pro (e-frontier.com) because of its *Bones* and *Image Warp* features, perfect for this style of animation. I was able to manipulate the rubber band image over time by assigning an IK (Inverse Kinematics) chain to it. Anime Studio also supports native Motion blur effects as seen above. The animation was then exported to QuickTime.

4 The Export Settings window provides support for adding Cue Points and Parameters. Click on the Video tab and choose your video settings. You can encode an alpha channel, resize the video, adjust the frame rate and set the key frame distance.

5 The Video Encoder allows you to Crop and Resize the video before exporting. Try cropping the video as much as possible to keep the file size down. Preview the animation using the frame indicator to ensure nothing will be inadvertently cropped.

8 With the FLV Component on the stage, you can position it based on any other design elements you wish to include. Here a simple graphic was added on a layer above to hide the top edge of the FLV. Content was also added with simple text fields. When compiled, the FLVPlayback component will load and play the external FLV during runtime in the Flash Player. You can control when the FLV starts by moving the component to a later or earlier frame in the Timeline.

The FLV progressively downloads, which simulates streaming. Depending on its size, playback starts within seconds of loading.

2 File size is always a concern when dealing with video files. Since this is only a site introduction, loading the animation quickly is priority. The QuickTime file is over six megabytes, an unacceptable size given it's only seven seconds long. Launch the Flash Video Encoder and add your video file. Then click on Settings to launch the Flash Video Encoding Settings window.

3 Using the encoding presets drop-down menu, select an encoding profile that best suits your image quality, file size requirements and Flash Player version.

6 Open Flash and go to Window > Components to open the Components panel and drag the FLVPlayback component to the stage. In the Component Inspector you can specify the path to your FLV file.

7 The intro animation is designed to fit in seamlessly with the rest of the page. Therefore the controller skin is removed completely using the Component Inspector.

9 Once your Flash document is published to the Web, visitors to the website are introduced with a Flash Video animation that they, without any inside information, assume is an animation made entirely with Flash. There is no indication that an FLV is being progressively downloaded, especially when combined with actual vector graphics. The resulting file size of the FLV is under 200k, very acceptable for Web animation.

Taking advantage of the FLV format can be very useful if you have very long animations that are very processor intensive as when played back in the Flash Player. Export your movie to the FLV format and progressively download it instead.

295

FLV tools and articles

THE UBIQUITY OF THE FLASH PLAYER is the reason why most of the Web surfing public can view Flash video without downloading additional plug-ins. This is the main reason why Flash video has grown so rapidly in recent years; the player had already penetrated the market as the most downloaded plug-in in the history of the Internet. Now that the FLV format has reached overwhelming popularity, various tools have sprouted that cater to this platform.

Wimpy is a free FLV player available from wimpyplayer.com. It is cross platform (Mac and PC) compatible, allowing you to watch your FLV and SWF files on your local drive.

An alternative free FLV player is available from Martijn de Visser and can be downloaded from his website martijndevisser.com. Keep in mind, Martijn's player is still in beta and he admits it may have some rough edges. Martijn offers the source files if you have an inkling to improve upon what he has already started.

The Flash Video Encoder lets you encode video files in either the On2 VP6 or Sorenson Spark video codecs. The Adobe Media Encoder CS5 is a stand-alone product that comes with Flash CS5. You can install it separately from Flash or other Adobe Creative Suite programs. The most useful feature is the ability to batch-process multiple video clips.

You may find that Adobe Bridge fulfills your needs when it comes to previewing and managing your FLV files. With Bridge, you can easily organize FLV files and folders, preview their contents and display their metadata.

There's more to the FLV format than what this chapter offers. I recommend visiting Adobe's Flash Developer Center, where you'll find a number of in-depth articles, tutorials and example files that will broaden your own Flash video horizons.

Flash Developer Center

http://www.adobe.com/devnet/flash/video.html

Encoding Flash Video

http://www.adobe.com/designcenter/dialogbox/encode_video.html

Selecting a Flash 8 video encoder

http://www.adobe.com/devnet/flash/articles/selecting_video_encoder.html

Handling cue points for audio files in ActionScript 2.0 and ActionScript 3.0

http://www.adobe.com/devnet/actionscript/articles/cue_points_audio.html

Controlling Flash Video with FLVPlayback programming

http://www.adobe.com/devnet/flash/articles/flvplayback_programming.html

Examining the ActionScript 3.0 Flash video gallery source files

http://www.adobe.com/devnet/flash/articles/video_gallery.html

Using the Adobe Flash CS3 Video Encoder

http://www.adobe.com/devnet/flash/quickstart/video_encoder/

Wimpy FLV Player (free)

http://www.wimpyplayer.com/products/wimpy_standalone_flv_player.html

Martjin de Visser FLV Player (free)

http://flv-player.us/index_mdv.php

■ Flash really comes to life when animation is combined with ActionScript for a truly interactive experience. The possibilities are endless when it comes to what can be achieved when design, animation and code overlap.

10 Interactivity

FRIEND AND COLLEAGUE DAVID STILLER is the contributing author of this chapter as his coding skills are far beyond mine. David developed some great examples that contributed to the success of this book and I am forever grateful for his friendship and talents. For this edition I decided to take a risk by going outside of my comfort zone and adding some of my own ActionScript examples. The risky part is that I am not a coder. My programming knowledge is as vast as my talent for building rockets, but with the right resources I have managed to learn enough ActionScript to get the job done.

The first couple of examples are real world projects where I use ActionScript in lieu of timeline animation for practical reasons. As a game designer it is often better to program motion than to use lengthy motion tweens or numerous keyframes and the following examples will demonstrate why.

Rotate Continuously

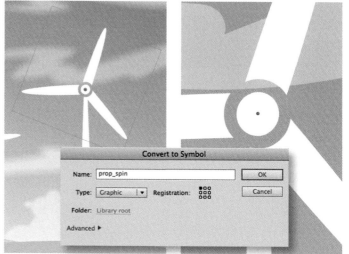

1 Let's first look at creating the animation using basic timeline methods. The propeller graphic is first converted to a Graphic symbol.

2 The critical part is making sure the propeller rotates at its center point. Using the Free Transform tool **Q** select the propeller symbol and verify that the white dot representing the symbol's center point is in the center of the propeller's axle. You can manually rotate the symbol to make sure it doesn't wobble.

HERE'S A SIMPLE EXAMPLE where I compare frame-based animation to animation controlled with ActionScript. Most often developers prefer to build Flash games at very high frame rates such as 60fps to create very smooth animation and to execute ActionScript faster. With high frame rates come longer timeline animations to accommodate the large number of frames per second. These long timelines can often become unmanageable and create larger file sizes - especially when using Motion tweens.

5 The speed of the symbol rotation is directly related to the number of rotations specified in the Properties panel and the length of the motion tween span. To adjust the speed of the rotation, click and drag the right edge of the tween span further down the timeline. The longer the tween span the slower the rotation animation will be. A shorter tween span will result in a faster animation.

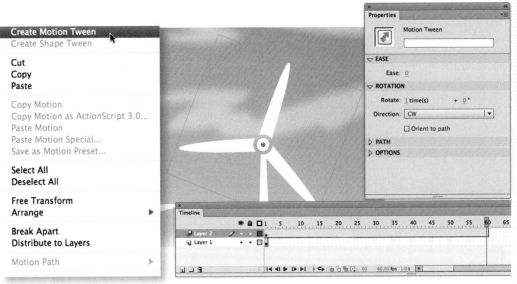

3 Right-Click over the symbol and select Create Motion Tween from the pop-up menu.

4 Flash will create a motion tween span a full second in length based on the document's frame rate. Select the tween span and in the Properties panel locate and expand the Rotation category. In the Rotate: 0 time(s) field enter a value of "1" to rotate the symbol a single full turn when the timeline is played.

Using ActionScript

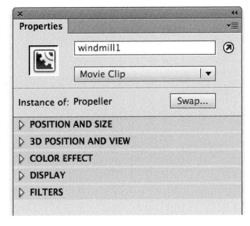

6 The alternative way to animate the windmill roatation is to use ActionScript. The Code Snippets panel will provide the code for you but first, convert the propeller symbol to Movie Clip behavior using the Properties panel. With the Movie Clip selected on stage, type in an instance name in the Properties panel. Here I typed in the name "windmill1". Open the Code Snippets panel by choosing Window > Code Snippets and expand the Animation folder. Locate the Rotate Continuously snippet and double-click it.

Continued...

Rotate Continuously (cont.)

```
/* Rotate Continuously
Rotates symbol instance continuously by updating its rotation property within an
ENTER_FRAME event.

Instructions:
1. The default rotation of the code as written is clock-wise.
2. To change the direction of the rotation to counter clock-wise, change '+=' to
'-=' below.
3. The '+=' operator is a shortcut to typing 'windmill.rotation = windmill.rotation
+ 10'.
4. To change the speed at which the symbol instance rotates, change the number 10
below to the number of degrees you want to rotate the symbol instance each frame.
Higher numbers cause faster rotation.
5. Because the animation uses an ENTER_FRAME event, it progresses only when the
playhead moves to a new frame, and the speed of the animation is also affected by
the frame rate of the FLA file.
*/

windmill1.addEventListener(Event.ENTER_FRAME, fl_RotateContinuously);

function fl_RotateContinuously(event:Event)
{
    windmill1.rotation += 1;
}
```

7 When you double-click a Code Snippet, Flash will automatically launch the Actions panel with all the required code to execute the respective action. To be even more helpful, Flash includes helpful comments that explain what each part of the code does and how it can be edited to suit your needs. Using the instance name of the Movie Clip, the EventListener is applied on line 13. An Event Listener is the way a Document Object Model (DOM) listens for an event to be triggered. The code on line 15 is the function that is called to animate the Movie Clip. Line 17 controls the rotation direction and speed. By default the rotation is clockwise, represented by the "+". If you want the Movie Clip to rotate counter-clockwise edit the "+" to "-". The number 1 is the speed of the rotation. Edit this value to change how fast the Movie Clip rotates. A higher value will rotate the symbol faster while a lower value will decrease its speed.

9 Each new symbol instance needs to have its own unique instance name for the code to work. Select each windmill symbol individually and edit the instance name in the Properties panel. Here I have kept the naming convention consistent by keeping the name "windmill" and changing the number at the end. My duplicated movie clip symbols can now be targeted with ActionScript using the instance names "windmill2" and "windmill3".

8 In some situations you may find the need to have multiple Movie Clips rotate within the same document. Here I have duplicated the windmill symbol to create 3 windmills for the scene. I scaled them to create the illusion of perspective and depth.

```
13    windmill1.addEventListener(Event.ENTER_FRAME, fl_RotateContinuously);
14    windmill2.addEventListener(Event.ENTER_FRAME, fl_RotateContinuously);
15    windmill3.addEventListener(Event.ENTER_FRAME, fl_RotateContinuously);
16
17    function fl_RotateContinuously(event:Event)
18    {
19        windmill1.rotation += 1;
20        windmill2.rotation += 1;
21        windmill3.rotation += 1;
22    }
```

10 Edit the ActionScript directly within the Actions panel (choose Window > Actions) to accommodate the additional symbols we want to animate. Copy and paste the first line of code twice to create a total of 3 Event Listeners. Edit lines 14 and 15 by changing "windmill1" to "windmill2" and "windmill3" respectively. Copy and paste the function line also to add a total of three functions and then change "windmill1" to "windmill2" and "windmill3". Test your movie and you will see all three windmills rotating. Now that you have three different Event Listeners and functions controlling each Movie Clip symbol, you can edit the code to control the speed and direction of each windmill as well.

HOT TIP

When learning ActionScript via the Code Snippets panel, don't be afraid to edit part of the code, test your movie and watch what happens based on your changes. Sometimes you will make animations play in reverse, play slower or faster and in some cases break the code completely. Playing with the ActionScript is all part of the learning process. You can always return to the Flash document and undo your changes and experiment more.

Endless Looping

MANY GAMES INCLUDE SCENES that introduce the setting and mood of the gameplay. In some cases these scenes have elements such as clouds or fog that slowly move across the screen for atmospheric effect. Moving graphics slowly requires long motion tweens. A higher frame rate requires longer motion tweens which creates larger file sizes. Using ActionScript to animate scrolling objects has its advantages over frame-based methods. It is easier to control the speed of the scripted animation and the file size will be much smaller when compared to tweened animation. It is also easier to loop the object seamlessly and endlessly with ActionScript. This example will show you how to use the Code Snippets panel to dynamically move fog across a background and then I'll show you how to edit that code to make the fog loop endlessly.

Credit goes to friend and talented illustrator Shayne Bingham and the Game Show Network for use of the artwork featured in this example.

1 The scene has fog slowly drifting across the mountain landscape so the first task at hand is draw the fog. Using the Brush **B** tool and the color white, loosely draw cloud-like formations to resemble fog. Here I started with white with the alpha set to a value of 18% to make it very transparent. With the basic fog shape finished I then adjusted the alpha value to 58% and drew more cloud-like shapes within the previous shape I had drawn. The final touch was more cloud shapes drawn with 100% white to achieve the fog shown above. I also extended the fog well beyond the canvas. The entire fog artwork was selected and converted to a Movie Clip symbol.

4 The fog was now pretty convincing but a bit too opaque. I really wanted the fog to be subtle, so I adjusted the alpha using the slider in the Color Effect section. I set the value at 36% which is just enough to see through the fog without it becoming too distracting. I don't want this effect to be too distracting.

2 Select the fog Movie Clip and in the Properties panel type in an instance name "fog". Expand the Filters section and click Add Filter button in the lower left corner and choose Blur filter from the selection menu.

3 By default the blur value will be at 5px which will not be blurry enough. Using the hot text sliders, adjust the value until the fog is blurred to your desired amount. I was happy with a blur value of 36.4px.

HOT TIP

This effect is not limited to fog. Just about anything can be panned across the screen as a background element such as clouds, a bird, a flock of birds or an airplane. I kept the fog animation very subtle as not to be distracting. Be careful not to abuse the power of animation, especially for games that may have a devoted user base. A new player may very well be dazzled by generous amounts of gratuitous animation but may also quickly tire of it if they play the game on a regular basis.

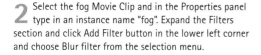

```
1
2   /* Animate Horizontally
3   Moves the symbol instance left or right across the stage by decreasing or increasing
    its x property within an ENTER_FRAME event.
4
5   Instructions:
6   1. The default direction of the animation is to the right.
7   2. To change the direction of the animation to the left, change the number 10 below
    to a negative value.
8   3. To change the speed at which the symbol instance moves, change the number 10 below
    to the number of pixels you want the symbol instance to move in each frame.
9   4. Because the animation uses an ENTER_FRAME event, it progresses only when the
    playhead moves to a new frame. The speed of the animation is also affected by the
    document frame rate.
10  */
11
12  fog.addEventListener(Event.ENTER_FRAME, fl_AnimateHorizontally);
13
14  function fl_AnimateHorizontally(event:Event)
15  {
16      fog.x += 10;
17  }
18
```

5 Open the Code Snippets panel by choosing Window > Code Snippets and expand the Animation folder. With the fog symbol selected locate the Animate Horizontally snippet and double-click it.

6 Flash will create a new layer and insert all the necessary ActionScript to move the Movie Clip containing the fog across the stage. By default the direction of the fog will be from left to right and the speed is at a value of 10. Test the movie. You will see the fog start in its original location on the stage, quickly slide off to the right of the screen and disappear. Obviously we are going to need to edit some of this code to make the effect more realistic.

Continued...

Endless Looping (cont.)

7 To make the fog even wider I duplicated the fog symbol by right-clicking over it and choosing Duplicate Symbol from the selection menu. I then dragged it to the left almost completely out of the viewable area and slightly overlapping the original fog symbol. With the duplicate symbol selected I gave it an instance name of "fog2".

```
fog.addEventListener(Event.ENTER_FRAME, fl_AnimateHorizontally);
fog2.addEventListener(Event.ENTER_FRAME, fl_AnimateHorizontally);

function fl_AnimateHorizontally(event:Event)
{
    fog.x += .3;
    if(fog.x >800) {
    fog.x=-1100;
    trace(fog.x);
}
```

9 Let's slow down the speed of the fog by editing the line of code that says *fog.x += 10;* All we need to do is change the number "10" to a lower value. I want my fog to move very slowly, so I used a value of ".3". The next step is detect when the symbol reaches a certain point off the stage, so we can tell it to return to a different location where it can start moving across the screen again. The code *if(fog.x >800)* { detects if the first fog symbol reaches the x coordinate of 800 (which is off the screen to the right). The next line of code, *fog.x=-1100;* will send the symbol to the x coordinate -1100 which is very far off the screen to the left. The trace(fog.x); is a simple test command that ensures the code is working. It has no functional value other than providing feedback to the developer when the code is being triggered.

```
fog.addEventListener(Event.ENTER_FRAME, fl_AnimateHorizontally);
fog2.addEventListener(Event.ENTER_FRAME, fl_AnimateHorizontally);

function fl_AnimateHorizontally(event:Event)
{
    fog.x += 10;
}
```

8 With 2 instances of the fog on the stage we will need 2 Event Listeners to control them. Copy the first line of code and paste it directly below it to create a new line of code. Edit this new line of code so that the instance name reflects the instance name of the duplicated symbol on the stage. In this case it is "fog2". Now we have Event Listeners for each symbol instance.

```
fog.addEventListener(Event.ENTER_FRAME, fl_AnimateHorizontally);
fog2.addEventListener(Event.ENTER_FRAME, fl_AnimateHorizontally);

function fl_AnimateHorizontally(event:Event)
{
    fog.x += .3;
    if(fog.x >800) {
    fog.x=-1100;
    trace(fog.x);

    fog2.x += .3;
    if(fog2.x >800) {
    fog2.x=-1100;
    trace(fog2.x);
}
}
```

10 Now all we need to do is copy the code from the previous step and paste it. Edit the first line to reflect the instance name of the duplicated symbol from step 7, in this case "fog2". Since the initial position of this duplicate symbol is further off stage to the left, it will always be "behind" the first symbol throughout the animation. Test the movie to watch the scene come alive as the fog slowly drifts across the mountain side in an endless loop.

HOT TIP

The position of both movie clips is based on the upper left corner of each symbol instance. When trying to determine the exact coordinate position of the instances, open the Info panel (Window > Info) and use the arrow keys to nudge the symbol into position. The info panel will prove the exact x and y coordinates that you can then use in your code.

Event handling

Contributed by David Stiller (www.quip.net)

WHEN SOMETHING OCCURS in a Flash movie, the occurrence is called an event. Events can be triggered by something in the Flash Player itself (system events) or by interaction from the person enjoying your content (user events). System events include, for example, the completion of an audio file or the incidence of a Timeline frame. Let's explore that second one for a moment. Think of the playhead in terms of a car. When the playhead moves along the Timeline, like a car driving along the street, it dispatches an "enter frame" event at a rate comparable to the movie's frame rate (by default, 12 frames per second). The event is simply a behind-the-scenes message that states, "Hey, I just entered a frame!" This happens, by the way, even if a *stop()* action tells the Timeline to halt.

If a car arrives at a duck crossing and hits the brakes, its engine continues to idle, after all. At any time, you can program other objects to react to this event. We'll build up to this ourselves in just a bit. First, let's respond to some user events.

When a user clicks one of your buttons, a number of mouse-related events is dispatched in much the same way as above. One event happens when the mouse is pressed, another when the mouse is released and, depending on the version of ActionScript you're using, yet another when the mouse is pressed inside a button symbol but released outside of it. In all of these cases, the event happens whether you respond to it or not. If you do respond, this is called event handling and you need to write a function for it.

1 Let's say you've paused the Timeline at frame 20 with a *stop()* action. From that point forward, you're halting the Timeline every ten frames, because you want to give the user a chance to read something important on each of those keyframes. You have the *stop()* part down, but how do you get the Timeline moving again?

2 Since you're planning to use a button, you'll need to put a button symbol on the stage. Use the Property Inspector to give your button an instance name — that's what allows ActionScript to call out this particular object from all the others and use that instance name to tell the button what to do. In this example the instance name is *myButton*.

ActionScript 3.0

myButton.addEventListener(event, function);

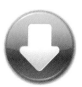

3 In ActionScript 3.0, the main way to associate an event handler function with an event is the *addEventListener()* method. In this case, we're "wiring up" the myButton instance by way of two parameters. The first parameter specifies what event to listen for and the second defines the function to perform.

4 These parameters can be simple, such as the event part *MouseEvent. MOUSE_UP* or fairly complex, such as the complete definition of a function, which might otherwise stand on its own.

5 Putting the pieces into place, these parameters would fit as shown. Use the Actions panel to type the following code into a keyframe at frame 1.

6 You could optionally use a named function, like this. See the difference? In this second approach, you're defining the function as an entity of its own, a custom function arbitrarily named *startTimeline()*, then using that function's name as the second parameter. Notice that it doesn't matter how many lines it takes to code up the *addEventListener()* method. As long as you provide the two parameters it's looking for, you're good.

```
ACTIONS - FRAME
1   myButton.addEventListener(
2       MouseEvent.MOUSE_UP,
3       function(evt:MouseEvent):void {
4           play();
5       }
6   );
```

```
ACTIONS - FRAME
1   function(evt:MouseEvent):void {
2       play();
3   }
```

```
ACTIONS - FRAME
1   myButton.addEventListener(
2       MouseEvent.MOUSE_UP,
3       function(evt:MouseEvent):void {
4           play();
5       }
6   );
```

```
ACTIONS - FRAME
1   function startTimeline(evt:MouseEvent):void {
2       play();
3       );
4   myButton.addEventListener(MouseEvent.MOUSE_UP, startTimeline);
5
```
scripts : 1 scripts : 1
Line 4 of 5, Col 63

Continued...

Event handling (cont.)

7 This ActionScript appears in frame 1 in a layer named "scripts", while the myButton symbol appears in its own layer, but also in frame 1. That's the important part, that they line up vertically; that is, they both appear in frame 1, so that they can "see" each other, otherwise the code and the button can't be associated. They might both appear in frame 2 or frame 10, it doesn't matter — as long as they line up.

ActionScript 2.0

ActionScript 2.0 handles things a bit differently. If you're publishing for Flash Player 8 or earlier, you can't use ActionScript 3.0 (only Flash Player 9 contains AVM2, the virtual machine that understands AS3). If your project specs require Flash Player 8 or back to Flash Player 6, here's a more "old-fashioned" approach to the previous scenario.

8 This time, the pattern is *myButton.onRelease* = function; and here, too, the function can be dictated right in the event handler or defined elsewhere as a named function.

Or...

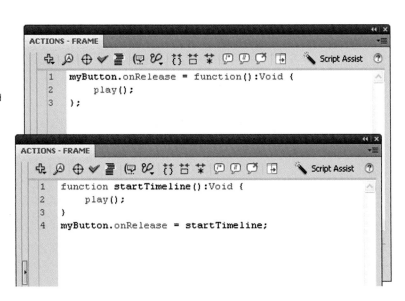

```
myButton.onRelease = function():Void {
    play();
};
```

```
function startTimeline():Void {
    play();
}
myButton.onRelease = startTimeline;
```

9 Let's make sure we're caught up on the nitty-gritty details. In the AS3 version, the event handler function receives a parameter that the AS2 version's function does not, captured here under the arbitrary name *evt*.

What's going on here? In this version of the language, every event carries with it an event object. In this sample, that incoming object isn't actually being used — we're just having the function execute a native *play()* action — but AS3 is pretty strict, so the function needs to at least let that object "in the door" even if it just sits there. The type of object matters, and this is a MouseEvent, so that explains the *:MouseEvent* suffix after evt. Finally, there's that :void business at the end. In AS3, type matters not only for in-coming objects, but also for outgoing objects. This is a function, and functions either return a value or they don't. This function does not — it just

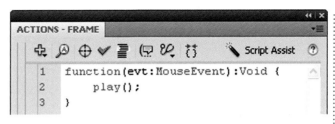

```
1   function(evt:MouseEvent):Void {
2       play();
3   }
```

performs an action, then quits — so the *:void* suffix lets AS3 know not to look for a return value. In the AS2 version, you'll notice the
:void suffix starts with an upper case letter. It's just one of those things. In AS2, all datatype suffixes start that way. In AS3, most do, but a handful don't, and those are all lower case. Yes, it's like learning state capitals back in grade school, but there are only three all-lower case examples: *int* (integers), *uint* (unsigned integers) and *void*.

10 In both AS3 and AS2, neither of these named function approaches (above) uses parentheses after the *startTimeline()* function. What gives? The reason for this omission is that the parentheses actually carry out whatever the function does. By leaving them off in these lines, you're telling ActionScript to carry them out when the event occurs, rather than when the playhead encounters them.

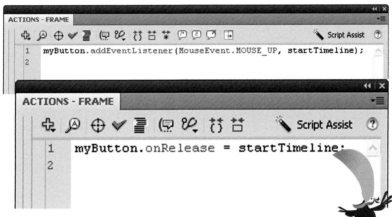

```
1   myButton.addEventListener(MouseEvent.MOUSE_UP, startTimeline);
2
```

```
1   myButton.onRelease = startTimeline;
2
```

11 In the Help files, which open in a browser, look up "on handler" and "onClipEvent handler", then use the "Refine results" area to filter your search for ActionScript 2.0, which covers both AS1 and AS2. To look up the AS2 events for buttons, search "Button class"; for Movie Clips, search "MovieClip class". You'll find even more events to pick from! For ActionScript 3.0, filter the Help books appropriately and look up button events under "SimpleButton" and Movie Clip events under "MovieClip". When you see a hyperlink under the Events heading (Show Inherited Events), click it. Believe it or not, buttons support around 30 events in AS3 – the exact number depends on the version of Flash Player you choose. Bear in mind that each new version of the language gives you greater control. In addition, the AS2 and AS3 approaches allow you to reassign and even cancel event handlers after the movie is compiled. The full list for each of these can be found in the built-in documentation and in the live docs:
http://help.adobe.com/en_US/AS3LCR/Flash_10.0/flash/display/MovieClip.html

What a drag

T HE *startDrag()* METHOD accepts a number of optional parameters that allow you to constrain the drag, that is to box it in to specified dimensions and it's really easy to do.

ActionScript 3.0

```
1   smileyFace.buttonMode = true;
2   smileyFace.addEventListener(
3       MouseEvent.MOUSE_DOWN,
4       function(evt:MouseEvent):void {
5           smileyFace.startDrag();
6       }
7   );
8   smileyFace.addEventListener(
9       MouseEvent.MOUSE_UP,
10      function(evt:MouseEvent):void {
11          smileyFace.stopDrag();
12      }
13  );
```

1 In this example, we're using a Movie Clip symbol, because the MovieClip class supports *startDrag()* and *stopDrag()* methods. The Movie Clip has the instance name *smileyFace*. This code goes in a keyframe where that Movie Clip starts. Two event handlers, this time. The *MouseEvent. MOUSE_DOWN* event occurs when the user clicks the mouse over the Movie Clip and triggers a function that initiates the *startDrag()* method. The *MouseEvent.MOUSE_UP* event occurs when the user lets go of the mouse over the Movie Clip. It triggers a function that initiates *stopDrag()*. The very first line makes the finger cursor show when the mouse moves over the Movie Clip. Unlike buttons, Movie Clips in AS3 don't show the finger cursor by default, even if you're handling mouse-related events. Note that the functions mention the *smileyFace* instance by name. This is a difference from how things worked in AS2.

ActionScript 2.0

```
1   smileyFace.onPress = function():Void {
2       this.startDrag();
3   };
4   smileyFace.onRelease = function():Void {
5       this.stopDrag();
6   };
```

2 Here's the AS2 version. This code goes in a keyframe where the movie clip starts. Note the absence of any sort of *buttonMode* reference. In AS2, buttons and movie clips alike display the finger cursor when mouse-related events are being handled. If you want to turn the finger cursor off, precede the code below with a single line: *smileyFace.useHandCursor = false;*. Even more important is the presence of the global *this* property. In AS2, the lines of code inside the function actually see that function as their "point of view". Because the function is associated with the *smileyFace* instance, the term *this* ultimately refers to *smileyFace* in this context.

Constrained drag and drop

ActionScript 3.0

1 Because AS3 has no "release outside" event, you can use a "mouse up" event for the Stage itself. If the movie itself is listening for the mouse to lift, it doesn't matter where the event occurs, even if the mouse lifts outside the button or Movie Clip it started in. The trick is to only handle this event when you need it. You might, after all, want to listen for stage-wide "mouse up" events for other reasons, so we'll only commandeer this event while the mouse is pressed for the drag. We'll give the event back after the release. To do this, use the named function approach.

```
ACTIONS - FRAME                                                    Script Assist
 1   function startDragHandler(evt:MouseEvent):void {
 2       smileyFace.startDrag(false, new Rectangle(50, 50, 250, 100));
 3       stage.addEventListener(MouseEvent.MOUSE_UP, stopDragHandler);
 4   }
 5   function stopDragHandler(evt:MouseEvent):void {
 6       smileyFace.stopDrag();
 7       stage.removeEventListener(MouseEvent.MOUSE_UP, stopDragHandler);
 8   }
 9   smileyFace.buttonMode = true;
10   smileyFace.addEventListener(MouseEvent.MOUSE_DOWN, startDragHandler);

 scripts : 1
Line 10 of 10, Col 70
```

ActionScript 2.0

2 Thanks to the *onReleaseOutside* event, things are much easier in AS2. Notice that AS2's version of the *startDrag()* method accepts five parameters instead of two. The last four correspond more or less to the Rectangle object in AS3's version, except these are actual coordinates rather than a starting point plus a width and height.

In the last line, the *onReleaseOutside* event is set to the same thing as the onRelease event, so the mouse will stop dragging whether or not it's inside the movie clip when the user lets go.

```
ACTIONS - FRAME                                                    Script Assist
 1   smileyFace.onPress = function():Void {
 2       this.startDrag(false, 50, 50, 300, 150);
 3   };
 4   smileyFace.onRelease = function():Void {
 5       this.stopDrag();
 6   };
 7   smileyFace.onReleaseOutside = smileyFace.onRelease;
 8

 scripts : 1
Line 8 of 8, Col 1
```

HOT TIP

In AS3, drag methods originate with the Sprite class, and Movie Clips inherit some of their functionality from Sprite. Buttons do not inherit from Sprite, which means they don't have access to these drag-related methods. That explains why we're using a Movie Clip in this example.

```
// ActionScript 1.0 and 2.0
someMovieClipInstance.startDrag
(lockCenter, left, top, right, bottom);
// ActionScript 3.0
someMovieClipInstance.startDrag
(lockCenter, {x, y, width, height});
```
The first parameter isn't so much about constraint as it is where the mouse stays during the drag. By default, the lockCenter parameter is false, which means dragging occurs from wherever the mouse first clicked the Movie Clip. If you set this parameter to true, dragging occurs from the Movie Clip's registration point.

The rest of the parameters are numbers, based on the parent Timeline of the Movie Clip. The way these numbers are provided depends on the version of ActionScript. An interesting thing happens with constrained dragging: if the mouse goes outside the bounds of the constraint, it might actually end up outside the Movie Clip when the user lets go. When that happens, the "release" event doesn't apply, because a bona fide release hasn't occurred. Instead, a "release outside" has. In AS1 and AS2, there is an event tailor made for this circumstance. In AS3, it takes a bit more effort.

313

Pausing the Timeline

ActionScript 3.0

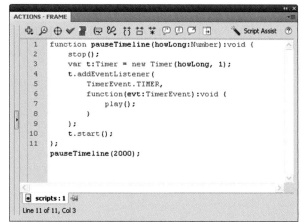

```
ACTIONS - FRAME

1   function pauseTimeline(howLong:Number):void {
2       stop();
3       var t:Timer = new Timer(howLong, 1);
4       t.addEventListener(
5           TimerEvent.TIMER,
6           function(evt:TimerEvent):void {
7               play();
8           }
9       );
10      t.start();
11  );
    pauseTimeline(2000);

scripts : 1
Line 11 of 11, Col 3
```

SOONER OR LATER you're going to want to pause the Timeline for a few seconds or even a few minutes, then resume the action after the viewer has had the chance to read something important or cast a lengthy gaze at your artwork. Flash banner advertisements are commonplace throughout the Web and the ability to pause the playhead to help emphasize a specific advertisement message can be critical to the success of the ad itself.

The obvious way to handle this is to add extra frames where you want the pausing to occur. Depending on the length of the pause, though, that can make for an unwieldy Timeline, especially if you have a high frame rate (five seconds at 30 fps is 150 frames of "dead space"). What if you could pull that off with a single frame?

1 This pause mechanism comes in two parts. If you only need to pause once, put both parts in the same frame; otherwise, put the function in frame 1, then call that function in later frames as needed. This is like an "everything" burrito. Everything you need is stuffed into this custom function. The first thing it does is stop the Timeline. Next, it declares a variable, *t*, and sets it to an instance of the *Timer* class. The two parameters, *howLong* and *1*, tell Flash how long to wait before the timer completes and how often to run the timer, respectively. Once the Timer variable is in place, things start looking familiar again: a *TimerEvent.TIMER* event is added to the *t* instance and told to perform a function that causes the Timeline to play again. Finally, the timer is started.

Once the function is in place, call it by name from the same frame or any subsequent frame. The value 2000 refers to 2000 milliseconds (that is, two seconds).

```
ACTIONS - FRAME

1   pauseTimeline(2000);
```

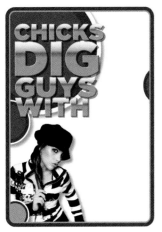
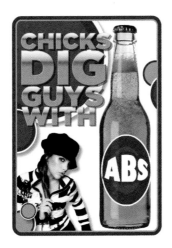
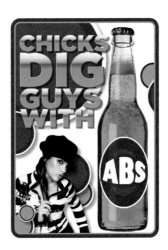

ActionScript 2.0

```
ACTIONS - FRAME
1    function pauseTimeline(howLong:Number):Void {
2        stop();
3        var id:Number = setInterval(
4            function():Void {
5                play();
6                clearInterval(id);
7            },
8            howLong
9        );
10   };
11
```

2 The AS2 version relies on the *setInterval()* function, which repeatedly triggers whatever other function you tell it to, as provided in its first parameter. The second parameter here, *howLong* defines when the triggering should occur, in milliseconds. A companion function, *clearInterval()*, stops the repeated triggering after a single run. How? Earlier, *setInterval()* returns a Number value that gets stored in the id variable, then *clearInterval()* references that number by way of id as its own parameter.

Here, again, you've got two parts. Put the first in frame 1. Then call it in that same frame or any later frame(s). Calling the function is the same as in the AS3 version.

```
ACTIONS - FRAME
1    pauseTimeline(3000);
```

Loading images (AS3)

1 The simplest way to load an image is to use the Loader class. Three short lines will do it. The variable photo is set to an instance of Loader. The *Loader.load()* method is invoked on the photo instance, with a *URLRequest* instance provided as the parameter. If you wanted to, you could certainly create a separate variable just for the *URLRequest* instance and pass in that instead, but it's shorter to drop the new *URLRequest()* expression inside the parentheses

```
1  var photo:Loader = new Loader();
2  photo.load(new URLRequest("dolphin.jpg"));
3  holder.addChild(photo);
```

of the *load()* method. The quoted string is the name (and path, if needed) of a JPG file. Finally, invoke the *addChild()* method and pass it the photo instance in order to actually display the loaded image. Without that third line, the image will load, but you'd never see it.

FLASH IS CAPABLE OF loading quite a few file formats at runtime, including audio (MP3), motion graphics (FLV and SWF), and images (JPG, GIF and PNG). When you load such files with ActionScript, you're doing your visitors a favor: not only does this practice reduce the file size of the main SWF; it also gives users the chance to decide which files they want to see. Why make them download it if they're not interested, right? With dynamic loading, everyone wins. Let's look at a JPG example using ActionScript 3.0.

3 If you want to change the scale of the imported image, or manipulate it in any other way, you'll have to wait until it's fully loaded before you do. An event handler makes this easy.

Handling Loader class event handlers is a bit different from previous examples in this chapter. Instead of applying *addEventListener()* directly to the Loader instance, you have to apply it, instead, to the *contentLoaderInfo* property of that instance. After that, it's business as usual. Here we're listening for an *Event.COMPLETE* event and adjusting the

```
1  var photo:Loader = new Loader();
2  photo.load(new URLRequest("dolphin.jpg"));
3  holder.addChild(photo);
4
5  photo.contentLoaderInfo.addEventListener(
6     Event.COMPLETE,
7     function(evt:Event):void {
8        holder.scaleX = 0.45;
9        holder.scaleY = 0.45;
10    }
11 );
```

scripts : 1
Line 11 of 11, Col 3

scaleX and *scaleY* properties of the holder Movie Clip to 45%. Again, this only works because the adjustment occurs after the image has loaded.

5 Create a third layer, name it scripts, and type the following ActionScript (top, right). Pretty familiar, huh? This line is identical to the corresponding line from the Loader example. The UILoader Component makes things a bit easier for you in that it turns the earlier three lines into one line of code.

At this point, you're set, but you'll probably want the progress bar to disappear after its work is done. You can take care of this with an event handler (bottom, right).

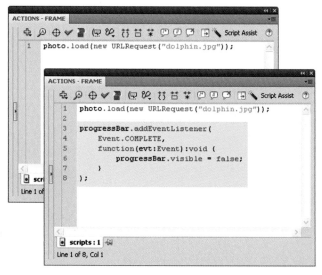

```
1  photo.load(new URLRequest("dolphin.jpg"));
```

```
1  photo.load(new URLRequest("dolphin.jpg"));
2
3  progressBar.addEventListener(
4     Event.COMPLETE,
5     function(evt:Event):void {
6        progressBar.visible = false;
7     }
8  );
```

scripts : 1
Line 1 of 8, Col 1

2 The *addChild()* line happens to give you some leeway. For example, create an empty Movie Clip and drag an instance of it to the Stage. Position it at 50 pixels in and 50 pixels down from the upper-left corner of the movie. Give this Movie Clip the instance name *holder*, and change that last line to *holder. addChild(photo)*. This time, the image loads into the empty Movie Clip, which means you can easily position it where you like.

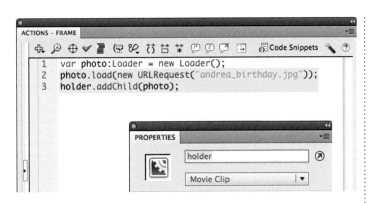

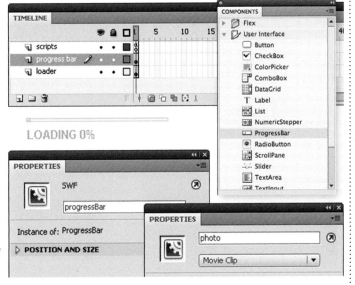

4 If you want to display load progress while an image loads, it's easy to do with the ProgressBar Component. Instead of the Loader class, we'll let the UILoader Component take over loading duties, which means you can also drop the holder Movie Clip. Starting with a new document, drag an instance of the UILoader Component to the stage and give it the instance name *photo*. Create a new layer and drag an instance of the ProgressBar Component to the new layer. Give it the instance name *progressBar*. Select the progressBar instance and flip to the Parameters tab of the Property Inspector. Set the source parameter to photo. This associates the loading mechanism of the UILoader Component instance, photo, with the visual display of the progress bar.

HOT TIP

The Parameters tab makes it easy to configure Components without having to use ActionScript, but if you prefer to code, you can program parameters by referencing the Component's instance name, then a dot, then the parameter in question. For example, step 4 would look like this: progressBar. source = photo.

6 You can test and simulate your movie by going to Control > Test Movie or using Ctrl + Enter on your keyboard. A new window containing your compiled SWF will open. Go to View > Bandwidth Profiler to show a graph of the downloading performance. Go to View > Download Settings to select the bandwidth profile you wish to test with. Once you've made your selection, go to View > Simulate Download to estimate how fast your image will most likely load under these conditions. Keep in mind Flash can only estimate typical Internet performance and not exact modem speeds.

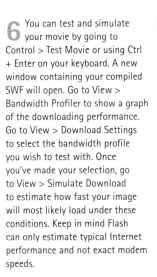
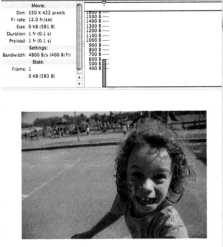
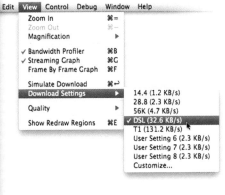

317

Loading images (AS2)

1 AS2 differs significantly in how it loads images. In fact, there's more than one way to do it. The approach that comes closest to the ease of AS3 involves the MovieClipLoader class. In this case, you'll want an empty Movie Clip. Again we'll call it holder, as before, to act as the container for your image which lets you position the JPG as desired. Loading the image isn't especially complicated, but responding when the load is complete ... that's a little more convoluted. Here's the easy part, first.

3 To recognize when the image has loaded, we'll need to program an event listener using an instance of the Object class. This generic object will act as a liaison between the MovieClipLoader instance and its event handler function. In this case, the association is not as direct as it is in the AS3 examples.

```
1  var photo:MovieClipLoader = new MovieClipLoader();
2  photo.loadClip("dolphin.jpg", holder);
3
4  var listener:Object = new Object();
5  listener.onLoadInit = function():Void {
6      holder._xscale = 45;
7      holder._yscale = 45;
8  }
9  photo.addListener(listener);
```

The name of the listener variable isn't important, but it's listening for events, so "listener" makes sense enough. This variable points to an object, and the object is given an onLoadInit property, which is set to a function (the event handler). Why onLoadInit? The MovieClipLoader class provides quite a few events, listed in the ActionScript 2.0 Language Reference, and this is the one that not only states when content is loaded, but allows access to the properties and methods of the loaded content. The function references the holder Movie Clip and sets its _xscale and _yscale properties to 45%. Finally, the MovieClipLoader instance, photo, is associated with the listener object. Note, in AS2, under these circumstances, that method is addListener(), not addEventListener().

2 In this case, photo is an instance of the MovieClipLoader class. The name is a bit misleading, because this class also loads JPGs, GIFs and PNGs, depending on what version of the Flash Player you publish to (see the Help docs for specifics). The MovieClipLoader.loadClip() method is invoked on the photo instance, specifying the file to load and the Movie Clip to load it into.

```
1  var photo:MovieClipLoader = new MovieClipLoader();
2  photo.loadClip("dolphin.jpg", holder);
```

HOT TIP

Properties like alpha and scale belong to different camps, between AS3 and AS2. In ActionScript 3.0, these sorts of properties generally range between 0 and 1, which makes 22% look like 0.22. In ActionScript 2.0, these usually range between 0 and 100.

4 Now that you know about event handling, dragging and dropping, pausing timelines and loading images, try testing yourself by developing a cool little Flash application that incorporates buttons that, when clicked, load external images to create a fun photo gallery. Then try extending this functionality to allow each image to be dragged and dropped around the Flash stage.

Toggling sound (AS3)

WE TOOK A QUICK LOOK at ActionScripted audio in Chapter 8, but that was only an hors d'oeuvre. In that exercise, you loaded sounds from the Library. By loading your audio from external files instead, you can reduce the overall size of your SWF and still have all the programmatic control described earlier. 10 to 1, you'll find that sound is a common part of your day-to-day Flash workflow, so let's explore a bit more.

1 One of the most commonly requested audio features in a Flash movie is a mute button, something that gives the user the option to temporarily pause the audio, or silence it while it keeps playing. We'll build up to that in just a moment, but first, you need some ActionScript that summons an MP3 file. In AS3, that means an instance of the Sound class and the URLRequest class. The first two lines create respective instances of the Sound and URLRequest

```
1  var audio:Sound = new Sound();
2  var req:URLRequest = new URLRequest("Tasty Jazz.mp3");
3  audio.load(req);
4  audio.play();
```

classes and store those objects in variables. As the URLRequest instance is created, note that it receives the name of an MP3 file outside the FLA file. After that, the Sound.load() method is invoked on the *audio* variable, which loads the file, and finally, the Sound.play() method plays the music.

3 Now that the playing sound is associated with a channel, you can invoke the SoundChannel.stop() method on the *channel* variable, like this: In this code, a button symbol has been given the instance name *btnMute*, and its MouseEvent.CLICK handler halts the playing sound.

```
1   var audio:Sound = new Sound();
2   var channel:SoundChannel;
3   var req:URLRequest = new URLRequest("Tasty Jazz.mp3");
4   audio.load(req);
5   channel = audio.play();
6
7   btnMute.addEventListener(
8       MouseEvent.CLICK,
9       function(evt:MouseEvent):void {
10          channel.stop();
11      }
12  );
```

5 If you want to resume the audio, rather than restart it from the beginning, use the SoundChannel. position property to find out how far the audio has played when you halt it, and an optional parameter to the Sound. play() method. Create a new variable to hold this information, such as *offset*.

```
1   var audio:Sound = new Sound();
2   var channel:SoundChannel;
3   var offset:Number = 0;
4   var req:URLRequest = new URLRequest("Tasty Jazz.mp3");
5   audio.load(req);
6   channel = audio.play();
7
8   btnMute.addEventListener(
9       MouseEvent.CLICK,
10      function(evt:MouseEvent):void {
11          offset = channel.position;
12          channel.stop();
13      }
14  );
15  btnRestart.addEventListener(
16      MouseEvent.CLICK,
17      function(evt:MouseEvent):void {
18          channel.stop();
19          channel = audio.play(offset);
20      }
21  );
```

2 That gets the sound rolling, but it doesn't give you the control to make it stop again. For that, you need an additional object: an instance of the SoundChannel class. Note how the instance is created and stored in a variable, just like the other two, but its value (a particular playing sound) is added in the last line of code.

```
ACTIONS - FRAME
1   var audio:Sound = new Sound();
2   var channel:SoundChannel;
3   var req:URLRequest = new URLRequest("Tasty Jazz.mp3");
4   audio.load(req);
5   channel = audio.play();
6
```

4 But that's only half the story, isn't it? To do this right, you'll want the user to be able to turn the sound off, and then back on, at will. You can do that with two buttons or a single button. Let's start with two, because it's easier. To restart halted audio, just re-associate the Sound instance with its SoundChannel instance, as before (this assumes a second button with the instance name *btnRestart*). Note that the restart button stops the audio, just like the mute button, before it restarts the audio. That extra line is there in case the user clicks the restart button first.

```
ACTIONS - FRAME
1   var audio:Sound = new Sound();
2   var channel:SoundChannel;
3   var req:URLRequest = new URLRequest("Tasty Jazz.mp3");
4   audio.load(req);
5   channel = audio.play();
6
7   btnMute.addEventListener(
8       MouseEvent.CLICK,
9       function(evt:MouseEvent):void {
10          channel.stop();
11      }
12  );
13  btnRestart.addEventListener(
14      MouseEvent.CLICK,
15      function(evt:MouseEvent):void {
16          channel.stop();
17          channel = audio.play();
18      }
19  );
```

scripts : 1

Line 19 of 19, Col 3

HOT TIP

Variable names are arbitrary, so what you're seeing here – audio, channel, offset – could just as easily be rock, paper, scissors ... but it's a good idea to name your variables in a descriptive way, so you recognize them for what they are later on.

Toggling sound (cont.)

6 Let's face it, two separate buttons are fine, but a single toggle button is definitely more cool. You can combine the previous MouseEvent.CLICK handlers into a single function when you reduce your pair of buttons to a single symbol. Because button symbols don't have programmable Timelines, you'll have to make this combined symbol a Movie Clip. Frame 1 of this Movie Clip should display whatever graphic makes sense in your case. If audio plays by default, as we've been doing, you'll want the symbol's first frame to show a "mute this audio" graphic, to indicate to the user that clicking the button will stop the audio. If that's your route, then put a "resume this audio" graphic in frame 2 of the same Movie Clip. Make sure to give your Movie Clip an instance name, such as *btnToggle*, invoke the MovieClip. stop() method on it right from the beginning, then update your code as shown in the figure.

Note the addition of a buttonMode setting of true, because this symbol isn't a button symbol. Without that line, the mouse cursor wouldn't become a pointer finger. The trick to this approach is pretty simple. An *if* statement checks the current position of the *btnToggle* symbol's Timeline. If the playhead is on frame 1, it means the "mute this audio" graphic is showing and the audio is already playing. Under that circumstance, the code you've already seen is repeated, and *btnToggle* itself is instructed to display frame 2 of its own

```
ACTIONS - FRAME                                    Script Assist
 1   var audio:Sound = new Sound();
 2   var channel:SoundChannel;
 3   var offset:Number = 0;
 4   var req:URLRequest = new URLRequest("Tasty Jazz.mp3");
 5   audio.load(req);
 6   channel = audio.play();
 7
 8   btnToggle.stop();
 9   btnToggle.buttonMode = true;
10   btnToggle.addEventListener(
11       MouseEvent.CLICK,
12       function(evt:MouseEvent):void {
13           if (btnToggle.currentFrame == 1) {
14               offset = channel.position;
15               channel.stop();
16               btnToggle.gotoAndStop(2);
17           } else {
18               channel = audio.play(offset);
19               btnToggle.gotoAndStop(1);
20           }
21       }
22   );
23
scripts : 1      scripts : 1
Line 25 of 25, Col 41
```

Timeline. Otherwise, the opposite is true, and the function restarts the audio and repositions the symbol's playhead at frame 1. If your audio does not play by default, you'll reverse the ActionScript inside the *if* statement. This code allows the same symbol to perform double duty, by shuttling it back and forth between two frames.

8 Another way to pause and resume audio is simply to update the volume while the audio keeps playing, in which case you're not really pausing at all, but muting. For this, you'll need one more object, an instance of the SoundTransform class. This gets a tad more complicated, but it paves the way for volume adjustment in general, which is the last thing we'll look at. The basic idea is that every SoundChannel instance is associated with a SoundTransform partner. The SoundTransform class features a volume property that controls the volume of the channel it's coupled with. See if you can connect the dots.

This time, a new variable named adjust holds a SoundTransform instance. The MouseEvent.CLICK handler sets the SoundTransform.volume property of the adjust variable, which mutes the audio, and adjust is then associated with the SoundChannel. soundTransform property of the channel variable. The same thing occurs when the button has already been toggled, except the volume property is set to 1 (100%; half volume would be 0.5).

```
ACTIONS - FRAME                                    Script Assist
 1   var audio:Sound = new Sound();
 2   var channel:SoundChannel;
 3   var adjust:SoundTransform = new SoundTransform();
 4   var offset:Number = 0;
 5   var req:URLRequest = new URLRequest("Tasty Jazz.mp3");
 6   audio.load(req);
 7   channel = audio.play();
 8   channel.addEventListener(Event.SOUND_COMPLETE, reset);
 9   function reset(evt:Event):void {
10       channel = audio.play();
11       channel.addEventListener(Event.SOUND_COMPLETE, reset);
12       btnToggle.gotoAndStop(1);
13   };
14
15   btnToggle.stop();
16   btnToggle.buttonMode = true;
17   btnToggle.addEventListener(
18       MouseEvent.CLICK,
19       function(evt:MouseEvent):void {
20           if (btnToggle.currentFrame == 1) {
21               adjust.volume = 0;
22               channel.soundTransform = adjust;
23               btnToggle.gotoAndStop(2);
24           } else {
25               adjust.volume = 1;
26               channel.soundTransform = adjust;
27               btnToggle.gotoAndStop(1);
28           }
29       }
30   );
```

7 When you're using the single button approach, make sure to write an event handler to set the button to its default state when the audio ends! This will be an event handler for a SoundChannel event.

This event handler has to be reassigned every time the SoundChannel instance is re-associated with a playing sound, so you'll find it convenient in this case to use a named function for the Event.SOUND_COMPLETE event –otherwise, you'd have to write out that particular function twice.

```
ACTIONS - FRAME                                          Script Assist
 1   var audio:Sound = new Sound();
 2   var channel:SoundChannel;
 3   var offset:Number = 0;
 4   var req:URLRequest = new URLRequest("Tasty Jazz.mp3");
 5   audio.load(req);
 6   channel = audio.play();
 7   channel.addEventListener(Event.SOUND_COMPLETE, resetButton);
 8   function resetButton(evt:Event):void {
 9       btnToggle.gotoAndStop(2);
10   );
11
12   btnToggle.stop();
13   btnToggle.buttonMode = true;
14   btnToggle.addEventListener(
15       MouseEvent.CLICK,
16       function(evt:MouseEvent):void {
17           if (btnToggle.currentFrame == 1) {
18               offset = channel.position;
19               channel.stop();
20               btnToggle.gotoAndStop(2);
21           } else {
22               channel = audio.play(offset);
23               channel.addEventListener(Event.SOUND_COMPLETE, resetButton);
24               btnToggle.gotoAndStop(1);
25           }
26       }
27   );

scripts : 1
Line 27 of 27, Col 3
```

HOT TIP

ActionScript 2.0 versions of these scripted audio examples are available on the CD. The principles are the same; it's really only the syntax that changes.

9 By applying the same principle, you can use the Slider component from the Components panel to throw together a quick volume slider. Get rid of the toggle button and drag out an instance of the Slider component. Give it an instance name, such as *volumeSlider*, and use the Component Inspector panel to configure its parameters like this:

This code assigns an Event. CHANGE handler function to the volumeSlider instance:

COMPONENT INSPECTOR	
Slider, <volumeSlider>	

Parameters | Bindings | Schema

Name	Value
direction	horizontal
enabled	true
liveDragging	false
maximum	1
minimum	0
snapInterval	0.1
tickInterval	0.1
value	1
visible	true

```
ACTIONS - FRAME                                          Script Assist
 1   var audio:Sound = new Sound();
 2   var channel:SoundChannel;
 3   var adjust:SoundTransform = new SoundTransform();
 4   var offset:Number = 0;
 5   var req:URLRequest = new URLRequest("Tasty Jazz.mp3");
 6   audio.load(req);
 7   channel = audio.play();
 8
 9   volumeSlider.addEventListener(
10       Event.CHANGE,
11       function(evt:Event):void {
12           adjust.volume = evt.target.value;
13           channel.soundTransform = adjust;
14       }
15   );

scripts : 1
Line 15 of 15, Col 3
```

Objects, objects everywhere

WHEN PROGRAMMING IN FLASH, it's helpful to think in terms of something called objects. In the real world, an object is generally defined as a material thing, something you can hold in your hands, observe and possibly manipulate, like a Rubik's cube. As often as not, you'll find that multiple copies of a particular object can exist at the same time. For example, you might belong to a Rubik's fan club, where each member brings a cube to weekly meetings in order to see who can solve the puzzle the fastest. On one level, everyone's cube is the same; and yet, everyone's cube is also unique. Each cube can be jumbled into millions of configurations, even though all are made in the same way from the same parts. Mr Rubik presumably has a blueprint for those parts in a filing cabinet somewhere.

Before we get too far afield, how does this analogy relate to objects in ActionScript? Let's look at the parallels. Just about everything in ActionScript can be described as an object. This includes such "material things" as Movie Clips, buttons and text fields, as well as intangibles like dates, arrays (lists of things) and sounds. Each type of object has its own set of characteristics, comprised of distinguishing attributes, things it can do, or things it can react to. It is the particular combination of these characteristics that defines an object's datatype, the thing that makes an object the type it is. In order to create an object, its "blueprint" must be consulted. In ActionScript, this is outlined by something called a class.

Classes determine objects

Classes define an object's properties, methods and events. Properties are the attributes an object has, such as a Movie Clip's width and height. Methods are things an object can do, such as loading an external JPG or jumping to a certain frame label. Events are things an object can react to, such as a mouse click or the occurrence of a Timeline frame. Conveniently, Flash's

documentation features two ActionScript Language References (2.0 and 3.0) that are closely structured around these classes. If you're dealing with a Movie Clip, search the term "MovieClip" and you'll quickly dial in to a handy Movie Clip Owner's Manual. If you're dealing with a button symbol in ActionScript 2.0, search the term "Button", making sure you're not reading from the separate Components Reference. For buttons in ActionScript 3.0, search the term "SimpleButton", because the Components Reference is combined with the general ActionScript Language Reference. Many classes build off of each other, so don't forget to click any hyperlinks in the documentation that say "Show Inherited Public Properties", "Show Inherited Public Methods" and the like. Doing so will give you the full picture of an object's capabilities.

By convention, class names are capitalized, and multiple words are combined into a single term, so if you're dealing with a text field, search "TextField"; if mouse events, search "MouseEvent", and so on. That makes it pretty easy to look things up. You just have to ask yourself two questions. First, "What object am I dealing with?" This will lead you to the necessary class entry. Then, "Am I trying to tell this object how to be, what to do, or how to react?" This will steer you toward the relevant property, method, or event summary. These tips should help you avoid a sense of "Where do I even begin?" when dealing with the built-in documentation.

Contributing author David Stiller is a career multimedia programmer/designer and co-author of Foundation Flash CS4 for Designers (friends of ED) and The ActionScript 3.0 Quick Reference Guide (O'Reilly). He likes anaglyph 3D photography, finely crafted wooden game boards, Library of Congress field recordings, and Turkish coffee. David is self-taught and gets a kick out of sharing "aha!" moments with others through consultation, mentoring and regular contributions to a variety of Flash forums. He lives in Virginia with his amazing wife, Dawn, and his beguiling daughter, Meridian.
www.quip.net

The default layout for Flash, above, is suitable for most users, but in time it might become limiting. The addition of a few custom extensions and commands can add a whole new toolset to Flash and an enhanced workflow.

11

Extending Flash

FLASH OFFERS A WIDE ARRAY of features for designing and animating. As great as it is, Flash can sometimes lack some of the functionality that you might benefit from. There always seems to be some drudgery that ought to be automated or some desperately needed tools that simply don't exist. Other than petition Adobe for these coveted new features, what's a poor "Flasher" to do? Thankfully, since Flash MX 2004, the curious and proactive Flash user has an alternative: Flash JavaScript, or JSFL for short. JSFL is a scripting language that interfaces directly with the Flash authoring environment. In a nutshell, it allows you to create your own Flash extensions.

Introduction to JSFL

Contributed by Dave Logan
www.nitrohandsome.com

1 The best way to dive into JSFL is to play around with the History panel. To open the History panel, go to Window > Other Panels > History. Select the Rectangle tool **R** and draw a rectangle. As you can see, the History panel behaves like it does in most Adobe programs, compiling a list of your actions.

AN EXTENSION IS BASICALLY a plugin, something that adds to Flash and extends its functionality. JSFL only affects the Flash authoring environment (i.e. Flash CS3) and has no effect on published Flash Player files (i.e. .swf files).

The best part about JSFL is that anyone can use it to speed up and improve their workflow. JSFL is based on the ECMAScript standard, which means it's very similar to other languages based off the standard such as JavaScript and ActionScript. If you don't know anything about programming, you're still in luck. You can create custom commands without touching a line of code.

5 Now go to the Commands menu, and lo and behold, there it is! Your very first Flash command. You can make all kinds of simple commands like this. If you find yourself doing some simple action over and over, create a command for it! Afterwards, you can access the command even more easily by assigning it a shortcut by going to Edit > Keyboard Shortcuts.

2 Select the Rectangle and delete it. You'll see each action added to the History panel.

3 Select the first event, Rectangle, which popped up when you drew the rectangle. Press the "Replay" button. Voila! The original rectangle reappears.

4 That's all fine and good, but clicking Replay over and over isn't very classy. Let's make it into a command. Click the floppy disk icon in the lower right hand side of the History panel to save this command. Name it something like "Create Rectangle".

To add your own shortcuts, you have to create your own shortcut set. It's easy. In the Keyboard Shortcuts window, click the little Duplicate Set button with two pieces of paper and an arrow at the top right. Name your set (it doesn't matter what) and press OK. Now you can modify and add your own shortcuts.

6 Afterwards, you can access the command even more easily by assigning it a shortcut by going to Edit > Keyboard Shortcuts.

7 There is a catch, however. Use the Brush tool to draw something on the stage. Look in the History panel. Notice the little red X next to the Brush event? That means that you can't use it in a command. To put it simply, Flash treats some tools a little bit differently than others, and because of that you can't use them in your commands. Despite that letdown, the important thing to understand is that the History panel can be used as the foundation of custom commands. This goes far beyond replicating rectangles.

Trace Bitmap and JSFL

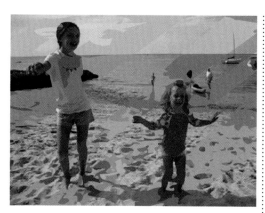

L ET'S SAY YOU'RE WORKING on a project and decide to give some video an artsy rotoscoped effect. A great way to achieve this in Flash is with the Trace Bitmap command. Trace Bitmap converts bitmap images into a vector graphic editable within Flash. But the command only works for one image at a time. That means to do a series of images you have to tediously apply the effect to each one.

Luckily, this is the type of thing JSFL excels at speeding up.

1 First, we have to apply the Trace Bitmap effect to one image. Import the image sequence from the CD by selecting File > Import > Import to Stage and navigate to *image_sequence001.png*. Select image_sequence001.png and click Open. A menu will pop up asking if you want to import all of the images in the sequence. Click Yes.

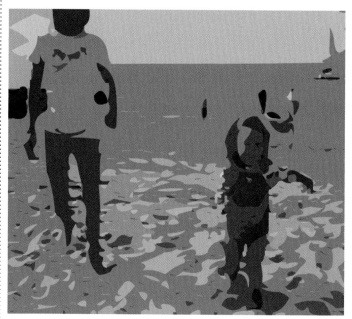

4 The Trace Bitmap panel also allows you to preview your current settings before committing to them. Change any of the setting values and click on "Preview" to see how they will affect your image. When you're happy with the results, click "OK". Depending on the complexity of the image, Flash will pause briefly while it converts the image into a series of vector shapes.

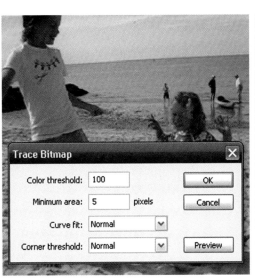

2 Each imported image will be placed in its own keyframe on the main Timeline. You can play your movie to see the "video" play as a sequence of frames.

3 Select the image in frame 1. Go to Modify > Bitmap > Trace Bitmap. In the Minimum Area box, type "5". This makes Flash re-evaluate what color to use for every 5 pixels instead of every 8, which produces a more realistic looking trace. Don't click "OK" just yet.

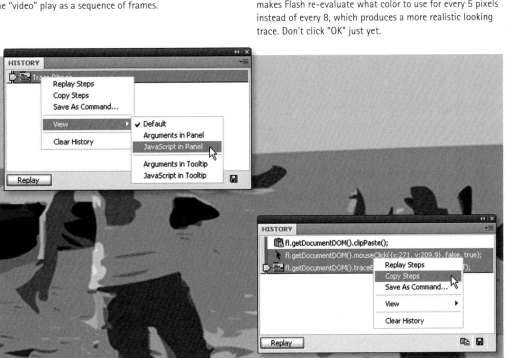

5 Cool, now to make it happen for all the other images. Right-click on the History panel and select View > JavaScript in panel. Your most recent actions should now look something like this:

fl.getDocumentDOM().mouseClick({x:117, y:160}, false, true);
fl.getDocumentDOM().traceBitmap(100, 5, 'normal', 'normal');

6 Don't worry if the first set of numbers is a bit different than yours. They correspond to the exact coordinates on the screen that you clicked on to select the image. Copy these steps by selecting them, right-clicking and selecting Copy Steps.

(Continued...)

331

Trace Bitmap and JSFL (cont.)

HOW DO I KNOW ALL THAT? Do I have all of JSFL's methods and arguments meticulously memorized? No. I clicked on the word mouseClick and the word traceBitmap and hit F1. Flash's Help popped up and instantly took me to the entry on these methods. Whenever you get stuck or confused, your first stop should be Help.

7 Go to File > New and select Flash JavaScript File. If you are not running Flash CS3 Professional, you'll notice there is no option to create a new Flash JavaScript File. Don't worry, just open up a text editing program like Notepad and carry on. JSFL in the end is just a text file, so it doesn't matter how you create it. A new tab opens up that only allows you to manipulate code. Paste the code that you copied from the History panel.

9 Let's shorten the code by creating a variable. Add the code to the beginning of the existing code. Go to the beginning of your top line of code and hit enter to make a new line. Type this: *var doc = fl.getDocumentDOM();* What this does is create a new variable, called doc, and stores within it the value of *fl.getDocumentDOM();*. It's a bit more complicated, but just think of it as an abbreviation.

```
trace_bitmap.fla*  Script-1*
1  var doc = fl.getDocumentDOM();
2  fl.getDocumentDOM().mouseClick({x:106, y:142}, false, true);
3  fl.getDocumentDOM().traceBitmap(100, 5, 'normal', 'normal');
```

11 While we're at it, let's define a few more variables. The first new variable, *tl*, is another abbreviation. It refers to the document's Timeline. The *curLayer* variable refers to the currently selected layer (which it gets from the *currentLayer* method), and the *curFrame* variable refers to the current frame we're on (which, again, it gets from the *currentFrame* method).

```
trace_bitmap.fla*  Script-1*
1  var doc = fl.getDocumentDOM();
2  var tl = doc.getTimeline();
3  var curLayer = tl.currentLayer;
4  var curFrame = tl.currentFrame;
5  doc.mouseClick({x:117, y:160}, false, true);
6  doc.traceBitmap(100, 5, 'normal', 'normal');
```

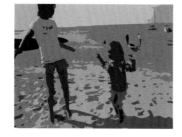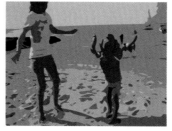

8 Let me explain a bit of the gibberish that you're looking at. The *fl* at the beginning of both lines refers to, you guessed it, Flash itself. The *getDocumentDOM()* method tells Flash that we wish to work with the currently active Flash document. Both *mouseClick* and *traceBitmap* are pretty self-explanatory; the former is the method that describes a single mouse click, and the latter is the method which actually turns the image into a bunch of vectors.

```
trace_bitmap.fla*  Script-1*
1  fl.getDocumentDOM().mouseClick({x:106, y:142}, false, true);
2  fl.getDocumentDOM().traceBitmap(100, 5, 'normal', 'normal');
```

The stuff inside the parentheses is the arguments that are passed to these methods. So the first line tells Flash to execute a mouse click at x:117 and y:160 within the active document (the false and true after the coordinates have to do with whether the Shift key is down). The second line tells Flash to execute a bitmap trace with the parameters you set when you went to Modify > Bitmap > Trace Bitmap. The threshold, or number of colors in the tracing, is set to 200, the minimum area is set to 5, and the curve fit and the corner thresholds are both set to normal. The ; at the end of both lines tells Flash that the line of code is over. Think of it as a period in a sentence.

10 Now go down to the next two lines of code and replace each *fl.getDocumentDOM();* with the more elegant *doc.* So now you should have something like this:

var doc = fl.getDocumentDOM();
doc.mouseClick({x:117, y:160}, false, true);
doc.traceBitmap(100, 5, 'normal', 'normal');

```
trace_bitmap.fla*  Script-1*
1  var doc = fl.getDocumentDOM();
2  doc.mouseClick({x:117, y:160}, false, true);
3  doc.traceBitmap(100, 5, 'normal', 'normal');
```

HOT TIP

Variables can generally be named whatever you like, but there are a few rules: no spaces in the names, no punctuation except for _ or $, and don't start the name with a number.

12 You now have variables that know what frame the user is on. Now let's find out how many frames are in that layer. In line 5, the frames property at the very end of that line returns an array, which gets stored in the *frameArray* variable. An array is basically a list of items. In this case, it's a list of frame objects. Arrays have a length property that tells you how many items are in the array; that's what's getting stored in the *n* variable from the expression *frameArray.length* in line 6. (If an array represented a year, it would have a length of 12, for each month.)

```
trace_bitmap.fla*  Script-1*
1  var doc = fl.getDocumentDOM();
2  var tl = doc.getTimeline();
3  var curLayer = tl.currentLayer;
4  var curFrame = tl.currentFrame;
5  var frameArray = tl.layers[curLayer].frames;
6  var n = frameArray.length;
7  doc.mouseClick({x:117, y:160}, false, true);
8  doc.traceBitmap(100, 5, 'normal', 'normal');
```

(Continued...)

Trace Bitmap and JSFL (cont.)

13 Now we have a variable that knows how many frames are in our selected layer. Why is this important? When you imported the image sequence, Flash put each one on its own frame. We want to use the Trace Bitmap command on each one, so the script has to know how many there are so it can tell how many times it should run the command.

```
trace_bitmap.fla*   Script-1*

1   var doc = fl.getDocumentDOM();
2   var tl = doc.getTimeline();
3   var curLayer = tl.currentLayer;
4   var curFrame = tl.currentFrame;
5   var frameArray = tl.layers[curLayer].frames;
6   var n = frameArray.length;
7   tl.setLayerProperty('locked', true, 'others');
8   doc.mouseClick({x:117, y:160}, false, true);
9   doc.traceBitmap(100, 5, 'normal', 'normal');
```

15 All that's left is finding a way to make Flash run the *traceBitmap* method for every frame. Luckily, that's pretty easy to do with a *for loop*.

A *for loop* is a type of control flow statement. A control flow statement is basically a way to change the normal flow of a program, one line after the other. *For loops* are ideal for going through lists of data, or an array of frames. The important parts of a for loop are within the parentheses. The first part, *i = 0*, declares that the variable *i* is initially set to *0*. The second part, *i < 10*, is the condition.

```
trace_bitmap.fla*   Script-1*

1    var doc = fl.getDocumentDOM();
2    var tl = doc.getTimeline();
3    var curLayer = tl.currentLayer;
4    var curFrame = tl.currentFrame;
5    var frameArray = tl.layers[curLayer].frames;
6    var n = frameArray.length;
7    tl.setLayerProperty('locked', true, 'others');
8    for (i=curFrame; i<n; i++) {
9        doc.selectAll();
10       doc.traceBitmap(100, 5, 'normal', 'normal');
11       tl.currentFrame = i + 1;
12   }
```

This means that the code contained within the brackets will only be executed if this condition is met. In this case, the condition is that *i* is less than 10. The third part, *i++*, tells the script what to do after each iteration, or turn. Each time the condition is met, the contained code is executed, and afterwards this statement is executed. Each time the code is executed, the value of *i* will be increased by 1. As complex as it looks, it's pretty simple in function. So the loop starts out at the currently selected frame, and as long as the current frame is less than *n* (that is, less than the length of the layer), the code within the brackets will be executed and the image will be traced. Finally, *tl.currentFrame = i + 1;* sets the current frame to the value of *i* (already the current frame) plus 1, which puts us on the next frame.

14 Next, add a command to lock every layer other than the one you're using. Why are you doing this? Because you need a better way of selecting the image we are going to trace. What if you have an image that doesn't end up in the area you clicked when you first ran the Trace Bitmap command? The script will fail. So instead of simulating a mouse click, you're going to lock all the other layers and then perform the *selectAll* method. The *selectAll* method does the same thing as using ⌘ A ctrl A.

```
var doc = fl.getDocumentDOM();
var tl = doc.getTimeline();
var curLayer = tl.currentLayer;
var curFrame = tl.currentFrame;
var frameArray = tl.layers[curLayer].frames;
var n = frameArray.length;
tl.setLayerProperty('locked', true, 'others');
doc.selectAll();
doc.traceBitmap(100, 5, 'normal', 'normal');
```

HOT TIP

Programmers often start *for loops* with 0 rather than 1 because arrays happen to start counting at 0. By matching these starting numbers, the *for loop* easily keeps pace. Frames, however, start at 1, which explains the arithmetic in line 11.

I hope this simple tutorial sparks your interest in Flash extensions. JSFL is a wonderful way to get additional usability and improved accessibility out of Flash, not to mention a great way to learn some programming fundamentals.

JSFL can do much more than ease your workflow. If you are determined and creative, the sky is the limit. It goes far beyond custom commands. People have used JSFL to create advanced exporters, cameras with depth, and even inverse kinematics skeletons in Flash. Just think of it! Adobe has given you the power to change the way Flash works and what it can do.

If you are interested in the topic, you should check out Extending Macromedia Flash MX 2004 by Keith Peters and Todd Yard. JSFL hasn't changed too much since its introduction, and this book is still basically the bible on the subject.

So the next time you complain about Flash, about a missing feature, a needed tool, or an arduous workflow, do everyone a favor and fix it.

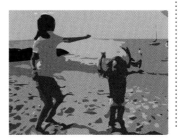

Dave Logan
www.nitrohandsome.com
www.dave-logan.com/extensions

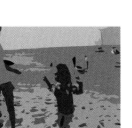

SHORTCUTS
MAC WIN BOTH

335

Enter current frame

Contributed by Dave Logan
www.nitrohandsome.com

OKAY, SO YOU'VE GOT THE BASICS OF JSFL scripting down and made a pretty nifty tool to boot. Let's go a step further, both in complexity and usefulness, and make a command that many Flash animators have waited quite a long time for.

As you've gone through this book, you've probably noticed that one common Flash animation technique is the use of nested animation in Graphic "packs". A good example of this is the tendency for animators to create a single mouth Graphic symbol for a character which contains every mouth shape; and then use a tool such as Warren Fuller's AnimSlider or Flash's built in Properties panel to select which frame is being shown at any given time. This time-tested workflow helps to significantly cut down on production time, sometimes in ways much more involved than the aforementioned mouth pack example. But back to JSFL. One annoying thing about using Graphic symbols in this way is that if you ever decide you need to change something in a specific frame (for example, you need to change a certain mouth shape in a mouth pack), you have to play a game of find-the-keyframe. When you enter the Graphic symbol by double clicking, Flash takes you to the very first frame of that Graphic. That's great if the frame you want to work with happens to be the first one, but oftentimes it's not. Before the advent of JSFL, animators had to remember exactly which frame they had set the Graphic symbol to and hunt it down in the Graphic's Timeline to make any changes to it. Let's fix that, shall we?

```
1   var doc = fl.getDocumentDOM();
2   var tl = doc.getTimeline();
3   var curLayer = tl.currentLayer;
4   var curFrame = tl.currentFrame;
5   var curElements = tl.layers[curLayer].frames[curFrame].elements;
6   var frameArray = tl.layers[curLayer].frames;
7   var graphicStartFrame = tl.layers[curLayer].frames[curFrame].startFrame;
8   var somethingSelected = false;
9   var selectedElement = 0;
10
11  for (i = 0; i<curElements.length; i++) {
12          if (curElements[i].selected == true) {
13              selectedElement = i;
14              somethingSelected = true;
15          }
16  }
```

Line 16 of 16, Col 2

2 Add the highlighted lines to the bottom of your code. This snippet of code goes through each selected element (if there are any) and checks to see if that certain element is selected. An element is basically anything on the stage – a Movie Clip, Graphic, text, shape, etc. When the script determines that something is indeed selected, it sets somethingSelected to true and stores the index value of the selected element into the variable selectedElement (aptly named, I might add). Onward!

```
1   var doc = fl.getDocumentDOM();
2   var tl = doc.getTimeline();
3   var curLayer = tl.currentLayer;
4   var curFrame = tl.currentFrame;
5   var curElements = tl.layers[curLayer].frames[curFrame].elements;
6   var frameArray = tl.layers[curLayer].frames;
7   var graphicStartFrame = tl.layers[curLayer].frames[curFrame].startFrame;
8   var somethingSelected = false;
9   var selectedElement = 0;
```

Line 9 of 9, Col 25

1 Open up a new JSFL document and save it as Enter Graphic at Current Frame (or something catchier if you can think of it). Let's proceed to step 2 and define our variables. Most of this should be familiar to you from the previous example. The only new stuff appears on the last 3 lines: the variables graphicStartFrame, somethingSelected, and selectedElement. Since it's beyond the scope of this book to get really in depth with more obscure JSFL properties (relatively speaking), just know that graphicStartFrame stores the startFrame property, the 0-based index of the first frame in a sequence on the main Timeline. So if you had a symbol appear at frame 9 and disappear on frame 20, all throughout graphicStartFrame would hold the value of 8 (because frame 9 corresponds to the frame index of 8. Fun, right?). The other two variables, somethingSelected and selectedElement, are both created to help us figure if there is something selected at all; and if so, what.

```
1   var doc = fl.getDocumentDOM();
2   var tl = doc.getTimeline();
3   var curLayer = tl.currentLayer;
4   var curFrame = tl.currentFrame;
5   var curElements = tl.layers[curLayer].frames[curFrame].elements;
6   var frameArray = tl.layers[curLayer].frames;
7   var graphicStartFrame = tl.layers[curLayer].frames[curFrame].startFrame;
8   var somethingSelected = false;
9   var selectedElement = 0;
10
11  for (i = 0; i<curElements.length; i++) {
12          if (curElements[i].selected == true) {
13              selectedElement = i;
14              somethingSelected = true;
15          }
16  }
17
18  if (somethingSelected == true) {
19  //code goes here
20  }
```

Line 20 of 20, Col 2

3 Next we're going to add a conditional to control the flow of this script. For this, we'll be using an if then statement like as shown highlighted above. So if the variable somethingSelected equals true, we want the script to execute the code inside the {curly braces}. The reason for this is that we want to be sure something is selected before the script runs, or else we could get some errors. Incidentally, the line //code goes here is a comment line. Anything you write with two forward slashes preceding it will be ignored by the script. Documenting your code for future use with comments is a good habit to get into.

(Continued...)

337

Enter current frame (cont.)

```
 1   var doc = fl.getDocumentDOM();
 2   var tl = doc.getTimeline();
 3   var curLayer = tl.currentLayer;
 4   var curFrame = tl.currentFrame;
 5   var curElements = tl.layers[curLayer].frames[curFrame].elements;
 6   var frameArray = tl.layers[curLayer].frames;
 7   var graphicStartFrame = tl.layers[curLayer].frames[curFrame].startFrame;
 8   var somethingSelected = false;
 9   var selectedElement = 0;
10
11   for (i = 0; i<curElements.length; i++) {
12           if (curElements[i].selected == true) {
13               selectedElement = i;
14               somethingSelected = true;
15           }
16   }
17
18   if (somethingSelected == true) {
19   // Finds out what kind of loop the symbol is (Single Frame, Loop, or Play Once)
20       var graphicLoop = tl.layers[curLayer].frames[curFrame].elements[selectedElement].loop;
21       // Finds out the selected graphics' first frame
22       var graphicFirstFrame = tl.layers[curLayer].frames[curFrame].elements[selectedElement].firstFrame;
23       var myArray = new Array();
24       for (i=0; i<frameArray.length; i++) {
25           if (i==frameArray[i].startFrame) {
26               var thisFrame = i;
27               myArray.push(thisFrame);
28               }
29       }
30       var keyFrame = 0;
31       // Finds out closest keyframe
32       for (i = 0; i < myArray.length; i++) {
33           if (myArray[i] <= curFrame) {
34               if (curFrame > keyFrame) {
35                   keyFrame = myArray[i];
36               }
37           }
38       }
39
40   }
```

Line 39 of 40, Col 1

4 Next, insert the highlighted code into the conditional, replacing the //code goes here line.

In the interest of time I'm not going to go through each line and tell you what's happening, but I do want to highlight a few ideas. First, any time you see [square brackets], we're doing something with an array. An array is basically a list of data, that, like for loops, starts at 0. So if you had an array called test that stored the words "hello" and "world", test[0] would equate to "hello", and test[1] would equate to "world." It's a bit confusing at first, but I assure you there are reasons why this is how it's done.

So some of those intimidating lines like
var graphicFirstFrame = tl.layers[curLayer].frames[curFrame].elements[selectedElement].firstFrame; are really just telling JSFL where to look for this data by going through a lot of arrays.

You can also see that I create an array called myArray and use a for loop to store all the start frames, which is the index (0-based) of the first frame in the sequence. In human terms, this means the code goes through each frame in the Timeline and finds each place a keyframe has been made. I then go through that array using a for loop (and using the array property length to do it as many times as there are array data) to find the closest previous keyframe, since that's the one we want to work with to figure out which frame the graphic is showing.

The logic for this is basically checking to see if whatever frame the array is working with is less than or equal to the current frame on the Timeline (e.g. if this frame occurs earlier in the Timeline or is the very frame we're on when we run this command). The script then stores this frame in a variable called keyFrame, and runs this evaluation over and over until we run out of frames or until the variable keyFrame holds a value greater than or equal to curFrame – the current frame we're on. Why? Because we only want to find the nearest previous keyframe. Any keyframes that occur after the current frame do us no good.

Whew. If you're new to scripting, that might seem kind of complicated. As you gain experience you'll be able to just glance at code like this and figure out what it does, but for now, just press on.

```
22   var graphicFirstFrame = tl.layers[curLayer].frames[curFrame].elements[selectedElement].firstFrame;
23   var myArray = new Array();
24   for (i=0; i<frameArray.length; i++) {
25       if (i==frameArray[i].startFrame) {
26           var thisFrame = i;
27           myArray.push(thisFrame);
28       }
29   }
30   var keyFrame = 0;
31   // Finds out closest keyframe
32   for (i = 0; i < myArray.length; i++) {
33       if (myArray[i] <= curFrame) {
34           if (curFrame > keyFrame) {
35               keyFrame = myArray[i];
36           }
37       }
38   }
39   // Figures out what frame should be shown in the graphic
40       var finalFrame = curFrame - keyFrame + graphicFirstFrame;
41       if (doc.getElementProperty("elementType") == "instance"){
42           // Checks if symbol is editable
43           if (doc.canEditSymbol()) {
44               // Enters edit mode
45               doc.enterEditMode("inPlace");
46               // Gets the frame count of the graphic
47               var graphicFrameCount = fl.getDocumentDOM().getTimeline().frameCount;
48               // If the frame is too high due to a Graphic loop, bring it down to what it should be
49               while (finalFrame > graphicFrameCount) {
50                   finalFrame = finalFrame - graphicFrameCount;
51               }
52               // If the graphic is set to single frame, set the frame to graphicFirstFrame
53               if (graphicLoop == 'single frame') {
54                   finalFrame = graphicFirstFrame;
55               }
56               // Set final frame
57               fl.getDocumentDOM().getTimeline().currentFrame = finalFrame;
58           }
59       }
60
61   }
```

Line 61 of 61, Col 2

5 Enter the highlighted code below the code you entered in the last section, but before the last curly brace }. This is the meat of the script. It figures out which frame to display by subtracting the index of the nearest previous keyframe from the index of the current frame we're at, and adds to that the first frame the graphic is set to on that frame. It then checks to see if whatever is selected is a symbol of some kind and if it can edit it. If it is a symbol and can be edited, it enters "edit mode", which is the same as double clicking on a symbol in the Flash IDE. It counts the number of frames in the graphic and stores them in a variable called graphicFrameCount.

Then we use a while loop, which is similar to a for loop. A while loop executes code for as long whatever it evaluates is true. The reason we're using one is to sort out what to do with graphic loops. If the selected symbol has been in a loop for a while, the current value of finalFrame will be bigger than the length of the graphic (its number of frames). We adjust for that by subtracting the length of the graphic from the finalFrame variable over and over until it is less than or equal to the graphic's length.

Next we check to see if the graphic is set to display one single frame. If so, we just set the displayed frame to the value we got from graphicFirstFrame and negate all the adjusting we just did for graphic loops.

Finally, we set the current frame to finalFrame, which takes us to the frame we were looking at on the main stage. Woo! We're done! Save your file and give it a try!

You could expand this further and eliminate a couple of pesky error messages that show up if the script isn't used correctly, but let's quit while we're ahead shall we?

Dave Logan
www.nitrohandsome.com
www.dave-logan.com/extensions

AnimSlider Pro

PIMP MY PROPERTIES PANEL! Warren Fuller of animonger.com has developed one of the most popular Flash plugins for animators. It's called the AnimSlider and it is simply indispensable if you use Flash for animation. In a nutshell, this plugin literally does everything the Properties panel does, but better and with many more features. Think of it as a one-stop panel for almost all your animation needs.

AnimSlider is so useful that it is the first plugin I install after installing or upgrading Flash. It will save you valuable production time and, as a result, will pay for itself many times over the more you use it. You can download a limited free version to get you started at *www.animonger. com/animsliderlimited.html.* If you decide you can't live without AnimSlider you can purchase and download the full or pro version at *www. animonger.com.*

Warren has developed an NTSC color safe palette that can be imported into the Swatches panel. This is a free *.clr file included on the CD with this book or from Warren's website. To use this palette, open the Swatches panel and click on the upper right corner drop-down arrow. Select Add Colors or Replace Colors and navigate to the NTSC.clr file on the CD provided or if you downloaded it from Warren's website to your local hard drive. You can learn more about color safety and video in Chapter 6.

The AnimTools plugin is a panel that includes the same editing tools found in the AnimSlider panel but conveniently grouped together for your convenience. The AnimTools panel includes two additional features that the AnimSlider panel does not.

The New Folder Tree feature creates a folder hierarchy in the current document's Library with one simple click. Type in a folder name in the pop-up dialog panel and click OK. Open the Library panel and notice your new folder tree created for you. This will greatly enhance the organization of your Flash file.

The Move to Existing Folder feature allows you to move Library items to existing folders. Select the objects in the Library you want to move, and click the Move to Existing Folder button. In the path dialog box, type in the case-sensitive name and path of your folder. For example, to move the selected items to a folder named "Arms" inside a folder named "Joe", type "Joe/Arms".

The total number of frames in the selected Graphic symbol is displayed here. The AnimSlider supports up to four digits. This is a huge improvement over the Flash Properties panel, which only supports two digits. Being limited to two digits makes it difficult to know how many frames are nested and what frame is actually being displayed.

Button tools are conveniently located and allow you a simple click for many common editing commands: Paste in Place, Flip Horizontal and Flip Vertical, Arrange Forward and Arrange Backward, Convert to Symbol, Reset Transformation Point, New Graphic Symbol, Reset Free Transformation, Convert Lines to Fills, New AnimPak Pro Symbol, Duplicate Layer, Apply a Motion Tween with or without easing and a Go To Frame Number feature.

You can toggle how AnimSlider reacts when you click on the slider portion of the panel. You can click and drag or click and "float" the cursor along the frames.

Change the play mode of multi-frame symbols using this handy drop-down menu.

Click and drag along the slider frames to play back the nested animation in your Graphic symbol. You can also click on a frame to change the current frame number you wish to be displayed. You can create keyframes on the main Timeline, select Single Frame from the AnimSlider's play mode drop-down and click on the frame number you wish to start or hold on. This is very handy for lip syncing with nested mouths as described in the Lip Syncing topic in Chapter 5.

These buttons work with AnimPak Pro Symbols which you can create from within the AnimSlider panel.

The current frame for the currently selected symbol is displayed here (and supports up to four digits).

You can also dock both the AnimSlider and AnimTools panels with Flash panels. The AnimSlider fits well with the Properties, Filters and Parameters panels while the AnimTools panel might be usefully grouped with the Transform and Align panels.

341

Ajar Extensions

JUSTIN PUTNEY OF AJAR PRODUCTIONS has written several extensions for Flash, geared towards the designer and animator. Justin is passionate about writing extensions, which is clearly evident in this quote from his website: "*I am officially addicted to making Flash extensions. It seems to tickle some very nerdy part of my brain.*" I highly recommend visiting and bookmarking his website:

http://ajarproductions.com/blog

http://ajarproductions.com/blog/flash-extensions

http://www.ajarproductions.com

By the time you read this, I am sure he'll have several more extensions available as he seems to post new ones almost daily. Thanks Justin!

FrameSync

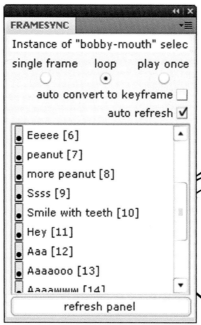

This is a handy-dandy animation plugin similar to Animonger's AnimSlider (previous example), except that it uses frame labels and requires no other setup. Create a new layer in your Graphic symbol containing your mouth shapes and add descriptive Frame Labels for each frame. Select the instance of the mouth symbol and click the "refresh panel" button (or check the "auto refresh" feature) in the FrameSync panel. Create a keyframe and then simply click the desired frame inside the FrameSync panel window to set your mouth shape.

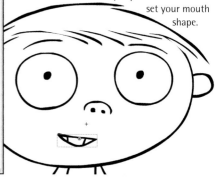

Roughen Edges

Flash is known for its smooth vector looking graphics. This extension adds a command that will remove that typical Flash vector look by roughening the edges of lines, fills, and drawing objects. It can also be re-applied for more dramatic effects. It's an imperfect implementation, so make sure to keep an eye on what you're doing. There can be some unexpected results, especially when applying it to one element repeatedly.

Queasy Tools

This extension creates Classic tweens, applies strong easing (both in & out), automatically adds keyframes, duplicates layers, swaps symbols from the Library, turns on bitmap smoothing, aligns objects, applies tinting to white and alpha to 50% or 0%, scaling, arranging flipping and more! It's like an info-mercial where they keep throwing in extra features!

Select Frame Range

Enter a starting frame and an end frame, click "OK" and this clever extension will select all the frames in between.

Motion Preset Preview

Once you've created a custom motion preset, you can use this command to immediately create a live preview from your current document.

Guide Maker

This is a very smart extension that provides a simple and clean way to create guides. You can specify guides based on a percentage of the stage or type in an exact numerical value that represents the number of pixels in between each guide. The integrated color picker is for customizing the color of the guide. Guides can even be saved and reused!

Convert Timeline to Symbol

This extension has been a long time coming. If you've ever needed to copy and paste long complicated animations into a symbol then this is for you. Just run this extension from the Commands menu, provide a name for the symbol and click "OK".

343

Swift 3D Xpress

SWIFT 3D XPRESS is a 3D extension for Adobe Flash that allows users to convert drawings and text on the Flash stage into 3D animations without having to leave the Flash interface. Swift 3D Xpress is a revolutionary 3D extension (plugin) that allows users to quickly convert 2D text and artwork into 3D animations without leaving the Flash interface. Vector objects on the Flash stage can be brought into the Swift 3D Xpress interface and customized using pre-built animations, lighting schemes and materials. The 3D scenes are rendered and placed into a specialized Movie Clip in Flash's Library for further use or future editing.

Swift 3D Xpress is a very easy and intuitive tool to use. It provides instant results and real-time 3D feedback when applying materials and animations. It's great for making anything from animated logos to animated buttons and more.

1 Create a shape in a new Flash document and select it. Go to Commands > Swift 3D Xpress to launch the extension. You will find your shape has been automatically extruded and placed in a 3D environment. Now you can modify various aspects of the 3D shape. Start by adding a beveled edge.

3 Click on the Lighting Trackball tab to edit the lighting of your 3D scene. How you adjust the lighting of your scene is directly related to how the materials of your object will look after being rendered. The placement of each light and the number of lights will affect the color contrast of the object. Experimentation here is key. There are several variations of animations that can be added to your object. Click on each thumbnail in the Animations panel to see a preview of the animation. Once you have decided which animation to use, drag and drop it to your 3D object in the Viewport.

2 Click and drag the Object trackball to rotate the selected object. You can also have the option to lock the rotation based on its horizontal and/or vertical axis.

Click on "Sizing" in the upper left menu and adjust the amount of depth to create a cube.

You can apply different materials by clicking and dragging your preferred material from the Materials panel directly to the surface of your 3D object.

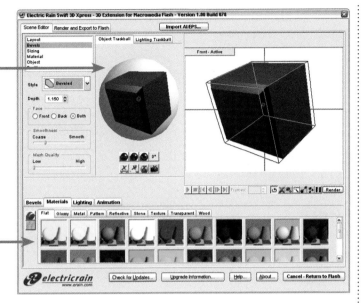

HOT TIP

You can apply various styles of beveled edges to your 3D object and control the depth of the bevel as well. Choose from Square (no bevel), Beveled, Outer Round, Inner Round and Step Down. You can even apply a material to the beveled edge that is different from a material chosen for the object's surface(s). You may also want to check out Swift 3D, the full stand-alone version from Erain (erain.com). It has all the same features of the Xpress version plus an advanced 3D modeling environment, Animation Path tools, Extrusion and lathe editing tools and more!

4 When you are satisfied with your work, click on the "Render and Export to Flash" tab. You have two format options to export to: Vector and Raster. Each will generate an image sequence that can then be converted to a Movie Clip or an SWF file.

The Vector format provides several options such as various Fill and Outline styles. You can also render Specular Highlights, Reflections and Shadows.

The Raster format also provides some options such as Quality level and Color Depth as well as Antialias Quality.

Once you have chosen your desired settings, click on Render Frames. Swift 3D Xpress will render each frame of the animation that can also be played within this same panel using the playback controls.

If you choose Create Flash Movie Clip, a Movie Clip containing your animation will be added to your Flash Document's Library. You can then drag it to the stage and incoporate it into your Flash project. If you choose Export to SWF File, Swift 3D Xpress will provide you with the option to name your SWF file and choose a location on your hard drive to save it to.

Flashjester

THE LIST OF FEATURES that Jugglor and Creator offer are so extensive, it is simply impossible to fit them all on just these two pages. As an animator, you'll be excited about Jugglor's Desktop Pet feature. Extend the interactive capabilities of your Flash animated character by dragging, dropping and bouncing your character around your desktop. This only scratches the surface of Jugglor's full range of features and to really gain an understanding as to how Jugglor can fully extend your Flash projector files, visit their website (www.flashjester.com) for a comprehensive feature list.

Creator is a screensaver creation tool from Flashjester that provides everything you need for converting your Flash movies to screensavers.

1 Jugglor provides the option to specify detailed information about your movie such as a title, a new Juggled name, the path to where you want the Juggled file, the size of the compiled projector file and detailed information regarding the movie's player version, size, width, height, frame rate, etc.

2 Jugglor's ActiveX settings allow you to control how your desktop pet will be rendered, how it will play or loop, customize the right-click menu and much more. I have included on the source CD a file named mudbubbleDesktopPet. fla. Open it and locate the layer named "Right-click menu". Select the Movie Clip instance in this layer and open the Actions panel to see the right-click menu code.

3 Jugglor's setup settings offer plenty of options for customizing the level of interactivity, right-click menu visibility, mouse and keyboard interaction, icon tray support and even Joystick support. You can also specify if and when you want your file to expire.

Creator

1 Creator shares a user interface very consistent with Jugglor. After launching Creator, start your screensaver project by populating the available fields in the General Settings section. This information will be available in the screensaver settings menu after it has been installed to the computer's operating system.

2 If your Flash file includes mouse events, or any type of interaction, *Always have Interaction* will allow interaction with the screen saver without closing it. You have the option of including or muting sounds or leaving it for the user to choose. Creator supports right-click menu options and multimonitor support. You can also set your expiration by run times (number of times it is executed), by a certain date, or after a certain by-day period (example, a 30-day trial).

3 This screen is the final step in creating a screensaver. It allows you to build your final project into an .scr screensaver file, and an .exe installer file. Additional files may be created, depending on which options you choose. Creator produces screensavers that are ready for distribution. Simply zip them or copy them to a storage medium, and you're ready to get your product out there. No plug-ins are required to run Creator-compiled screensavers! Creator bundles all required plug-ins so your users don't have to worry about them.

HOT TIP

Flashjester also makes a great tool called JShapor that allows you to customize the shape of your projector files. Without JShapor, projector files published from Flash will always be square, specifically the width and height you specified in the document's properties. Using JShapor's transparency tool, it's easy to shape the projector however you want.

Toon Boom

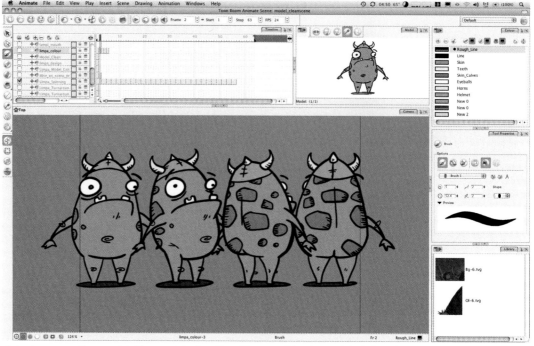

Animate comes with a very intuitive user interface. The wide array of drawing tools include various brush tips to create a unique look. The smart color ID system combined with the color model make it very easy and fast to color characters.

I KNOW THIS IS A BOOK focused primarily on the Adobe Flash program, but it seems necessary to mention a wonderful new program called Animate. Animate is a complete animation program from Toon Boom, a company who has been focused on delivering some of the best animation software since 1994. Some of Toon Boom's other popular animation programs include Toon Boom Studio and Digital Pro. Animate is their latest animation tool and it boasts an impressive list of features, many similar to the Flash feature set. But what makes Animate worth mentioning is what separates it from Flash, specifically the features it has that Flash does not and in some cases Animate does better.

Animate's similarities to Flash include vector drawing tools, pressure sensitivity, image vectorization, keyframing, onionskin, inverse kinematics and symbols. But that is where the similarities end and Animate excels with color ID and palette styles, ability to rotate the canvas, an ink and paint tool, X-sheet, 3D multi-plane camera, forward kinematics,

morphing, compositing effects and more. Animate can also export to FLV, SWF, MOV and image sequence formats, allowing content made with Animate to be integrated into a Flash project if desired.

Both share an impressive toolset that overlap with each other in many areas but Flash remains the choice of platforms when it comes to interactive content such as websites and games due to its native programming language ActionScript.

Both Flash and Animate are powerhouse programs for delivering engaging animation for a multitude of formats. If you come from an animation background then I highly recommend adding Animate to your toolset.

Download the free Personal Learning Edition of Animate here:
http://www.toonboom.com/products/animate/trial.php

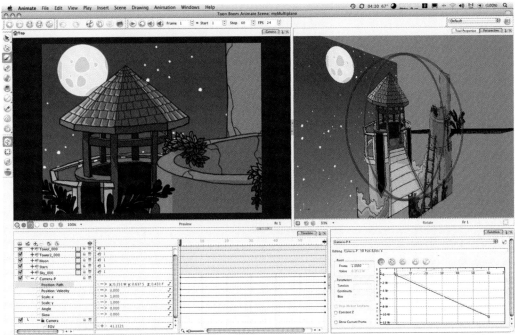

The scene planning process is a breeze in Animate. Thanks to the Perspective view you can lay out your scene and plan impressive camera moves. The Function editor conveniently enables you to set your velocity and keyframes. Also the enriched Timeline offers direct access to functions.

HOT TIP

Visit www. toonboom.com to learn more about Animate and the rest of the Toon Boom product family. Aside from offering the best professional level animation software, they also provide some very cool animation software for children too!

Add special effects directly in Animate. Effects include blur, shadow, tone, highlight, glow, and transparency, to name a few, and come with customizable parameters to give your animation a more professional and richer look.

349

Flash Decompiler Trillix

FLASH DECOMPILER TRILLIX by Eltima Software is a powerful tool that enables you to convert Adobe Flash SWF files back into FLA format. Flash Decompiler completely supports Flash CS3 and CS4 and ActionScript 3.0.

Flash Decompiler Trillix can convert Adobe Flex files into Flex Builder projects. ActionScript can be saved to AS and TXT file formats. Images can be extracted into PNG, JPEG and BMP formats while sounds can be extracted to WAV and MP3 files. Text fields can be extracted to TXT, HTML and RTF formats.

If you have ever lost a Fla because it was accidentally deleted or became corrupt, you know how truly awful it is to have to start all over again. If you still have the published SWF then all is not lost.

1 The main window has a very clean and polished user interface that is easy to navigate. You can play and pause the SWF movie as well as zoom in and out using the clearly laid out Frames and Zoom controls. The thumbnail bar provides a preview of all decompiled elements (shapes, images, morphs, sounds, video, fonts, texts, buttons, frames and scripts).

3 You can specify what objects you want to extract and which ones you do not. Here only the ActionScript thumbnail is selected and the ActionScript contained in the SWF is displayed in the main player window. Click the Extract button to convert the ActionScript to either an AS or TXT file.

2 Click on a thumbnail window to view its contents in the large main player window below. You can extract content based solely on the currently selected thumbnail or extract the entire contents of the SWF at once.
To extract the objects simply select the objects you want to extract by selecting their checkbox and click the Extract button.

HOT TIP

To check out more Flash related products visit the Eltima website: www. eltima.com

4 You can choose the destination folder to extract your file(s) to. The default folder is the same folder the original SWF is in. During the extraction process you will see a progress bar and any error or warning reports. Once the extraction is complete, the decompiler will create individual folders based on the number of assets you selected. Each folder will be named appropriately based on its contents.

Flash Optimizer

W HY WOULD YOU NEED to compress vector graphics? Aren't they already small enough? Is there any way to compress what is already optimized? Flash Optimizer uses a series of mathematical algorithms to optimize the output format of Flash. The main purpose of optimization is to compress Flash files with the least amount of quality loss and optimize them for faster download. Flash Optimizer manages to compress SWF files up to 60-70% and you have total control over each and every optimization option. With just two clicks you will reduce the file size of your Flash project by 50% or more!

1 Flash Optimizer provides an integrated workspace logically divided into separate panels, windows and menu options which are integrated into a single larger application window. The toolbar across the top provides shortcuts to all main functions of the Flash

Optimizer. The preview panel displays the selected SWF file. Here you can use the playback controls to play the animation as well as stop, rewind and fast forward it. You have the option to open multiple SWF files and select between them using the file list at the bottom of the main window.

2 Use the menu navigation to select from a list of default compression types or click on the gear icon in the toolbar to launch the Optimization Parameters window where you can use sliders to manually fine-tune the amount of compression based on the contents of your SWF file. The Flash Optimizer will also compress bitmaps, sounds and even video, all based on individual settings you control!

3 After optimization is complete, the main preview window will be split into 2 previews: the left side provides a preview of your original SWF file and the right side provides the optimized SWF file. Here you can visually compare the differences in optimization before committing to the change.

HOT TIP

To check out more Flash related products visit the Eltima website: www. eltima.com

353

Pimp my Flash

GETTING THE BEST OUT OF FLASH can sometimes mean customizing it to suit your needs.
Since Flash MX 2004 and the introduction to JSFL, many commands and extensions have been
developed to enhance your Flash workflow. From custom JSFL commands to customizing the
panel layout to customizing keyboard shortcuts, Flash can truly be molded into a tool that suits
your personal design and animation preferences.

Many of the available extensions for Flash are installed via the Adobe Extension Manager.
The AEM is installed
along with Flash
CS5 and will launch
automatically when
you double-click
a file with the
".mxp" extension.
Once installation is
complete, Flash will
need to be restarted
before using the
extension. Clicking
once on the name
of each extension
will update the
bottom panel with
a description of

what the extension is designed to do. These descriptions are written by the developers of the
extensions and often include a URL that explains in more detail how the tools can be used
in various workflow environments. In some cases, the developer has links to video tutorials,
extension updates and contact information.

Make sure you check out the extensions available on the source CD. If you don't find a
specific extension you need then feel free to send me an email through my website (*www.
keyframer.com* or *www.mudbubble.com*) and if I have it I will send it to you or point you in the
right direction as to where it can be found online.

David Stiller (*quip.net*):

Apply Motion Tween.jsfl, Apply Shape Tween.jsfl, mudbubble_Pause.mxp, mudbubble_FPSMeter.mxp

Justin Putney (*ajarproductions.com*):

Break text into lines.mxp, Unify Stroke and Fill.mxp, Combine Textfields.mxp, Convert timeline to symbol. mxp, Export as Motion Preset Preview.mxp, FrameSync.mxp, Guide Maker.mxp, Invert Frame Selection.mxp, Move layers to new folder.mxp, Queasy Tools.mxp, Roughen Edges.mxp, Select Empty Layers.mxp, Select Frame Range.mxp, SelectFrames_toStartAndEnd.mxp, Set stage to element size.mxp

Dave Logan (*animatordavelogan.com/extensions/*):

AutoColor.mxp, CreateMaskingLayer.mxp, CustomZoom.mxp, DefaultColors.mxp, FocusLayer.mxp, FrameAllLayers.mxp, KeyAllLayers.mxp, KeyframeJumper.mxp, Label Jumper.mxp, SkipAround.mxp, SquashAndStretch.mxp, SwapColors.mxp, SymbolizeFrames.mxp, ViewLayer.mxp

Dave Wolfe (*toonmonkey.com/extensions.html*):

drawGuide.mxp, frameEdit.mxp, frameExit.mxp, layercolor.mxp, libAppend.mxp, mergeLayers.mxp, MultiSwap.mxp, NewAnimClip.mxp, TimingChart.mxp, toggleGuide.mxp, toggleOutline.mxp, traceSequence.mxp, tween2keys.mxp

Senocular (*senocular.com/flash/extensions/*):

distributetoframes.mxp

..

Some of the JSFL commands on the source CD include a *readme* file to help explain what they do when you run the command. For scripts that will appear as items in the Commands menu, save the JSFL file in the Commands folder in the following location:

Windows XP:

C:\Documents and Settings\user\Local Settings\Application Data\Adobe\ Flash CSX\language\Configuration\Commands

Windows Vista:

C:\Users\user\AppData\Local\Adobe\FlashCS3\language\Configuration\Commands

Mac OS X:

Macintosh HD/Users/userName/Library/Application Support/Adobe/Flash CSX/language/Configuration/Commands

12. What's new in CS6

ADOBE FLASH CS6 introduces some new animation features geared towards game development. The most notable new feature is the Sprite Sheet Generator which allows you to quickly and easily create a sprite sheet from a symbol containing an animation. Another great new feature is the CreateJS extension that exports your Flash animation to the HTML5 /Canvas platform.

This chapter is a brief overview of some of these new CS6 features. To evaluate Flash CS6 for yourself, I recommend downloading the trial version and seeing first hand if CS6 is right for you.

Sprite Sheet Generator

ADOBE FLASH PROFESSIONAL CS6 introduces a new tool called the Sprite Sheet Generator. This feature allows you to generate a sprite sheet from any symbol or image on the stage or in the document Library. Sprite Sheets are an efficient way to add looping animations to games because they can be rendered using the GPU.

This example examines how to convert a looping animation into a sprite sheet using the Flash Sprite Sheet Generator. Flash is one of the best tools for creating interactive content – a groovy crossroad where animation and interactivity purposely collide with beautiful results. If there's one thing I've noticed in the past year, it's been the undeniable shift in web technology. We've all been hearing the term "HTML5" being tossed around and less talk about "Flash". I've even heard people say that HTML5 is going to be the true Flash killer. As an animator I've enjoyed using Flash for well over a decade, but am I worried that the future of Flash is in question? Not at all. No technology lasts forever, but Flash is here to stay at least a while longer. And it's clear Adobe thinks so too. Introducing the Adobe Flash CS6 Sprite Sheet Generator.

1 Before creating the sprite sheet, we'll need an animation. I've chosen to animate a character I designed for the Starling Framework (http://starling-framework.org/).

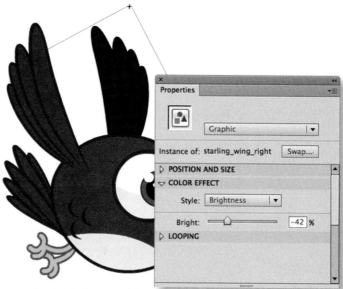

4 I copied the instance of the symbol containing the wing animation and pasted it to a new layer below the body of the bird. I then flipped it horizontally and positioned it for the bird's left wing. To add a slight sense of depth, I selected the instance of this symbol and applied a subtle color effect. Choose Brightness from the Style drop-down menu and lower its value using the slider. The idea here is to darken it slightly to push it back from the rest of the body.

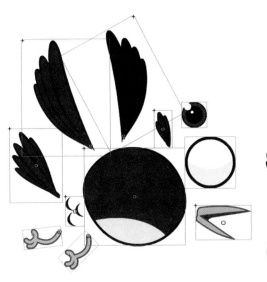

2 The bird avatar for the Starling Framework was conceived using the Adobe Photoshop Touch App, uploaded to the Adobe Creative Cloud and then imported and re-drawn in Adobe Flash Professional CS6. As I drew the bird using Flash's vector tools, I broke down each part into separate assets and converted them to symbols.

3 The next step was to create the wing animation. I double-clicked the wing symbol and animated it using a method known as frame-by-frame animation where each key frame is a new drawing.

5 The entire bird animation was nested inside a Graphic symbol and placed on the main timeline. To generate the sprite sheet, right-click over the symbol instance and choose Generate Sprite Sheet from the popup menu.

6 The alternative way to create a sprite sheet is to right-click over the symbol listed in the Library panel and select Generate Sprite Sheet from the pop-up menu.

HOT TIP

Sprite sheets don't always have to be animations. Many game engines use sprite sheets to load all of the assets that the game requires and in many cases the assets are static objects.

Continued...

Sprite Sheet Generator (cont.)

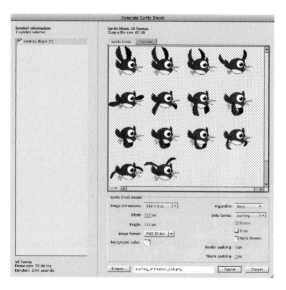

7 The Generate Sprite Sheet will open in its own panel providing several options as to how you can export your sprite sheet.

8 By default the sprite sheet image dimensions are set to "Auto size", but you can customize the dimensions by choosing any of the preset sizes from the Image dimensions drop-down menu.

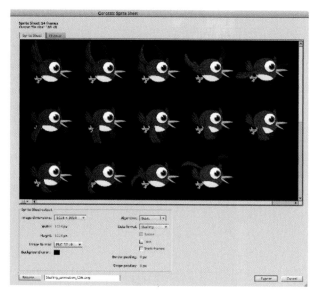

11 Here's the Sprite Sheet panel updated to reflect the new background color change. In most cases you will want a transparent background so that the images can be dynamically "painted" on to any background regardless of their complexity.

12 Click the Algorithm drop-down menu to choose between Basic and MaxRects. The Basic setting is best for simple animations. Sprites are arranged in rows. The MaxRects setting is used to pack the frames more tightly together.

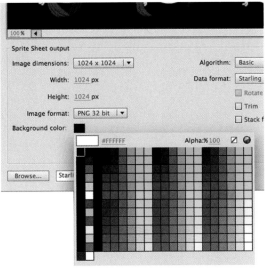

9 From the Image Format drop-down menu, select between PNG 8 bit, PNG 24 bit, PNG 32 bit and JPEG formats. If optimization is a concern, you can choose PNG 8 bit format with transparency to bring the file size down considerably.

10 You can also set a custom background color for your sprite sheet by clicking the Background color swatch and selecting a new color from the palette or mixing your own by clicking the small mixer icon in the upper right corner of the color palette panel.

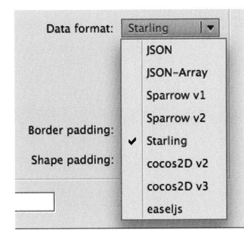

13 The data format describes the x, y, width, height and other info for each frame of animation in the sprite sheet. The developer uses this data to produce an animation from the sprite sheet for whatever framework they are using.

14 You can preview the sprite animation at any time by clicking on the Preview tab above the sprite window. If you haven't already, go to *gamua.com/ starling/* to download the Starling package to your computer. For more information about the Starling Framework and specifically how to incorporate a sprite sheet into a game engine, read Thibault Imbert's article *Introducing the Starling 2D framework* by going to *adobe.com/devnet/flashplayer/articles/introducing_Starling.html*.

CreateJS Extension

UNLESS YOU HAVE LIVED UNDER A ROCK for the past year, you have probably heard the term "HTML5 Canvas" mentioned throughout the web and social media. HTML5 supports the drawing of graphics within a web page using web standards such as JavaScript. The advantage of HTML5 is the support it has with modern day devices such as Apple's iPhone and iPad. Up until Flash CS6 we have never had a way to convert content created in Flash to be supported within the HTML5 Canvas platform. Introducing CreateJS, an extension for Flash CS6 that publishes animations, including tweens, vector shapes and symbols in a single click.

Adobe Creative Suite family /

Flash Professional CS6 / Toolkit for CreateJS

Overview Features Tech specs Reviews FAQ Showcase Buying guide

Flash to HTML5 and the CreateJS toolkit

As devices and platforms multiply, it's more challenging than ever to create expressive content that can reach the widest audience possible. The Adobe® Flash® Professional Toolkit for CreateJS — a complimentary extension available for Flash Professional CS6 users — enables you to leverage the rich animation and drawing capabilities of Flash Professional CS6 while you make the transition to creating HTML5-based content.

Leverage the industry-leading tool for creating animations and interactivity
Many designers are familiar with the Flash Professional authoring environment. The Toolkit for CreateJS will enable you to leverage the core animation and illustration capabilities of Flash Professional, including vectors, bitmaps, classic tweens, and sounds.

Convert your library to JavaScript in one click
Traditionally, interactive designers have leveraged Flash Professional to create assets that target both the Flash Player and Adobe AIR runtimes. With the Flash Professional Toolkit for CreateJS, you can now easily export assets and animations to JavaScript using the open source CreateJS framework. The output generated is nicely formatted, readable, and editable JavaScript code. This can jump start your ability to design highly expressive content that is optimized for the web and mobile.

 Download for Flash Professional Toolkit for CreateJS

A closer look

Video tutorial
Learn about the CreateJS framework and the Adobe Flash Professional Toolkit for CreateJS on Adobe TV.

How-to guide
Visit the CreateJS Developer Center on the Adobe Developer Connection for a series of articles that will help you get started with the CreateJS framework and Toolkit.

FAQ
View the FAQ with information about the Adobe Flash Professional Toolkit for CreateJS.

1 The CreateJS feature in Flash CS6 is actually an extension that needs to be downloaded and installed as it does not ship with the the Flash authoring tool. Open your browser and go to *adobe.com/products/flash/flash-to-html5.html* and click the link to download the CreateJS extension.

2 Locate the downloaded CreateJS extension installer on your local hard drive and double-click it to launch the Adobe Extension Manager. The Extension Manager will walk you through the process of installing the CreateJS extension. You will need to have the Flash CS6 program closed for the install to be successful. Once installed, relaunch Flash CS6. If at any point you want to remove the CreateJS extension or any other installed extension, launch the Extension Manager and select the program from the products section and then select the extension from the extensions list. Click Remove to uninstall the selected extension.

HOT TIP

CreateJS does not embed fonts. If you have fonts in your Flash document you will want to use web safe fonts.

3 For this example I have created a 12-frame animation cycle of a character running. The entire character was created using Flash's drawing tools using all vector strokes, fills and gradient fills. The arms and legs contain nested animations as well.

Continued...

363

CreateJS Extension (cont.)

4 To open the CreateJS panel choose Window > Other Panels > Toolkit for CreateJS.

5 The CreateJS publish command can also be accessed via the Commands menu which means you can assign a keyboard shortcut to publish your Flash content for HTML5 support (you just need to make sure the CreateJS panel is already open).

7 The published folders and files are created in organized fashion in the same directory as the Flash document. From here you can use your preferred HTML editor to open and edit the code to suit your needs. Grant Skinner, the author of the CreateJS extension, provides some detailed information as to how you can add interactivity to your project by editing the HTML file: *adobe.com/devnet/createjs/articles/getting-started.html*

Name
🔳 fighter_runcycle.fla
📄 fighter_runcycle.html
js fighter_runcycle.js
▼ 📁 images
▼ 📁 libs
js easeljs-0.4.2.min.js
js movieclip-0.4.1.min.js
js tweenjs-0.2.0.min.js
▼ 📁 sounds

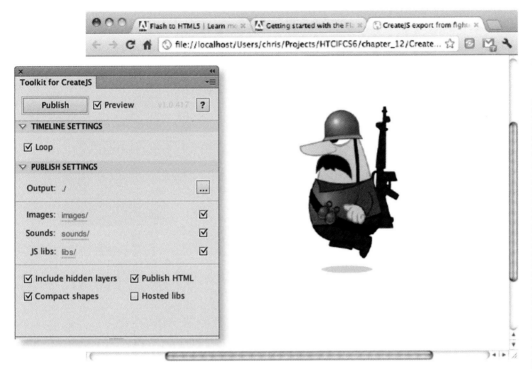

6 Publishing to HTML5 is as easy as clicking the Publish button in the top left corner of the CreateJS panel. If Preview is checked your default browser will automatically open to display the published HTML file and animation. In the CreateJS Publish Settings section you can choose the directory where you want the published files to be created or leave it as is to have the resulting files created in the same directory as the Flash document. By default the Images, Sounds and JS libs options are checked as well as Include hidden layers, Publish HTML and Compact shapes.

8 The CreateJS extension does have its limitations however. The extension does not support custom easing curves, new-style motion tweens (only classic motion tweens), the Bone tool, masks, motion guides or shape tweens. If you have images in your Flash document, CreateJS will export them as JPG or PNG32 format depending on if they contain an alpha channel.

The CreateJS extension for Adobe Flash CS6 is a great way to extend your Flash content beyond the Flash Player. To learn how to incorporate your published content into a game engine visit the following links:

Getting Started with the Flash Professional Toolkit for CreateJS (Grant Skinner)
adobe.com/devnet/createjs/articles/getting-started.html

Getting Started with the Flash Professional Toolkit for CreateJS (video)
tv.adobe.com/show/getting-started-with-flash-professional-toolkit-for-createjs/

Adobe® Flash® Professional Toolkit for CreateJS (PDF)
http://wwwimages.adobe.com/www.adobe.com/content/dam/Adobe/en/products/flash/pdfs/flash-to-html5.pdf

The Future of Flash

SOME OF YOU MAY RECALL the various incarnations of the Flash authoring tool over the past several years. Adobe Systems celebrated the 10 year anniversary of Flash in 2006, and this being the 16th year of Flash, I thought I'd take a trip down Flash memory lane. I assure you my age does qualify me to write about this topic, the proof being every time I find myself perpetually scrolling for the year I was born when filling out online registration forms.

1996: Known as FutureSplash, it was a bare-bone basic graphics editing tool with a simple Timeline. Macromedia bought it and called it Flash 1.0.

1997: Flash 2 was released with the addition of the Library and Symbols (just graphic behavior, the world actually rotated without Movie Clips up to this point).

1998: Flash 3 introduced Movie Clips, dot-syntax style ActionScript, javaScript plugin integration and the stand-alone player. Transparency was also added at this point if I remember correctly.

1999: Flash 4, holy streaming MP3's Batman!

2000: Flash 5 gave us big advances in ActionScript, smartclips and HTML text formatting.

2002: Flash MX came with not only the beginning of what would prove to be 2 years of confusion surrounding its name (why not "Flash 6"?), but also components, streaming video and XML support to name a few.

2003: Flash MX 2004 should have shipped with aspirin due to the headaches we all got trying to explain the meaning behind the name and its version number (why not "Flash 7"?) to newbies over and over and over again. On the flip side it did give us ActionScript 2.0, behaviors, OOP, Media Playback components and more. But then again it did give us the first and only update due to a massive amount of bugs and instability (version 7.2).

2005: Flash 8 brought back the ever popular numerical naming convention. A collective sigh of relief was heard around the world. It also included filters, blend modes and a higher quality video codec.

2007: Flash CS3 Professional (acquired by Adobe Systems Inc. and integrated into their Creative Suite). The new features consisted of Adobe Photoshop® and

Illustrator® importers (huge!), the ability to convert animation to ActionScript, the Adobe Creative Suite user interface, ActionScript 3.0, an advanced debugger, Device Central, additional drawing tools, interface components, QuickTime Exporter and more video and coding tools.

2008: Flash CS4 Professional gave us a new Motion tween model in addition to the Classic method of tweening. Both have their advantages and disadvantages but were most useful when combined. The Motion Editor made its debut as did Motion Tween Presets. We finally got Inverse Kinematics but are still waiting for it to fully mature. Animating 2D objects in 3D space was made possible with the 3D Transformation tool. The Deco tool made its debut as did the Adobe Kuler panel, a vertical Properties panel, an improved Library panel and H.264 support for video files.

2010: Flash Professional CS5 offered us the Spring feature inside the Bone tool, Code Snippets, a new text rendering engine, iPhone application support, XFL and FXG file format support among other things.

2011: Flash Professional CS5.5 gave us the ability to copy and paste layers, the ability to scale content when changing the stage size, export and convert symbols to bitmaps for better performance on mobile devices as well as a few other features.

2012: Flash Professional CS6, most notably the Sprite Sheet Generator and the CreateJS extension for publishing Flash content to HTML5.

So what's next? As an animation tool, Flash still has room for improvement. I don't feel Flash suffers from lack of features but rather a lack of improvements to existing ones. Let's hope for an improved Bone tool and a simplified, single Motion tween model that encompasses both object and frame-based features. Let's integrate the Motion Editor into the Timeline and let's combine Movie Clips and Graphic symbols into a single entity that supports ActionScript, Filters and Blend Modes.
Regardless of whether or not these features see the light of day, the Flash team is a truly dedicated group of individuals who work very hard to provide us with the tools we have grown to love. I thank you.